C000129897

JAMES ROSENQUIST
PAINTING AS IMMERSION

Museum Ludwig, Cologne
ARoS Aarhus Kunstmuseum

PRESTEL
Munich · London · New York

JAMES ROSENQUIST

Edited by Stephan Diederich and Yilmaz Dziewior

PAINTING AS IMMERSION

Jim often compared his approach to art-making to Thelonius Monk's method of music-making: "All ways *always*." This exhibition shares that spirit and reveals Jim's ability to stretch scale and expand time and space in order to extend our dimensional world. The Rosenquist family and Rosenquist Studio thank Yilmaz Dziewior, Stephan Diederich, and the entire Museum Ludwig staff for creating this wonderful exhibition. Jim was very happy that these works would be shown, and we are glad his spirit continues in the Museum Ludwig galleries, and later in those of ARoS Aarhus Kunstmuseum.

Mimi Thompson Rosenquist

Foreword

In 1972 the Josef-Haubrich-Kunsthalle in Cologne hosted the first large exhibition of the works of James Rosenquist in Germany. With *Rainbow, Untitled (Joan Crawford Says . . .), Forest Ranger, Horse Blinders*, and *Star Thief*, the Museum Ludwig is home to several of the artist's essential artworks. And in 2004, when ARoS Aarhus Kunstmuseum opened its new museum with a show titled *Pop Classics*, featuring the collection of Peter and Irene Ludwig, Rosenquist's works from Cologne were among the highlights in Aarhus. In 2016 James Rosenquist's *Passion Flower* was donated to ARoS by The Merla Art Foundation / Dennis and Jytte Dresing Collection. We are pleased that the exhibition *James Rosenquist: Painting as Immersion,* conceived by the Museum Ludwig, will also travel to ARoS and the works can now be presented in both places, firmly embedded in his impressive oeuvre.

This is the first show to exhibit the works of this prominent American Pop artist in a comprehensive context, which includes their cultural, social, and political dimensions. By displaying them with source materials— some of which have never been shown in public—as well as with collages identified by the artist as "sources," and with many of the original advertisements from old *Life* magazines that form the basis of these works, a historical universe is thoroughly explored and visualized—for a great many of James Rosenquist's innovative images spring from his marked interest in the social and political events of his time.

A good example of this is the impressive installation *F-111*, a Pop-era icon. Rosenquist made it in 1964—65, during one of the most politically turbulent years in the United States. His main motif is the F-111 fighter plane—at the time, the latest in high-technology weaponry—combined in a disturbing way with images of everyday American consumerism. The painting surrounds viewers on all sides. Reflected in built-in aluminum panels, they themselves become part of the work and are immediately challenged to question what they see. Along with this key work from the collection of the Museum of Modern Art, the show also features *Horse Blinders* (1968—69) and *Horizon Home Sweet Home* (1970); this is the first time that all three installations Rosenquist made for the legendary Leo Castelli Gallery will be on display together.

Rosenquist's attempt to draw viewers into the image, to involve them visually, physically, emotionally, and intellectually, is also expressed in a three-part ensemble of works called *The Swimmer in the Econo-mist*, which Rosenquist made in 1997—98 for Deutsche Guggenheim in Berlin. Picasso's *Guernica* and other stock images from his own and our collective history and identity are captured in the more than twenty-seven-meter-long main painting, resulting in an unsettling vortex of time periods that visualizes rapid changes in identity—and not only German identity.

The exhibition revolves around the central aspect of "painting as immersion," as the artist himself calls it, and at the same time, it offers a broad overview of Rosenquist's oeuvre. The collage-like paintings from the 1960s—in which Rosenquist's background as a painter of enormous billboards in Times Square is clearly articulated—are featured alongside biographically motivated images from the 1970s and his work on cosmic spatial phenomena in his later, large-format paintings.

Rosenquist himself authorized the concept and the selection of pieces for this show, and accompanied the process of developing it from the very beginning. Now, this large museum exhibition pays tribute to the artist, who died on March 31, 2017. Besides the works from the Museum Ludwig collection and the generous loans from James Rosenquist's studio, important works from the following museums and institutions will also be on display: the Dallas Museum of Art; the Sammlung Deutsche Bank, Frankfurt am Main; the Tate, London; the Museum of Contemporary Art, Los Angeles; the Walker Art Center, Minneapolis; the Museum of Modern Art, New York; the Solomon R. Guggenheim Museum, New York; Centre Pompidou, Musée national d'art moderne / Centre de création industrielle, Paris; the Philadelphia Museum of Art; the Andy Warhol Museum, Pittsburgh; the Saint Louis Art Museum; Moderna Museet, Stockholm; and Yale University Art Gallery, New Haven. Furthermore, loans from the McCormick Gallery / Art Enterprises, Chicago; the Simon Lee Gallery, London; Acquavella LLC, New York; Pace Gallery, New York; and the Galerie Thaddaeus Ropac, Paris have made considerable contributions to the show's success. Private lenders include Ricard Akagawa, São Paulo; William Kistler, New York; Barbara and Richard Lane, New York; the collection of Ekaterina and Vladimir Semenikhin; and others who would like to remain anonymous. We are very grateful to all who loaned their works in support of this ambitious project.

Stephan Diederich and Yilmaz Dziewior curated the show and were kindly aided throughout the planning process by the Rosenquist Studio. Lise Pennington curated the Danish version of the show with Anne Mette Thomsen. Thanks go to the catalogue's authors for their interesting and informative texts. The graphic conception and design for the catalogue was in the competent hands of Tino Grass, who went far beyond the call of duty to assist us in our project. Leonie Pfennig was responsible for editing the texts and photographs. We also thank Simone Schmahl and Talia Walther for their multifaceted work in research and preparation. Christin Wähner was responsible for the complex management of loans. All departments of the Museum Ludwig, including administration, registration and tour management, fundraising, press and public relations, conservation, carpentry, technical management were involved in this ambitious exhibition in manifold ways. All who have contributed to the realization of the catalogue and the exhibition deserve our sincere thanks.

We would not have been able to realize this ambitious exhibition without substantial financial support. Here, our thanks go to the Peter and Irene Ludwig Foundation, namely Brigitte Franzen and Isabel Pfeiffer-Poensgen. As a reliable partner of the Museum Ludwig, the Foundation has generously supported the current show, which features an artist who is so very important to the Ludwigs' collection. We are also greatly obliged to the Terra Foundation for American Art, which has already provided the Museum Ludwig with essential assistance for previous large exhibitions of American art, and has now done so once again for the Rosenquist exhibition in Cologne and Aarhus. For committing itself to this project in an extraordinary fashion, we thank the Gesellschaft für Moderne Kunst at the Museum Ludwig. Our particular gratitude goes to the board, especially chairwoman Mayen Beckmann, and the management, particularly Carla Cugini. We would like to extend our sincerest thanks to a number of members for their additional commitment in funding the exhibition and the catalogue: Marie-Luise Becker, Gabriele Bierbaum, Jennifer Brügelmann, Sabine Crasemann, Heidi and E. W. Graebner, Kathrin and Karl-Eriwan Haub, Gabriele and Karl-Dieter Kortmann, Paul Köser, Hendrina and Karl Adolf Krawinkel, Irmgard and Robert Rademacher, RheinEnergie AG, Ringier Collection, Jörg Rumpf, Sparkasse KölnBonn (funding from special-purpose revenue of the "Save and Win" Lottery of the Rhineland Association of Savings Banks), Stiftung Storch, Karin and Dr. Rolf Wickenkamp, and further members of the Gesellschaft für Moderne Kunst at the Museum Ludwig, who wish to remain anonymous.

We also would like to thank Thaddaeus Ropac for his support. The elaborate restoration of the *Horse Blinders* environment, which was necessary before the exhibition could be undertaken, was made possible by the Ministry of Culture and Science of the State of North Rhine-Westphalia as part of the conservation program for visual arts and by the Wüstenrot Foundation, and for that we thank them heartily. The conservation work was professionally conducted by Isabel Gebhardt, Sandra Schäfer, Diana Blumenroth, and Sarah Grimberg. Everyone involved deserves our deepest thanks.

Special thanks go to Sarah C. Bancroft, Michael Harrigan, and Kevin Hemstreet, as well as to the entire team at the artist's studio. Our greatest thanks go to James Rosenquist in respectful remembrance, as well as to Mimi Thompson Rosenquist for her faith in us and for her constructive and pleasant cooperation. Without her kind and competent support, it would not have been possible to realize this project in its current form.

Yilmaz Dziewior
Director, Museum Ludwig

Erlend G. Høyersten
Director, ARoS Aarhus Kunstmuseum

Contents

Works

1 **Astor Victoria**, 1959
 Billboard enamel and oil on canvas
 67 × 82 ½ in. (170.2 × 209.6 cm)
 Estate of James Rosenquist

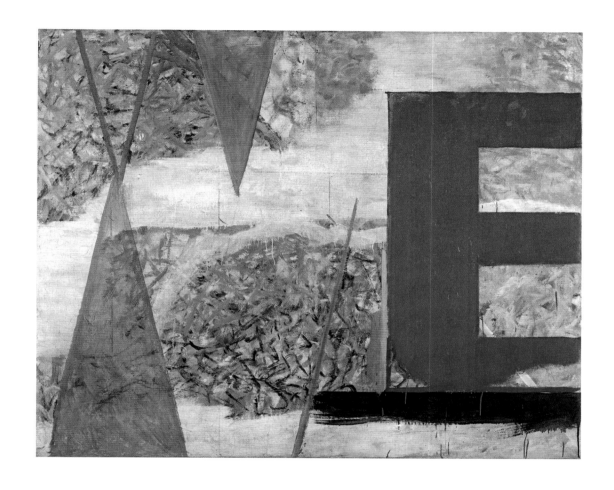

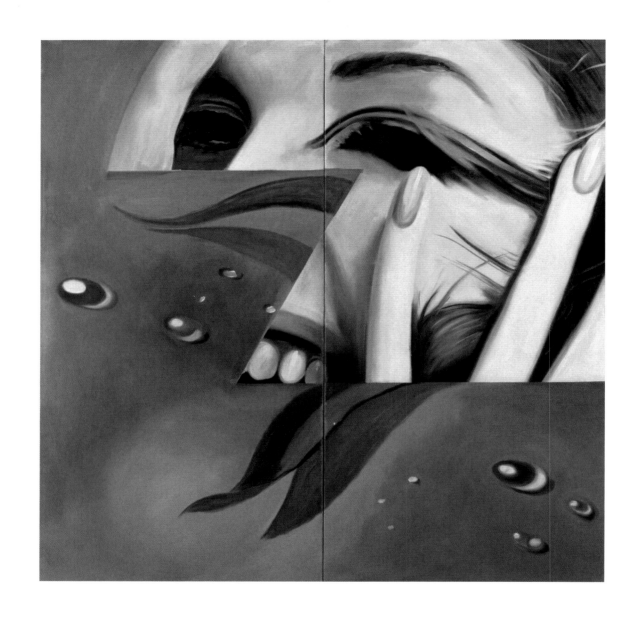

2 **Zone**, 1960–61
Oil on canvas
95 ¼ × 96 ½ in. (241.9 × 245.1 cm)
Philadelphia Museum of Art,
Purchased with the Edith H. Bell Fund, 1982

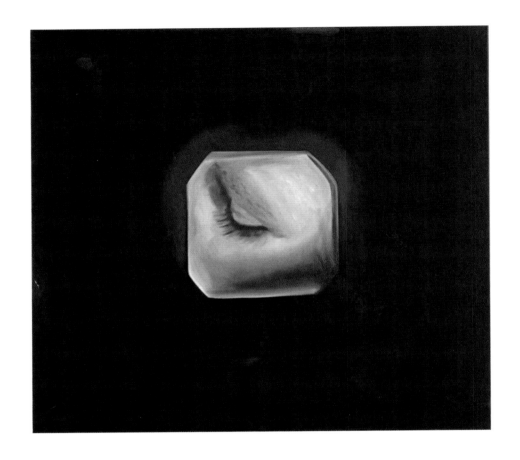

3 **Exit**, 1961
 Oil on canvas
 30 ⅛ × 33 in. (76.5 × 83.8 cm)
 Collection Barbara & Richard S. Lane

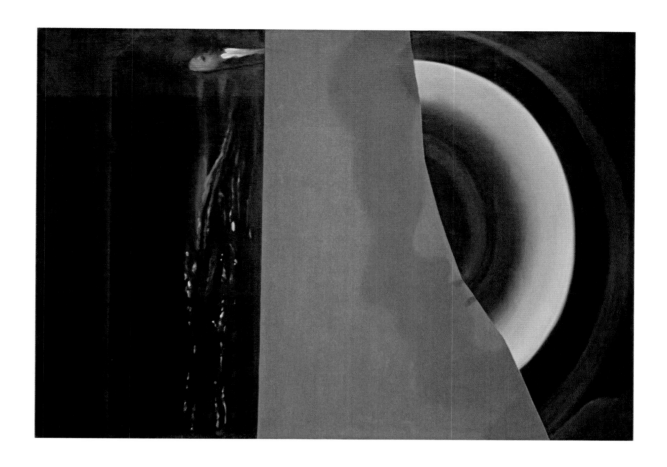

4 **Shadows**, 1961
Oil on canvas
68 × 96 in. (172.7 × 243.8 cm)
Estate of James Rosenquist

5 **Rainbow**, 1961
Oil on canvas and glass, with painted wood
47 13/16 × 60 ¼ in. (121.5 × 153 cm)
Museum Ludwig, Cologne,
Donation from the Ludwig Collection 1976

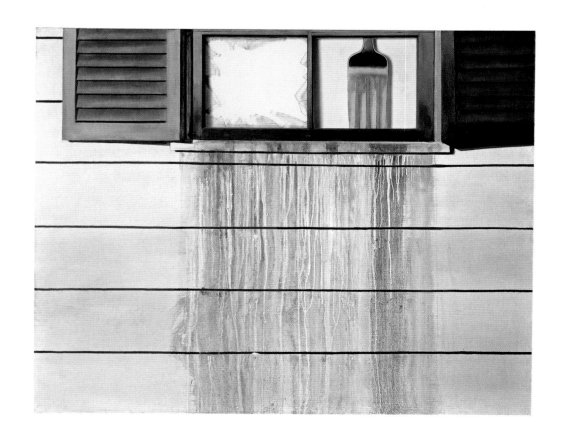

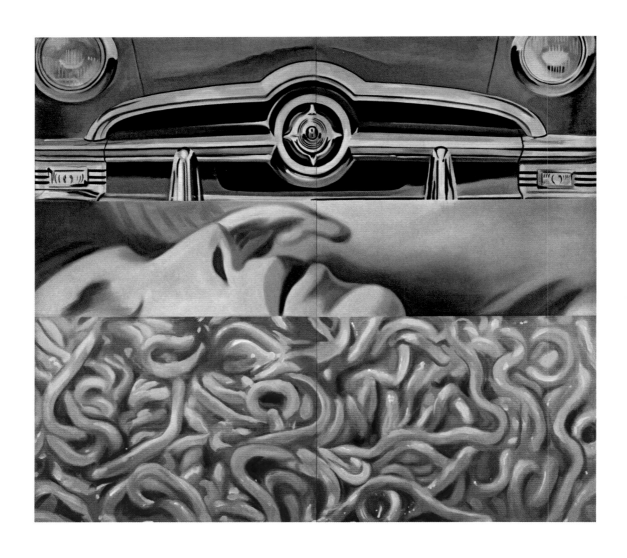

6　**I Love You with My Ford**, 1961
Oil on canvas
82 ¾ × 93 ½ in. (210.2 × 237.5 cm)
Moderna Museet, Stockholm

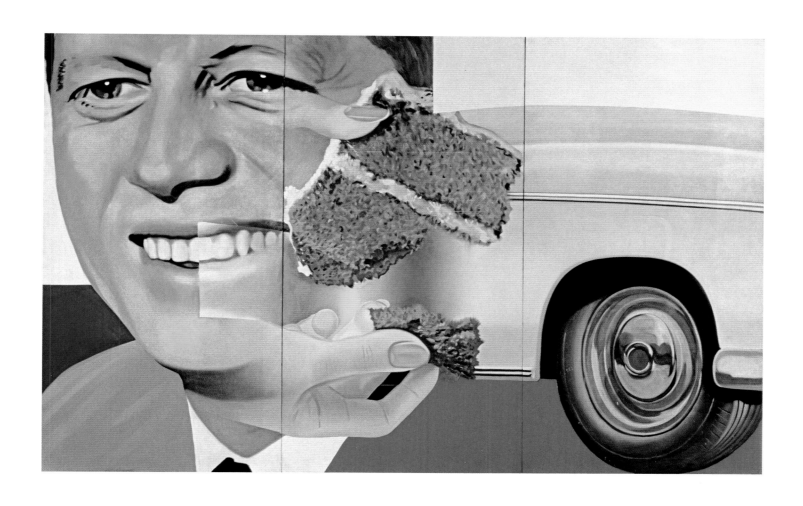

7 **President Elect**, 1960–61/1964
Oil on Masonite
7 ft. 5 ¾ in. × 12 ft. (228 × 365.8 cm)
Centre Georges Pompidou, Musée national d'art moderne /
Centre de création industrielle, Paris

8 **Hey! Let's Go for a Ride**, 1961
Oil on canvas
34 ⅛ × 35 ⅞ in. (86.7 × 91.1 cm)
Private collection

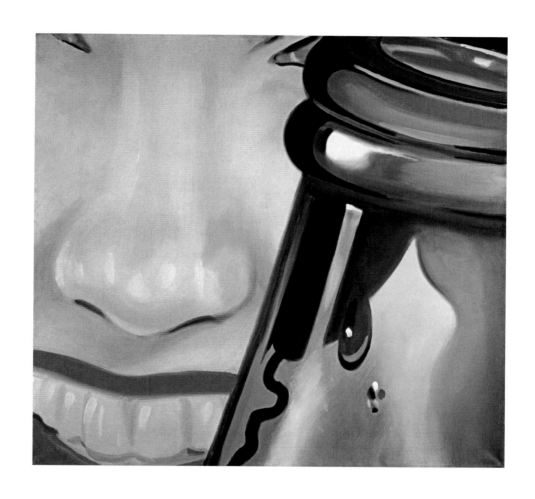

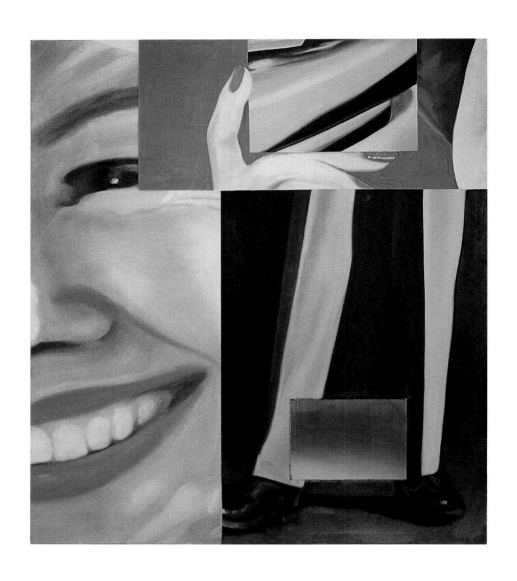

9 **Look Alive (Blue Feet, Look Alive)**, 1961
Oil on canvas, with mirror
67 × 58 ½ in. (170.2 × 148.6 cm)
Private collection

10 **Noon**, 1962
 Oil on canvas, with battery-operated light and flashlight reflector
 36 × 48 ¼ in. (91.4 × 122.6 cm)
 The Museum of Contemporary Art, Los Angeles,
 The Panza Collection

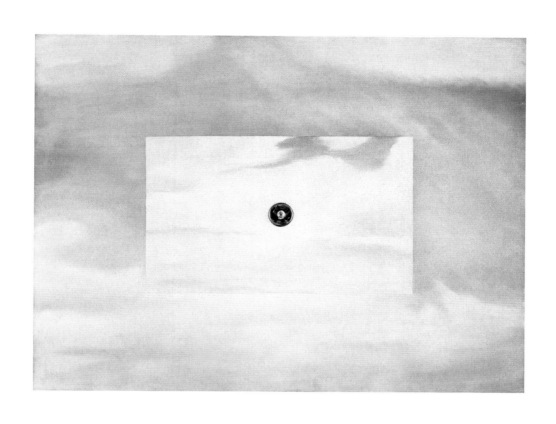

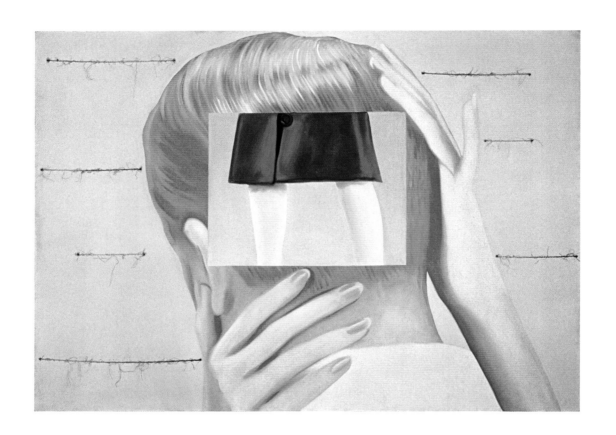

11 **Waves**, 1962
Oil on canvas and twine
56 ⅛ × 78 in. (142.6 × 198.1 cm)
The Museum of Contemporary Art, Los Angeles,
The Panza Collection

12 **Sightseeing**, 1962
Oil on canvas and glass, with painted wood and metal hardware
48 × 60 in. (121.9 × 152.4 cm)
The St. Louis Art Museum,
Purchase with funds given
by the Shoenberg Foundation, Inc.

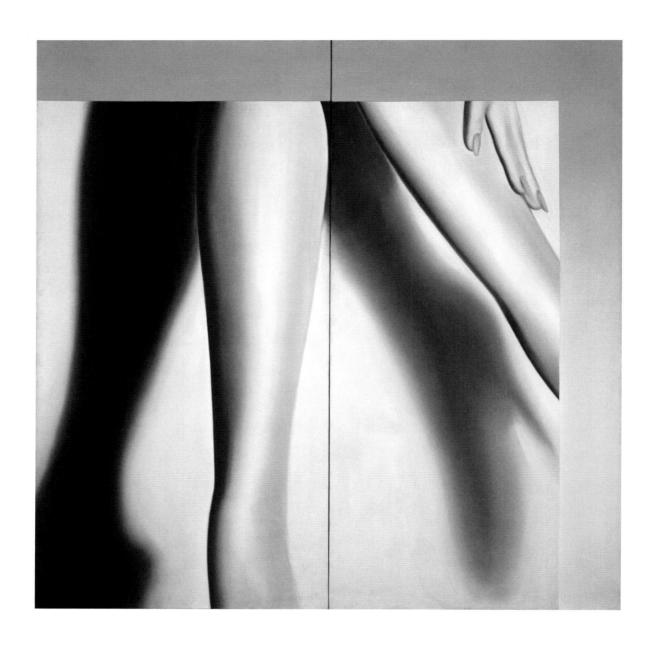

13 **Above the Square**, 1963
Oil on canvas
84 × 84 in. (213.4 × 213.4 cm)
Private Collection, Courtesy Acquavella Galleries

14 **Untitled (Joan Crawford Says…)**, 1964
Oil on canvas
92 × 78 in. (233.7 × 198.1 cm)
Museum Ludwig, Cologne,
Donation from the Ludwig Collection 1976

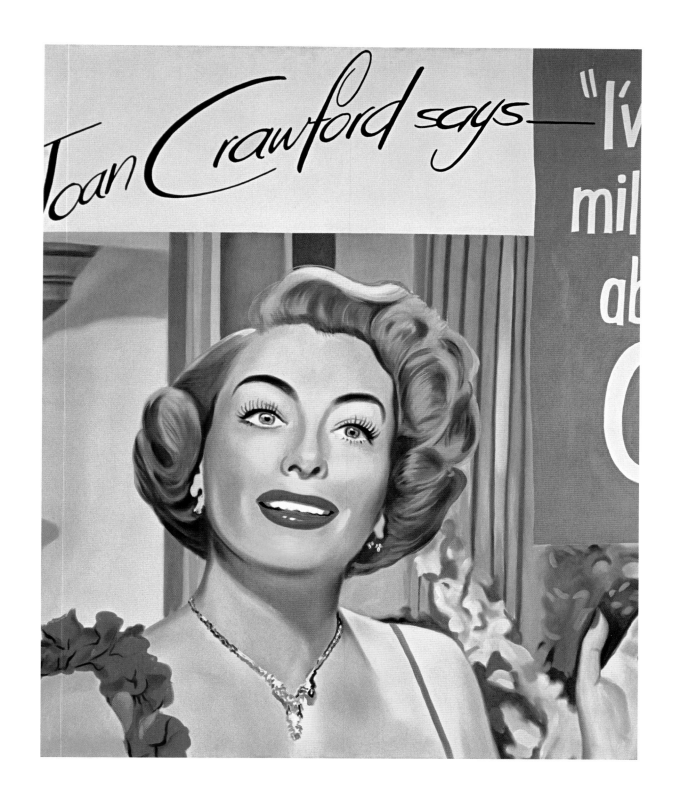

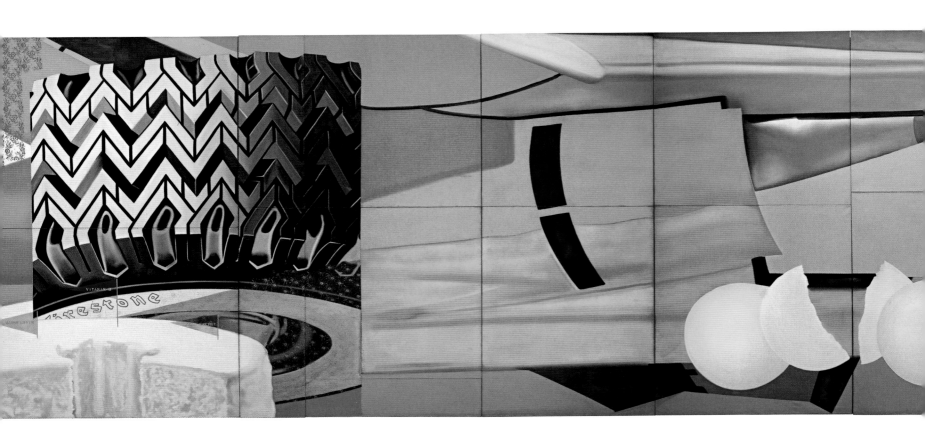

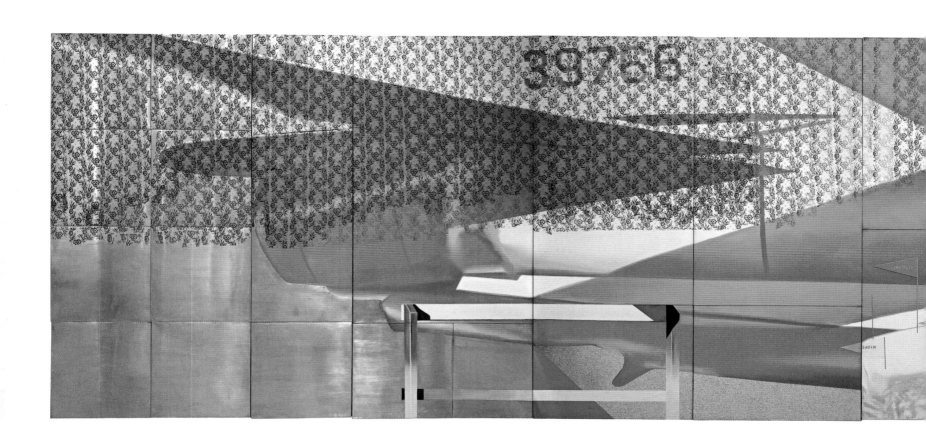

15 Previous spread: Installation view of *F-111* at Leo Castelli Gallery, 1965

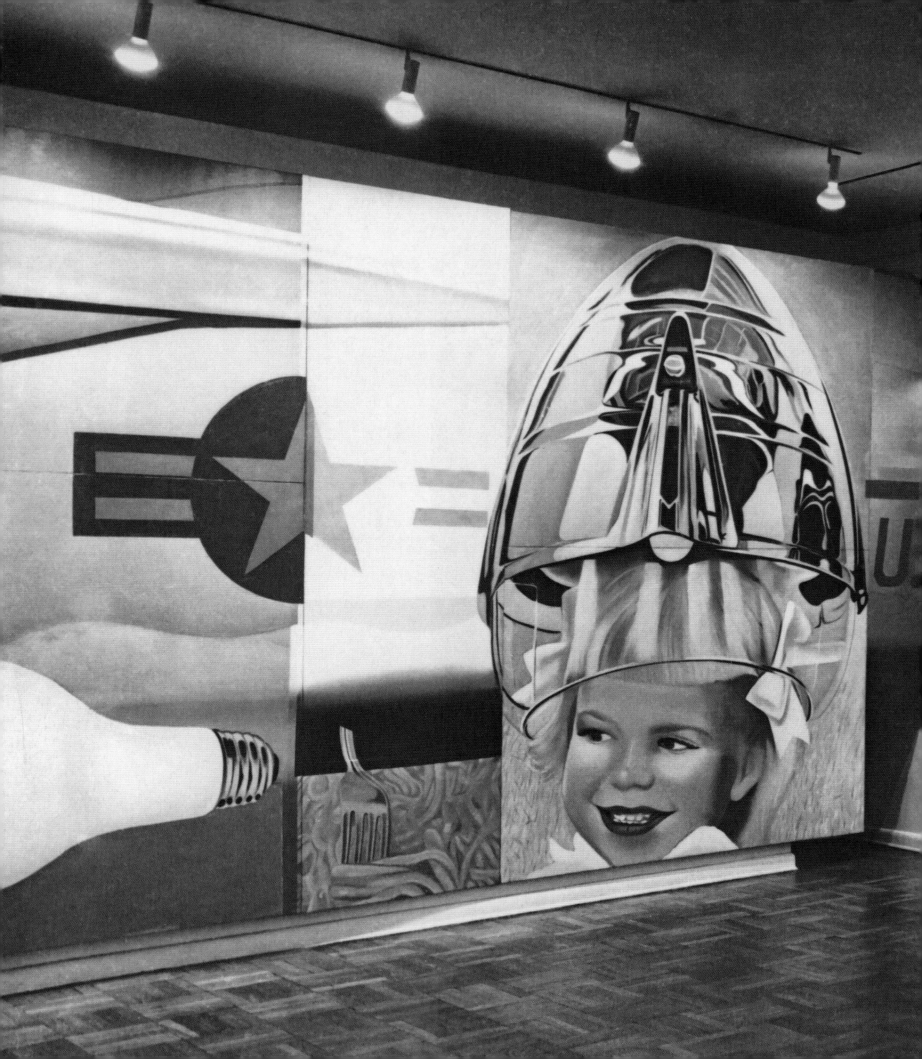

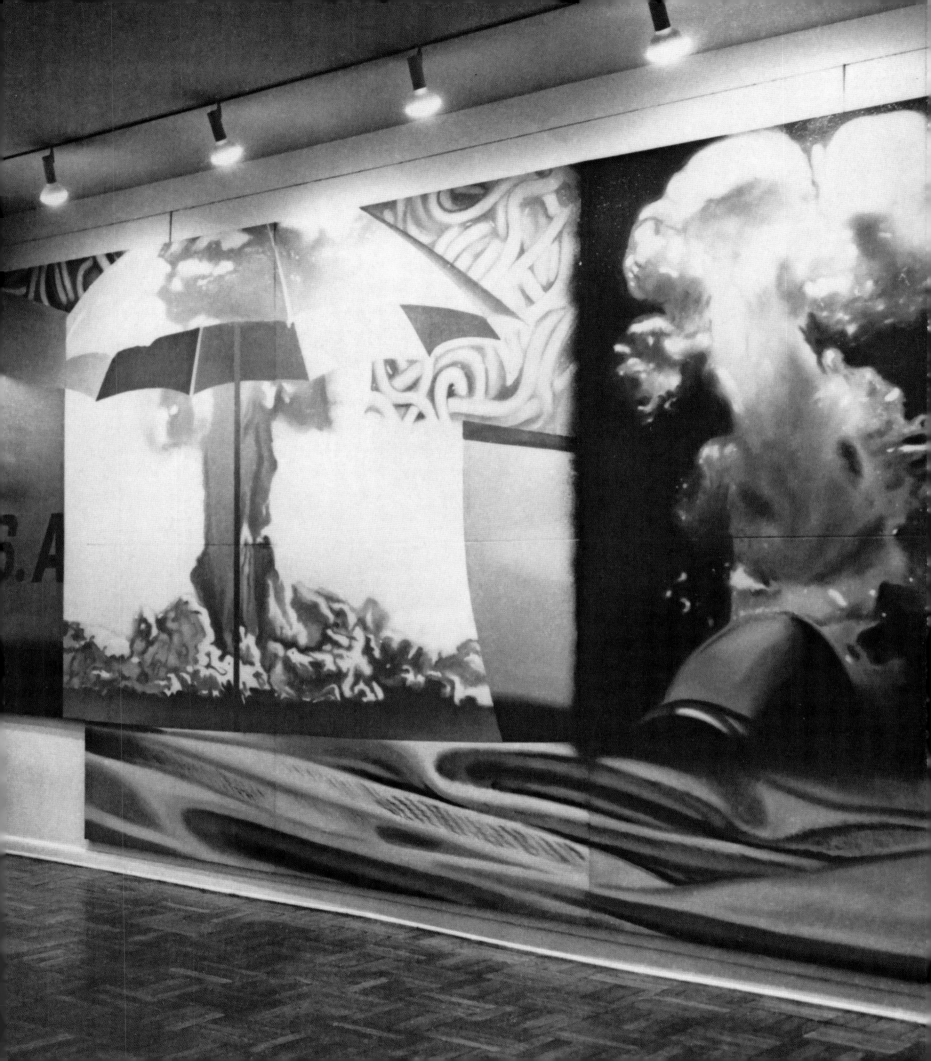

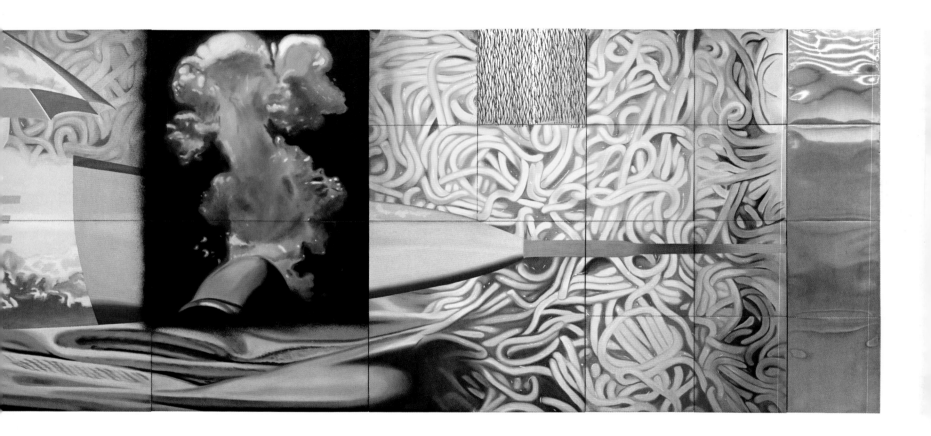

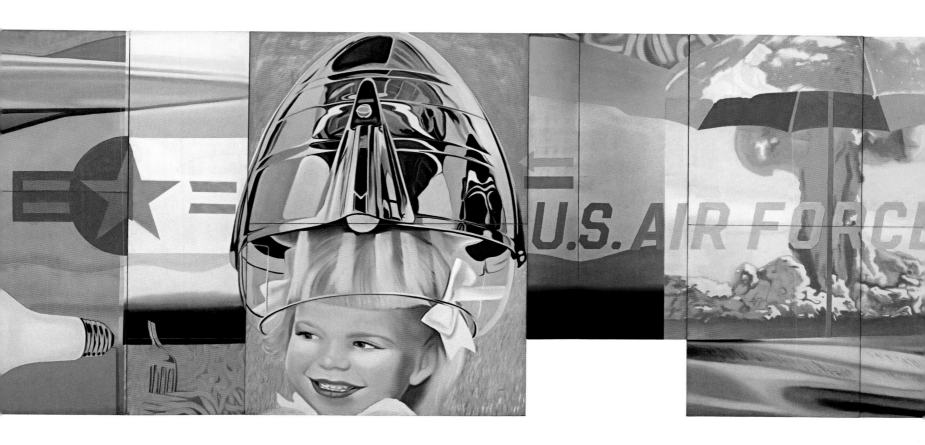

16 **F-111**, 1964—65
Oil on canvas and aluminum (multipanel room installation)
10 × 86 ft. (304.8 × 2621.3 cm)
The Museum of Modern Art, New York,
Purchase Gift of Mr. And Mrs. Alex L. Hillman
and Lillie P. Bliss Bequest (both by exchange), 1996

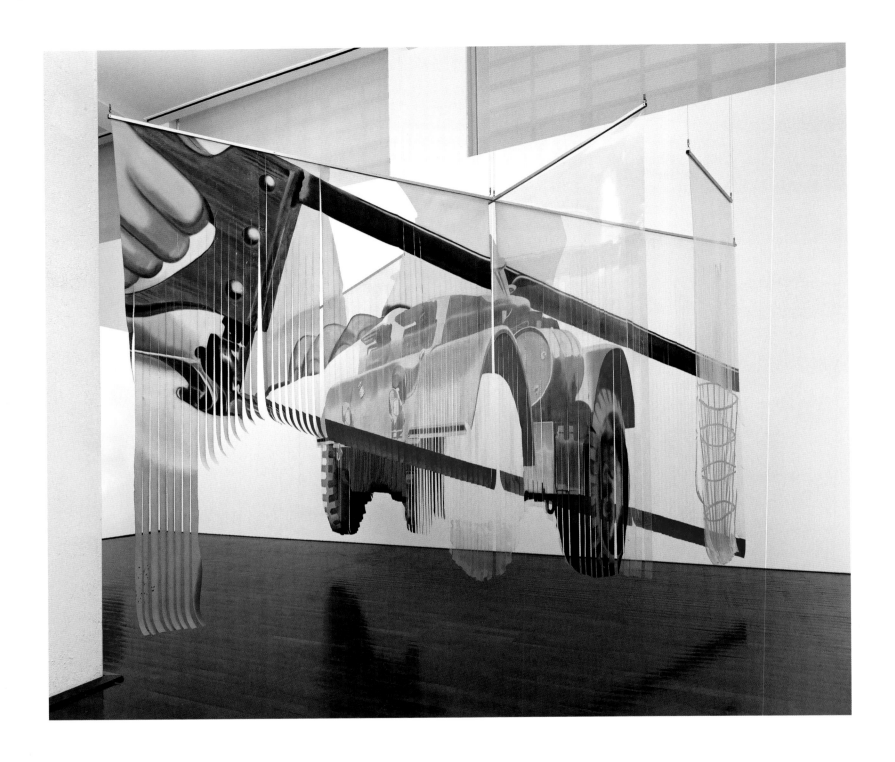

17 **Forest Ranger**, 1967
Oil on slit and shaped Mylar
Two intersecting panels, each ca. 9 ft. 6 in. high (289.6 cm)
Museum Ludwig, Cologne,
Donation from the Ludwig Collection 1976

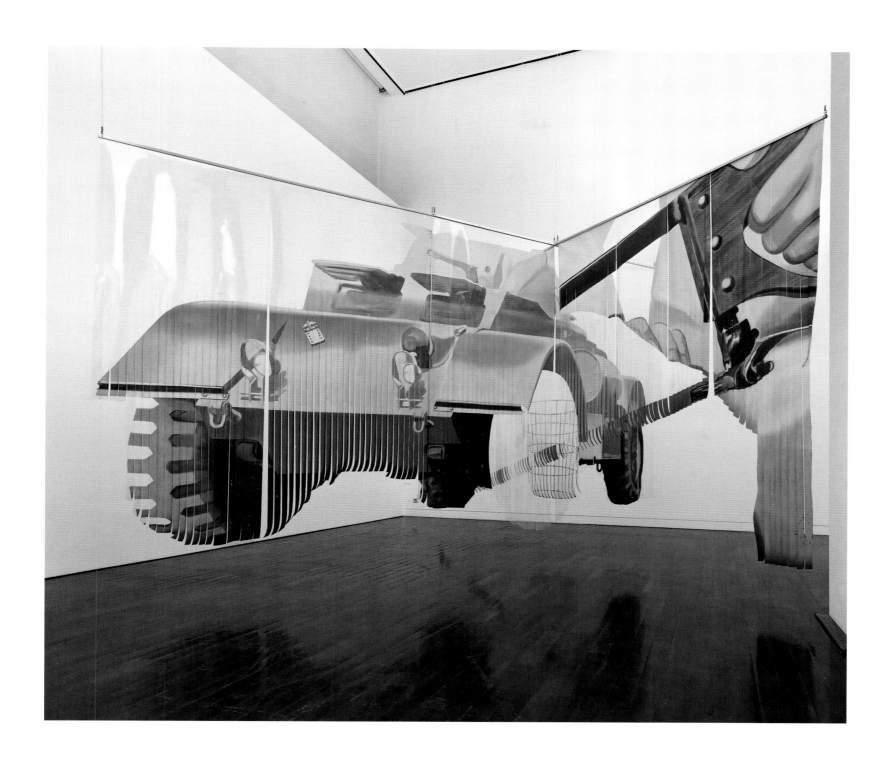

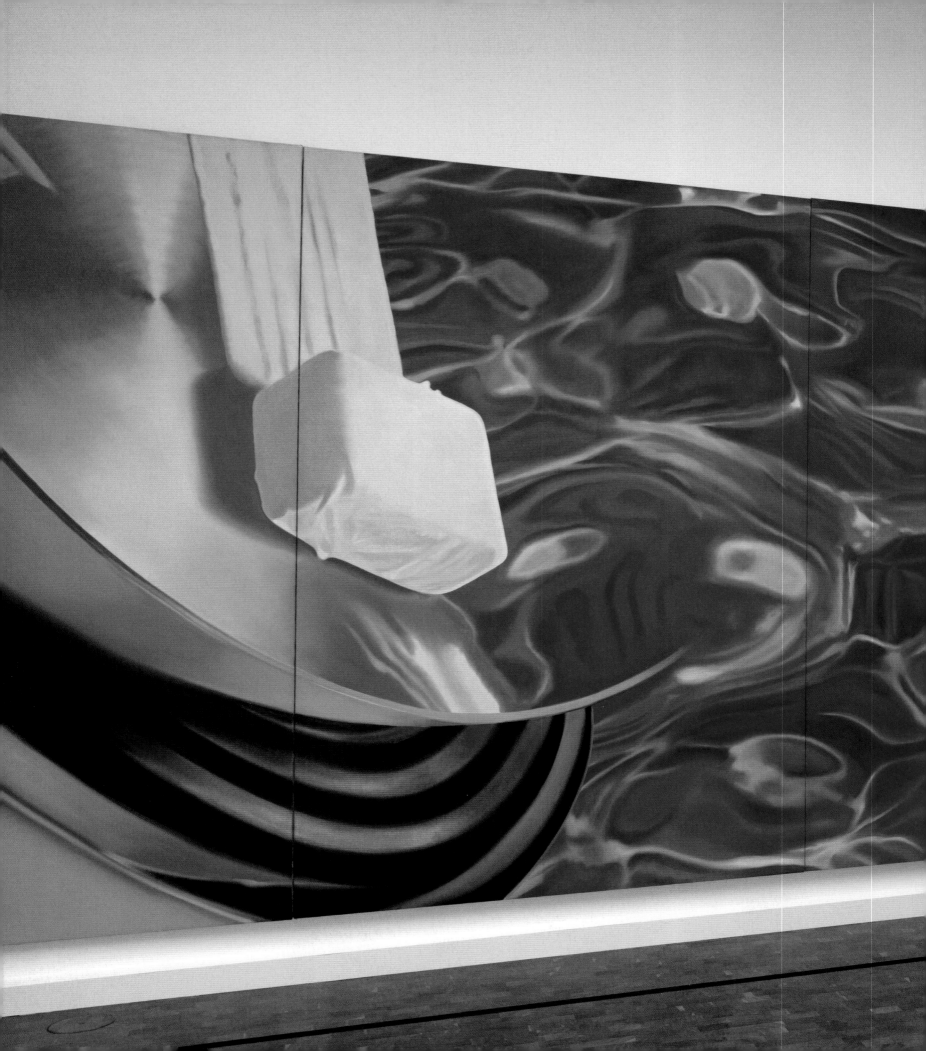

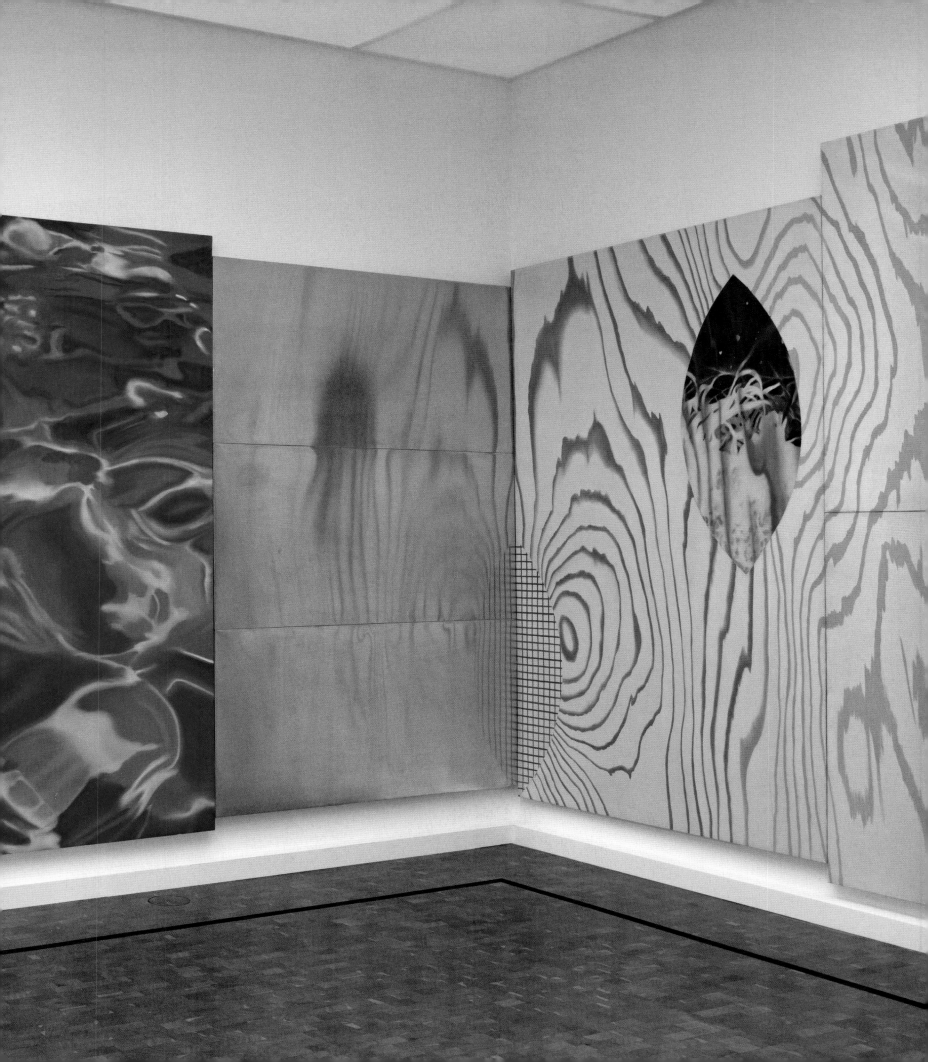

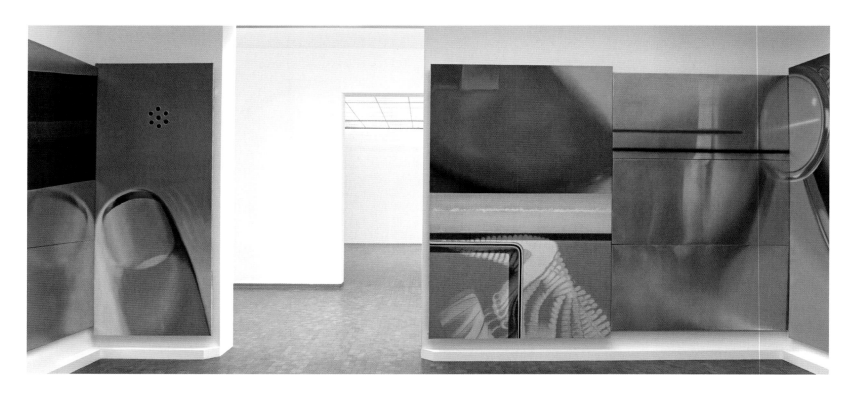

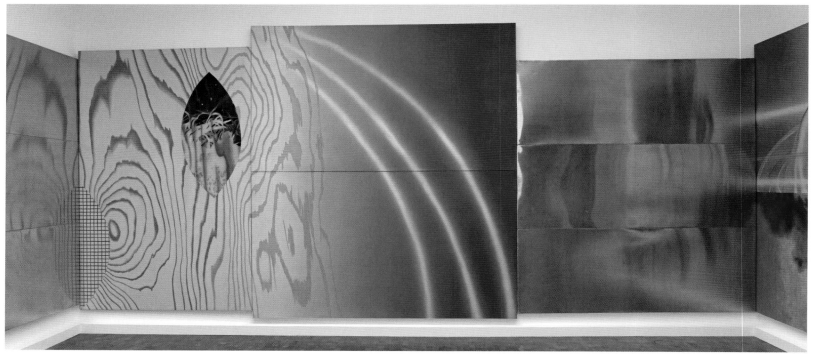

18 **Horse Blinders**, 1968–69
Oil on canvas and aluminum (multipanel room installation)
10 ft. × 84 ft. 6 in. (304.8 × 2575.6 cm)
Museum Ludwig, Cologne,
Donation from the Ludwig Collection 1976

19 Previous spread: Installation view at Museum Ludwig, Cologne,
James Rosenquist: Painting as Immersion, 2017

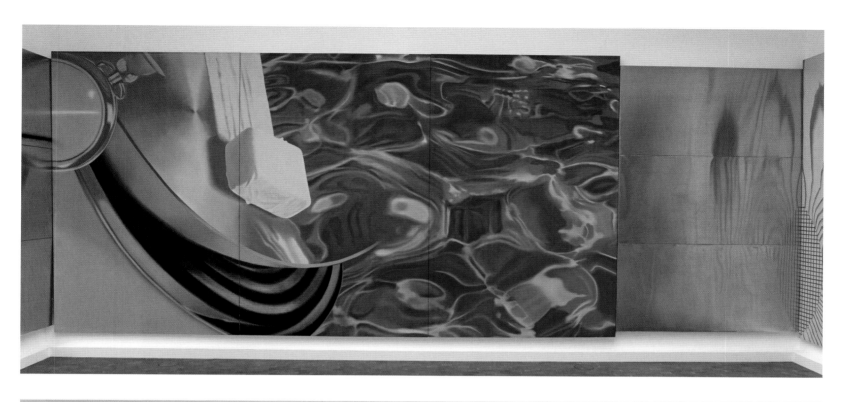

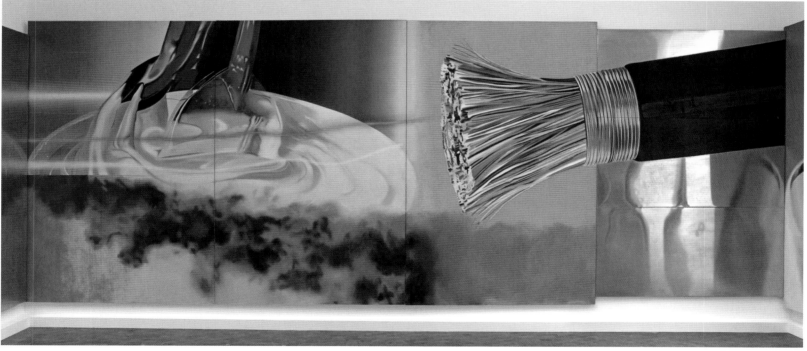

Next spread:

20 **Horizon Home Sweet Home**, 1970
Oil on canvas, with aluminized Mylar and dry ice fog (multipanel room installation)
27 panels, each ca. 8 ft. 6 in. × 3 ft. 4 in. (259.1 × 101.6 cm)
Estate of James Rosenquist

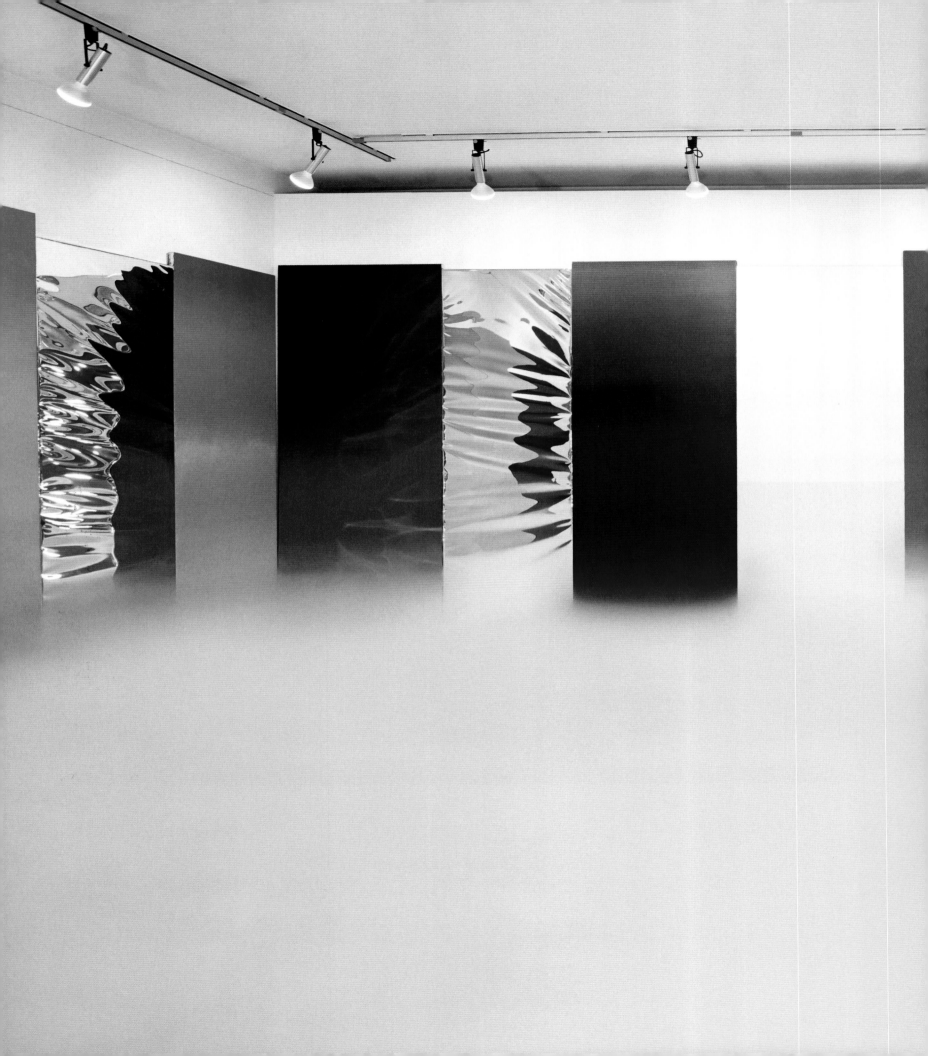

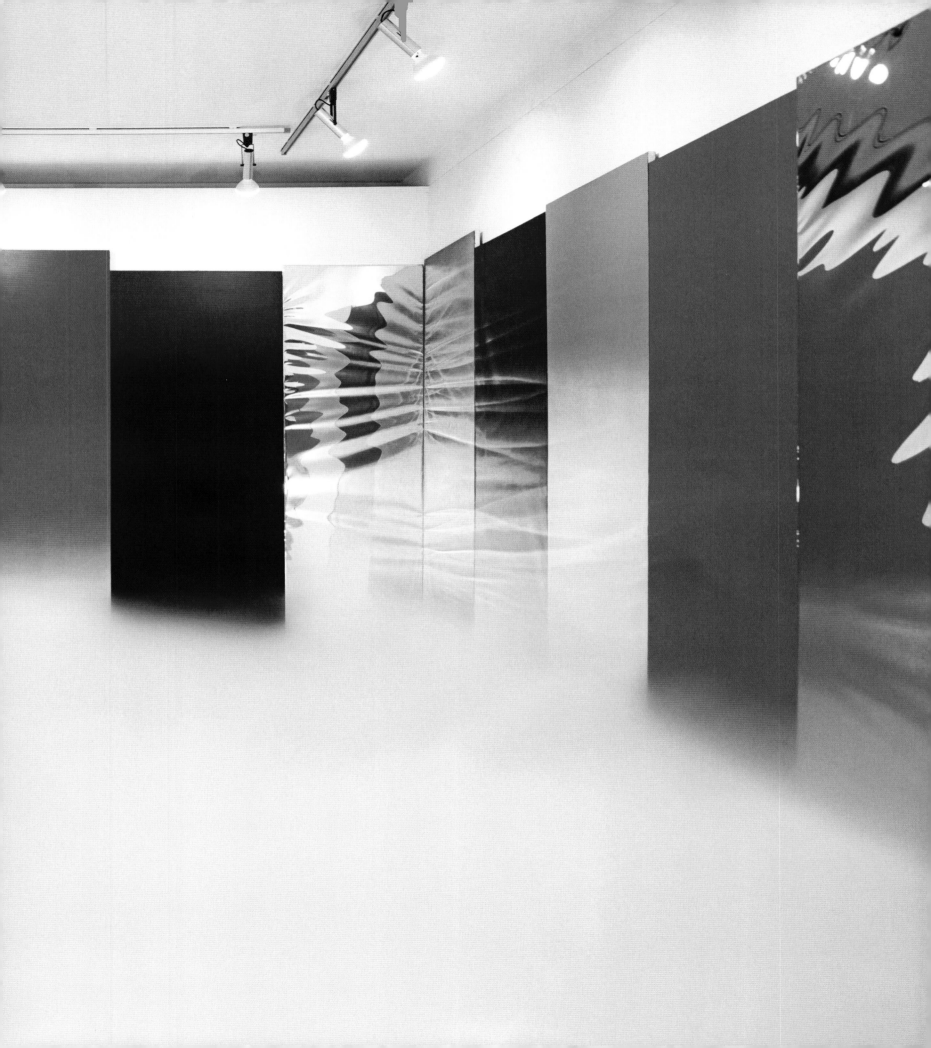

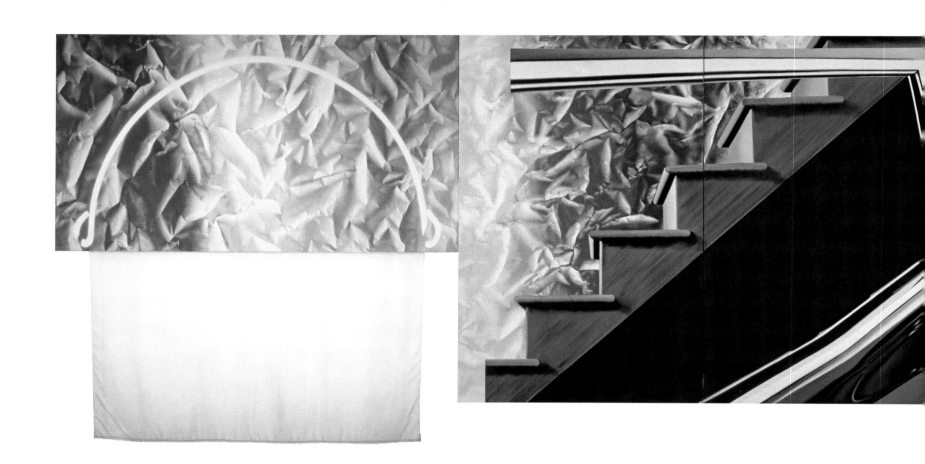

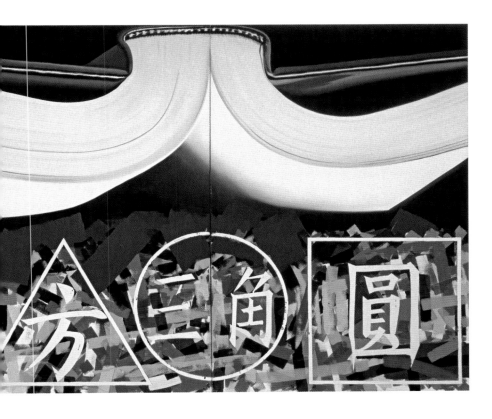

21 **A Pale Angel's Halo** and **Slipping Off the Continental Divide**, 1973
Acrylic on canvas, with marker on fabric; oil and acrylic on canvas
9 ft. 5 in. × 9 ft. (287 × 274.3 cm); 8 ft. 6⅛ in. × 21 ft. 11¼ in. (259.4 × 668.7 cm);
overall size: 9 ft. 5 in. × 30 ft. 11¼ in. (287 × 943 cm)
Estate of James Rosenquist

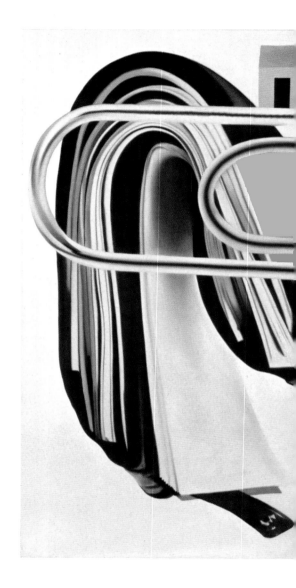

22 **Paper Clip**, 1973
Oil and acrylic on canvas
8 ft. 6 ¼ in. × 18 ft. 8 in. (259.7 × 569 cm)
Dallas Museum of Art,
Gift of The 500, Inc., Elizabeth B. Blake,
Mr. and Mrs. James H. W. Jacks, Mr. and Mrs. Robert M. Meltzer,
Mr. Joshua Muss, Mrs. John W. O'Boyle, Dr. Joanne Stroud,
and two anonymous donors in honor of Robert M. Murdock

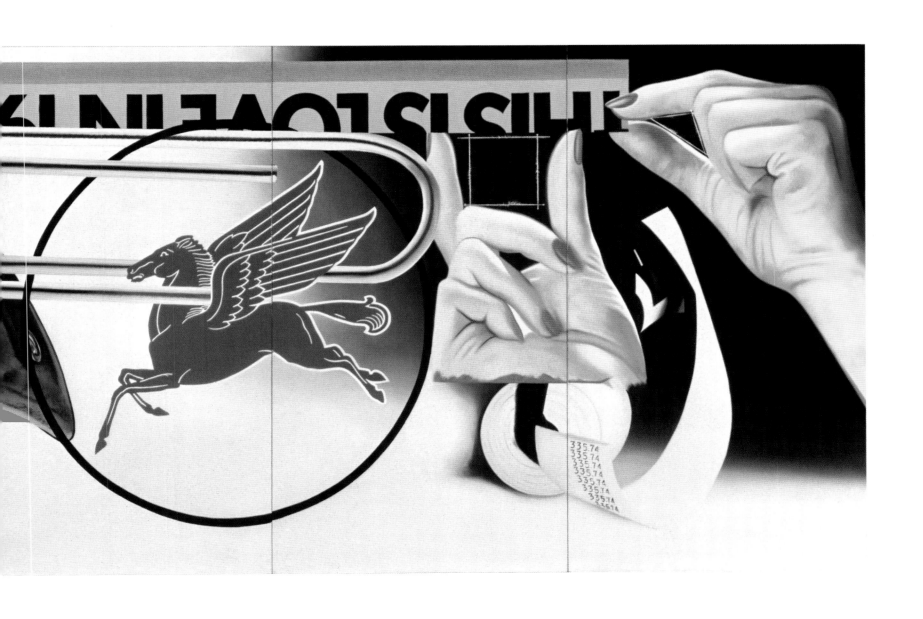

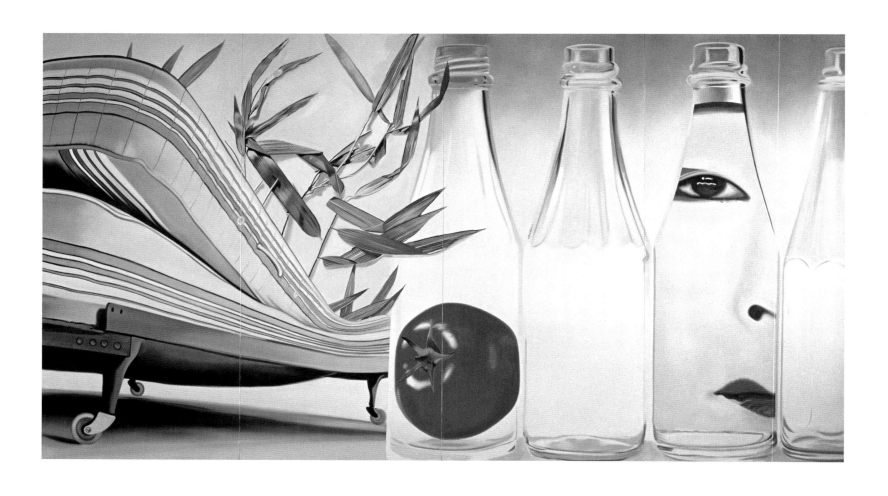

23 **Terrarium**, 1977
Oil on canvas
6 ft. 9 ¼ in. × 12 ft. 3 in. (206.4 × 373.4 cm)
Courtesy of Ricard Akagawa

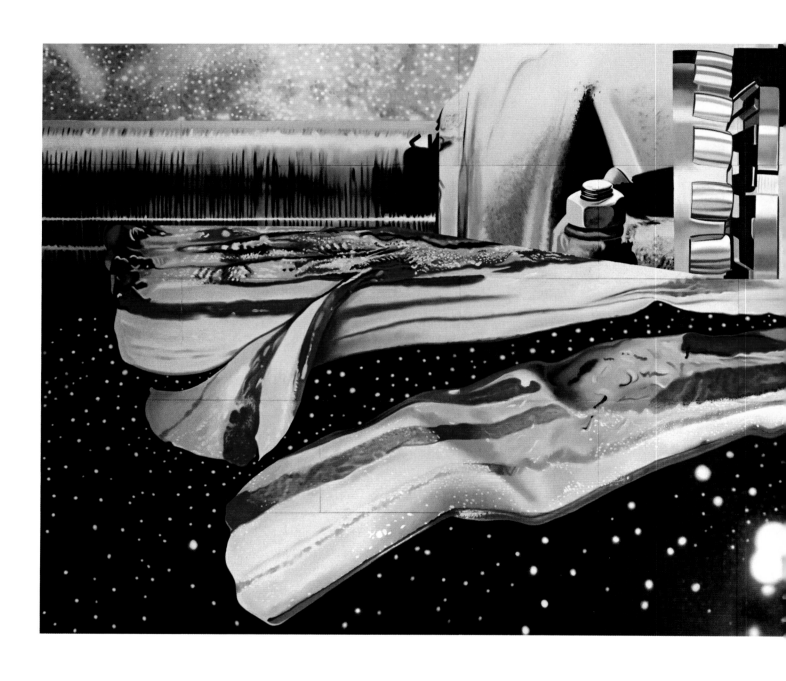

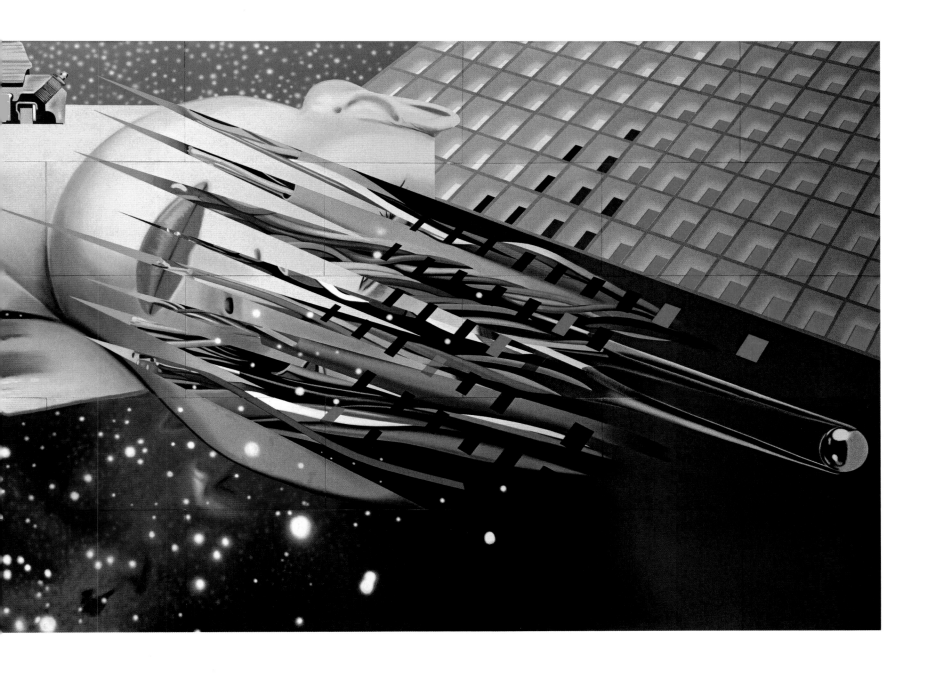

24 **Star Thief**, 1980
Oil on canvas
17 ft. 1 in. × 46 ft. (520.7 × 1402.1 cm)
Museum Ludwig, Cologne,
Loan Peter and Irene Ludwig Foundation, Aachen 1995

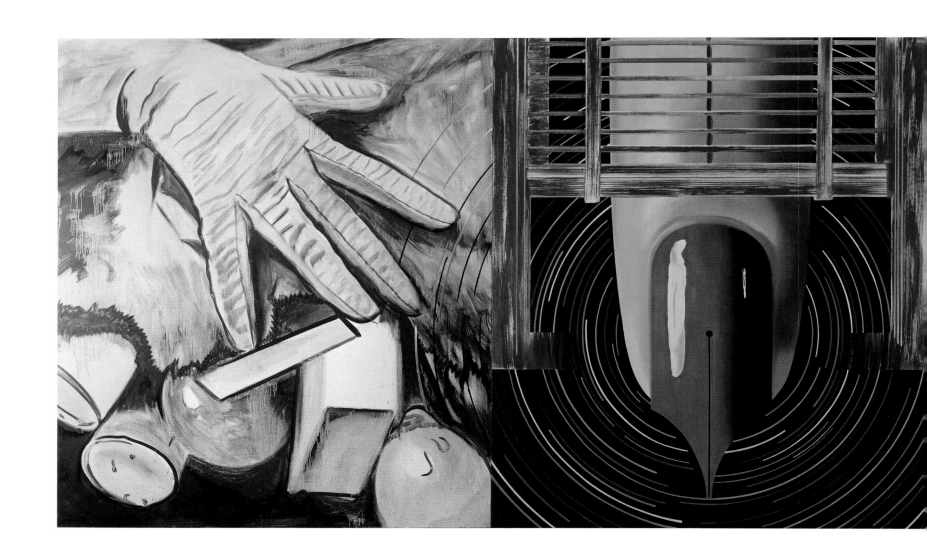

25 **While the Earth Revolves at Night**, 1982
Oil on canvas
6 ft. 6 in. × 16 ft. 6⅜ in. (198.1 × 503.9 cm)
Yale University Art Gallery,
Charles B. Benenson, B.A. 1933, Collection

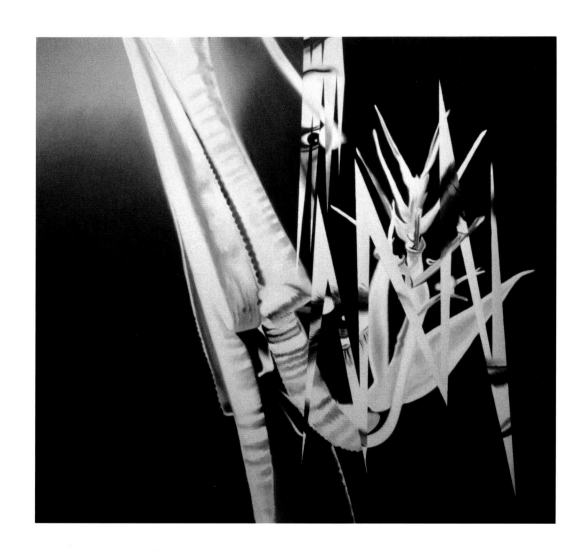

26 **The Prickly Dark**, 1987
 Oil on canvas
 67 ⅞ × 70 in. (172.2 × 177.8 cm)
 William Kistler

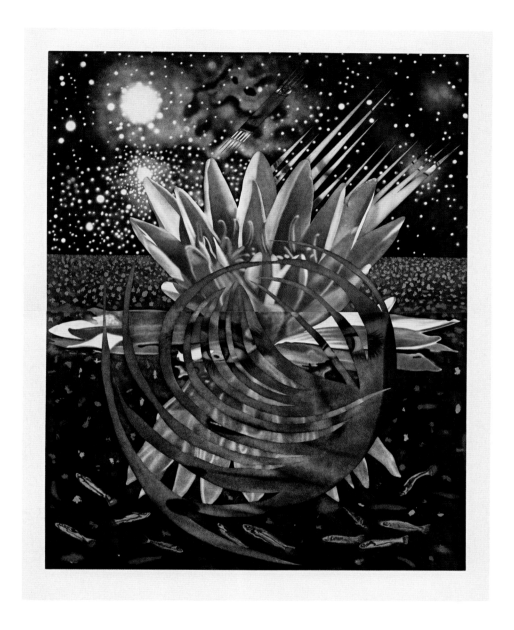

27 **Welcome to the Water Planet**, 1987
Aquatint
75 ¾ × 60 in. (192.4 × 152.4 cm)
Publisher: Graphicstudio U.S.F.
Printer: Graphicstudio U.S.F.
Edition: 55 + 1 BAT, 2 PPs, 2 Pres. Proofs, 1 NGA Proof, 1 GS Proof, 1 USF Proof, 7 APs
Estate of James Rosenquist

28 **Welcome to the Water Planet**, 1987
Oil on canvas
13 × 10 ft. (396.2 × 304.8 cm)
Collection of Ekaterina and Vladimir Semenikhin

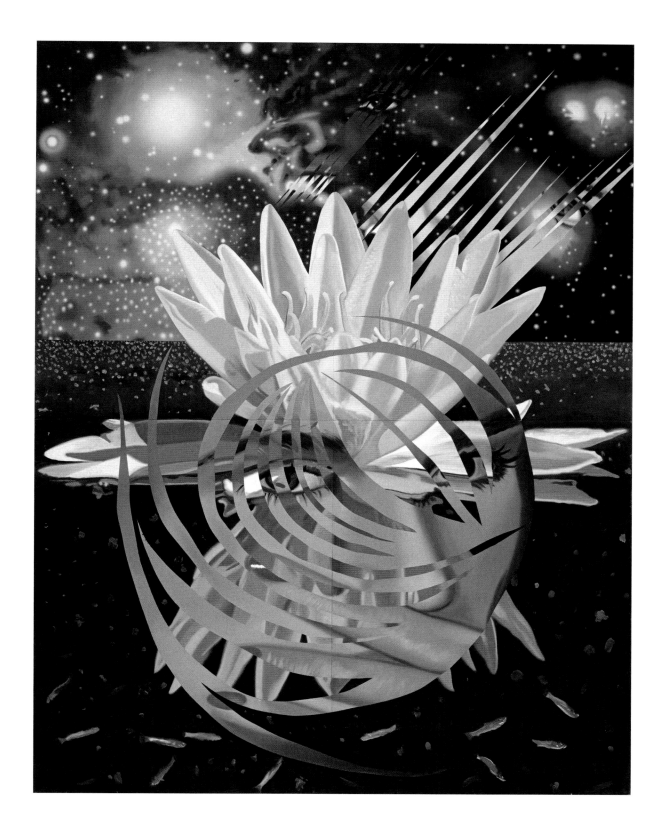

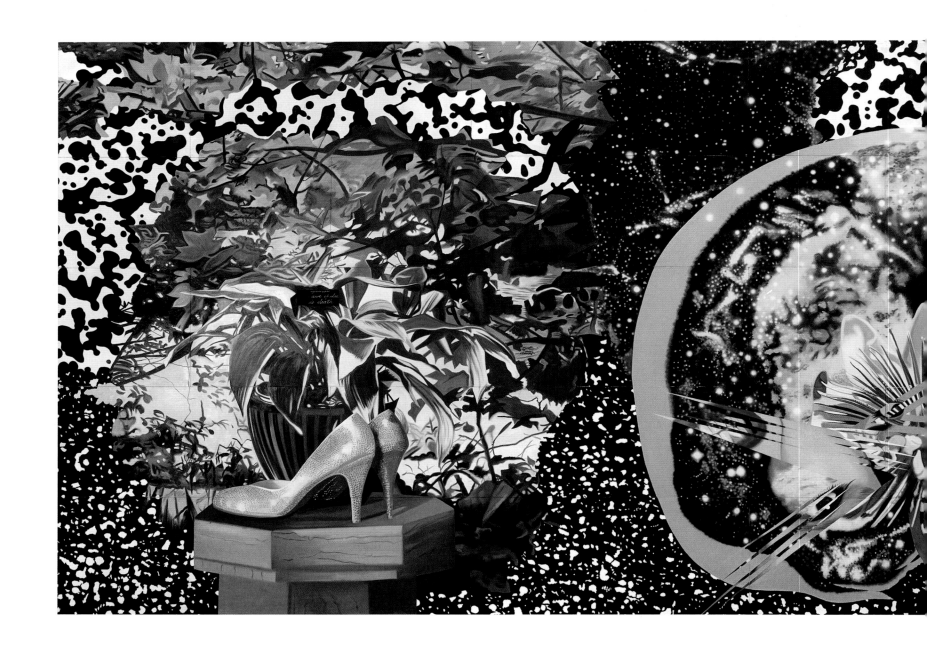

29 **Through the Eye of the Needle to the Anvil**, 1988
Oil and acrylic on canvas, with oil on recessed plywood panel
17 ft. 1 in. × 46 ft. (520.7 × 1402.1 cm)
Estate of James Rosenquist

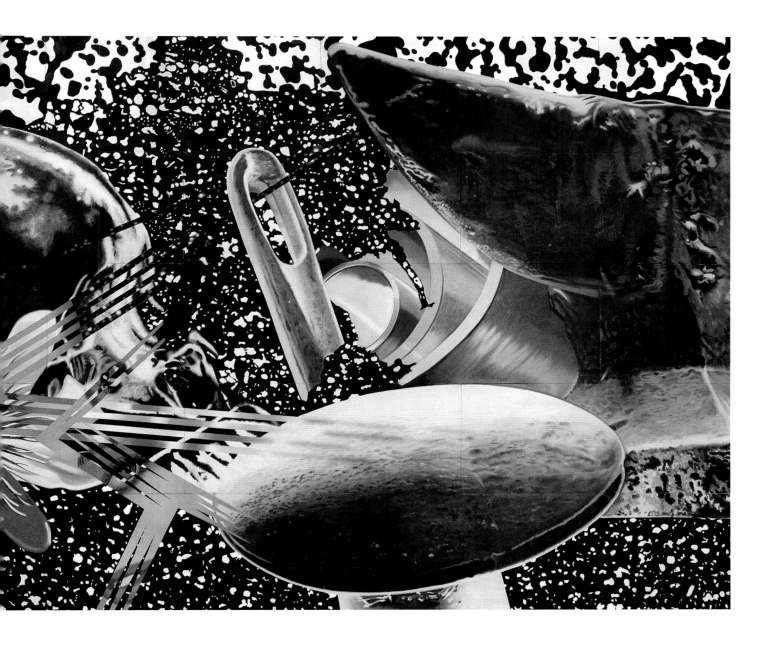

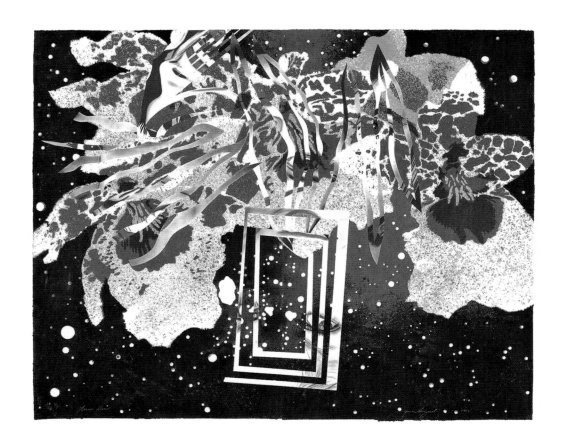

30 **Time Door Time D'Or**, 1989
Colored pressed paper pulp, with lithograph
97 ½ × 120 in. (247.7 × 304.8 cm)
Publisher: Tyler Graphics Ltd.
Printer: Tyler Graphics Ltd.
Edition: 28 + 1 RTP Proof, 1 TP, 9 CTPs, 2 PPs, 1 Archive Proof, 12 APs
Estate of James Rosenquist

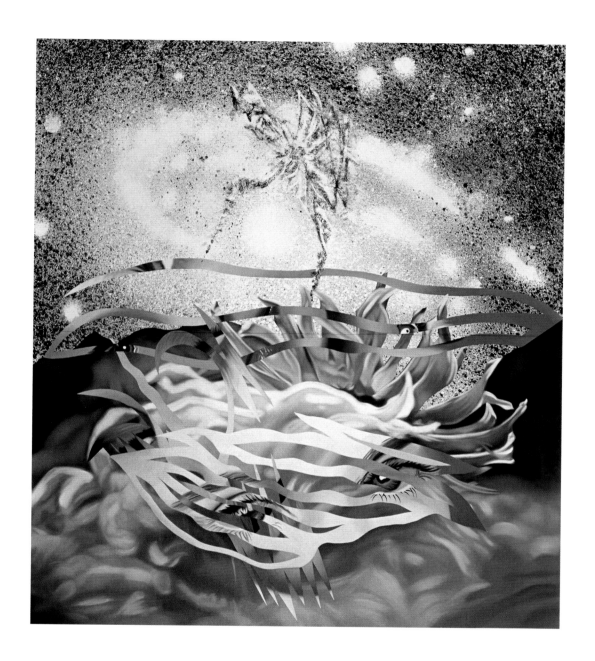

31 **The Bird of Paradise Approaches the Hot Water Planet (Grisaille)**, 1989
Oil and acrylic on canvas
96 × 84 in. (243.8 × 213.4 cm)
Art Enterprises, Ltd., courtesy of McCormick Gallery, Chicago

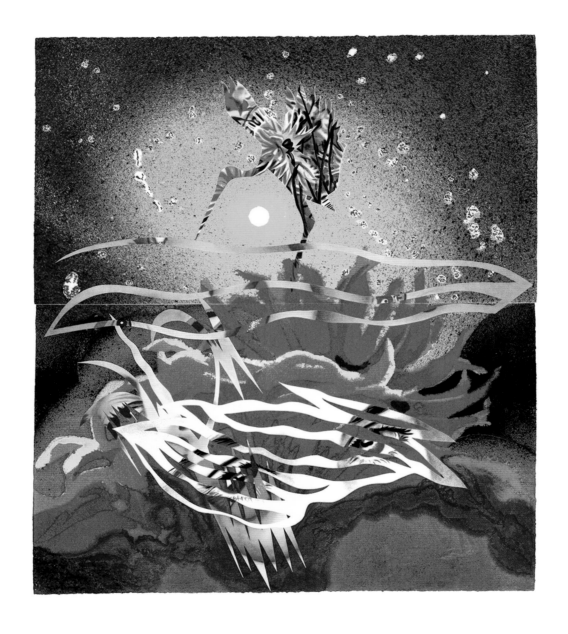

32 **The Bird of Paradise Approaches the Hot Water Planet**, 1989
Colored pressed paper pulp, with lithograph
97 × 84 ½ in. (246.4 × 214.6 cm)
Publisher: Tyler Graphics Ltd.
Printer: Tyler Graphics Ltd.
Edition: 28 + 1 RTP Proof, 4 CTPs, 2 PPs, 1 Archive Proof, 10 APs
Estate of James Rosenquist

33 **Imagine an Apple Eaten**, 1990
Oil on canvas
8 × 15 ft. (243.8 × 457.2 cm)
Estate of James Rosenquist

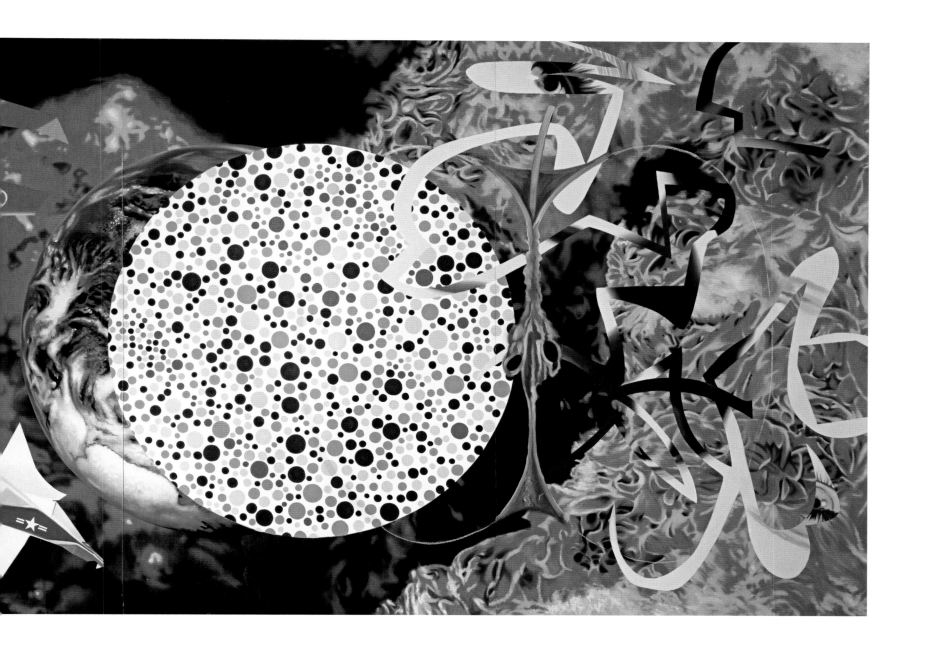

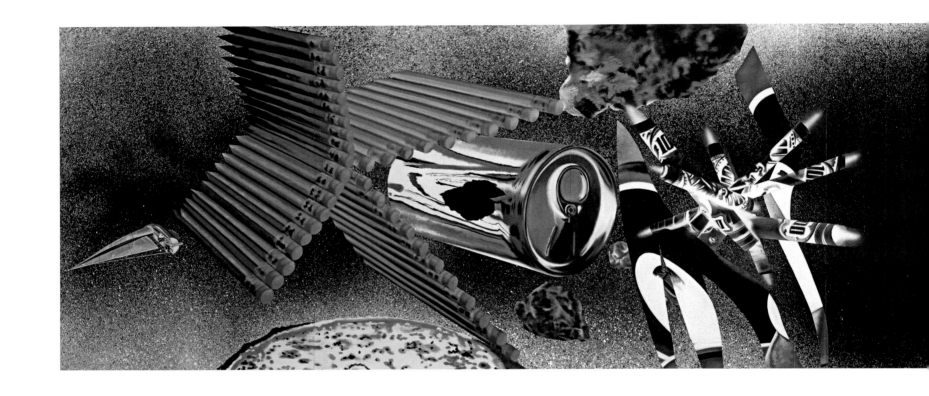

34 **Time Dust—Black Hole**, 1992
Oil and acrylic on canvas
7 × 35 ft. (213.4 × 1066.8 cm)
Estate of James Rosenquist

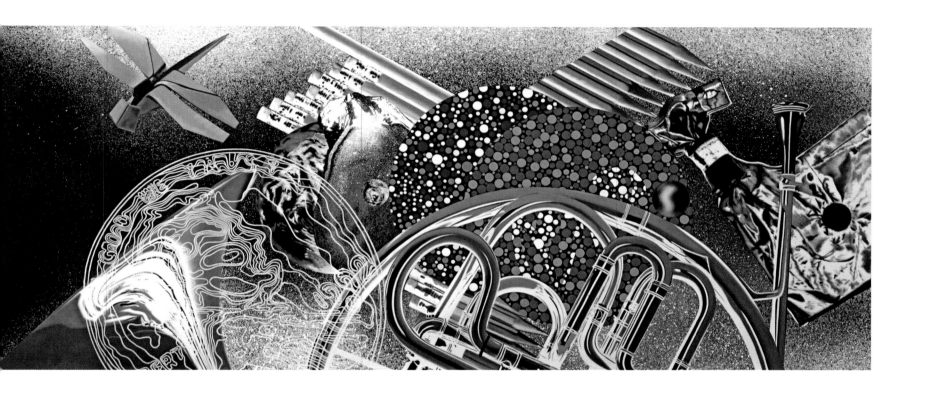

35 **Time Dust**, 1992
Colored pressed paper pulp, with lithograph, screenprint,
relief, etching, stamping, and chromed metal chain
7 ft. 1 ¾ in. × 35 ft. (217.8 × 1066.8 cm)
Publisher: Tyler Graphics Ltd.
Printer: Tyler Graphics Ltd.
Edition record: 8 + 1 RTP, 2 APs, 1 Archive Impression
Tate: Presented by Tyler Graphics Ltd. in honour of Pat Gilmour,
Tate Print Department 1974-7, 2004

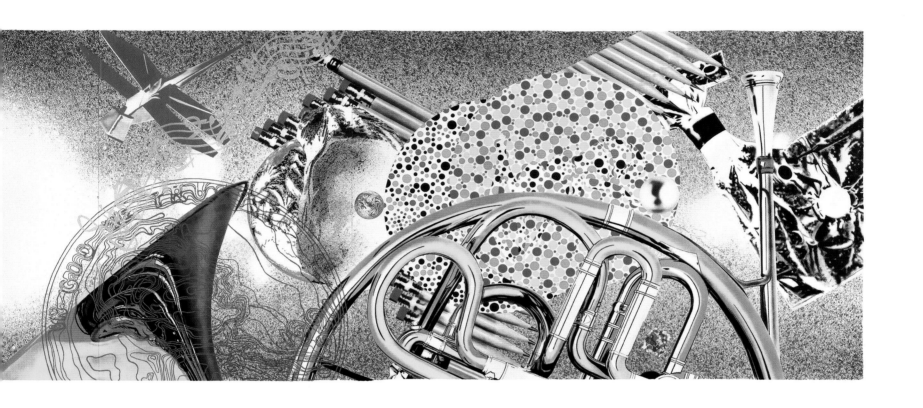

36 **Untitled**, 1995
Oil on canvas
16 × 16 ft. (487.7 × 487.7 cm)
Estate of James Rosenquist

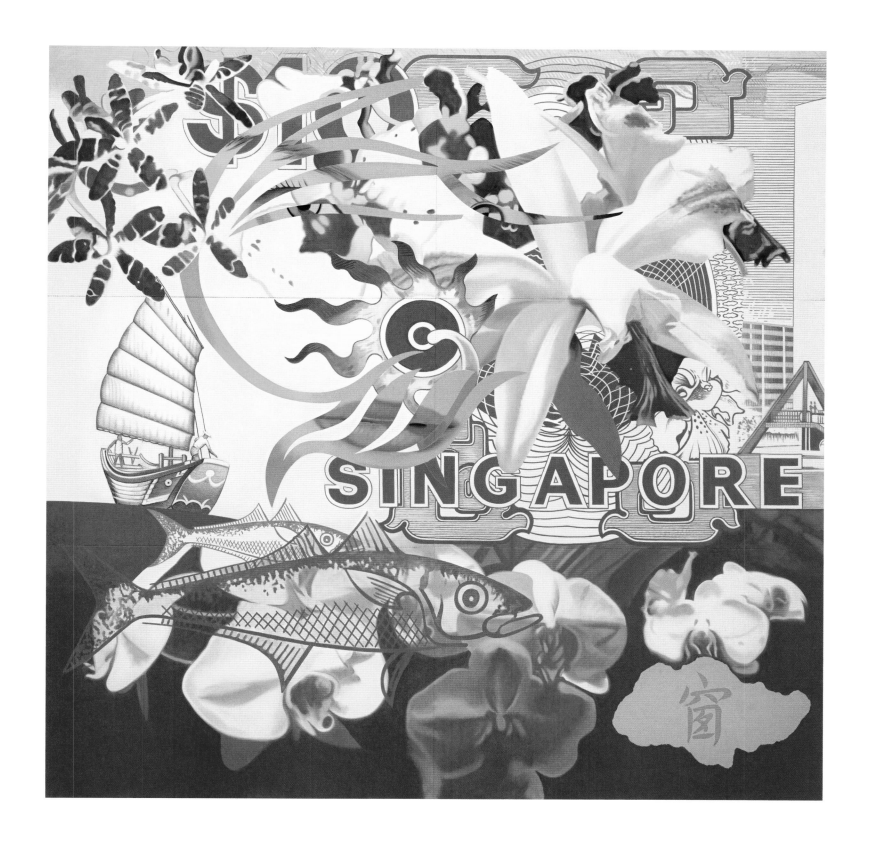

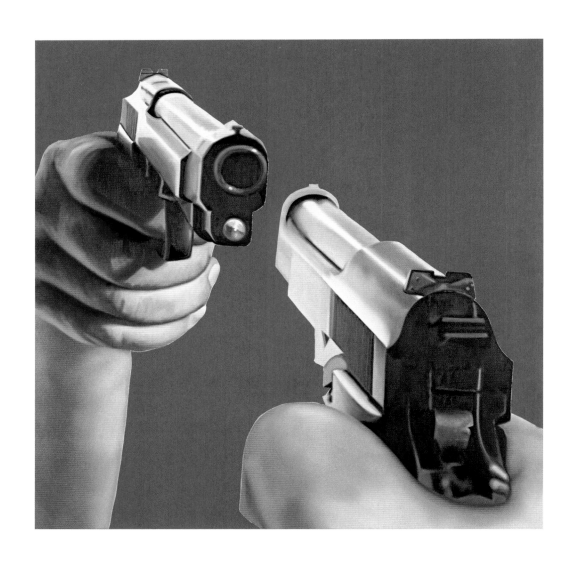

37 **Professional Courtesy**, 1996
Oil on canvas
48 × 48 in. (121.9 × 121.9 cm)
Estate of James Rosenquist

38 **The Meteor Hits Monet's Garden**, 1996–99
Oil on canvas, with attached Plexiglas sheet
9 × 8 ft. (274.3 × 243.8 cm)
Private collection

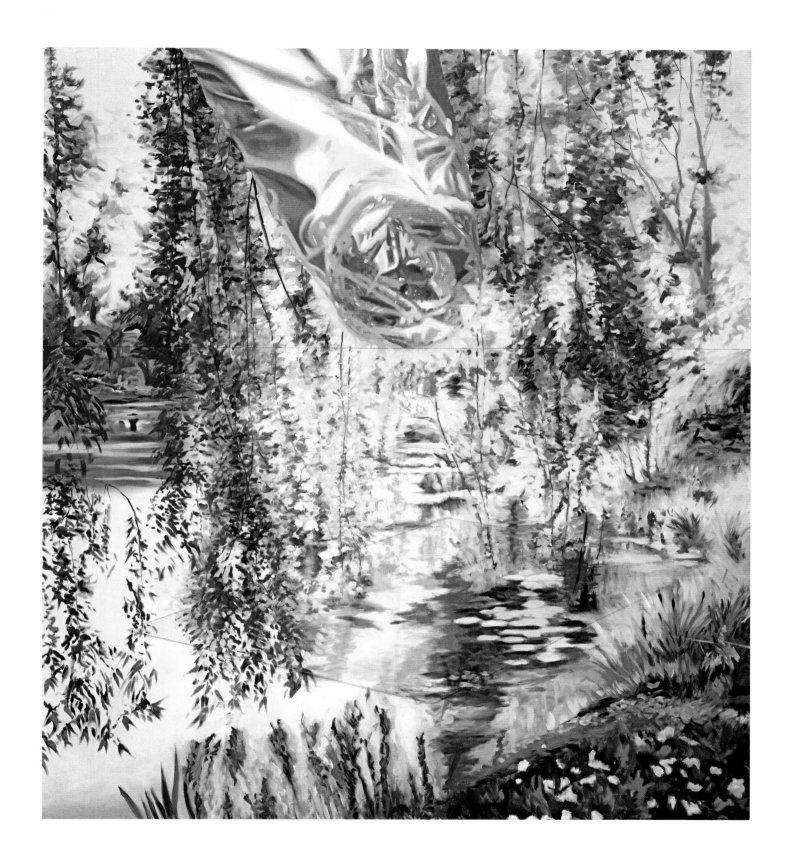

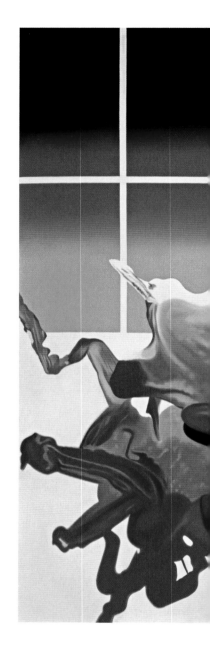

39 **The Swimmer in the Econo-mist #3**, 1997–98
Oil on shaped canvas
13 ft. 2 in. × 20 ft. ³⁄₁₆ in. (402 × 610.1 cm)
Solomon R. Guggenheim Museum, New York,
Commissioned by Deutsche Bank AG in consultation
with the Solomon R. Guggenheim Foundation
for the Deutsche Guggenheim, Berlin

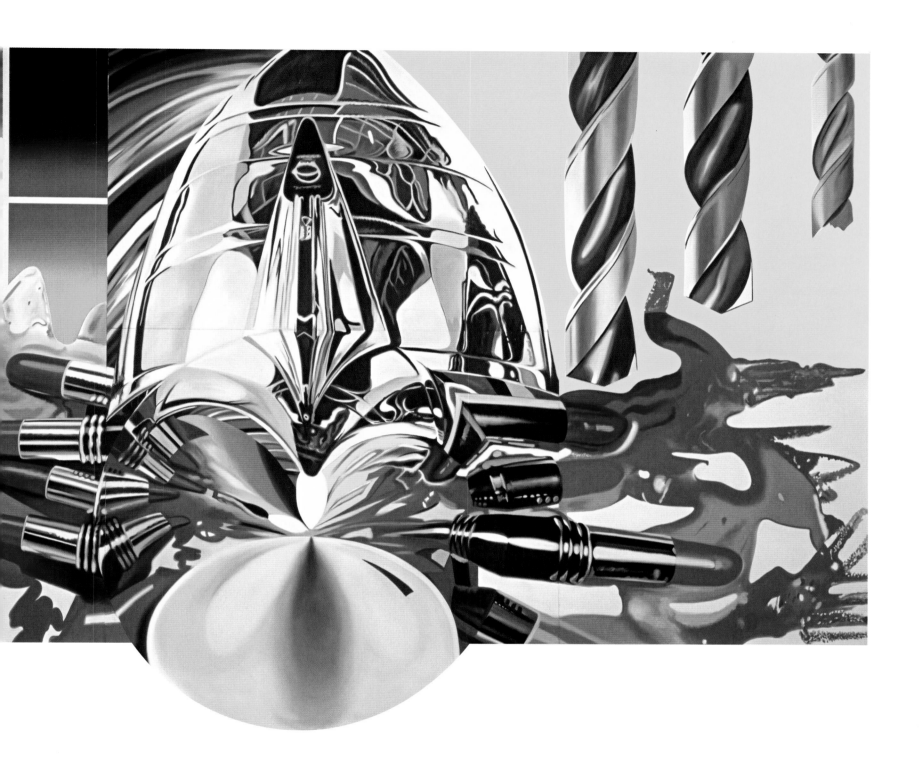

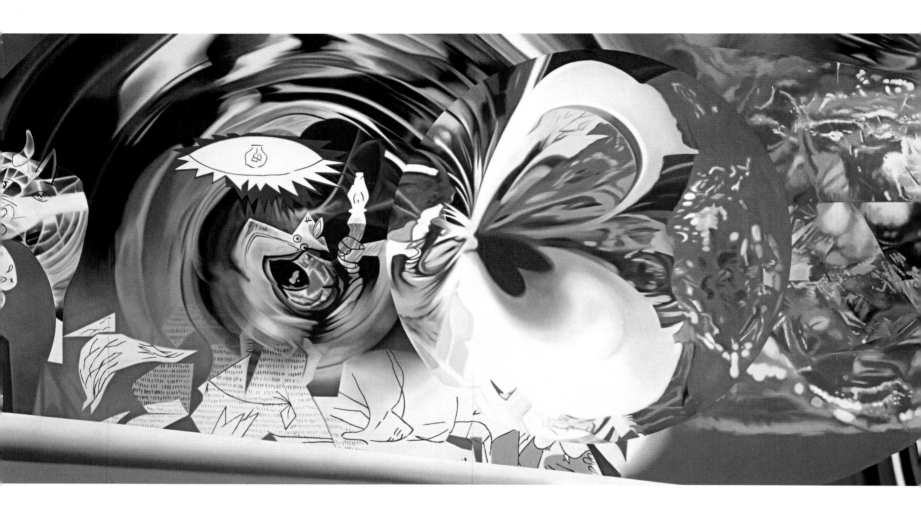

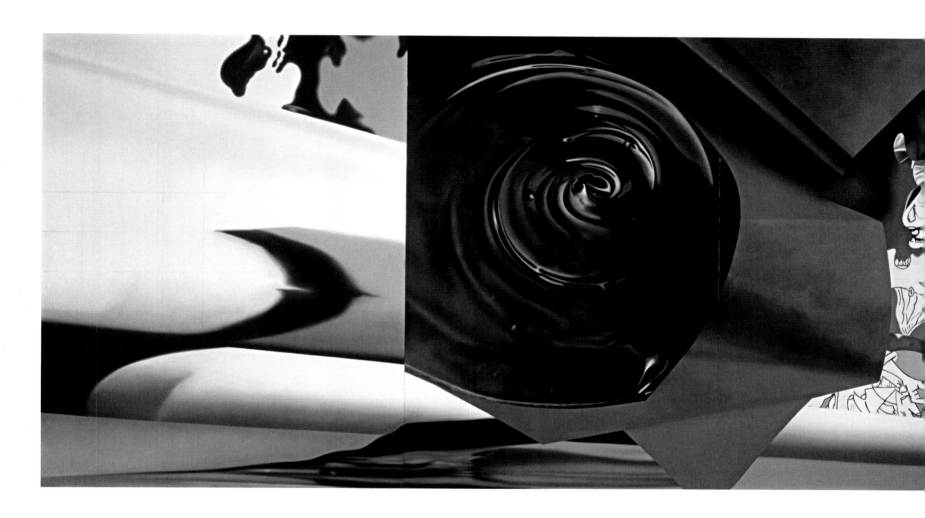

40 Previous spread: View of the exhibition
James Rosenquist: The Swimmer in the Econo-mist
at Deutsche Guggenheim, Berlin, 1998

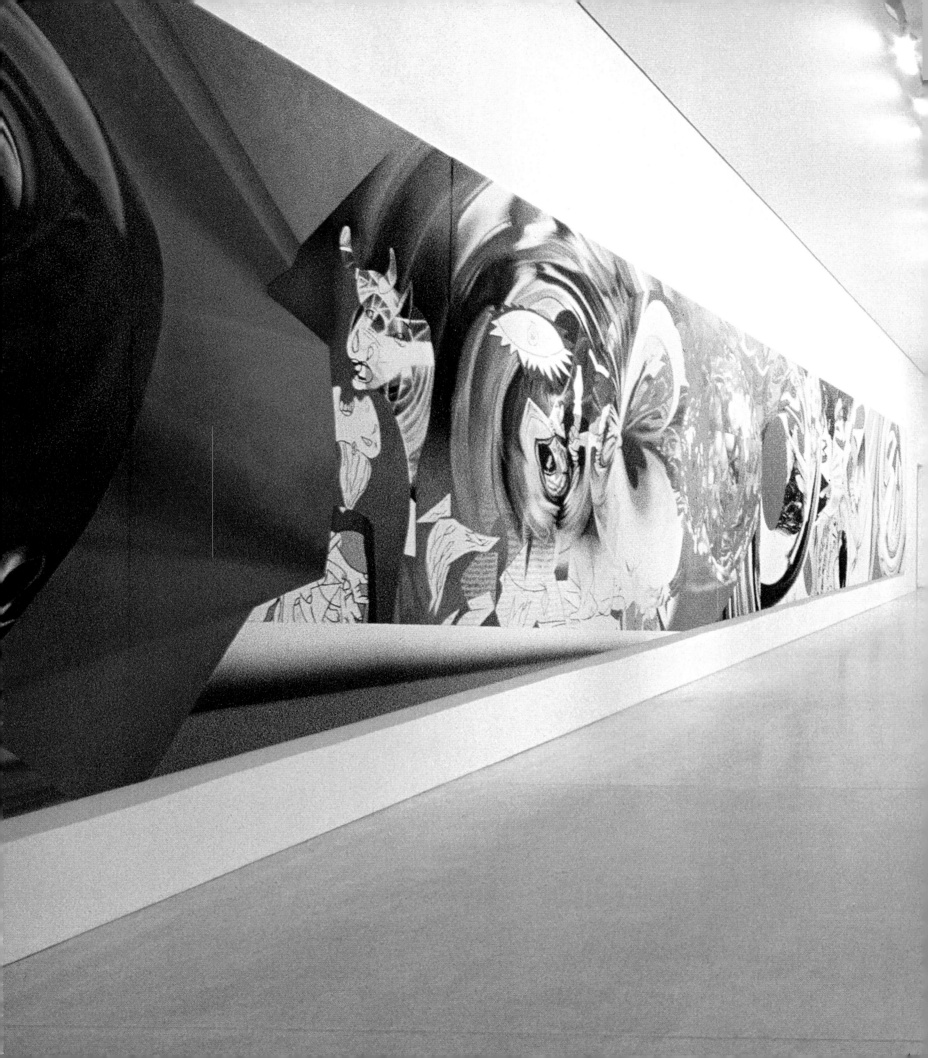

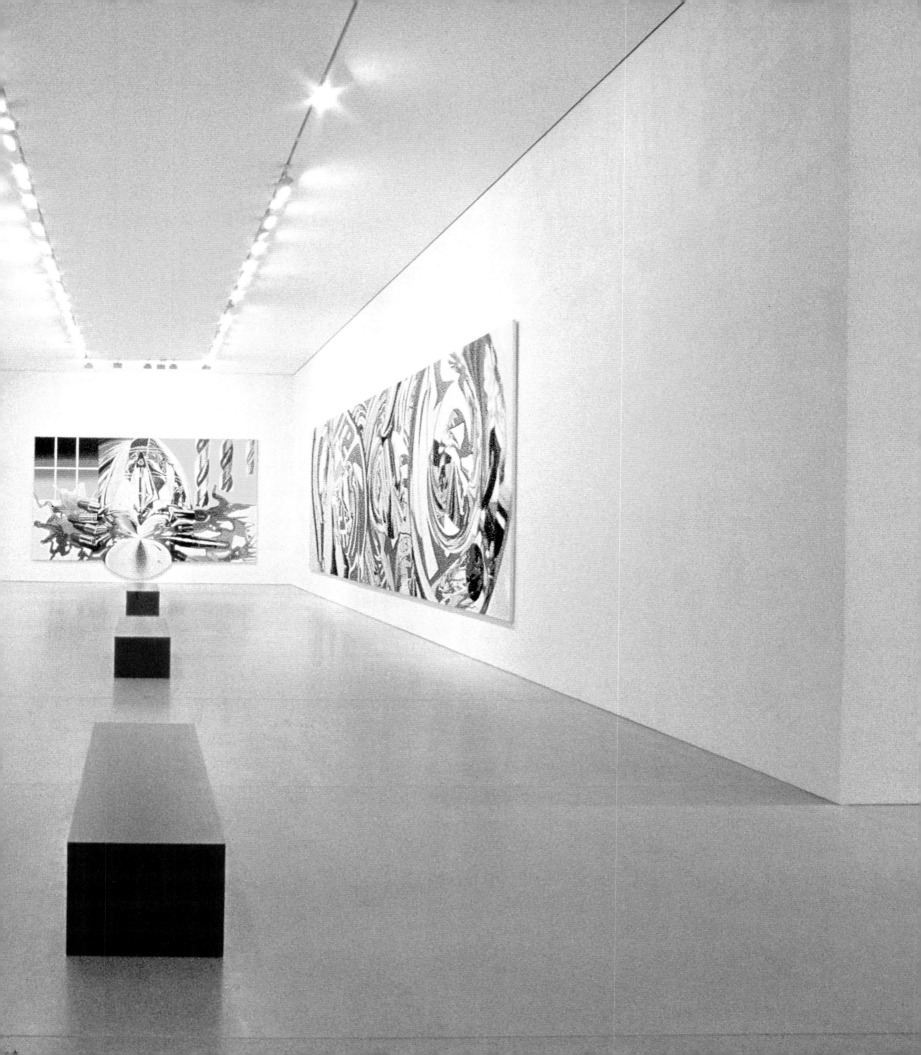

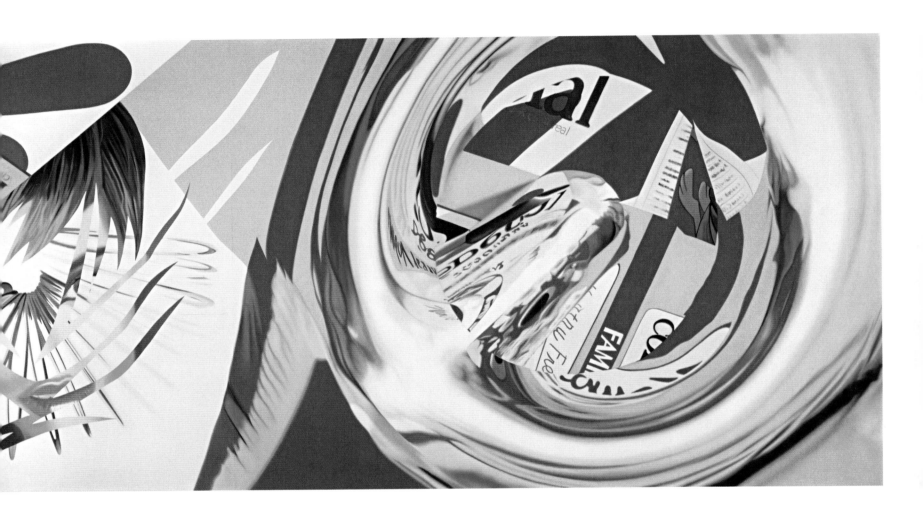

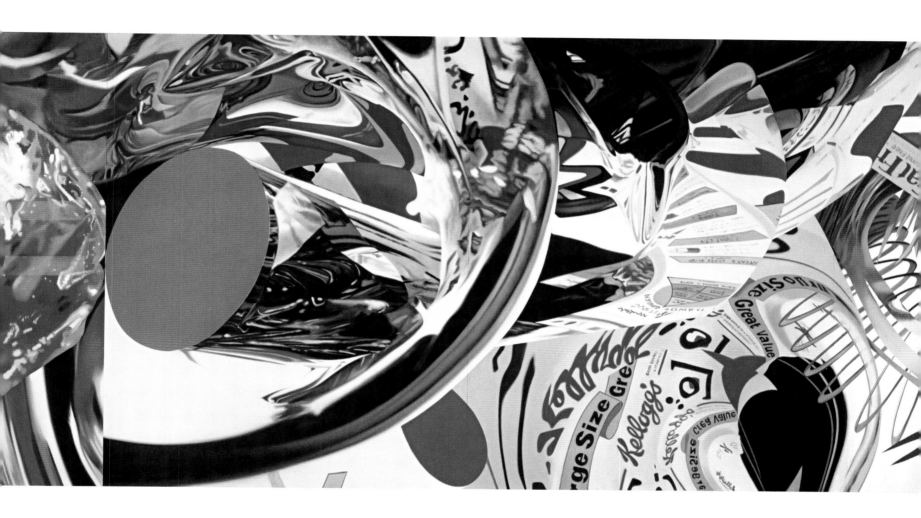

41 **The Swimmer in the Econo-mist #1**, 1997–98
Oil on canvas
11 ft. 6 ¾ in. × 90 ft. 3 ¾ in. (352.4 × 2752.7 cm)
Solomon R. Guggenheim Museum, New York,
Commissioned by Deutsche Bank AG in consultation
with the Solomon R. Guggenheim Foundation
for the Deutsche Guggenheim, Berlin

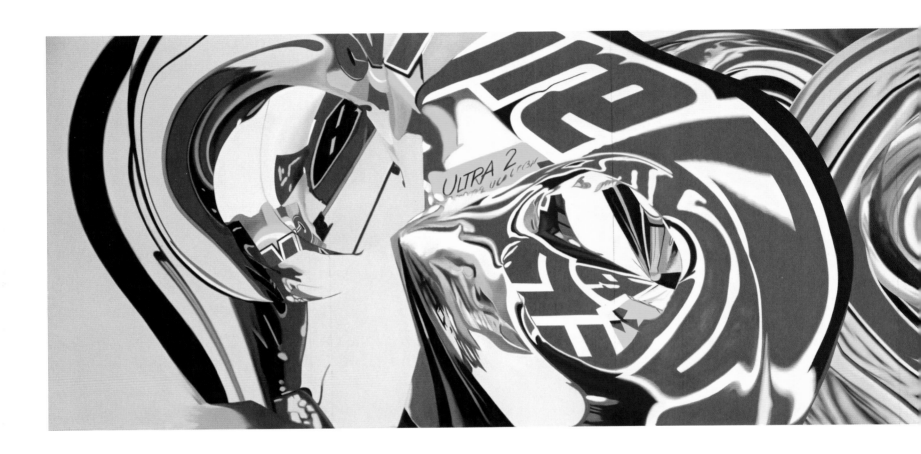

42 **The Swimmer in the Econo-mist #2**, 1997
Oil on canvas
11 ft. 6 1/16 in. × 48 ft. 1/16 in. (350.7 × 1463.2 cm)
Solomon R. Guggenheim Museum, New York,
Commissioned by Deutsche Bank AG in consultation with
the Solomon R. Guggenheim Foundation
for the Deutsche Guggenheim, Berlin

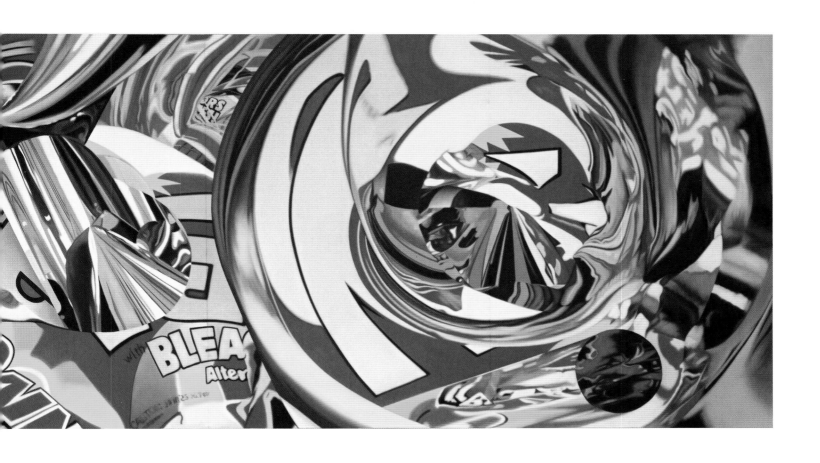

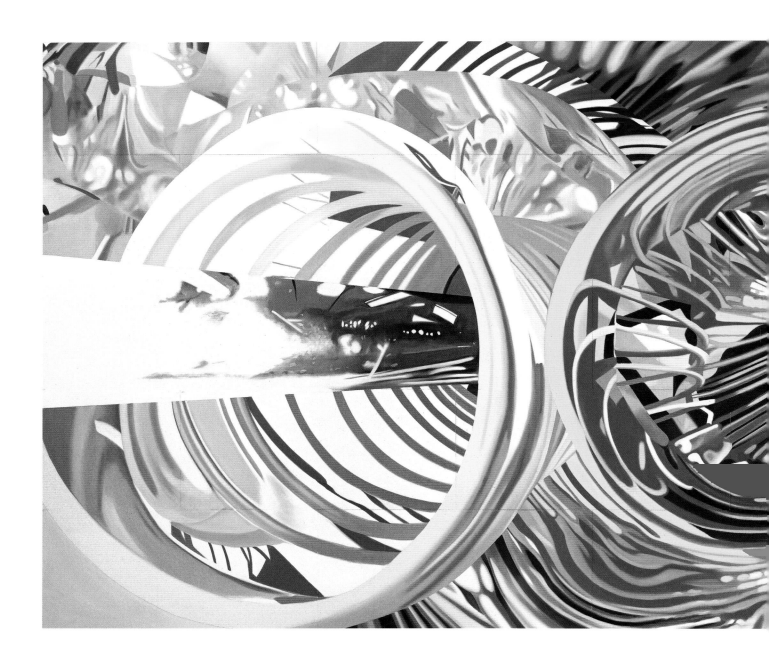

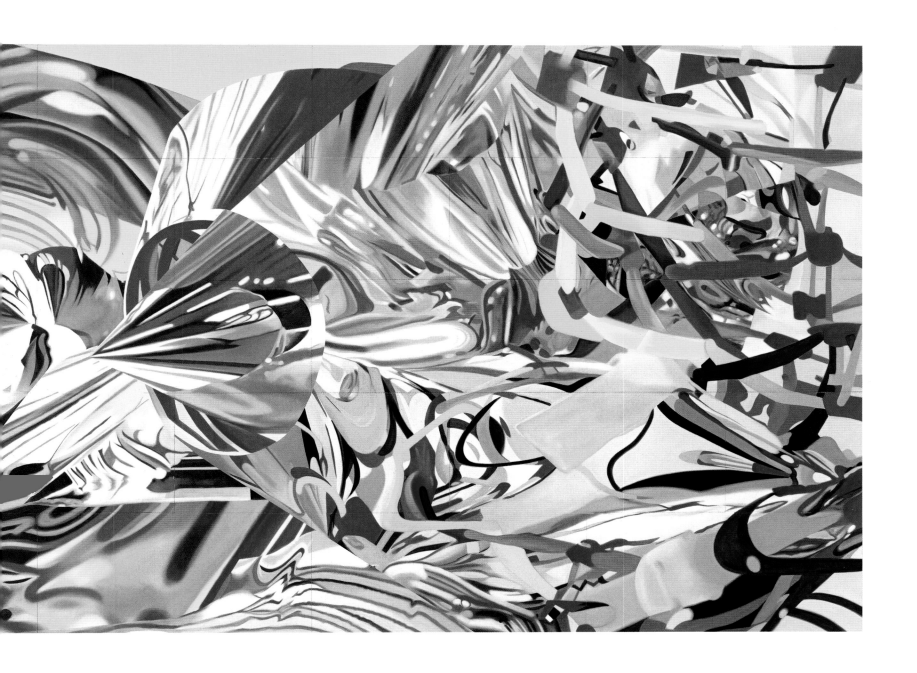

43 **The Stowaway Peers Out at the Speed of Light**, 2000
Oil on canvas
17 ft. 1 in. × 46 ft. (520.7 × 1402.1 cm)
Estate of James Rosenquist

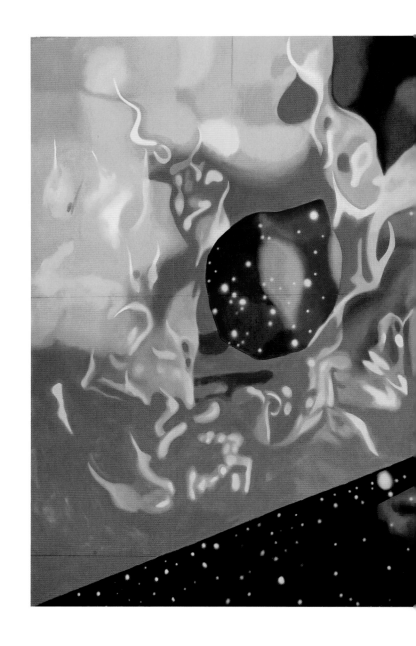

44 **The Geometry of Fire**, 2011
Oil on canvas
11 × 25 ft. (335.3 × 762 cm)
Estate of James Rosenquist

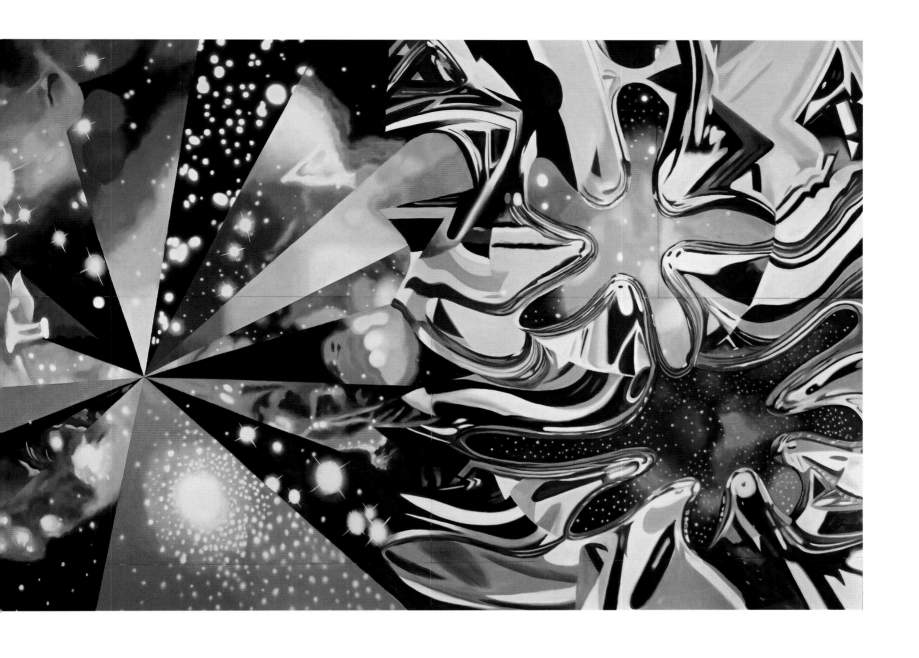

Diving into the Image: A Walk through the Exhibition with James Rosenquist

Stephan Diederich

I want people who look at my paintings to be able to pass through the illusory surface of the canvas and enter a space where the ideas in my head collide with theirs. —James Rosenquist[1]

"Painting as immersion."[2] This is how James Rosenquist describes the central theme of *F-111*, arguably his best-known work, in his autobiography. It holds true as a motto for his entire career: from his beginnings as a sign painter—standing on the scaffolding close up to the emerging image, virtually overwhelmed by its vast color planes— to his room-scaled works that envelope the viewer from all sides, like *Horse Blinders*. It can also be understood in the literal sense: the painted works on free-hanging strips of clear Mylar, slit from top to bottom and made to be walked through, like *Forest Ranger*. And finally, it culminates in the engulfing color swirls and the unfolding cosmic spaces that were developed in the later paintings. From creation to reception, the dissolution of the border between individual and work forms a common thread throughout his output.

But what, exactly, is implied when Rosenquist uses the term *immersion* regarding the triad of artist, artwork, and viewer? In the age of virtual reality, it has practically become *the* catchphrase for characterizing states of consciousness and an individual's relation to the world. In light of rapid innovations in computer-augmented cognition—and even "reality creation"—art has long since ceased being the sole vehicle for creating immersive experiences. The potential negative effects that an unreserved immersion into an artificial, heteronomous virtual reality might have on one's personhood—from the abandonment of critical distance to a complete loss of one's sense of reality—are increasingly manifesting, as game designers develop more deceptive virtual environments and game controllers, with the goal of merging the identity of the player with that of the game character in toto. Rosenquist, who was always sensitive to social changes and *zeitgeist* phenomena, assuredly would have viewed this sort of slipping into virtual worlds with suspicion. In his own work, he fundamentally refused to employ computer technology: "I don't want the footprint of the computer in my work. I am old fashioned in this way. I like it low-tech! Low-tech can be visually incredible."[3]

What is true for the modern entertainment industry here is indeed relevant for art: immersive experience through digital technology is increasingly regarded as a key phenomenon for understanding artworks. In the context of art, however, immersion is by no means new. Media theorists like Oliver Grau have traced the immersive relationship of image and viewer in comparative historical studies, including the frescoes in the Villa dei Misteri in Pompeii, the illusionistic perspective rooms of the Renaissance, Baroque ceiling paintings, panoramic paintings of the late eighteenth and nineteenth centuries, and Monet's *Nymphéas* (Water Lilies). This was radically transformed by the invention of the cinema, and the arrival of the digital age brought profound changes and new forms along with it, like the computer-generated virtual realities that have found their way into the art world in the form of interactive projection chambers: the so-called CAVEs.[4] Underlying all of these works, differing throughout the centuries in terms of technique and appearance, is the desire to suspend the distance between viewer and image space. The immersive power of a work is heavily dependent on its cultural origin and the viewing habits of the particular historical context in which it was made. The novelty and freshness of the illusionary medium plays an important role. New media, and virtual reality in particular, have changed our viewing habits and expectations; when viewing Rosenquist's work, we must be conscious of this and bear the context of its creation in mind.

When referring to the artistic topos of immersion in the context of his creation of *F-111*, Rosenquist named Claude Monet, Jackson Pollock, and, significantly, his friend Barnett Newman as sources of inspiration who transcended the boundary between person and painting. Above all, peripheral vision—a concept that was of paramount importance for Newman's compositions—played a decisive role in Rosenquist's ideational approach. When focusing on the individual stripes in Newman's vast color field paintings, which extend beyond the field of vision, he observed parallels to his earlier work as a billboard painter: "Everything that is fed into the side of one's eyes is what lays claim to reality. It makes you think about your orientation. In a sense his idea reminded me of a sensation I'd had while painting billboards. When you get close to an image, all you see is the color and this one line you're painting . . . It occurred to me that if you focused on this one line, your eye filled with all the other color coming at you from the two sides . . . Monet and Jackson Pollock had also experimented with the concept of peripheral vision."[5]

Not only act of viewing, but also the creative process was already characterized by immersive experience: "I'd seen a photograph of Monet standing in the middle of his paintings, which were spread around him on the floor. Monet set his canvases around the room and looked at them in order to get the right kind of color saturation in his eyes. All this color was streaming into his eyes, so whatever he looked at was inflected by peripheral vision. . . . For that reason, Pollock walked on his paintings and painted them directly on the floor. His methods provided a total saturation of the eye because he was only five feet from the floor. The painting was all around him; he couldn't escape it . . . He was immersed in it; he was inside it. When I began *F-111* I would try to do something similar: to put the viewer inside the painting."[6]

The clarity with which Rosenquist cites such points of reference in his work is typical of the straightforward narrative style characteristic of his autobiography *Painting Below Zero*, which was published in 2009. The first part of the book offers a self-ironic coming-of-age story, in which Rosenquist coolly depicts the circumstances in which he created his paintings. At the outset he illuminates the method of his often peculiar-seeming image juxtapositions that occasionally tread into the realm of surrealism. "Throughout my childhood the strangeness of things made a great impression on me."[7] And in an equally laconic manner, he describes the fundament of another notable quality of his work: the sensation of vastness, which played a role in its installation and dimensions since the start. "I grew up in North Dakota where the land is totally flat, like a screen on which you can project whatever you imagine."[8] James Rosenquist found the sudden focus on the immersive aspects of his work thrilling, and it would have been illuminating, as well as an absolute pleasure, to tour this exhibition with him. May this attempt to imagine something similar, by way of his published remarks, convey a bit of the complexity of his work.

45 Barnett Newman and an unknown woman
 in front of *Cathedra*, 1958

46 Claude Monet in his studio in Giverny
 with panels of *Les Nymphéas*, 1920

47 Claude Monet's *Les Nymphéas* installed
 at the Musée de l'Orangerie, Paris, 1927

48 Jackson Pollock working on *Autumn Rhythm*,
 photograph by Hans Namuth, 1950

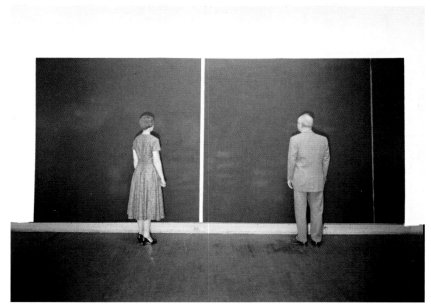

45

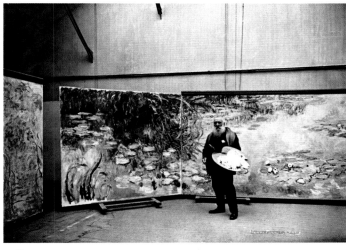

46

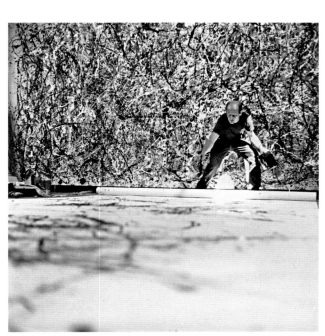

48

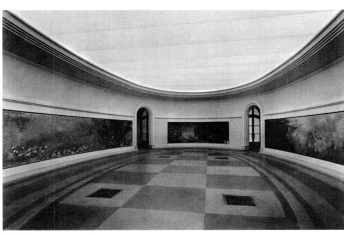

47

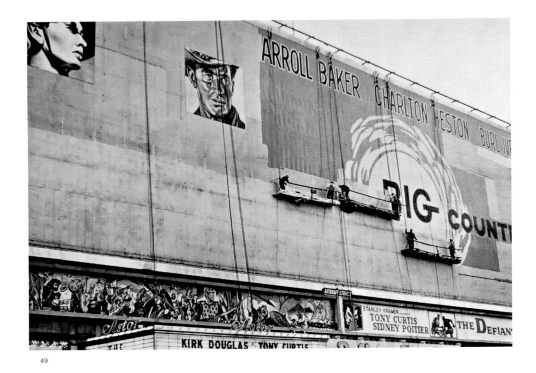

49

49 The *Big Country* movie billboard in progress,
the block-long Astor and Victoria sign, Times Square,
Broadway between Forty-fifth and Forty-sixth Streets,
New York, ca. 1958
(movie released on October 1, 1958)

50 Rosenquist working on the Castro Convertibles sign on
the Latin Quarter building at Forty-seventh Street
between Broadway and Seventh Avenue, Times Square,
New York, 1959

51 Rosenquist in front of wall arranged with source
materials, Broome Street studio, New York, 1966

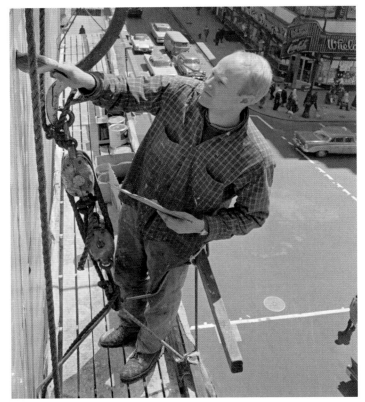

50

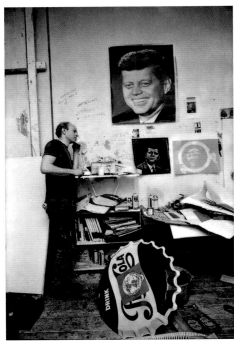

51

96

Through the Eye of a Needle

The monumental work *Through the Eye of the Needle to the Anvil*, which is painted partly in grisaille and partly in contrasting bursts of color, reveals profoundly personal sources as well as motifs that remain open to interpretation. "Most of my paintings have personal meaning for me, and I use the images intuitively to represent ideas, states of mind, feelings."[9] In light of such a pronouncement, it is already evident that Rosenquist's personal motives for choosing his subject matter can lead to a deeper understanding of the work. It was the death of his mother that prompted him to reflect on her ultimately unfulfilled life: "I always thought of my mother as someone who was avant-garde and very smart. But towards the end of her life she became discouraged. When she was young she'd been a pilot in North Dakota. Her hero was Amelia Earhart. I remember asking her if she had ever gotten her pilot's license. She said, 'No, that was before women's liberation, but I flew all over the place anyway.' … Women weren't supposed to do much of anything when she was growing up. I think my mother's lack of education was the source of some of her unhappiness. My mother was an artist, but she never really got to express that in her life."[10]

With a height of more than five meters and a width of fourteen meters, the multilayered image—like a nostalgic film that mixes black-and-white and color sequences in a widescreen, CinemaScope format—fully envelops the viewer: a pair of high heels, abandoned on a plinth, flowers, a skull, the eye of a gigantic needle, an anvil surrounded by high-contrast, and sparkling patterns and fragments of space that suggest microcosms and macrocosms interchangeably. The extent to which this juxtaposition of imagery develops an existence of its own—and the associative threads that might unfurl—is indicated by Rosenquist's own perspective on one of his own canvases: "So, this painting, *Through the Eye of the Needle to the Anvil*, has to do with the end, with dying. In part, it's about the sewing needle. Like the way the tiniest point of intuition, feminine intuition or artist's intuition, can become a larger production, perhaps evolve into a movie, a play, or a dance. Something like that can come through the eye of the needle and become this weighty thing."[11]

The private nature of the work is especially evidenced by a wooden black box, about the size of a moving crate, which is hidden behind the painting. The attentive viewer will notice a small rectangular opening above the shoes, which reveals a cryptic inscription inside: "after all in awe of itself is death" (fig. 247)—a sort of personal space for thinking, representative of the innate, retained immersion of the artist within the painting. Already at the beginning of the exhibition, this work challenges the common, overly simplified portrayal of the artist as a painter of bright, Pop surfaces.

With the Eyes of a Billboard Painter

Nevertheless, Rosenquist's roots as an advertising painter can be felt throughout his entire oeuvre; particularly the works created in the 1960s employ the experience he gathered in this field. "Working on billboards immersed me in the act of painting," he stated.[12] Whether it is an early work, such as *Astor Victoria* from 1959, or the 1995 painting *Untitled* (Singapore)—which, in its format and appearance, resembles a masterfully composed advertising panel—references to the world of billboards abound. *Astor Victoria*, painted on the threshold between his abstract period and the introduction of concrete objects to his work around 1960, does not only bear the name of the movie theater, whose gigantic, 120-meter-long advertising panel Rosenquist painted in the preceding year, as paint foreman with a team of colleagues. Furthermore he also uses the contours of letters and the partly visible grid from the process of painting billboards as motifs in this painting—with billboard enamel noticeably still being used as the painting material.

The world of billboards is also evident in the mindful selection of subjects coming, so to speak, from the world of advertising, such as *Above the Square*, *Untitled (Joan Crawford Says…)*, and *President Elect*. Similar to *Astor Victoria*, the title of *Above the Square* references Rosenquist's place of work as a sign painter, high above Times Square, as do the close-up view of the large-scale image fragment and the blue sky, which would shine in the periphery vision of the painter.[13] Although the painting is primarily concerned with visual phenomena, the representations of Joan Crawford and John F. Kennedy have a more psychological focus. Here, Rosenquist uses the tricks of the trade to expose the mechanisms of the kind of self-promotion that, to this day, increasingly influences mass-media portrayals of celebrities. "I called them self-portraits, because by employing the same slick, glossy techniques they used in their own advertising and public relations I could mirror their self-inflation."[14] Rosenquist refers to these "self-portraits" of socialites as his "first examples of overt social criticism of American culture."[15] In this manner, the painting of Joan Crawford is not a direct portrayal of the actress, but rather a portrait by way of detour: a cigarette advertisement in which she functions as brand ambassador. The individual is stylized into a star, who in turn—degraded to the level of promotional material—has nothing more significant to say than a generic advertising slogan. In light of the artificiality of this calculated performance, Rosenquist questions the reasons for this kind of self-marketing, which he recognized in Kennedy. "He already looked like an ad. I was interested in the idea that he was a sort of living advertisement for himself. He was like an ad come to life. I was curious as to how and why people wanted to project themselves like that."[16]

The artist openly admitted that, his critical stance notwithstanding, the design strategies of the advertising world had an aesthetic appeal. "It was simply the idea of doing something that had the same *force* as advertising, using their techniques and bizarre imagery."[17] He was able to apply not only a large part of the technical tools and image repertoire gleaned from his years as a professional sign painter; in regard to fundamental artistic issues, the rich experience of painting large-scale images in an everyday context—in terms of color effects and the combination of imagery, distance, and nearness—proved to be a source of inspiration for the artist. "My aesthetic may have come from being too close to what I was painting to know what it was. I didn't give a damn about the images themselves as I was painting them … All that interested me was their color and form.… I would become deeply involved in using color and form when I was painting the side of a big piece of juicy chocolate cake."[18]

A key part of Rosenquist's reflections was devoted to questioning the function of his work's subjects: signifiers or pure form? This question ultimately went unanswered in the artist's writings, but it is perhaps this duality that accounts for the considerable allure of his work. At the breakpoint between the somewhat outdated "universal language of abstraction" and the fresh realism of Pop art, the young Rosenquist was occupied with the cardinal subject of form and content. Intimately familiar with the world of oversized sets and symbols that, when viewed up close became abstract lines, areas of form, and expanses of color in which one could lose oneself, he developed his personal pictorial

vocabulary in the overlapping territory between thing, color, and form. "The nonobjective painters . . . had aimed for their own zero association—no images, no references. But I wanted to get to a zero below that of French nonobjective painting whose content was nothing but color and form. The idea of a zero below abstraction came to me when I recalled how numb I became from painting these damn things up close day in and day out on billboards. I thought maybe I could make an aesthetic numbness out of these images, a numb painting where you don't really care about the images—they are only there to develop space. So I decided to dive into the common pool of popular images, anonymous images from advertising."[19]

Rosenquist attempted to address the danger of overinterpreting meaning—an inclination that was inherent to the gestural, abbreviated form of Abstract Expressionist painting—by using unspectacular everyday themes, chosen for their formal qualities. "Maybe by using imagery from my billboard painting days I could go below zero, because if I chose images not for their content but for their form and color, what was on the canvas would be only what I had chosen to put there. No one would be able to see—as they might have in an arabesque in one of my previous abstract paintings—a bird, a plane, Superman, a crucifixion, or anything else if I hadn't intended it."[20]

Rosenquist took the matter to extremes in one particular painting, whose subjects—chosen on the basis of pure form, rather than interpretive value—have been explained in the most diverse and at times adventurous of ways since it was realized in 1961. "*I Love You with My Ford* is an abstract painting using the front grille of a car, two people whispering, and a field of spaghetti."[21] According to the artist, he chose the model of car, which at the time was already ten years old, in order to invoke the maximum degree of indifference in the viewer: it was neither new enough to be desirable, nor old enough to be nostalgic. And his choice of spaghetti for imagery, culled from a 1954 advertisement, he described as being "just an instinct about images as pure form."[22]

As informative as Rosenquist's statements regarding the compositions of his paintings may be, his downplaying of the meaning of their subjects should be viewed with circumspection. At the very least, the artist underestimates their suggestive impact. Even if the portrayed objects in his work do not primarily stand for their concrete material qualities, diverse possibilities for interpretation are inherent within them, whether as one of Rosenquist's personal ciphers—such as the commemorative painting of his mother—or through associations, made by the viewer in each individual interpretive context. A multitude of economic and political cross references can be traced in the range of chosen subjects. If we compare the composition studies for *F-111*—nearly abstract color fields—with the complex network of references the subject matter introduces,[23] Rosenquist's multitrack approach to painting becomes clear. In the second part of *Painting Below Zero*, he pays special attention to the metaphoric qualities of his chosen imagery, as when he explains the central subject of the 1982 painting *While the Earth Revolves at Night*: "In the center of the painting is a huge finger with a lacquered nail doubling as a pen nib, suspended at a window behind a venetian blind. The fingernail shaped into a pen point was dedicated to women authors who write and read at night while star movement and nighttime and machinery rolls on. It's about the quiet at night when people write. Her pen is inscribing star trails."[24] Such a preliminary fixing of the symbolic content can, at times, be almost too restrictive. The innate magic inherent in Rosenquist's paintings, hidden in the bizarre subject juxtapositions, requires a fundamental openness.

With this in mind, even the artist's comments should merely offer a possible point of view. "I wanted to make mysterious pictures. . . . From early on I developed an attraction for the incongruous. I had no wish to try to resolve visual contradictions. I felt that aesthetic disparities were actually questions, questions that I did not need to answer . . . Each person seeing the painting will come away with a different idea."[25] The work titles—often aphorisms or wordplays that reflect Rosenquist's encrypted associations and even occasionally make contradictory levels visible—are also to be viewed within this context. "The titles of my paintings are frequently ironic: the opposite of what you see, or a pun. Sometimes a title will set off an idea. The images themselves are expandable; therefore the painting itself is also expandable. In my paintings I only hope to create a colorful shoehorn for someone who sees it, to make that person reflect on his or her own feelings."[26]

All of these considerations and cross references within his work are based on collage principles, which were fundamental for Rosenquist's work.[27] He speaks of the "enigma of collage, something I would spend my life trying to unravel. . . . With collage you are free to create your own narrative. That and an element of mystery is what originally attracted me to the process."[28] In retrospect, Rosenquist described his world outlook as a reservoir of clashing contradictions. "By the time I was a teenager I'd found my way out by picking up pieces here and there, like clues to a puzzle. I'd found a way of looking at the world as disconnected images brought together for an unknown purpose. Without realizing it, I deliberately sought out the incongruities that would match my memories."[29] Later, in addition to studying works of art—Schwitters, for example, or the Cubistic fragmentation of objects in Picasso and Braque—the image structure of the advertising world was influential. "Most advertising is based on getting your attention by juxtaposing things that don't belong together. Advertising uses a crude form of surrealism to get your attention," Rosenquist observed.[30] As a sign painter, he had already internalized the colorful, motley repertoire of subject matter in every possible constellation. Beginning in the 1960s cut-out advertisements and photographs from *Life* magazine became fertile ground for his work. When one looks at contemporary photographs of his studio, the floor covered with this reference material, it can be taken literally—and Rosenquist makes the comparison himself: "It was like nature, a kind of flora of images."[31]

Collages made from image fragments served as studies for his paintings; they differ from the paintings, however, in that their dimensions are unaltered, matching their respective source material. "My earlier collages (with the images still in their original size) often look like a scattering of junk, because the maquettes were just the starting point—the end result, with the images scaled to different sizes, was the painting itself."[32] The arbitrary proportions of the subject matter are an essential part of Rosenquist's work. Every bit as succinct as his conveyance of basic information about his pictorial language and world views, provided in the beginning of his autobiography, he notes: "There's no scale in the brain. An image of the most colossal monument and the tiniest ant can rest side by side in your mind. The mundane and the bizarre can fuse into a language of images that float to the surface when you least expect it."[33]

The first work in which the above-described principles of composition were applied is *Zone* (1960). In the course of its development, Rosenquist overpainted the canvas again and again, experimenting with various techniques, forms, and subjects. "After I'd painted out everything, I painted a blown-up image of a black tomato and part of a lady's face in gray. That's all."[34] Looking back, the artist characterized *Zone* as

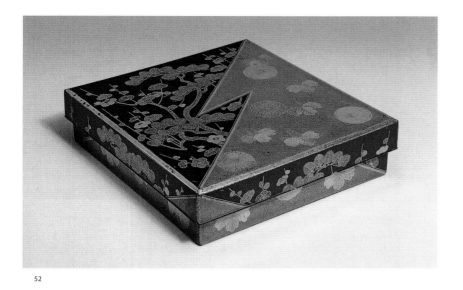

52

52 Unknown artist, Japan, 16th century
Writing box with pines, plums, chrysanthemums, and paulownias; 16th century; black lacquer with gold *maki-e*, pearskin ground (*nashiji*), and pictorial pearskin ground (*e-nashiji*), 2 ½ × 9 ¾ × 9 ⅛ in. (6.4 × 24.8 × 23.2 cm)
Minneapolis Institute of Art, Mary Griggs Burke Collection, Gift of the Mary and Jackson Burke Foundation 2015.79.407a–f

53 Rosenquist's Coenties Slip studio, with the paintings *President Elect* (partial view on left) and *Zone*, New York, 1961

54 *Welcome to the Water Planet IV (Close Lightning)*, 1988
Oil on canvas
96 × 84 in. (243.8 × 213.4 cm)
Private collection

53

54

"a place in the mind where, like archaeology, things are covered up."[35] Similar to the secret box in *Through the Eye of the Needle to the Anvil*, here it is that which is obscured, known by the artist alone, that has quintessential relevance for his own access to the work. The two perfectly merged, fragmented subjects remain visible in all of their unsettling dissimilarity and proximity. The title refers to the jagged zone where the subjects collide like lightning. The zigzag combination of two different images has parallels to the Japanese Kodai-ji style, a form of *katami-gawari* (alternating sides).[36] Found in Japanese textile art, ceramics, and notably lacquer decorations from around 1600, this use of a lightning-shaped diagonal division to separate two different images—one calm and the other rich in detail, one light and one dark—adds drama and spatial depth to the image surface. Rosenquist further developed this style of composition, increasing it exponentially with vibrant interconnections of various picture planes, in his subject superimpositions of the 1980s, which will be discussed later.

The close-up perspective that Rosenquist used in *Zone* subsequently became a significant formal structure for connecting the work and viewer. Rosenquist visibly redirects the line of action by assigning the image an active role in the virtual space. The realm between painting and individual is no longer merely a space of perception on the side of the viewer. Rather, it accordingly becomes an active space for the subject matter. "All previous painting is like looking out a window. Even with the epic paintings of Delacroix, the panoramic battle scenes in the Louvre, you are still looking out onto a vista. My painting is more like smashing images in your face."[37] In order for the painting to address the viewer in such a manner, it does not necessarily have to be large scale. "In *Hey! Let's Go for a Ride*, the girl's face and the soda bottle burst out of the frame right in your face. You're in the picture. It's coming at you as if you're a couple of inches from the girl holding the soda bottle. You almost have to back off."[38] In particular, the extremely fragmented nature of the seductive subject—who is automatically extended beyond the painting's borders in the viewer's mind—gives the relatively small work an expansively dynamic element.

The enormous presence of subject matter that Rosenquist achieved here served as the foundation for the *Handgun Paintings* that were made thirty-five years later, in which the artist made the ubiquity of firearms in American society and the downplay of their dangers through film and television the subject of critique. When, in *Professional Courtesy*, he ironically pointed the muzzles of two guns at one another in a dynamic diagonal—a hopeless, deadlocked stalemate—it is unclear who is actually the target.[39] The mirrored composition reveals a space fraught with tension, defined by the cropped close-up of hands that are pointing pistols into and out of the painting, playfully negating the boundaries of the painted surface. As a result, it is up to the viewer to determine the roles of the gunmen.

In *Look Alive (Blue Feet, Look Alive)*, Rosenquist uses other means to project the individual into the image. The painting, made in the same year as *Hey! Let's Go for a Ride*, plays with the idea of mirroring the visitor in the work. "When you look into the mirror you see your own feet reflected—they are now incorporated into the painting."[40] While the fragments of the viewer, dissolving with the painted legs, become part of the image's subject, the border between both levels of reality are blurred. In the variability of the collage-like mirrored image, both movement and time become factors of the work. The artist discussed his fascination for fragmented moving images in a memory from his youth: "Fragmented images from the movies have been a big influence on my paintings ... I'd block out the upper part of the screen, framing the lower left-hand corner with my hands, and watch what kind of dynamism would develop in that little section.... It was a fascinating experiment, because by doing that you disregarded the content of the film ... you created a surreal movie of your own."[41]

In the painting *Waves*, realized shortly thereafter, Rosenquist superimposed a painted rectangular segment of a woman's legs on top of the image of the back of a man's head, around which the hands of a woman are wrapped, suggesting that they are kissing. Next to the intimated kissing scene—which, as the main subject, fills out the entirety of the canvas and is painted in a transfiguring shade of pink—the naturalistic skin tone and the green fragment of a coat make this superimposed image appear to actually be the "real" picture plane. Just as the mirror in *Look Alive (Blue Feet, Look Alive)* serves as a reflection surface for the viewer, the compositionally similar arrangement of the rectangular segment in *Waves* becomes a projection surface for possible mental images, be it visions in the head of the portrayed that are intrinsic to the painting, or thoughts that might arise in the mind of the viewer, who may picture him or herself in the position of one of the figures, who remain faceless, their identity withheld. The real, threaded strings may, as the title suggests, illustrate the invisible interpersonal waves and at the same time counteract the union of the kiss by way of their association with the formal properties of a fence. Playing with various levels of reality and spatial references, Rosenquist developed a web of imagery, in which we see ourselves involved, as if in a dream. "The brain itself is a collage machine. All day long you unknowingly take pictures in your mind of the things you see; in your sleep you try to sort these juxtapositions through dreams. And that's what I'm trying to do in my paintings."[42]

Rosenquist's endeavor to merge viewers and works culminates in his paintings made on transparent Mylar, created between 1966 and 1968. Hanging freely in the room, the transparent film offers not only interesting, transparent perspectives and light effects; offset and arranged crosswise, they added a third dimension to painting. In *Forest Ranger*, it is an armored vehicle and a gigantic handheld meat saw that penetrate each another; the grid structure of a wire wastebasket forms an additional spatial plane. Significant for the viewer's participation, however, is that Rosenquist cut the painted film into thin strips, so that we can physically enter the work, similar to walking through a beaded curtain. Upon contact, the image surfaces are put into motion. They come to life. "I was still very much into Eastern thinking and I began to consider how I could dematerialize my paintings," described Rosenquist, explaining his motivation.[43] "The underlying concept was the idea of molecular transference: to simulate molecular displacement by reconfiguring the structure of inanimate objects so you could pass through them. You could exchange your molecules with that of the painting."[44] At the same time, however, he addressed the appearance of the image, which would inevitably disappear when viewers physically immersed themselves in it, much as reflections on water would be disrupted by a diver. "You would literally be inside the imagery—but paradoxically, at the moment of entry, the painting would become invisible. When you were inside it, the image would disappear and then come together again after you'd passed through it."[45] At the latest it becomes clear now that for Rosenquist, immersion has nothing in common with virtual reality. Rather, it is always accompanied by a moment, in which the painting reveals itself in its artificiality.

Although Rosenquist did not continue to formally pursue the hanging paintings, the considerations he made during this period in regard

to spatial composition had an appreciable effect on his later work, as Evelyn Weiss observed in the catalogue to his 1972 exhibition in Cologne.[46] In the following period the artist created works such as *Horse Blinders* and *Horizon Home Sweet Home*, which along with *F-111* make up the triad on display in the Leo Castelli Gallery rooms at the end of the exhibition.

In the Vortex of Image and Current Events

James Rosenquist's largest work, *The Swimmer in the Econo-mist*, is a monumental three-painting suite that was commissioned by the Deutsche Guggenheim Berlin and created between 1997 and 1998. Its longest panel stretches on for 27.5 meters, making its subject matter only graspable in its entirety when one walks the length of it, reminiscent of an enormous East Asian handscroll. In addition to the giant advertising panels in widescreen format, which he implemented often enough, a childhood memory may have indicated his early predilection for epic painting sequences: "Paper was scarce and expensive, but my mother found me long rolls of discarded wallpaper to draw on. I could draw huge narrative scenes on the back of these sheets, beginning with soldiers creating gun emplacements, digging trenches, and then moving on to the next giant battle scene involving catastrophic explosions."[47] Here, swirling, distorted figures culled from advertisements for laundry detergent and cornflakes get together with fragments of two famous antiwar paintings: Picasso's *Guernica* and Rosenquist's own *F-111*. They are joined in the same way by a red-hot meteorite and the splintered, seductive face of a young woman. Accompanied on the opposite side of the room by a counterpart measuring 14.6 meters, the painting sequence leads to the third panel on the front wall. Symmetrically placed—an arrangement that does nothing to lessen the explosive impact of the painting—is the hairdryer from *F-111*, surrounded by numerous self-quotations out of the artist's pictorial vocabulary, with lipstick creating a moving aura of red streaks. In the background, a black-red-golden twilight can be seen through a paned window: "*The Swimmer in the Econo-mist* is a skewed post-cold war story of politics and economics, war and commerce. Nature and technology clash, and war and industry continue their old pact.... It's one I've told before— and not only in *F-111*—but this time it takes place in Germany after the fall of communism.... I tell history in terms of fragments, the fragments butt up against each other, and the story gets told from the friction they create. I wanted to bombard the viewer with implausible juxtapositions.... In *Swimmer* I set out to illustrate different kinds of fears that worried us: our involvement in self-destruction, our addiction to war weapons and brutality. The painting refers to a narrative of ideas of extinction: from hydrogen bombs, from a meteor, from ecological disasters or widespread hunger.... But how do you alleviate these fears? You work toward something positive."[48]

Given the work title, the room that the viewer walks through stretches out like an elongated swimming pool. "The title came from an image of a swimmer in a fog swimming toward something, not knowing where he's going but just swimming, swimming, swimming."[49] Surrounding the viewer on three sides, *The Swimmer in the Econo-mist* develops a real suction effect, as if it were a portal for time traveling. Parts of the *F-111* fighter jet and fragments from *Guernica*, rendered in historicizing black-and-white, make up the prelude, interrupted by an oversized, creamy swirl. "The black swirl next to it is the idea of liquid memory— how our memory is viscous, we forget things, we all suffer from cultural amnesia," stated Rosenquist.[50] Along the further drift through time

and space, Picasso's famous outcry is also absorbed. The gray-toned opening scene is transformed on both sides into a jarringly colorful world, as if reflected in a funhouse mirror. A collection of photographs, created by means of a simple tube, mirrored from the inside, served as the source material for this spectacular image-vortex. "In order to express the tumultuous tenor of our time, I needed a new vocabulary of momentum, speed, and immediacy to shake up the picture plane ... I wanted the eye to swim through the kaleidoscopic images, get pulled into visual whirlpools; to make the surface unstable so the focus would zoom from close-up to long shot, from black-and-white to Technicolor."[51]

The Absence of Color

The interaction of grisaille and color, as in the painting *Through the Eye of the Needle to the Anvil*, found at the beginning of our exhibition, plays a significant role in Rosenquist's visual thinking. "To paint in grisaille is to deal with the void—a void of color,"[52] he observed already in respect to *Zone* (1960), which is painted entirely in grayscale. A complete lack of color or an extremely targeted use thereof is typical of the early paintings from the 1960s. "Painting in black-and-white tonalities was similar to working with the snapshots from which I'd painted billboard images."[53] The connection Rosenquist makes here to the mostly achromatic templates not only suggests they were a concrete source for subject material; it also connotes his work process on the scaffold, in which he had transformed many of the small-format black-and-white snapshots into billboards with monumental color surfaces. The transposition into color that took place in the artist's mind is reflected throughout his entire body of work, in a complex relationship of color and object. "I began to develop my own idiosyncratic vocabulary of color; like Rimbaud's 'Alchemy of the Word,' where he says, 'I invented the color of vowels!' ... Except that my chromatic alphabet came from Franco-American spaghetti and Kentucky bourbon ... In my mind, I associated colors with real objects ... The imagery itself was dispensable to me—it was the color and texture that I was interested in. If I felt like painting red I might paint a great big tomato."[54] Pure abstract color, connected to mental pictures of concrete items, often motivated the appearance of corresponding objects in the paintings. The lack of color in the grisaille subjects, on the other hand, stimulates the imagination and allows viewers the freedom to make their own imaginary colorations.

Furthermore, structural idiosyncrasies come to light more concisely in purist color compositions. In the two equally mysterious paintings *Exit* and *Noon* Rosenquist explores the phenomena of focusing, and more specifically the dissolution of boundaries, touching on two kinds of immersive viewing experience. In the center of *Exit* is a closed eye, while in *Noon* a flashbulb with a reflector guides our gaze into the middle of the picture. The vast black surface, which surrounds the eye like a peephole, has a similarly contrary function, making center and periphery the subject, just as the double framing of the light blue, cloudy sky functions in *Noon*. Despite the—for Rosenquist—relatively small formats, these image planes expand far beyond the borders of the canvas— although a full, all-over expansion is thwarted by the confusing, independent existence of their center points. "I was fascinated by the fact that light can actually make things disappear,"[55] observed Rosenquist in reference to the flash of light in *Noon,* which, for a moment, outshines everything. As if its counterpart, in *Exit*, the black of the picture plane emphasizes the glimmer of light, leaking weakly outward, and the gentle modulation of the fragmented face.

The extent to which the grisaille works were a productive ground for experiment is likewise evidenced by the fact that Rosenquist created both black-and-white and color versions of many of his subjects. The grisaille and garishly colorful print variations of *The Bird of Paradise Approaches the Hot Water Planet* make it clear that, despite having the same format, each has quite a different visual impact, due to the accentuation of individual passages, spatial impact, atmosphere, and the coldness or warmth of the image. Rosenquist's monumental print *Time Dust*, made using dyed paper pulp, was also the starting point for a painting, created almost exclusively in shades of gray, featuring a near-identical subject. As the appendage to the title indicates (*Time Dust–Black Hole*), the respective spatial nature of the works is entirely different. While the objects in the color print float in front of a glistening, light background, the threatening radiance of the grisaille painting is determined by its jet-black center. Of the image's strange content, the artist stated: "This came out of an idea I had been thinking about: the area in space where the United States and Russia had jettisoned many tons of space junk. It occurred to me that this was a kind of permanent museum where nothing would ever disintegrate. Imagine an old square-rigged ship out there in fine shape, sailing on forever."[56]

Through the Illusion of the Canvas into Space

Like much of Rosenquist's work—especially that which was made after the 1980s—the setting for these scenarios is outer space. "Since I was a child I've been fascinated with space exploration ... Space travel is at the intersection between technology and imagination but, like anything the government or the military is involved in, it's an ambivalent enterprise—it has the potential for both transcendence and Star Wars type of destruction."[57] Just as relics of consumerism and misplaced items from creative works float, so to speak, aimlessly in space like archaeological material in *Time Dust*, the objects in *Star Thief* (1980) can be read as metaphors for the human spirit of discovery and urge to study the unknown.[58] This gigantic painting is one of Rosenquist's most misunderstood works, beginning with the former-astronaut and CEO of Eastern Airlines Frank Borman's refusal to acquire it for the Miami International Airport. At the time, he publically polemicized: "Space doesn't look like that. I've been in space and I can assure you there's no bacon in space."[59] According to Rosenquist, the pieces of bacon stand for natural life on earth in general, for humans and animals alike. "It's a metaphor. It's about being a living creature ... The bacon symbolizes flesh as meat that we eat, as well as the tender fiber of which we are all made."[60] Its juxtaposition with the fragmented face of the prone woman provoked criticism as well. The female head, however, is meant to represent the potential of the human spirit. "I thought of a metaphor for work, for exploring, for discovering. It occurred to me that you cannot get into space, or even into your own mind, without a lot of work."[61] The shaded, overlapping layers and infiltration of various levels of subject matter—like the head, bunch of cables, and twinkling universe—was applied for the first time in *Star Thief*.[62] Rosenquist not only optimized the image surface's capacity for receiving subject matter; much more he opened the image space, extended it, showed the further levels of reality that exist beyond, created links: in this case between "the mechanical and the eternal—and us."[63] The effect of these spaces is enigmatic. They harbor secrets, challenge the viewer to enter and explore them. The advancement into unknown zones— pictorial spaces, real spaces, as well as mental spheres—becomes the content of the work, "getting deeper and deeper into space, into thinking. *Star Thief* is a cosmic allegory, a metaphor of work. The star is

a thief, the thief that induces curiosity, pulling people to go to a distant thought."[64]

The theme of the wayfarer underlies the monumental work *The Stowaway Peers Out at the Speed of Light*. As in *Star Thief* or *The Swimmer in the Econo-mist*, it is the idea of a journey into the unknown, which is inherent in painting that is "abstract" in the broadest sense. "I called the painting *The Stowaway Peers Out at the Speed of Light*, because a stowaway is someone who doesn't know where he is going or if he is going to make it."[65] The painting is part of a series that references Albert Einstein's special theory of relativity, "in which he describes the different points of view of both a traveler in space and an observer. In these paintings, the spectator and the traveler looking at the same thing see it differently because of the light refraction. I connected this to the wildly divergent reactions to my paintings ... So, in *The Stowaway Peers Out at the Speed of Light* (2000), what people are looking at is something that has been changed by the speed of light in the same way that ideas shift in my paintings as you look at them."[66] Here, Rosenquist also mixes associative, disparate trains of thought. He was familiar with the moment of transition, the disintegration of pictorial objects, from his days as a billboard painter, when the colossal objects would begin dissolving into abstract color planes right in front of his eyes. He was determined to convey this intangibility, the fallacy of a simple determination. At the same time, the interpretive openness that was also inherent in his paintings of concrete objects, was central here. According to Rosenquist, a successful painting lends itself to a gradual interpretation, offering the viewer both the directness of a billboard at first glance, as well as the hidden truths that increasingly reveal themselves. "A painting is a kind of time machine. It's essential that the painting communicate its energy and intensity to the person looking at it instantly, while at the same time it has to have elements that only become apparent after you have looked at the painting for a while."[67]

Rosenquist generally worked with straightforward, technical tricks. For the series *Speed of Light*, he used a mirrored tube to create the distorted images that served as his source material, just as in *Swimmer*. Even the complex compositions contain a playful, self-conscious moment of artificiality that lends them an element of mystery and at the same time protects them from the bare illusionism of virtual reality: "It's a painted effect, it isn't computer-generated. I like those old-school Hollywood devices. For instance, in the movie *Close Encounters of the Third Kind*, when the little boy opens the door, we see these big clouds rushing at him from the sky. How did they do that? They poured milk in a big fish tank, and as the milk dissolved into the water, the swirls of the suspended milk looked like clouds, and they photographed it. This kind of invention always intrigues me—where you come up with imagery that befuddles the viewer. For my specific purpose these are the most effective techniques."[68]

For its formal qualities and unfathomability, the cosmos is an ideal arena for Rosenquist's imaginings: "To me, space is a very abstract thing— star novas, black holes, solar wind—these are imponderables. Cosmological questions are hard to comprehend, so when I use images of outer space in a painting, it's to represent something incomprehensible—like the future."[69] A similarly ungraspable occurrence is manifested in the painting *The Meteor Hits Monet's Garden*, which ironically plays with chance and probability, and in *The Geometry of Fire*, inspired by a real-life catastrophe. The fire that wreaked havoc on his house and studio in Aripeka put his life in a cosmological context, where beauty and horror, development and decay were inseparable. This ambivalence is expressed

in the painting *Welcome to the Water Planet*, from the series of the same title. Rosenquist inverts the perspective here; instead of humans, projecting their longing and thirst for knowledge into the universe, we are met with an alien intelligence, discovering earth. "If aliens were to visit us, they would see the earth with both its beauty and its problems. And at the same time it was about seeing the earth as a Garden of Eden that we could lose in an instant. I was thinking about the subconscious of young people who have to take the threat of nuclear holocaust out from under their pillows and then put it back in order to be able to sleep."[70]

The varying perspectives that Rosenquist works with here characterize the complex perspective framework with which his paintings confront the viewer. At the end of the exhibition are two groups of works, in which the immersive experience is evident, both in relation to the world around us and the world within.

Surrounded by the World of Images

In *F-111*, *Horse Blinders*, and *Horizon Home Sweet Home*—three room-scaled paintings created between 1964 and 1970 for the dimensions of the Castelli Gallery—Rosenquist pursued the already mentioned phenomenon of peripheral vision and its potential to involve the viewer in the painting. Since all three works will be extensively discussed in separate essays,[71] this segment is primarily concerned with elucidating their innate immersive qualities. Just as the antithetically chosen title *Horse Blinders* lets on, in this sequence of environments, Rosenquist challenges our perception beyond possible centers of vision. By forcing the integration of the peripheral zones of vision, he underpinned both the expansion and the distractions of visual experience. "As in *F-111*, the painting was about peripheral vision, about looking at something and questioning it because of everything else you're seeing at the same time, the things on the peripheries that affect your vision."[72]

The artist's description of his work process makes clear that peripheral vision should not be understood in the sense of optical experience alone. The expanding of one's perspective is rather to be taken figuratively as well—for example, when comprehending the political opinions of others, uncomfortable facts, and surrounding circumstances. In his typical approach, linking different contextual levels, he notes: "*Horse Blinders* is a political pun, optically expressed—with vision just outside the scope of direct sight, and aluminum panels reflecting and distorting light, imagery, and the viewer. The idea came from an experience in Stockholm. When I showed *F-111* there, the two directors of the Moderna Museet were Carlo Derkert and Pontus Hultén. Carlo called himself a young Marxist, even though he was in his fifties. He said, 'When hanging an exhibition, we never have a tough painting on the left. We always hang the hard paintings on the right because, as you know, the left is softer.' I thought, this situation is like sparring partners; some areas are softer than others. And I wondered, what the hell is that about? So I decided to do a big painting where you couldn't see left, and you couldn't see right. You could only see straight ahead. *Horse Blinders* was the result."[73]

References to current political events—from bugging operations regarding DNA analysis, to the so-called Six-Day War—can be found next to existential meditations and references to Eastern philosophy. As sources of inspiration, Rosenquist cites both the psychological *The Tale of Genji* for its universality and ambiguity—written more than a thousand

years ago—as well as the casual remarks of his assistant Bill McCain: "You know, existence is like a piece of hot butter in a frying pan."[74]

The open mind with which Rosenquist operates his thematic repertoire finds its formal equivalent in the generously flowing implementation of the imagery. In a consistent refinement of *F-111*—in which the separate subjects, united by the circular fuselage of the fighter jet, are for the most part rigidly placed on top of each other—the subjects in *Horse Blinders* are continuously fused into one another. In synergy with the reflective aluminum panels, they form a comprehensive space, which not only surrounds, but rather assimilates the viewer in a unified atmosphere. While the use of aluminum was limited to two sections in *F-111*, here the artist deliberately places it in all four corners of the room; corners, which are in turn visually negated by the moving reflections. The adjacent areas of the paintings become as diffuse as the shape and movement of the viewer. "I love the way the aluminum panels in the corners very faintly reflect the images they are facing—and the smoothness and subtlety of those reflections."[75]

Ultimately, in *Horizon Home Sweet Home*, freed from the dead weight of the object world, the theme becomes being in space. Soft color gradients alternate with reflective panels of aluminized Mylar, which resemble the rippled surface of water; the floor, on which the viewer stands, is cloaked in dry-ice fog. "I had an idea about dislocation in space, with astronauts looking in their monitors trying to find their way home. To achieve the feeling of dematerialization, I wanted to create an effect of painted panels that appeared to be floating in space ... It was an extension of my concept of dissolving the painting as an object, immersing the viewer in the painting, and making it an environment—color as a state of mind."[76] The boundary-expanding space, perceived as flowing and omnidirectional, offers no contextual cues to the objective world. Brought back to their own emotional state, viewers should break through their physical boundaries and, together with the other viewers, expand into the unified atmosphere.

Painting as a Memory Bank: The Journey Within

Rosenquist repeatedly makes it clear that immersion is not only to be understood as a response to the work, but as a characteristic of the act of creation as well, during which the artist finds access to his own personal history and subconscious. In the first sentence of his autobiography, Rosenquist suggests that, for him, painting is tantamount to an immersion in the self. "Painting has everything to do with memory. Images of the unexpected, the surreal, well up unbidden in your mind—as do things you haven't resolved. A bizarre scene from your childhood that seemed unfathomable to you at the time will linger in your memory for years."[77] In another section he states the extent to which an existing painting can function as a key to his own past: "I think of my paintings as memory banks; they remind me of different parts of my life—where I was and what I did. It keeps my sanity."[78]

For Rosenquist, the seventies were a time of upheaval, personal crisis, disorientation, and new directions. He described the work from this period as being saturated with private meaning; a sort of autobiographical alphabet. He referred to his late works, on the contrary, as having a tendency toward the theoretical. "They're about things I have only a vague notion of."[79] But even here, it was an emotionally engaged approach to the subject that drove him and is often reflected in his work in the form of a question. The healthy equanimity that painting offered, as well

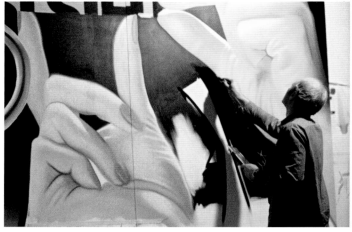

55

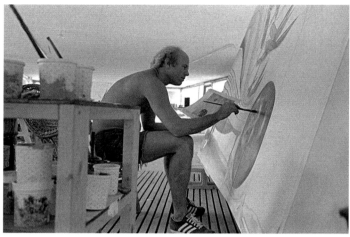

56

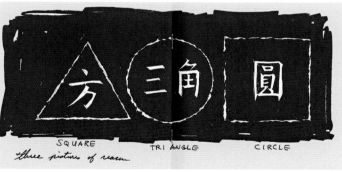

57

55 James Rosenquist working on *Paper Clip*,
Bowery Street studio, New York, 1973

56 James Rosenquist working on *Terrarium*,
Aripeka, Florida, 1977

57 A page from the artist's book *Drawings While Waiting
for an Idea*, 1979. Rosenquist takes up the motif of the
transposed Zen symbols triangle, circle, and square
from *Slipping Off the Continental Divide*

as the therapeutic need that it fulfilled for his way of relating to the
world, becomes clear when he states: "When things become peculiar,
frustrating, and strange, I think it's a good time to start a painting."[80]

Under the heading "My World Turns Upside Down,"[81] Rosenquist
describes a period of years marked by the serious car accident that he
suffered along with his family and the indirectly connected separation
from his first wife—years marked by financial problems and insecurity,
but also by a change of location and the search for a way to carry on.
"Whatever I'm feeling I need to express through images, symbols. Often
I would flatten the images out until they were almost unidentifiable, as
in *Paper Clip*. Sometimes I just didn't want to say too clearly what was
going on. There's a mystery to them, and what had happened was also
a mystery to me. Enigmatic symbols kept the adrenaline up."[82] Just as
Rosenquist, in that last casual comment, attempts to downplay the
previously stated meaning of his subject matter, his nihilistic state of
mind can, upon second look, also be recognized in the painting: hidden
behind the dynamic winged horse and the manicured, feminine hands,
with their advertising appeal. Here, a giant paper clip creates an infinite
loop around the Pegasus, which is trapped in a black circle and incapable
of free flight. The wallet is filled with blank pieces of paper, and the
cash-register roll is printed over and over again with the same sum. One
of the woman's hands frames an empty square, while the other holds an
upside-down sign that, cut off, contains the barely legible message:
"THIS IS LOVE IN 1971." "This was my state of mind at the time. That's
when I was broke. Emptiness, zero, nothing."[83]

The often-painful need to make decisions, fear and desire, conse-
quences, growing out of either action or procrastination—all of this
worried Rosenquist and found expression in his self-reflective works.
"To me, the bed in *Terrarium* is about love in a bottle,"[84] he outlines the
confounding metaphor of this painting, created in 1977 and painted
at a point in time when the things in his life once again began to find
order. With the help of an old Japanese paradox, the artist meditates
on desire, love, and the consequences of action. What do you do if your
favorite house pet secretly hides in your favorite vase, growing up
unnoticed? Once you have finally discovered it, it is already too late.
Do you break the vase and save the animal? "The face in a bottle is like
your love in a jar ... You take your favorite thing and you strangle it."[85]

A Pale Angel's Halo and *Slipping Off the Continental Divide* make up
Rosenquist's preferred combination of two paintings, the culmination of
the upheaval of those years—when he attempted to ground himself by
diving into his own emotional state, his past, and the future. In her
contribution to the present publication, Sarah Bancroft refers, in detail,
to the work's genesis and complex imagery, which was subjected to
various transformations throughout the course of the preliminary
studies.[86] There is a car window (a reminder of the accident) that looks
out into blackness, over which a staircase stretches, without beginning
or end. There is a book, which has been opened, turned over, and left
there, and a crumpled rainbow. The old Zen symbols of triangle, circle,
and square should symbolize a harmonious universe, but here, in this
absurd transposition of the form and the associated characters, they
create only confusion and chaos. A piece of white polyester cloth,
like a gossamer curtain, replaces a part of the rainbow and addresses
the painting as a surface, suggesting that it is necessary to stride
through it, in order to dive into the space beyond it, to discover its
hidden messages and histories. In his natural manner, Rosenquist
remarked: "It's just a continuation of my interest in playing with the
picture plane. It's like hanging sheets. Very delicate."[87]

Notes

1 James Rosenquist and David Dalton, *Painting Below Zero: Notes on a Life in Art* (New York: Alfred A. Knopf, 2009), 326.

2 Rosenquist and Dalton, 155.

3 James Rosenquist, quoted in Sarah Bancroft, "James Rosenquist and the Blades of Time," in *Time Blades*, exh. cat. Acquavella Galleries New York (New York, 2007), unpaginated.

4 Oliver Grau, *Virtual Art: From Illusion to Immersion* (Cambridge, 2003).

5 Rosenquist and Dalton, *Painting Below Zero*, 154.

6 Rosenquist and Dalton, 154–55. On Newman's preoccupation with peripheral vision, see also Tom Holert's essay in this volume, 191–92.

7 Rosenquist and Dalton, 7–8.

8 Rosenquist and Dalton, 3.

9 Rosenquist and Dalton, 241.

10 Rosenquist and Dalton, 296–97.

11 Rosenquist and Dalton, 297.

12 Rosenquist and Dalton, 52.

13 See Sarah Bancroft's essay in this volume, note 8.

14 Rosenquist and Dalton, *Painting Below Zero*, 112.

15 Rosenquist and Dalton, 115.

16 Rosenquist and Dalton, 113.

17 Rosenquist and Dalton, 88.

18 Rosenquist and Dalton, 95.

19 Rosenquist and Dalton, 88.

20 Rosenquist and Dalton, 88.

21 Rosenquist and Dalton, 96.

22 Rosenquist and Dalton, 97. In addition to the Ford advertisement from *Life* magazine, Rosenquist used a part of an ad for the cosmetics manufacturer Veto as a source image for the middle section of the painting.

23 See in particular Tino Grass's essay in this volume, 143ff.

24 Rosenquist and Dalton, *Painting Below Zero*, 273.

25 Rosenquist and Dalton, 10–11.

26 Rosenquist and Dalton, 98.

27 See in particular Sarah Bancroft's essay in this volume, 110ff.

28 Rosenquist and Dalton, *Painting Below Zero*, 10.

29 Rosenquist and Dalton, 18.

30 Rosenquist and Dalton, 81.

31 Rosenquist and Dalton, 81.

32 Rosenquist and Dalton, 94.

33 Rosenquist and Dalton, 4. See also *Rainbow*. In this melancholy painting, Rosenquist works with a section of an advertisement for Alcoa Aluminum, featuring a window with an open folding shutter. He transformed the dirty streaks on the side of the house into a rainbow-like, iridescent veil of color. In the window, one pane of which is broken, is a clearly personified, colossal fork. Formally echoing the streaky striations and the battens of the window shutters, it is also associated with the basic human need for nourishment.

34 Rosenquist and Dalton, 91.

35 Rosenquist and Dalton, 91.

36 See Miyeko Murase, *Turning Point: Oribe and the Arts of Sixteenth-Century Japan*, exh. cat. (New York: Metropolitan Museum of Art, 2003), 13–14, 301ff.

37 Rosenquist and Dalton, 82–83.

38 Rosenquist and Dalton, 107.

39 See James Rosenquist, in *James Rosenquist: Target Practice*, exh. cat. (Salzburg: Galerie Thaddaeus Ropac, 1996), unpaginated.

40 Rosenquist and Dalton, *Painting Below Zero*, 107.

41 Rosenquist and Dalton, 105–06.

42 Rosenquist and Dalton, 90.

43 Rosenquist and Dalton, 190.

44 Rosenquist and Dalton, 191.

45 Rosenquist and Dalton, 191.

46 See Evelyn Weiss, *James Rosenquist: Gemälde—Räume—Graphik* (Cologne, 1972), 96.

47 Rosenquist and Dalton, *Painting Below Zero*, 13.

48 Rosenquist and Dalton, 317–18.

49 Rosenquist and Dalton, 316.

50 Rosenquist and Dalton, 317. Since the painting was actually made for the Guggenheim Bilbao, its use of *Guernica* received an unexpected new meaning when the location was changed to Berlin: "Now that the work was to be displayed in Berlin, the use of the Guernica image in the commission had another, ironic connotation, since it had been the German Condor Legion that bombed Guernica in the spring of 1937," Rosenquist and Dalton, 316.

51 Rosenquist and Dalton, 319. On Rosenquist's themes and distorted images made with a mirrored tube, see in particular Sarah Bancroft's contribution in this volume. James Rosenquist kept the use of the Mylar tube private, and Sarah Bancroft writes about it in detail for the first time in her essay in this volume, 119.

52 Rosenquist and Dalton, 90.

53 Rosenquist and Dalton, 102.

54 Rosenquist and Dalton, 94–95.

55 Rosenquist and Dalton, 139.

56 Rosenquist and Dalton, 296.

57 Rosenquist and Dalton, 326.

58 On *Star Thief* and the other exhibited works in the cosmos context, see also Sarah Bancroft's contribution in this volume, 119.

59 Rosenquist and Dalton, *Painting Below Zero*, 266.

60 Rosenquist and Dalton, 268.

61 Rosenquist and Dalton, 255.

62 On Rosenquist's "crosshatched technique" see Sarah Bancroft's contribution in this volume, 116.

63 Rosenquist and Dalton, *Painting Below Zero*, 275.

64 Rosenquist and Dalton, 256.

65 Rosenquist and Dalton, 327.

66 Rosenquist and Dalton, 326.

67 Rosenquist and Dalton, 290.

68 Rosenquist and Dalton, 327.

69 Rosenquist and Dalton, 343.

70 Rosenquist and Dalton, 295.

71 For *F-111* see the essay by Tino Grass, for *Horse Blinders* Isabel Gebhardt, and for *Horizon Home Sweet Home*, as well as the environmental aspects of Rosenquist's work around 1970, see Tom Holert, all in this volume.

72 Rosenquist and Dalton, *Painting Below Zero*, 196.

73 Rosenquist and Dalton, 196.

74 Rosenquist and Dalton, 198.

75 Rosenquist and Dalton, 198.

76 Rosenquist and Dalton, 206.

77 Rosenquist and Dalton, 3.

78 Rosenquist and Dalton, 222.

79 Rosenquist and Dalton, 342; see also 222.

80 Rosenquist and Dalton, 195.

81 Rosenquist and Dalton, 209.

82 Rosenquist and Dalton, 242–43.

83 Rosenquist and Dalton, 223.

84 Rosenquist and Dalton, 241.

85 Rosenquist and Dalton, 241–42. An advertisement for Hunt's ketchup featuring a row of empty glass bottles—one of them containing a plump, juicy tomato—served as the source material. The unfathomable woman's face came from a printed photo-graphic spread in *Life* from Erwin Fieger, displaying the stylistically made-up visage of a Japanese Kabuki actress. The text from the advertisement for Sealy mattresses, from which Rosenquist borrowed the bed, began with the line: "Sooner or later you'll be sorry."

86 See Sarah Bancroft's essay in this volume, 113–14.

87 Rosenquist and Dalton, *Painting Below Zero*, 214.

Collages
Source Material
Working Processes

James Rosenquist and Collage: Esoteric Loci

Sarah Bancroft

Popular culture isn't a freeze-frame; it is images zapping by in rapid-fire succession, which is why collage is such an effective way of representing contemporary life. The blur between images creates a kind of motion in the mind. —James Rosenquist[1]

In a handwritten note scrawled on a 1980 source collage, James Rosenquist commented on the decline of oil and steel and the future of computer software. At the time, the United States was having its second energy crisis in a decade and the domestic economy was in recession. Rising fuel prices brought rising consumer anxiety. American heavy industry was indeed declining, while Apple computers and Atari video-game consoles were becoming popular consumer items. Rosenquist captured this cultural moment in the brilliant *House of Fire* (1981), both in the source collage (1981, fig. 58) and in the finished painting (fig. 59). It serves as both a tribute and an elegy for the furnace of domestic manufacturing and heavy industry.

Artists illuminate our experience of immediate history, often by reflecting it in a different light. Rosenquist lit this late twentieth-century moment on fire, emphasizing or questioning the power of the US economy, even as oil and steel industries declined.

The source collage shows the three-part conceptual ground for the painting. An upside-down bag of groceries on the left emphasizes the economic downturn. A bucket of molten steel, suspended through an open window and radiating at the center of the painting, represents what had once been one of America's leading industries. An array of lipsticks, in tight military formation on the right, refers to petroleum and also ammunition. This amounts to a sophisticated iconic rendering of a historical moment. The painting trumpets America's traditional industrial strength in a bold and powerful composition. The domestic economy, the American house of fire, was changing. Would we continue to be a "house of fire," or would our enterprises dwindle?

As it turned out, the analog world of heavy industry was diminishing while the digital world of information technology was increasing, exponentially. Nevertheless, in his own artistic practice, Rosenquist remained analog and tactile. He never digitized his production. "I try to make my paintings zing! They have to zing, and to me the human mind is much zingier and more sophisticated than any computer I could use," Rosenquist said with enthusiasm, and he continued, "I don't want the footprint of the computer in my work. I am old fashioned in this way. I like it low-tech!"[2] Each Rosenquist painting began with an idea that was fleshed out in a handmade source collage. *House of Fire* exemplifies his conceptual and compositional approach to artmaking that began in the 1960s and continued over the course of nearly five decades of production.

The heart of Rosenquist's conceptual and compositional practice was the collaging of existing images, usually taken from printed advertising, news photography, and photographs Rosenquist shot or commissioned. With these materials he created compositions that pondered personal experiences and memories. Sometimes he used them to address his quandaries. For the viewer, they often hover at the edge of comprehension. He approached his works intuitively, as a visual language, and he always hoped that something in them would "get away" even from him.[3]

In the 1950s, James Rosenquist painted billboards and signs in Midwestern states and in New York City. As a commercial artist, he became fluent in the visual language of advertising. He often painted the same advertisement repeatedly at different locations across New York City. In this way his occupation steeped him in the power and politics of advertising. Ultimately he harnessed this knowledge, and subverted it, to create distinctive and powerful noncommercial images ripe with the visual drama of twentieth-century America. By the 1960s, his paintings incorporated commercial sign-making techniques as well as images of people and products derived from advertisements and photographs.

After quitting his day job painting "on the boards" (the scaffolding on which he stood to paint billboards in Times Square and across New York City), Rosenquist took over the former studio of artist Agnes Martin at 3–5 Coenties Slip in lower Manhattan in 1960. A community of artists (including Charles Hinman, Robert Indiana, Ellsworth Kelly, Lenore Tawney, Agnes Marten, and Jack Youngerman) had congregated there, converting old sail-making lofts and warehouses into studio spaces, and it was among them that Rosenquist began working full-time on his fine art.

"The idea of using images from the recent past came to me while I was in Coenties Slip. On a hunch, I started looking for old *Life* magazines and avidly collecting them. I was cutting pages out of *Life*, and as I was looking at them I began to say to myself, this stuff is ridiculous.... Most advertising is based on getting your attention by juxtaposing things that don't belong together. Advertising uses a crude form of surrealism to get your attention."[4]

Zone (1960–61; fig. 2) is the first Rosenquist painting to include jarring shifts in scale for which he became known. The composition interlocks found images in a zigzag pattern, delineating the zones of two distinct images. The upper-right section depicts a woman's face with hands raised to her cheek and forehead (derived from a black-and-white advertisement for Angel Skin lotion [fig. 73]). The lower-left portion of the canvas features a close-up view of a freshly washed tomato and stem, shimmering with drops of water (plucked from a magazine ad for Campbell's tomato products [fig. 72]). The tomato is an enlarged fragment, depicted in a larger scale than the face and hands. And whereas the original Campbell's ad was produced in vibrant color, Rosenquist painted the tomato in pure grisaille. Sans the rich red skin and bright green stem the image becomes mysterious. "I thought if I painted things in different scales, it would make them hard to recognize, abstract, and the images would seep out slowly," Rosenquist said. "I could make a more mysterious painting this way."[5] The final collage for *Zone* no longer exists. But an early sketch for the painting and a clipping of the Angel Skin advertisement illustrate some preliminary thoughts and plans for the painting (fig. 74). The finished composition simplified the ideas explored in the original sketch. After much revision, Rosenquist was able to resolve in *Zone* the formal considerations of advertising that he had wrestled with in pursuit of his own visual language, and laid the groundwork for five decades of artistic production to follow.

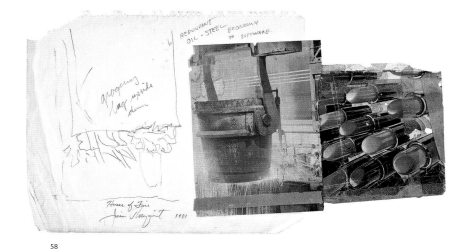

58

58 *Source and Preparatory Sketch for
 House of Fire*, 1981
 Magazine clippings and mixed media on paper
 14 × 25 11/16 in. (35.6 × 65.3 cm)
 Estate of James Rosenquist

59 *House of Fire*, 1981
 Oil on canvas
 6 ft. 6 in. × 16 ft. 6 in. (198.1 × 502.9 cm)
 The Metropolitan Museum of Art, New York,
 Purchase, Arthur Hoppock Hearn Fund,
 George A. Hearn Fund and Lila Acheson
 Wallace Gift, 1982

60 James Rosenquist in front of source material
 pinned to the wall of his Broome Street studio,
 New York, 1966

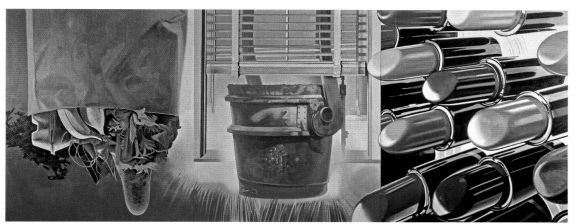

59

60

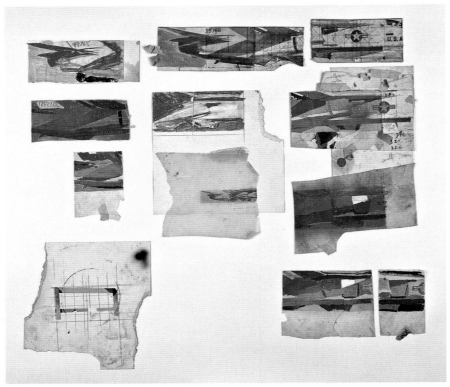

61

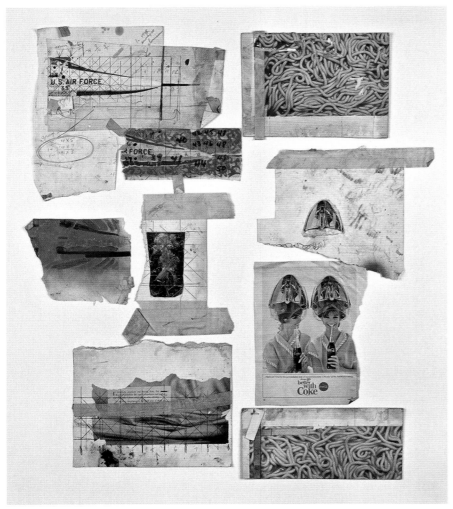

62

61 *Sources and Preparatory Sketches for F-111*, 1964
Mixed media collages and sketches
The Museum of Modern Art, New York, promised gift of
Marie-Joseé and Henry R. Kravis
(Photo taken before consolidation of some elements)

62 *Sources and Preparatory Sketches for F-111*, 1964
Mixed media collages, sketches, and photographs
The Museum of Modern Art, New York, promised gift of
Marie-Joseé and Henry R. Kravis
(Photo taken before consolidation of some elements)

"I started by writing things on the wall, jotting down notes, clipping things out of magazines and stapling them to the walls As I was stapling the pages of magazines to the wall, I did not know exactly why I was doing it. What attracted me in ads was the mystery, the strangeness of these bits of commercial propaganda—they were enigmas In this way I could make a mysterious painting using the most banal materials."[6] (fig. 60)

Rosenquist understood the power of cropping and framing. His compositions often imply scenes that expand beyond the confines of the canvas. For example, *Hey! Let's Go for a Ride* (1961; fig. 8) could be mistaken for a cropped detail of a larger advertisement. It is comprised of elements from two distinct ads, one for Carling's Red Cap Ale and one for Dr. West's Miracle-Tuft toothbrushes (figs. 88 and 89). In this work, the artist created a new scenario that hints at a flirtatious encounter totally liberated from the original commercial promises of frosty beverages and cleaner teeth. Rosenquist spoke of a chance encounter from his early days in New York, when a convertible full of young women pulled up next to him on the street and invited him to "jump in" and join the party. Perhaps the youthful serendipity of opportunity in that event inspired this small, appealing canvas: beers and bright smiles and young Americans.[7] In *Above the Square* (1963; fig. 13) a cropped, close-up view of a woman's legs and hand occludes the bluebird sky behind. The grisaille view is a visual synecdoche for the woman as well as for the billboard. This painting captures the experience of a person painting a massive billboard at close range above Times Square, large enough to fill one's peripheral vision, with the expansiveness of open air and blue sky behind.[8]

The collages are both a product and a document of the time in which they were made. They served as roadmaps for the paintings, used to create deadpan transcriptions onto canvases.

That Pop artists used commercial art-making techniques to achieve fine-art results is a defining characteristic of Pop art. Rosenquist persisted in using found advertising images with such consistency that they eventually defined his practice. When he was a sign painter with the Local 230 of the International Brotherhood of Painters and Allied Trades, his union boss provided him with unscaled images to be painted on billboards around the city. Later, on his own, he chose which images to paint, and where, how, and what size he would paint them. "Each image in my paintings must originate somewhere else.... either in some publication or in a photograph or in real life, but not just in my head," Rosenquist said. "If I were to choose images solely from my imagination, I'm afraid they might seem too artistic. The viewer should be able to recognize the image purely for what it is without applying any meaning to it. Still, I want the image to carry a collective meaning within the collage."[9]

In *President Elect* (1960–61/1964; fig. 7), he borrowed the image of John F. Kennedy from a 1960 presidential campaign poster (fig. 83). Rosenquist juxtaposed this portrait with images of prosperity and consumerism in order to ask, "Here is this new guy who wants to be President of the United States during the Eisenhower era: What is he offering us?"[10] The source collage (fig. 86) positions the handsome John F. Kennedy alongside an advertisement for Swan's Down cake mix (fig. 84) and an ad for a Chevrolet car (fig. 85), suggesting Kennedy was pitching himself as well as an economic program and prosperity that would put food on your table and a car in your garage. Rosenquist often selected images from ads that were ten or fifteen years old (like the ad

for a 1949 Chevrolet in this collage), to ensure the objects were immediately recognizable by the viewer without triggering nostalgia. They were symbolic rather than specific; the idea of a car and a piece of cake was important rather than the precise brand or model.

In the final composition, the lovely hand holding a piece of chocolate cake has been shifted left, and now flows from Kennedy's eye socket and chin into a grisaille offering of cake while a porcine portion of the yellow car looms at far right. Both Kennedy and the car occupy more space in the final composition than in the collage, an adjustment Rosenquist achieved by gridding each section of the collage to a different scale: he scaled up Kennedy and the car, while scaling down the cake. He gridded both the collage and the painting panel in order to transfer images by hand from the smaller study onto the larger surface. This came directly from his billboard experience. He called it the Brooklyn Bridge technique, and he perfected the freehand approach to scaling up by working "on the boards" in the 1950s. He subsequently used this technique over the course of his fine-art career.

In 1964, Rosenquist began planning the room-sized installation for his monumental painting *F-111* (1964–65; fig. 16). Most paintings in Rosenquist's oeuvre have one and sometimes two source collages. For this eighty-six-foot-long painting Rosenquist developed no fewer than twenty-one separate source collages and studies (figs. 61 and 62); he later combined some of the individual elements onto single backing boards, resulting in the fifteen source collages and studies we see now (figs. 122–27, 129, 130, 137, 139–44, 151). (Rosenquist engaged in planning on this scale with a few other room-sized paintings: *Horse Blinders* [1968–69; fig. 18], *Horizon Home Sweet Home* [1970; fig. 20], and *The Swimmer in the Econo-mist* [1997–98; figs. 39–42].) As a nuanced yet bold statement, in *F-111* the artist was asking this question: why were we building bombers rather than schools and hospitals? Planned for the front room of the Leo Castelli Gallery in 1965, the source collages elaborate Rosenquist's plan to animate the newest F-111 fighter-bomber with products and experiences from everyday life. Source collages and drawings illustrated the composition that would be arranged along the four walls of the room. Rosenquist also noted areas to spray with Day-Glo paint (on top of his more traditional oils, in case the Day-Glo faded over time).

Most of the images came from *Life* magazine, not counting the spaghetti at the far-right end. Rosenquist commissioned photographs from Hollis Frampton for this section. Rosenquist's intentions were clear from the beginning, right down to the overlaying Day-Glo paint. (The Day-Glo colors have remained stable to this day).

Starting in 1964, James Rosenquist began collecting everything he could find about the state-of-the-art F-111 fighter-bomber. He produced collages and studies and began his monumental painting in his Broome Street studio, in SoHo, in Manhattan. Conceived as a panorama, the eighty-six-foot-long painting of the F-111 measures about thirteen feet longer than the aircraft itself. Conceived as a statement against the military-industrial-complex, he wanted its image to invade the viewer's peripheral vision from all four walls of the Castelli Gallery.

Like the watersheds of the Rocky Mountains known as the Continental Divide, American artists in the Midwest also tend to flow either east or west, to Manhattan or Los Angeles. *Slipping Off the Continental Divide* (1973; fig. 21) refers to Rosenquist and his peers who made their ways to the coasts to pursue careers as artists. Rosenquist moved from

Minneapolis to New York City, and he identified this painting as "a metaphor for my past life and my future: yesterday, today, and tomorrow.... One way or another, you leave your home, you slip off the Continental Divide, which goes east or west."[11] The work is also a meditation on the devastating traffic accident that befell his family in 1971. (The accident severely injured Rosenquist's first wife and his son, and it endangered the family's financial security for a time.) Coming through this adversity, James Rosenquist found himself turning away from the pages of his past and moving ahead into an uncertain future. In 1973 he moved to Florida, eventually building a house and studio there.

In developing the composition, Rosenquist used a children's picture book as a source material (see fig. 209). Above an illustration of two children wading through water, he wrote "GOING NOWHERE," summing up his feelings of life being on hold at that moment. In the painting, a car window frames a staircase that leads nowhere. An open book has been turned over midway through; in the source collage and drawings studies, the book is suspended above crosshatched nails that mark time as if charting days passed (see figs. 208, 211, and 212). In the final composition, a circle, square, and triangle symbolizing the universe have replaced the nails. The artist has synthesized multiple ideas into one composition, with stories both personal and universal.

Rosenquist often mentioned that "the hardest thing for an artist to find is an idea."[12] Only after he had mulled over and developed an idea for a painting (and not before) did he set to work creating a source collage. In his Aripeka, Florida, house (where he built a residence and studio in the 1970s and 1980s), Rosenquist stacked and piled a massive and growing collection of magazines, books, photographs, and printed ephemera in the "drawing room" adjacent to his living room and kitchen. He searched through this vast ad hoc library for just the right image. (He also photographed specific elements for some compositions.) His studio assistants cut out the selected images from a magazine or book with an X-ACTO knife, and Rosenquist collaged these onto paper. The collages were then transferred to a larger board for stability. Some of the collages—mainly the ones used for the largest paintings—were gridded out. For other paintings, a canvas was assembled in the drawing room. Under dim lights, collage images were projected onto a canvas using an old-fashioned opaque projector, so that he could quickly make underdrawings in charcoal. Some scholars and critics have surmised that Rosenquist may have resorted to projection in crafting his largest works. The truth is that he never painted any of his works using projection. In the "drawing room" he did project some collages onto smaller and medium-sized canvases in order to make underdrawings efficiently. "I like to get the images [underdrawings] up as quick as possible," said Rosenquist, "and then play with them. That's when the magic happens."[13] Once an underdrawing in charcoal had been sketched on the primed canvas, the canvas was moved to the hangar-like studio next door. Placed there on a large wall, Rosenquist would begin painting by hand under natural light, with collage in hand as his guide. (The collage often provided notes and samples of color.

63 Weyerhaeuser Plasticlad Advertising

64 James Rosenquist working on *Star Thief*, 1980

63

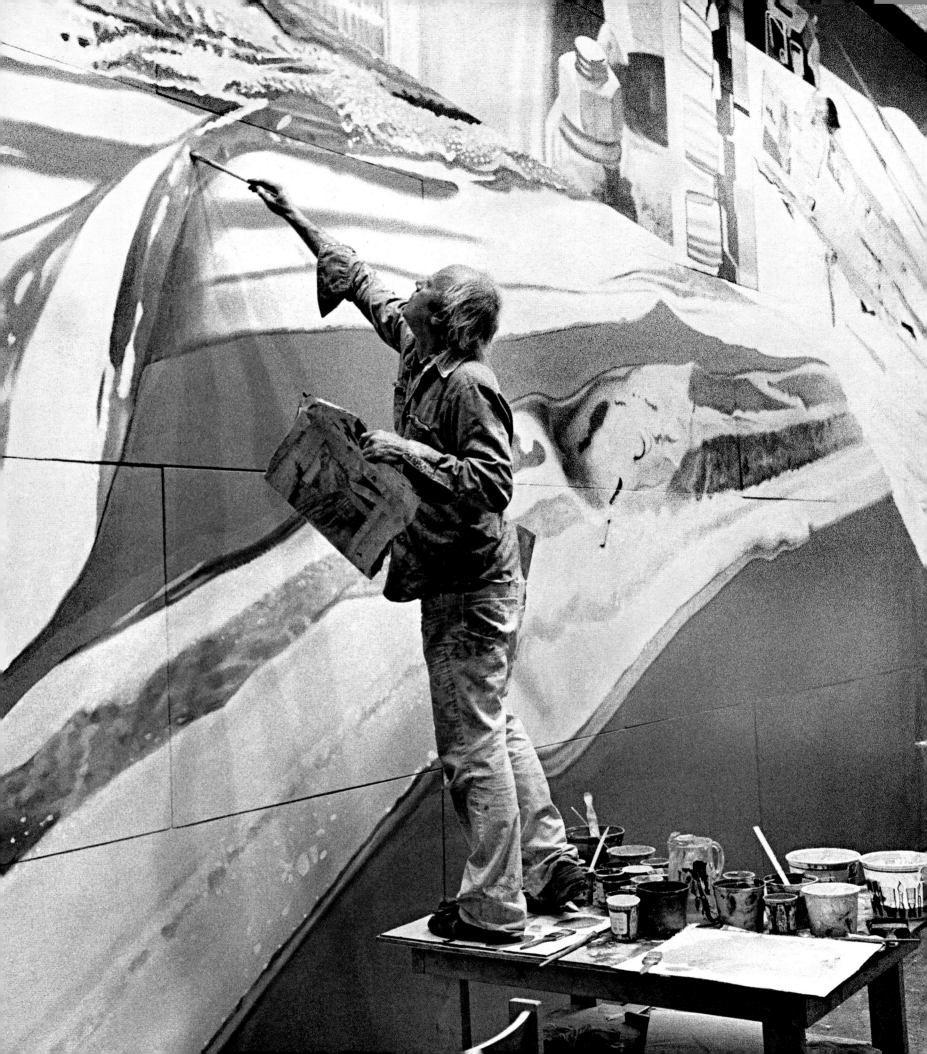

He often transferred these notes on color to the canvas). For the largest works—those that would not fit in his drawing room—he gridded both collage and canvas to scale up the collage imagery and executed the underdrawings by eye, without the aid of projection. (If a source collage is gridded, it is a good bet that the canvas was likewise gridded and the charcoal underdrawing was scaled up by hand.)[14]

In 2003 curator Walter Hopps and I installed a long swathe of Rosenquist's collages in a corridor of the Mies van der Rohe pavilion at the Museum of Fine Arts in Houston on the occasion of the artist's 2003 retrospective. The works were revelatory. The overall display made clear, at a glance, a few technological developments that Rosenquist had incorporated into his collage process over the years. By the late 1980s a color photocopy machine became a vital tool in his collage process. Mechanical enlargement and reduction features gave the artist added flexibility to scale the individual images and components directly, before finalizing the source collage. The machine saved a step because, by enlarging and reducing images, he could quickly scale each photocopied element to fit as desired in the source collage before transposing the collage's composition to canvas. This was similar to Rosenquist's use of an opaque projector to quickly dispatch the underdrawing that enabled him to focus on the business of painting. Rosenquist used efficient technology to improve his workflow but he never varied in his hand-painted approach to the composition on canvas.

In the 1980s Rosenquist began using what he called a "crosshatched" technique, showing foreground and background through slivered images that overlapped. He used it first in the painting titled *Star Thief* (1980; fig. 24). Rosenquist mentioned the shard-like fronds of the saw palmetto trees growing around his Florida studio had inspired the technique. In collages, he was cutting out wisps of overlay material to reveal fleeting visions of women's faces beneath (see figs. 228, 243, 245, 246, 250, 262). Splicing allowed him to compress distinct intersecting imagery with great efficiency; it allowed him to exploit multiple fields and subjects; and allowed him to combine these effects within the limits of one pictorial space as further exemplified by *Welcome to the Water Planet* (1987; fig. 28), *Time Door Time D'Or* (1989; fig. 30 for the related print), and *Untitled* (1995; fig. 36).

In 1981 photographer Bob Adelman spent more than a month documenting the process of Rosenquist painting *Star Thief* in his New York City studio. Measuring seventeen by forty-eight feet, *Star Thief* became the first of a handful of billboard-sized paintings Rosenquist produced in New York and Florida in the decades that followed. *Star Thief* was also the first to incorporate the slicing and splicing of imagery so evident in his work in the 1980s.

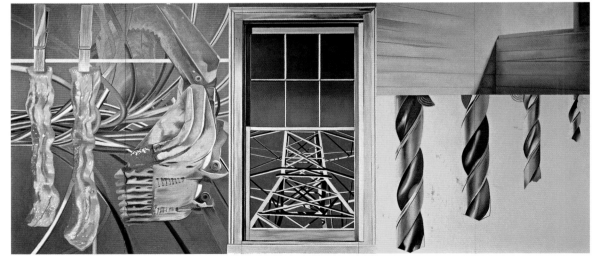

65

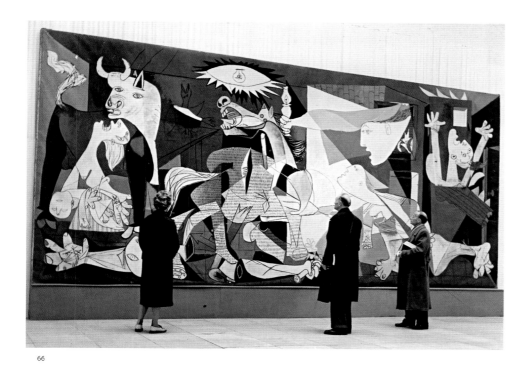

65 *Industrial Cottage*, 1977
 Oil on canvas
 6 ft. 8 in. × 15 ft. 2 in. (203.2 × 462.3 cm)
 Smithsonian American Art Museum,
 Museum purchase through the Luisita L.
 and Franz H. Denghausen Endowment

66 Pablo Picasso's *Guernica* (1937),
 exhibited at Haus der Kunst, Munich, 1955

67 View of the exhibition *James Rosenquist:
 The Swimmer in the Econo-mist*
 at Deutsche Guggenheim, Berlin, 1998

66

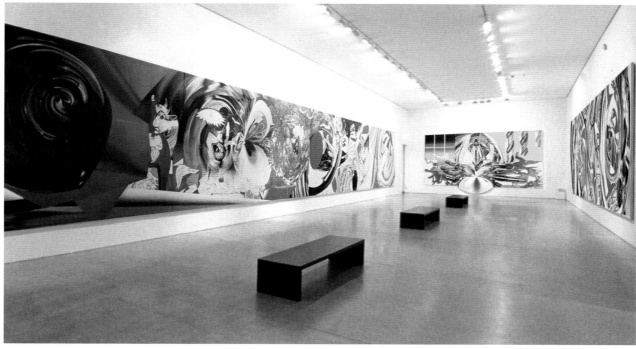

67

68 View of *The Stowaway Peers out at the Speed of Light*
(2000) in Rosenquist's studio, Aripeka, Florida, 2000.
(The artist subsequently changed the green section
at lower left to yellow before exhibiting the painting.)

69 *Multiverse You Are, I Am*, 2012
Oil on canvas
11 ft. 4 in. × 10 ft. 5 in. (345 × 318 cm)
Private collection

70 *Source for Multiverse You Art, I Am*, 2012
Collage, with adventitious marks, mounted on paper
23 ¼ × 21 in. (collage), 26 ³⁄₁₆ × 22 ¾ in. (sheet)
(59.1 × 53.3 cm [collage], 66.5 × 57.8 cm [sheet])
Estate of James Rosenquist

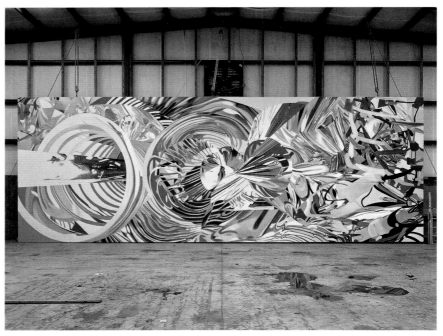

68

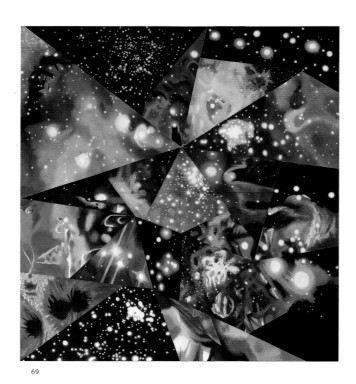

69

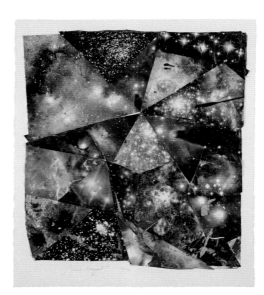

70

The source collage for *Star Thief* (1980; fig. 228) presents a lively, multilayered impasto of imagery—the slivered head jauntily interlaced with multicolored wiring that flows into a pair of tweezers gripping a ball bearing, itself set against three-dimensional, white paneling. Neck and head extend from a shaft and pillow block with the shoulder seemingly trimmed into rashers of bacon offset by nuts and bolts and machine parts—the whole ensemble floating through the vastness of galactic space against a backdrop of stars. The slivered imagery used in the head allowed him to show foreground and background simultaneously and greatly increased the visual information in the composition.

Rosenquist described the intent of the painting not as a depiction of space travel in the literal sense, but as a metaphor for creative exploration. He explained, "The star is the original attraction. Once you reach the star, you make a diversion because you can see even further. So, the star is the 'thief' that brings you to all the places you didn't originally plan to go. It is like thinking: the more [thinking] you do, the deeper you go, and the more mysteries you see and want to discover."[15]

Rosenquist's superb facility with a paintbrush was forged through years of painting large-scale billboards. His ability to render what was mapped out in the *Star Thief* collage was never the challenge. It was the secret body of ideas in his collage that formed an esoteric locus for each mysterious narrative, and this required his mental energy and focus. The collage was the real work, as well as the real test. "I stick the collages on the wall and, if I still like them after a month or two, I make a painting."[16]

In 1996 Rosenquist was commissioned by Thomas Krens, director of the Guggenheim Museum in New York, to create a monumental work for Deutsche Guggenheim Berlin in Germany. In response to this commission, Rosenquist improvised new tools for creating dynamic imagery that would impact his painterly style for more than a decade.

For Rosenquist, "painting means making some reference to one's time."[17] As he had done with *F-111*, Rosenquist wished to capture the tenor and tempestuous nature of the times in a monumental statement for the Deutsche Guggenheim Berlin project. He created a three-painting suite titled *The Swimmer in the Econo-mist* (1997–98, figs. 39, 41, 42). Krens explained the work "is, in Rosenquist words, about 'the tumult of our economy,' the ups and downs experienced around the world and, in particular, in the United States today and in Germany in the years after reunification, the swirling vortices that barrel across the vast expanse of these paintings and give the work its exceptional dynamism mark an entirely new direction in the artist's visual vocabulary."[18]

Rosenquist developed many studies and source collages for the three paintings, and incorporated the colors of the German flag, as well as imagery from Pablo Picasso's painting *Guernica* (1937; fig. 66) and from his own history painting *F-111*. The two long, horizontal paintings (*painting 1* and *painting 2*) resonate with a flurry of bright or somber imagery that tumbles across the picture plane.

To achieve these swirling vortices of color, Rosenquist crafted a cylinder lined with reflective silver Mylar. By photographing objects inside the reflective cylinder from above, Rosenquist distorted otherwise recognizable imagery, creating a swirling effect in which breakfast cereal boxes and laundry detergent boxes gyrate across the picture plane, hurtling alongside a swirling distortion of *Guernica*. At the fulcrum of

painting 1—where the composition transitions from Picasso's grisaille to Rosenquist's bright color—a fiery meteor radiates in the center. For *painting 3* (the smallest of the three paintings, and the focal point of the suite), red lipsticks melt and morph into a central reflective disk beneath the metal hair dryer borrowed from *F-111*. The iconic bonnet of the hair dryer is flanked by a window glowing with a sunset the colors of the German flag at left and drill bits from another Rosenquist painting entitled *Industrial Cottage* (1977; fig. 65) at right. True to form, Rosenquist successfully adapted existing imagery and repurposed it for his own vision. Rosenquist utilized low-tech means to achieve high-keyed, dramatic effects.

Rosenquist alluded to the new tool, the reflective cylinder, in several studies for *The Swimmer in the Econo-mist*. Drawings and notes in multiple studies reference a tunnel, including: "sketch for Guernica tunnel" in one (fig. 270), and "detail of F-111 in a tunnel" and "Guernica time tunnel" in another (fig. 269). These were made alongside and concurrent with the source collages that used photographic imagery created using the cylinder.

He planned to surround the visitor in the velocity and visual cacophony of this three-painting-suite (see fig. 40). His quotation of history paintings that address the terror and the folly of warfare—*Guernica* in *painting 1* and *F-111* in *painting 3*—were well developed in the multiple source collage and studies for these works, as was the immersive installation plan for the paintings (see figs. 270 and 275). In *F-111*, Rosenquist identified the girl beneath the hair dryer as the virtual pilot of the plane. In the collage study for *The Swimmer in the Econo-mist* (*painting 3*), she is nowhere to be found, yet Rosenquist wondered whether she is still driving the economy or is the beneficiary of the post-industrial, digital economy in a note that reads: "THE PILOT OR THE HEIRESS IN THE HOT INTER HAIR NET." (fig. 280)

While working on the *Swimmer* paintings, Rosenquist explained, "Well, it's a totally optical space. It's a new device for me, really, it's like an exclamation that shows change ... When this all goes together, you'll walk in the front door of the museum, and this ninety-foot painting should propel itself down to one end of the room and to the other, and then around the room. The priority for me is visual invention, and really, content is secondary, but then the content is what grounds the picture"[19]

In the early 2000s, Rosenquist began a new body of work—the Speed of Light series—that explored themes of perception and embraced nonobjectivity to a greater degree. *The Stowaway Peers Out at the Speed of Light* (2000; fig. 43) is the largest painting in the series, billboard scale. The source collage was developed from photographs shot by the artist using the reflective cylinder anew (fig. 282). In this instance, the objects shot in the cylinder are not readily recognizable, and the composition approaches near complete abstraction even as it conveys a sense of speed and motion and momentum. The color photographs have been photocopied, cut, and collaged until just so. Rosenquist extended a part of the composition at far left with a drawing that completed the whirlpool forms in black ink. He further noted the colorscheme as "rose," and "orange" to refer to during the painting stage.

The Stowaway Peers Out at the Speed of Light was conceived and executed on the eve of Rosenquist's full-career retrospective organized by the Guggenheim Museum that opened in 2003, as the artist was

considering the breadth of his entire career as well as how visitors would perceive his oeuvre.[20]

In this body of work, Rosenquist likens himself to Einstein's theoretical observer traveling at the speed of light. He noted that another observer viewing the same object—his artwork—would neither see nor perceive it the same way he did. His exquisite compositions might suggest mysterious narratives with cosmic and elusive themes, yet he knew that he was walking a tightrope between the convincing illusion and the literal representation of esoteric concepts (fig. 68).

In 2009 a raging brush fire destroyed Rosenquist's Florida home, studio, office, and more than sixty acres of his land. Two years later he created the large-scale work *The Geometry of Fire* (2011; fig. 44). The related collages and the painting address the fire for the first time, and likewise reveal the beginnings of a new series in the cosmic imagery emanating from the center.

Like an ignition point or the first flash of fire, the composition explodes from a central point. For the source collage (2011; fig. 284), Rosenquist cut slices from images of nebulae, star systems, and galaxies and pieced them together into a central starburst. Variegated colors and patterns of multiple star systems make up the rays of the sunburst, and he worked and reworked this area as the many layers of collage attest. The amorphous, melting imagery of the silver hubcap on the right side of the composition was created with the aid of the reflective cylinder. On the left side, hungry flames lick across the cosmos. A color photocopy machine was used to achieve the desired scale for each element, and all were collaged together by hand. The title is a paradox. Rosenquist explained. "The title is ultimately nondescriptive, because there is no such thing as geometry in fire, it's just wild, totally reckless, an accidental illumination and immolation. Humans always want to inject geometry and meaning into nature, but it's a mystery."[21]

The cosmic space depicted in *The Geometry of Fire* continues in the Multiverse series of paintings that followed (Rosenquist's last body of work). The collages and paintings reveal a multitude of star-studded universes. (This is exemplified in the painting and related source collage for *Multiverse You Are, I Am* [2012]; figs. 69 and 70). This imagery is sliced and regrouped in a kaleidoscopic, triangulated manner, puzzle-pieces of myriad existences at once. Using photographs of deep space produced by the Hubble Space Telescope and other sources, Rosenquist created several small-scale collages from which he painted a smaller number of canvases. The collages are intimate in size, most measuring under sixty centimeters (twenty-four inches) in height and length. They feel expansive—even at this scale—as they extrapolate and explore multiple views of the cosmos at once. The titles of the works convey various definitions of multiverse, including Parallel Worlds, Multiverse, Alternative Universe, The Meta Universe, Alternative Realities, Super Mega Universes. The collages are like a stained-glass vision of the galaxy, broken into disparate shards interpolated and radiating across the collage and canvas.

Having jettisoned the trappings of our material and terrestrial existence in the last of his compositions, Rosenquist liberated the artworks from the stentorian tone of advertising, and they now echo with the profound vastness of space. From quotidian *Life* magazine advertisements to sublime photographs of distant galaxies, Rosenquist transformed these powerful visual materials at hand to ponder our daily existence and our universal connection.

I'm interested in visual phenomena. There's so much that we know nothing about. Here we are in our natural environment and the mysteries of the universe are all around us. I've been spending my whole life working on something I know nothing about. I want to paint these mysteries. —James Rosenquist[22]

Notes

1 James Rosenquist and David Dalton, *Painting Below Zero* (New York: Alfred A. Knopf, 2009), 101.

2 Rosenquist in conversation with the author, July 2007; previously published in Sarah Bancroft, "James Rosenquist and the Blades of Time," in *James Rosenquist: Time Blades*, exh. cat. (New York: Acquavella Contemporary Art, Inc., 2007), unpaginated.

3 "… I can usually tell you what they are about. It all has meaning to me. As I explain my paintings, I hope that they get away from me, that the idea takes off and has a life of its own," James Rosenquist quoted in Michael Amy, "Painting, Working, Talking: Michael Amy Interviews James Rosenquist," *Art in America* 2, February 2004: 108.

4 Rosenquist and Dalton, *Painting Below Zero*, 80–81.

5 Rosenquist in conversation with the author, summer 2014; previously published in Bancroft, "James Rosenquist: Six Decades of Artmaking," Bancroft, *James Rosenquist: Illustrious Works on Paper, Illuminating Paintings*, exh. cat. (Stillwater: Oklahoma State University Museum of Art, 2014), 3.

6 Rosenquist and Dalton, *Painting Below Zero*, 81 and 83.

7 Rosenquist in conversations with the author, 2000–05.

8 In conversation with the author in 2000–03, Rosenqiust mentioned the title references Times Square as well as the "square" or rectangle of the billboard. The title alludes to the tempting strip of sky beyond.

9 Rosenquist quoted in Todd Brewster, "Evolution of a Painting," *Life* 4, no. 2 (Feb. 1981), 94.

10 Rosenquist in conversation with the author, December 2002 and January 2003; previously published in Sarah Bancroft, "Anonymity, Celebrity, and Self-Promotion," in Bancroft and Walter Hopps, *James Rosenquist: A Retrospective*, exh. cat. (New York: Solomon R. Guggenheim Foundation, 2003), 72.

11 Rosenquist and Dalton, *Painting Below Zero*, 213–14.

12 Rosenquist in multiple conversations with the author, 2000–16.

13 Rosenquist in Brewster, "Evolution of a Painting," 86.

14 The author is grateful to Kevin Hemstreet, studio assistant and head preparator in the Rosenquist studio, and Michael Harrigan, director of archives and research, for discussing and clarifying Rosenquist's collage and painting process in Aripeka, Florida.

15 Sarah Bancroft, "Space and Scientific Phenomena," in Bancroft and Hopps, *James Rosenquist: A Retrospective*, 230.

16 Daniel Kunitz, "In the Studio: Master of Space and Time," *Art+Auction*, February 2014, 70.

17 Rosenquist quoted in Robert Rosenblum, "Interview with James Rosenquist by Robert Rosenblum," in *James Rosenquist: The Swimmer in the Econo-mist*, exh. cat. (New York: Solomon R. Guggenheim Foundation, 1999), p. 11.

18 Thomas Krens, "Preface," in *James Rosenquist: The Swimmer in the Econo-mist*, 5.

19 Rosenquist in Rosenblum, "Interview with James Rosenquist by Robert Rosenblum," 10.

20 The exhibition, *James Rosenquist: A Retrospective*, was cocurated by Walter Hopps and the author and opened at the Menil Collection and the Museum of Fine Arts Houston in Texas before traveling to the Solomon R. Guggenheim Museum (the organizer), Guggenheim Museum Bilbao, and Kunstmuseum Wolfsburg.

21 Rosenquist in conversation with the author, summer 2014; previously published in Bancroft, "James Rosenquist: Six Decades of Artmaking," 9.

22 Rosenquist in conversation with the author, September 2009; previously published in Sarah Bancroft, "The Hole in the Wallpaper: Conversations with James Rosenquist," in *James Rosenquist: The Hole in the Middle of Time and the Hole in the Wallpaper*, exh. cat. (New York: Acquavella Contemporary Art, Inc., 2010), 9.

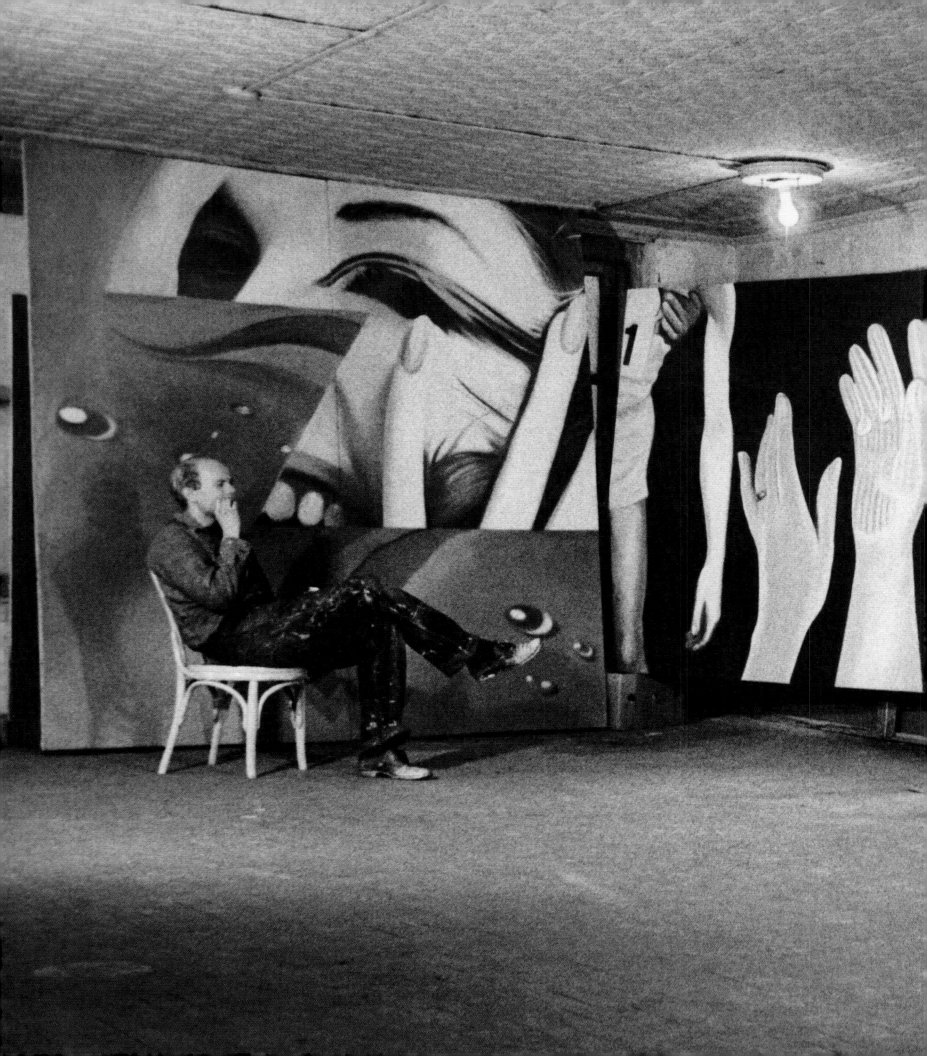

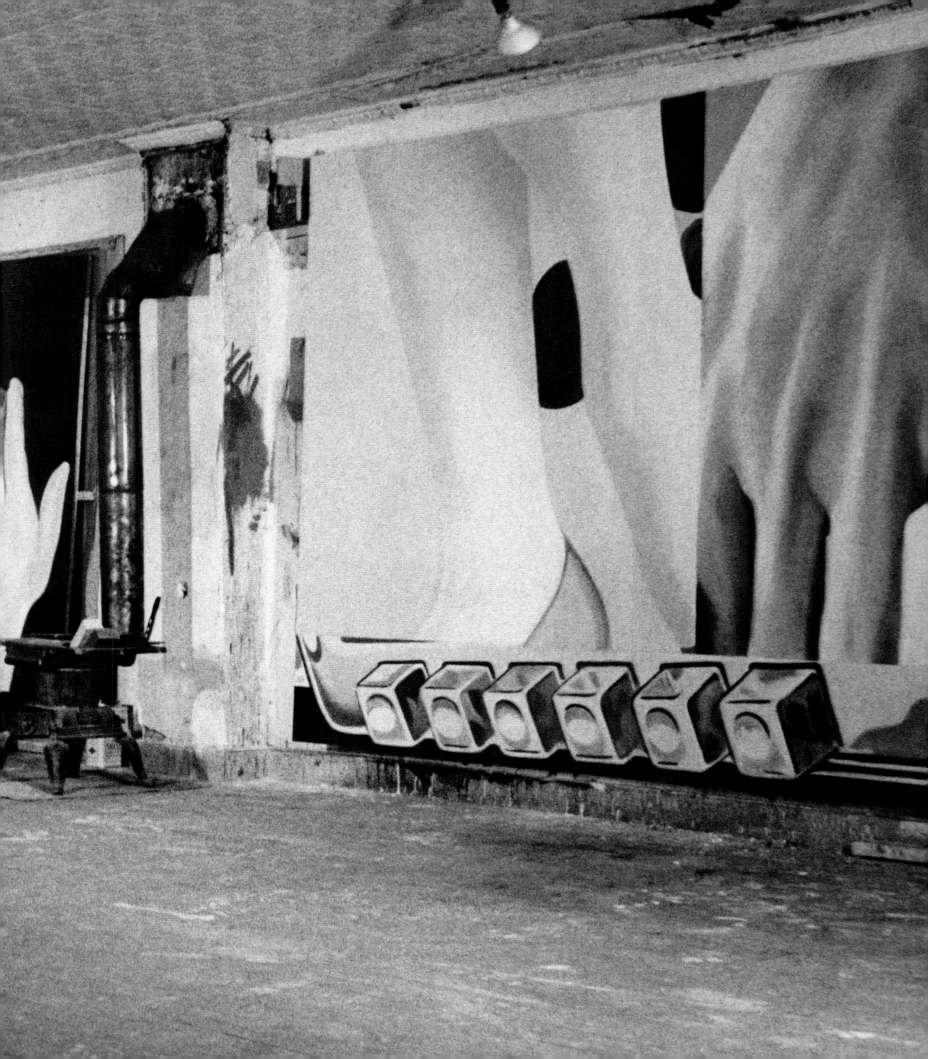

Zone, 1960–61

71 Previous spread: Rosenquist in his
Coenties Slip studio, New York, 1961.
Works from left to right: *Zone* (1960–61),
Flower Garden (1961), and *Pushbutton* (1961)

72 Advertisement for Campbell's
in *Life* magazine, September 20, 1954, pp. 38–39

73 Advertisement for Angel Skin
in *Life* magazine, January 13, 1961, p. 3

74 *Source and Preliminary Study for Zone*, 1960
Pencil on paper; magazine clipping
11 1/8 × 18 5/8 in. (28.3 × 47.3 cm)
Estate of James Rosenquist

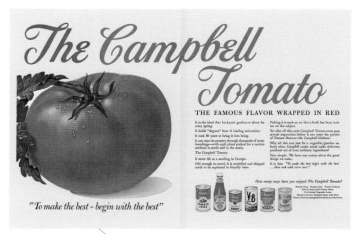

72

73

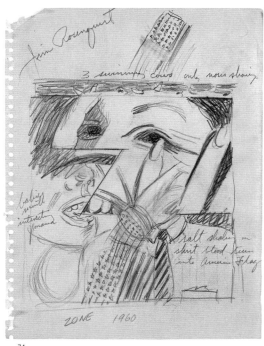

74

124

Flower Garden, 1961

75 "A Medical Student Runs a Four-Minute Mile and . . .
An 'Impossible' Goal Is Reached,"
Life magazine, May 17, 1954, pp. 28–31

76 Advertisement for Playtex Gloves
in *Life* magazine, May 17, 1954, p. 49

77 *Source for Flower Garden*, 1961
Magazine clippings and mixed media on paper
6 ⅞ × 8 ½ in. (17.5 × 21.6 cm)
Estate of James Rosenquist

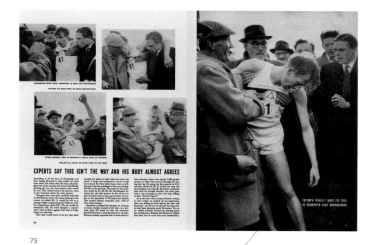

75

76

77

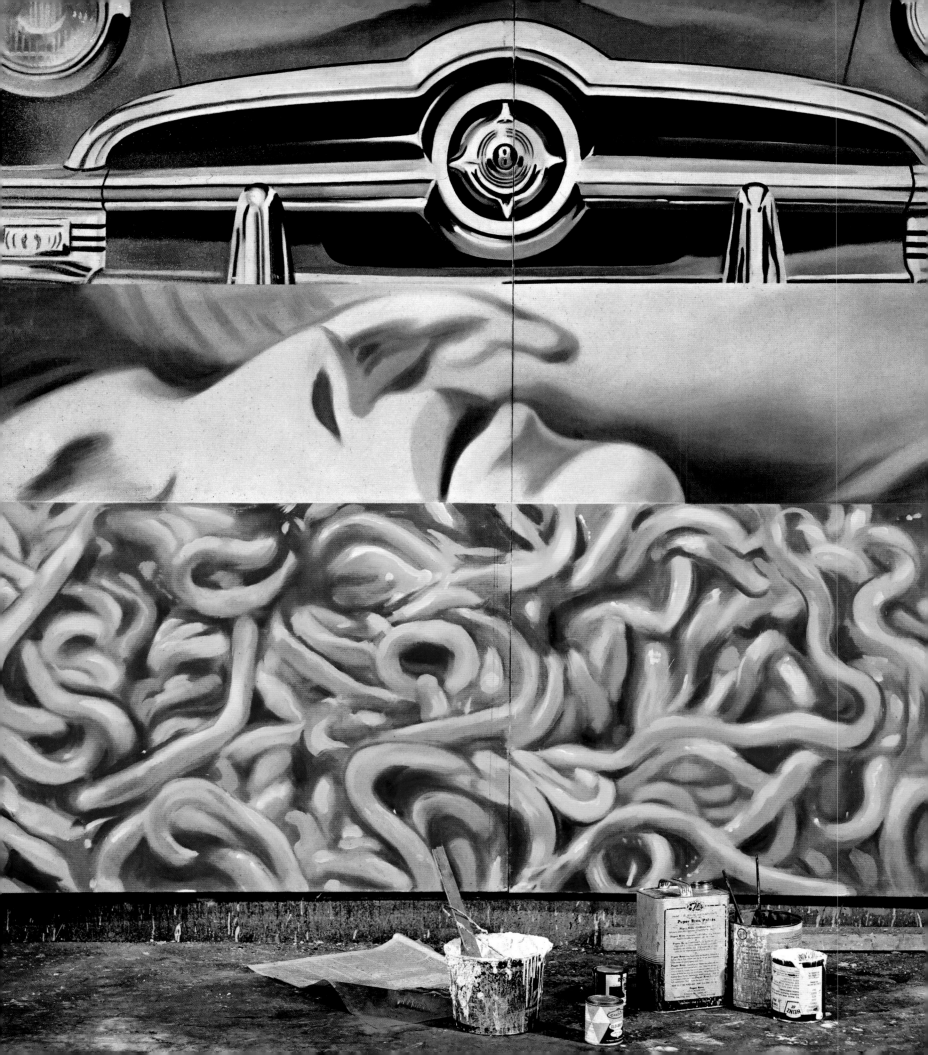

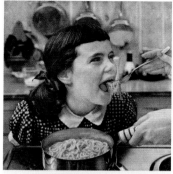

79

80

81

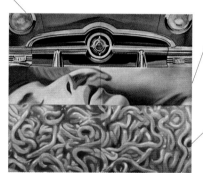

I Love You with My Ford, 1961

78 View of *I Love You with My Ford*, 1961

79 Advertisement for Ford
in *Life* magazine, April 24, 1950, p. 8

80 Advertisement for Veto
in *Life* magazine, January 14, 1957, p. 3

81 Advertisement for Franco-American Spaghetti
in *Life* magazine, December 6, 1954, p. 208

82 *Source for I Love You with My Ford*, 1961
Magazine clipping and mixed media on paper
7 ¼ × 9 ¹³⁄₁₆ in. (18.4 × 24.9 cm)
Estate of James Rosenquist

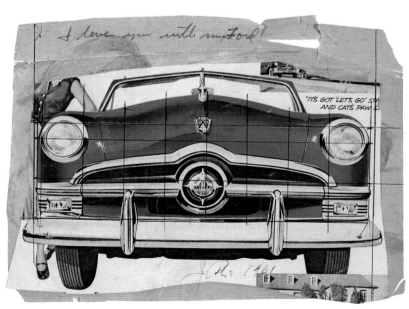

82

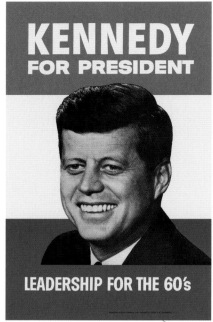

83

84

85

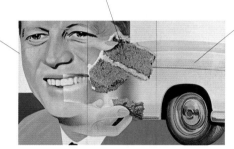

President Elect, 1960–61/1964

83 "Kennedy for President,"
election campaign poster, 1960

84 Advertisement for Swans Down
in *Life* magazine, August 23, 1954, p. 75

85 Advertisement for Chevrolet
in *Life* magazine, March. 14, 1949, pp. 34–35

86 *Source for President Elect*, 1960–61
Cropped poster, magazine clippings, and mixed media
14 ½ × 23 ¹³⁄₁₆ in. (36.8 × 60.5 cm)
Private collection

87 James Rosenquist with left panel of *President Elect*
in his Broome Street studio, New York, 1964

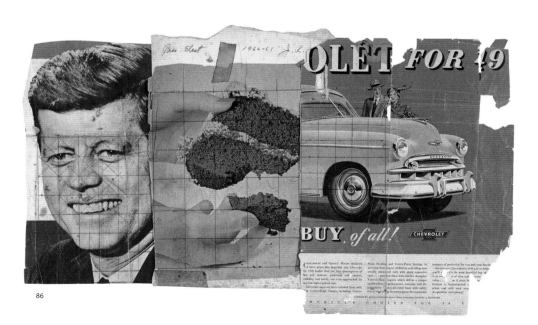

86

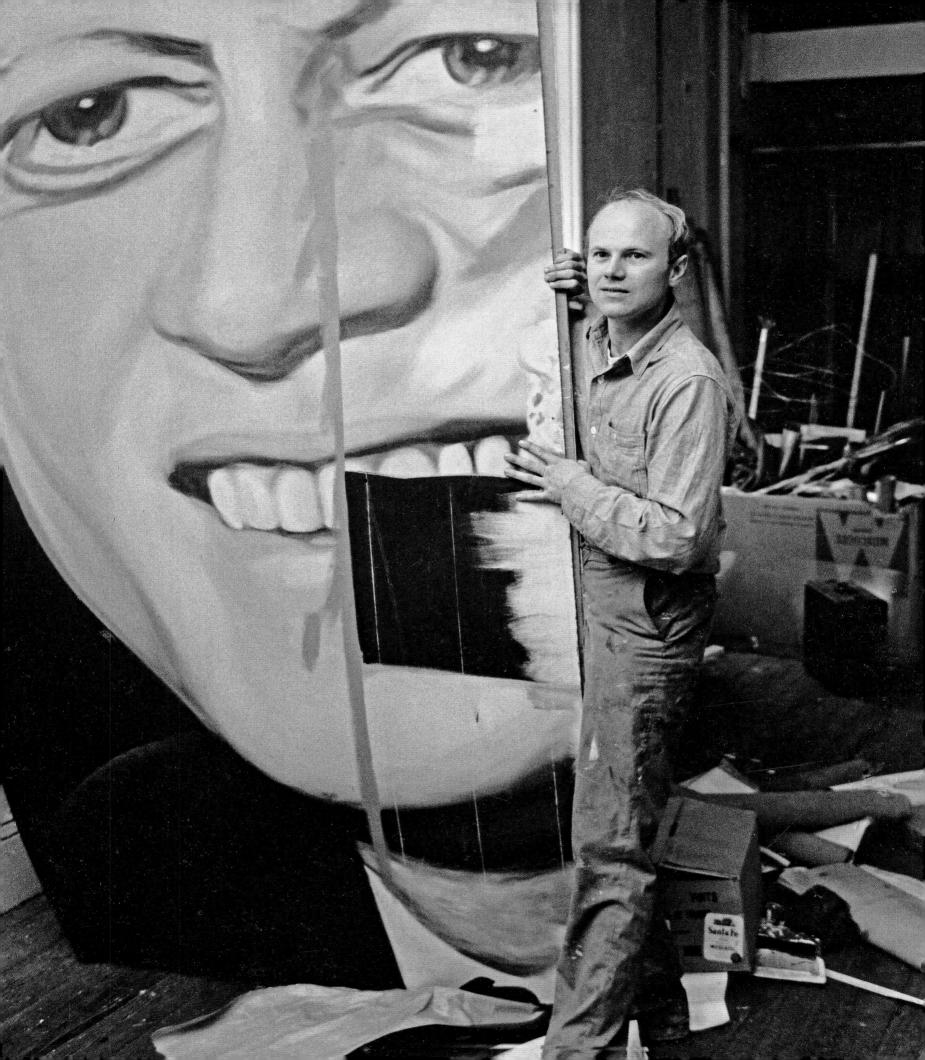

Hey! Let's Go for a Ride, 1961

88 Advertisement for Dr. West's Miracle Tuft
in *Life* magazine, June 6, 1949, p. 30

89 Advertisement for Carling's Ale
in *Life* magazine, June 6, 1949, p. 134

Opposite page: Detail

Rainbow, 1961

90 Advertisement for Alcoa Aluminum
in *Life* magazine, April 19, 1954, p. 135

91 *Source and Preparatory Sketch for Rainbow*, 1961
Magazine clipping and mixed media on paper
11 ¾ × 13 ¹⁵⁄₁₆ in. (29.9 × 35.4 cm)
Private collection

88

89

90

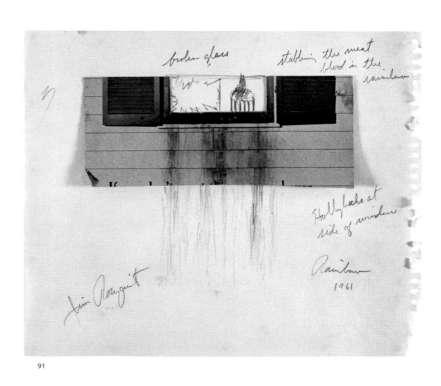

91

Look Alive (Blue Feet, Look Alive),1961

92 *Sources and Preparatory Study for Look Alive
(Blue Feet, Look Alive)*, 1961
Mixed media on paper
11 × 14 11/16 in. (27.9 × 37.3 cm)
Estate of James Rosenquist

92

Waves, 1962

93 Advertisement for Valcream
in *Life* magazine, January 13, 1958, p. 58

94 James Rosenquist in his studio, photograph
by Ugo Mulas, 1964

93

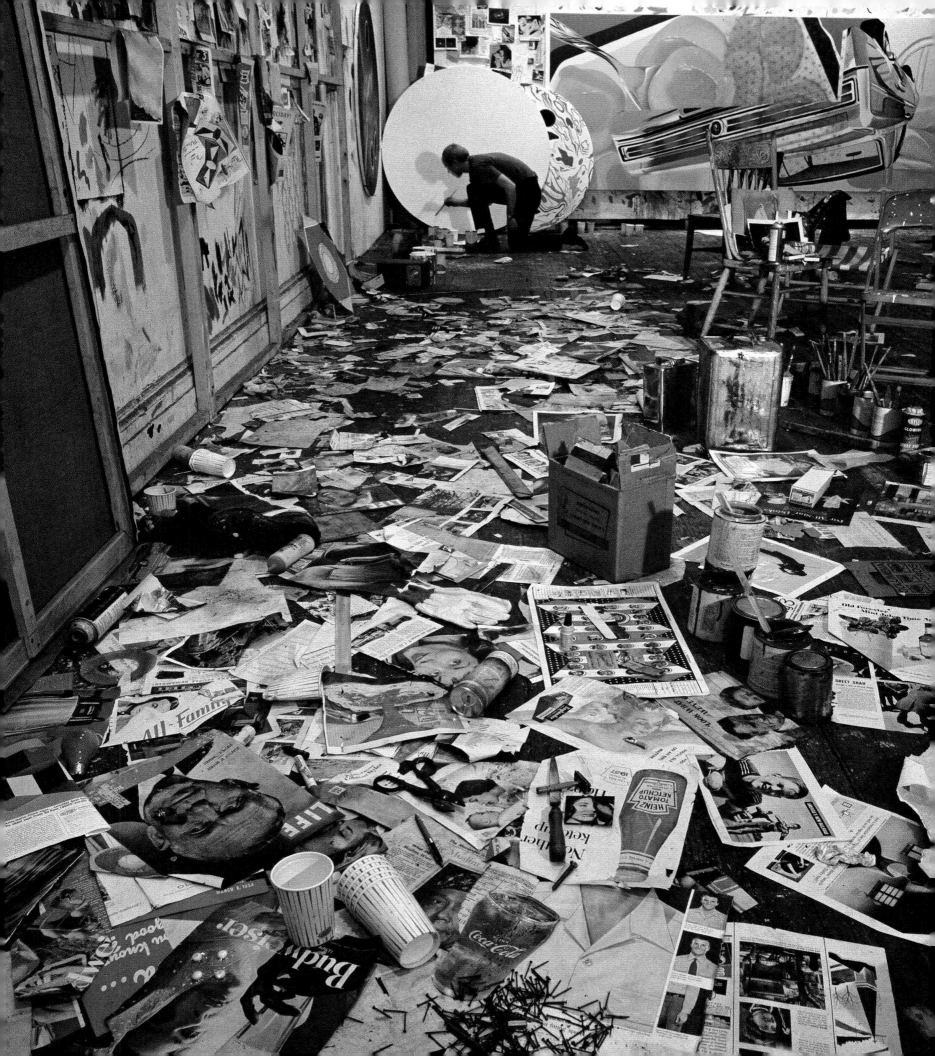

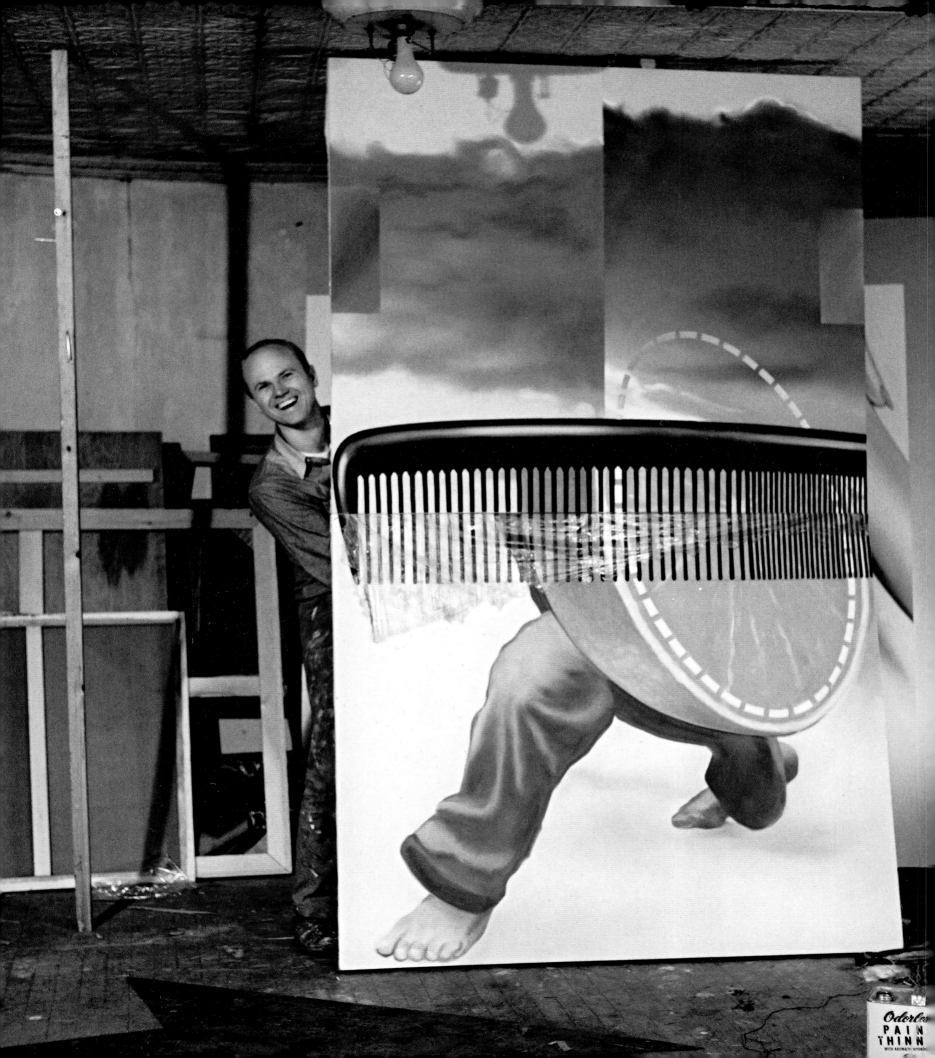

96

97

98

Early in the Morning, 1963

95 Rosenquist with *Early in the Morning*, 1963

96 Advertisement for J. William Horsey
 in *Life* magazine, February 16, 1948, p. 88

97 "South African Racial Hatreds Erupt in Riots,"
 Life magazine, February 7, 1949, pp. 27–31

98 Advertisement for ACE combs
 in *Life* magazine, August 18, 1947, p. 100

99 *Source and Preparatory Sketch for
 Early in the Morning*, 1963
 Magazine clippings and mixed media on paper
 13 15⁄16 × 13 15⁄16 in. (35.4 × 35.4 cm)
 Estate of James Rosenquist

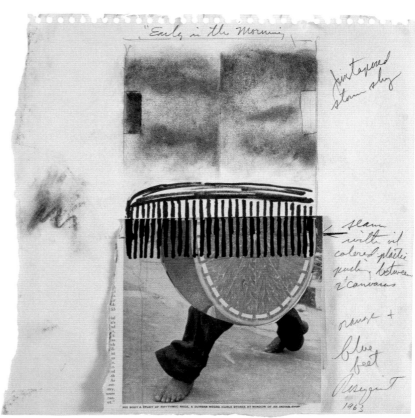

99

135

Untitled (Joan Crawford Says . . .), 1964

100 Advertisement for Camel
in *Life* magazine, August 27, 1951, back cover

101 *Source for Untitled (Joan Crawford Says . . .)*, 1964
Magazine clipping
7 ⅜ × 5 1/16 in. (18.7 × 12.9 cm)
Estate of James Rosenquist

Opposite page: Detail of *Untitled
(Joan Crawford Says . . .)*, 1964

100

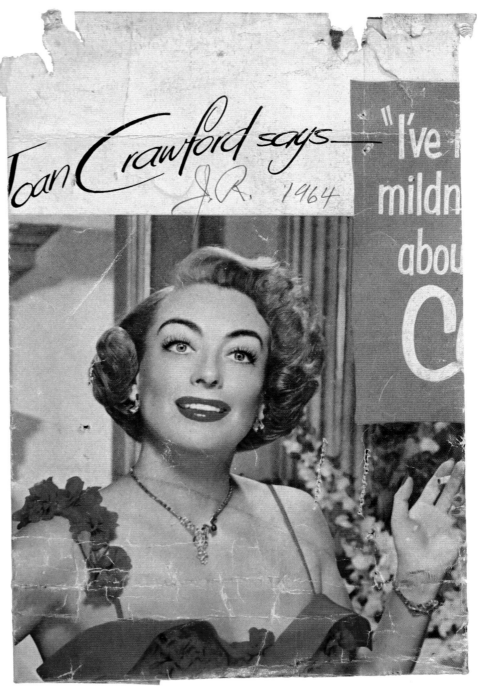

101

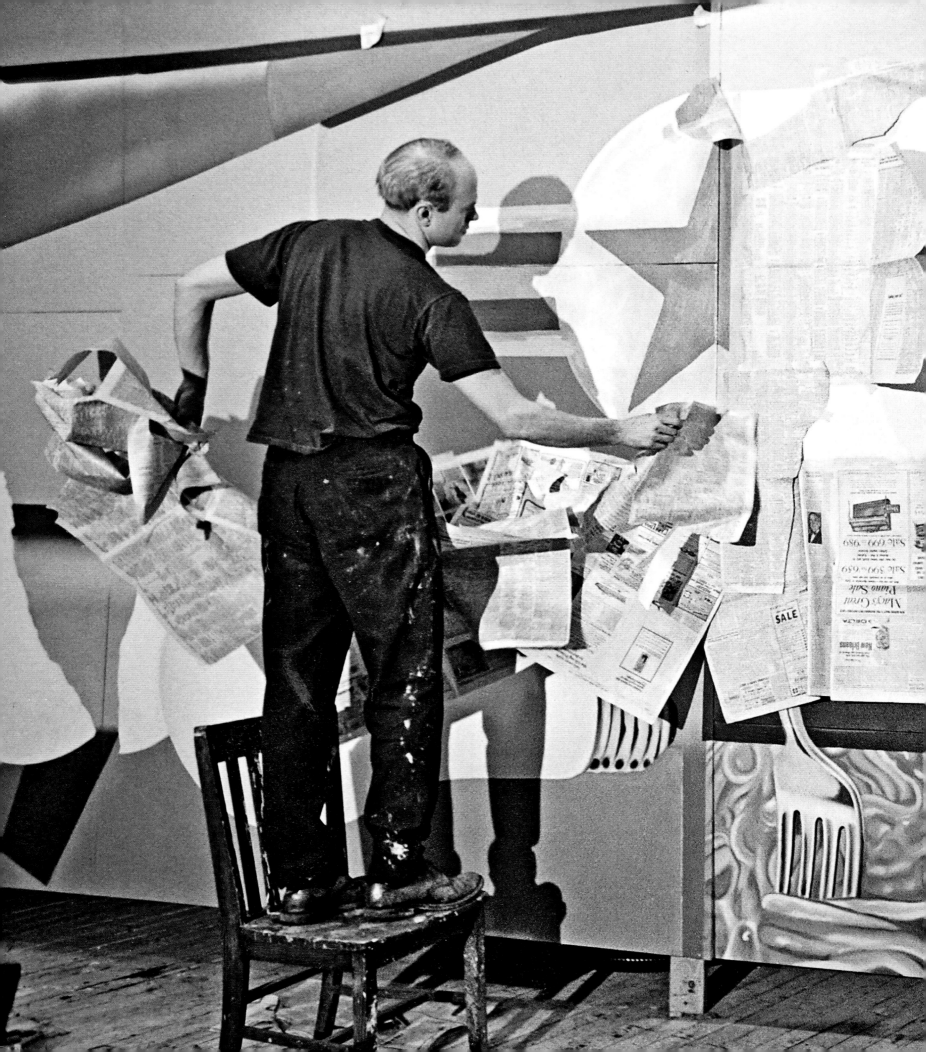

F-111, 1964–65

103

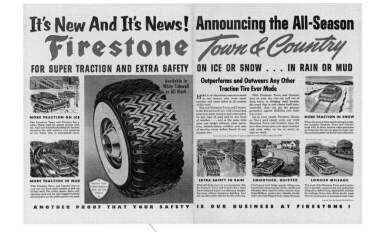

104

108

109

110

111

105

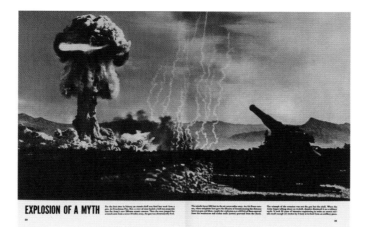

106

107

112

113

114

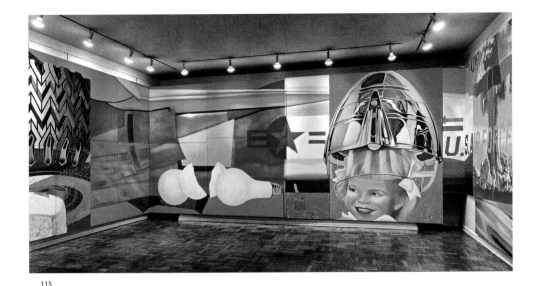

115

115 Exhibition view, *F-111,* at Leo Castelli Gallery, New York, 1965 (colored version based on the original photograph, see fig. 148)

116 General Dynamics F-111 Aardvark during a test flight, 1964. James Rosenquist used this image for *F-111*.

117 James Rosenquist installing the fifty-one aluminum and canvas panels for *F-111*, Broome Street studio, New York, 1964

118 *F-111* in process, Broome Street studio, New York, 1964–65

116

117

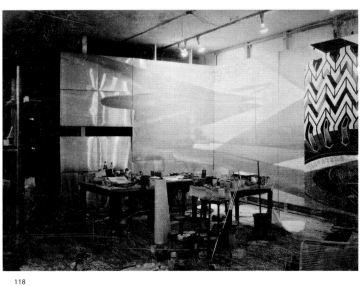

118

F-111

Tino Grass

In F-111, I question the collusion between the Vietnam War, income taxes, consumerism, and advertising.—James Rosenquist[1]

On April 17, 1965, *F-111* was shown to mark the occasion of Rosenquist's first solo exhibition with Leo Castelli in New York. At roughly twenty-six meters wide and three meters high, the work's measurements were tailored exactly to the gallery, where it stretched across all four walls of the space. A single surface with bright, colorful motifs and mirrored elements, it is impossible to apprehend at once. "In this picture, because it did seal up all the walls, I could set the dial and put in the stops and rests for the person's eye in a whole room instead of allowing the eye to wander and think in an empty space. You couldn't shut it out, so I could set the rest."[2]

An abstract floral pattern, a hurdle, a cake sporting six small flags, a car tire with a distinctive profile, a second pattern, three colored lightbulbs—the middle one broken—a fork just about to twirl spaghetti, a little girl with bows in her hair under a chrome-plated hairdryer ... in the background, a bright green meadow, a gap or missing section, an atomic explosion with its mushroom cloud covered by a beach umbrella, a piece of folded-up fabric, a diver beneath a cloud of bubbles, one more pattern, and then a large mass of spaghetti. Behind it all, looming over the entire piece: a fighter jet, bordered by aluminum panels on the left and right, bearing the logo and insignia of the U.S. Air Force. The individual images are larger than life—even the fighter jet, the central motif and namesake of the piece, is fifteen feet larger than the actual aircraft.

James Rosenquist was used to handling these dimensions and aware of the motifs' visual power. Back when he was painting billboards, he put enormous bottles of whisky, ads for upcoming movies, company logos, and advertisements for cigarettes and other products onto the biggest billboards in Times Square, in Brooklyn, and in many cities across the United States. He translated postcard-sized originals into motifs many meters high. Perched high above and often only an arm's length away from the motifs he was painting, Rosenquist would walk two or three blocks away during his breaks in order to get a sense of scale for his oversized images.

Examining Rosenquist's work inevitably leads one back to his collages of source material. Motifs clearly taken from advertisements have been cut out and ripped until it is impossible to tell where they came from or what the original context was. These full-page illustrations were models for his commercial work painting billboards: using the grid technique he termed the "Brooklyn Bridge method," Rosenquist scaled them up drastically. They also sketched out concepts and ideas for his own works, and he marked them up with handwritten notes. Rosenquist elucidated on this working method in an interview: "Without the preliminary work, the sketches and planning, I would not be able to get to the final image. I would not be able to go further without building, metaphorically, a telescope. The work allows me to see further."[3]
In 2012, on the occasion of his exhibition at the Museum of Modern Art, Rosenquist met a woman who identified herself as "the little girl under the hairdryer" in *F-111*: a central motif that he also worked into his

collages (fig. 130). As a child model, she had posed for an advertisement that he would later use in his work. It must have been a nice moment, creating a surprising and unforeseeable connection between the present day and the time when the work was created. The advertisement itself shows a little girl in the driver's seat of a convertible (fig. 112). In *F-111*, this girl became the pilot of the fighter jet. The scene has clearly been directly lifted from the original advertisement, a fact which only becomes apparent when the two are carefully compared. Rosenquist commented: "I've never included commercial imagery in a painting for its own sake, for its 'popness' alone. In my paintings there's always a reason for an image being there."[4] But what are the reasons? And what is the consequence? It is much like a puzzle, only the individual pieces are not stored in a box but must first be located. Fragments of advertisements scattered across roughly 1,500 issues of *Life* magazine were the main source of material for Rosenquist's collages. They contain three decades of U.S. history, socially relevant issues and politics: the effects of World War II, Truman, the economic boom, John F. Kennedy, the space program, the Eisenhower era, the Cold War, Russia, looking to Europe and the wider world, the Korean War, atomic bomb tests, the Vietnam War, the Civil Rights movement, Martin Luther King, Marilyn Monroe ... events from the 1940s to the 1960s that must have had a strong influence on Rosenquist and inevitably affect our interpretation of the work as we search for the "background."

In *F-111*, Rosenquist tells a visual story—a consumer world in pictures lined up along a fighter jet, which, depending on the angle and context, raise questions and spark dialogue about the collision between society and what was then a starkly present military complex, all the while thwarting efforts to reach clear-cut conclusions. Henry Geldzahler was a step ahead when he summarized this in the bulletin of the Metropolitan Museum of Art: "In its own terms the painting is so powerful and consistent that the viewer's total attention is given to absorbing it. Before and after the confrontation the immemorial question, Is it art? suggests itself. One may also wonder, Will its impact last? Such questions can be answered only with time. For the moment the painting makes a big statement and makes it convincingly."[5]

F-111

The General Dynamics F-111 Aardvark was still being developed as a tactical fighter plane for nuclear missions when Rosenquist chose it as the central motif of his work in 1964 (fig. 116). A short time beforehand, he had seen a decommissioned long-range bomber at an amusement park, which had quickly become a visitor attraction there. The Convair B-36 Peacemaker, a product of the Cold War, had never seen action. Millions of dollars were invested in its development and production, financed by American taxpayers,[6] that could have been spent on schools, hospitals, and infrastructure instead. This thought was at the front of Rosenquist's mind in *F-111*. At the end of 1962, the Department of Defense, under Robert McNamara, ordered the production of twenty-two prototypes. At the time, nobody could have known that the program would eat up nine billion U.S. dollars—as opposed to the estimated 439 million dollars—and would only result in a third of the agreed-on number of planes. In the 1950s and 1960s, going over budget was not unheard of, but the development of the F-111 went higher above its estimate than ever before.

Rosenquist also thought hard about the cost of his own *F-111*. Uncertain that he would be able to sell the work as a whole, he planned to sell

119 Cameron Booth, *Bad Lands*, 1955
Oil on canvas, 36 × 46 in. (91.4 × 116.8 cm)
Minneapolis Institute of Art,
The Julia B. Bigelow Fund 55.34

120 Hans Hofmann, *The Lark*, ca. 1960
Oil on canvas, 60 1/8 × 52 3/8 in. (152.7 × 133 cm)
University of California, Berkeley Art Museum and
Pacific Film Archive

121 James Rosenquist, *Untitled*, 1957
Oil on paper, mounted on paper
7 7/16 × 9 5/16 in. (18.9 × 23.7 cm)
Estate of James Rosenquist

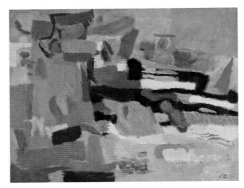

119

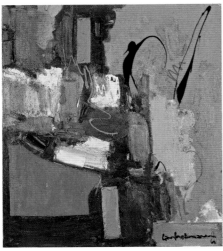

120

121

each of the fifty-one elements individually: "I wanted to relate the idea of the new man, the new person who appreciates things, to this painting. It would be to give the idea to people of collecting fragments of vision. One piece of this painting would have been a fragment of a machine the collector was already mixed up with, involved in whether he knew it or not. The person has already bought these airplanes by paying income taxes or being part of the community and the economy. The present men participate in the world whether it's good or not and they may physically have bought parts of what this image represents many times."[7] However, Leo Castelli reserved the right to cancel these sales in the event that someone bought the entire piece. Returning home from holiday on the day the exhibition was dismantled, the collector Robert C. Scull bought the work without having laid eyes on it in the gallery—thereby keeping it intact.[8]

Rosenquist started off work on *F-111* by recreating the dimensions of the gallery space in his Broome Street studio. He affixed aluminum and canvas panels to the walls of his construction, covering eighty square meters. The photograph that served as his basis shows the jet with its landing gear down. In the collages and the work itself, this has been removed and the jet is positioned horizontally. Pictures from Rosenquist's studio show how the aluminum panels were put in place. The grid used to transfer the images is also visible (fig. 117). First affixed along the wall, the panels later fit into the corners, reflecting each other to form a fluid transition. Depending on their position and perspective, viewers, too, are drawn into the piece. Rosenquist used this effect for the first time in *F-111* and increasingly so in the installations that followed it, including *Horse Blinders*, *Horizon Home Sweet Home*, and *Flamingo Capsule*. One further aspect of his work from that time is his use of peripheral vision, which makes use of the viewer's awareness of the areas surrounding a central focal point. This results in one continuous surface in the place of separate images, the spaces between which form a structure and offer the eye a relief. Inches from the enormous billboards, Rosenquist's experience painting billboards had already made him aware of the phenomenon of peripheral vision, and he further developed his thinking in conversation with Barnett Newman[9] and by examining works by Claude Monet and Jackson Pollock.

His paintings from 1957 (fig. 121) reveal a very different connection, this time to his teacher and his teacher's teacher. Himself a student of Hans Hofmann, Cameron Booth was Rosenquist's mentor at the University of Minnesota from 1952 to 1954, and had previously taught at the Art Students League, which Rosenquist would later also attend. "He was an incredible painter. He drew realistically, he was an unbelievable colorist and, later on, a colorful abstractionist.... From him I learned oil painting, egg tempera, and Renaissance-style underpainting. I studied perspective, color theory, and figure drawing with him."[10] Parallels to Hofmann and Booth are visible in these early works, and also in *F-111*. His collages and studies trace the conception of the aircraft fuselage, from blocks of single colors in neon colors to apparently abstract color compositions (fig. 125). The crucial difference however, is that Rosenquist did not randomly apply the paint as he had done in his early paintings, but closely followed the forms, surfaces, and shadows of the fuselage as they appeared on the photograph. He added a layer of "One Shot Fluorescent Colors" over the sections filled in with oil-based paint, and marked the relevant collages with "DAYGLO OVER PERMANENT OIL," "dayglo over existing color to change color," and "day glo color over existing color if dayglo fades"—which reveals his desire not only to achieve a specific color effect, but also to extend the painting's longevity.

122 *Source for F-111*, 1964
Photographic reproduction
and mixed media
4 ¼ × 22 ¾ in. (10.8 × 57.8)

123 *Source and Preparatory Study
for F-111*, 1964
Photographic reproduction
and mixed media
9 ¼ × 21 ¾ in. (23.5 × 55.2 cm)

124 *Preparatory Study for F-111*, 1964
Aluminum and mixed media on paper
8 ½ × 32 in. (21.6 × 81.3 cm)

125 *Preparatory Study for F-111*, 1964
Mixed media on paper
11 ¾ × 12 in. (29.8 × 30.5 cm)

126 *Preparatory Study for F-111*, 1964
Mixed media on photographic
reproduction and paper
13 ¾ × 11 ½ in. (34.9 × 29.2 cm)

127 *Source for F-111*, 1964
Photographic reproduction
and mixed media on paper
13 ¾ × 14 ¾ in. (34.9 × 37.5 cm)

The Museum of Modern Art, New York,
promised gift of Marie-Josée and
Henry R. Kravis

122

123

124

125

126

127

128 Polaroid by James Rosenquist of source
collages for *F-111* arranged on floor,
Broome Street Studio, New York, 1964

129 *Preparatory Study for F-111*, 1964
Mixed media on magazine clipping
10 ¼ × 10 ⅜ in. (26 × 26.4 cm)
The Museum of Modern Art, New York,
promised gift of Marie-Josée and
Henry R. Kravis

130 *Source for F-111*, 1964
Magazine clipping, unidentified clip-
ping, and mixed media on paper
10 × 11 ½ in. (25.4 × 29.2 cm)
The Museum of Modern Art, New York,
promised gift of Marie-Josée and
Henry R. Kravis

131 *F-111*, in progress in the studio, 1965

132 Detail of *F-111* with floral pattern and
flag with U.S. Army stencil type

133 View of a rocket silo for nuclear weapons

128

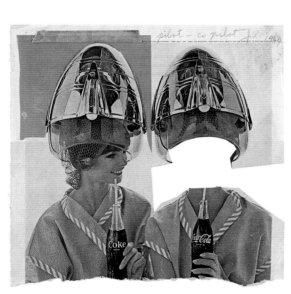

129

130

The central motif is the little girl beneath the hairdryer, which is turned into a pilot's helmet in *F-111*. The Dow Chemical advertisement shows her dressed identically and with the same hairstyle next to her doll, which could also be her twin sister. She is at the wheel of the vehicle, her doll next to her in the passenger seat—just like in the cockpit of the fighter jet, whose special feature was that two pilots could fly and operate the aircraft together. In the background, the girl's family sits in a field of grass, in vacation mode and surrounded by nature. The advertisement promises lasting beauty and a relaxed life, courtesy of one hundred percent Saran (fig. 112). Saran (polyvinylidene chloride, or PVDC) is a registered trademark of Dow Chemical: an oxygen- and water-resistant material that was used as a protective film for U.S. military planes. During the Vietnam War, it was used to make insoles for army boots used by the military in the tropics. From 1953—the year the advertisement was printed—onward, the company entered the consumer market and used the finely woven synthetic material to produce car seat covers, garden furniture, bags, hair for dolls—as can be seen in the advertisement—and later went on to make plastic food wrap. The word "Saran" is made up of Sarah and Ann, the names of John Reilly's wife and daughter. Together with Ralph Wiley, Reilly codeveloped the product, which had been invented in 1939, for the Dow Chemical Co. The production of magnesium for manufacturing lightweight parts for fighter jets made Dow Chemicals one of the most important wartime companies. Between 1965 and 1969, Dow produced the incendiary weapons napalm B, which replaced napalm, first used in Berlin in 1944, and the defoliant chemical Agent Orange, both of which changed the face of the Vietnam War.[11]

The hairdryer is from a 1964 Coca-Cola advertisement (fig. 113). This was the most recent advertisement to be used in *F-111* and shows two women, each holding a bottle of Coca-Cola. Like the little girl and her doll in the Dow advertisement, they could be twins—they are even looking in the same direction. In the collage itself, Rosenquist noted "pilot—copilot" and erased the face of the right-hand woman, making her anonymous and impossible to recognize. In his collage, he sets the left-hand hairdryer against a light pink section, which he carries over to the actual artwork. The chrome-plated hairdryers look like high-tech devices—seen on their own, they could be airplane turbines or missile warheads. In Rosenquist's early source collages (figs. 60, 61), one can see the advertisements intact and without notes, before he turns them into their later form. The little girl is absent from the initial collages and only appeared at a later point in time.

By stripping the context away, the artist obscures similarities between the advertisements and *F-111*, even though they are a substantial part of the piece. Other dialogues only become apparent upon close inspection and comparison. The hairdryers from the Coca-Cola advertisement bear the inscription "Speed King." In *F-111*, Rosenquist changes this to "Queen," and crowns the little girl to make her a queen. Looking at the piece as it was originally installed, the girl is looking diagonally at the tire on the left-hand wall, which was taken from a 1952 Firestone advertisement (fig. 104). Rosenquist turns it on its side, so that its jagged profile and shape recollect a royal crown. A polarity is created between the masculine symbol of a king and the hairdryer, which has been turned into a crown. The tonality, the use of the same color for completely different materials—chrome and rubber—also enhances the dialog. "I painted the tread on the bottom of the snow tire (which suggests something cold) in a very bold, precise way ... It's a Firestone tire, but to me it implied the idea of industry, the military-industrial complex, so it represents some sort of capitalistic enterprise ..."[12] Alongside car tires, the Firestone Tire & Rubber Company also manufactured other products from the 1940s onward, including various military goods, grenades, gun carriages, wings, oil, and gas tanks for airplanes, pilot seats, and helmets for soldiers.[13] From 1951, at the beginning of the Cold War, Firestone worked together with other companies to develop the MGM-T Corporal, the United States' first surface-to-surface missile that could be armed with a nuclear warhead.[14]

132

133

131

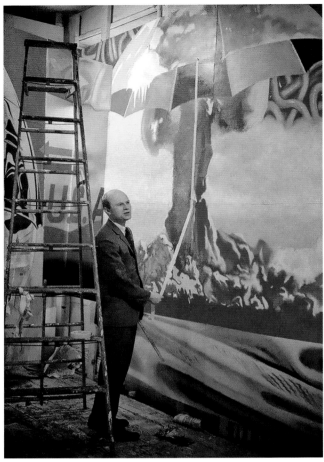

134

135

Directly beneath the tire, a cut cake continues the oval form. The open shape cut off at the bottom resembles a "tube." With increasing rearmament on the part of the Western powers—led by the United States—and of the so-called Eastern Bloc under Soviet leadership, the end of the 1950s saw the construction of underground launch facilities for intercontinental nuclear missiles, overwhelmingly located in the Midwestern states, where Rosenquist also grew up (fig. 133). The "angel cake" depicted was taken from a Pillsbury advertisement from October 1952 (fig. 109) and functions as a metaphor for one such missile silo. In the early 1960s, Pillsbury Company began collaborating with NASA and the U.S. Army Laboratories on the development of food for astronauts in space. This was underpinned by their own Hazard Analysis and Critical Control Points (HACCP) concept, a standard still used today to avoid food-related hazards. Rosenquist topped the cake with small flags reminiscent of territorial markers, intervals, or even birthday candles, marking them with ingredients such as protein, iron, vitamins, and the energy value of foodstuffs. In the 1950s, the Wheat Flour Institute launched the first campaigns to use food labeling for the "fashion conscious" (fig. 110). The lettering used on the flags was stenciled on and is still used today to mark military devices.

This scene is contrasted with an atomic explosion on the other side of the room. The inspiration for that image comes from a *Life* magazine article entitled "Explosion of a Myth" from July 8, 1953 (fig. 106). It shows the firing of the first nuclear artillery rockets as part of the U.S. Nuclear Weapons Test Program on the Frenchman Flat test site in Nevada. "Atomic Annie" was developed as a tactical surface-to-surface weapon against enemy troops in the field. It took ten years of intensive development to miniaturize the warhead until it could be fired by a howitzer. With a fifteen-kiloton blast, it was about as powerful as "Little Boy," the atomic bomb that had been dropped on the Japanese city of Hiroshima eight years previously, killing 66,000 people on impact. Rosenquist transformed the black-and-white original into a bright red mushroom cloud on the canvas, removed the mountains on the horizon, and painted the background a homogenous yellow. An open beach umbrella stands in front of it, its stand sticking straight into the center of the explosion, echoing the symmetrical shape of the detonation. "I suppose the umbrella could be something like fallout, but for me it's like someone raising his umbrella or raising his window in the morning, looking out the window and seeing a bright red and yellow atomic bomb blast, something like a cherry blossom, a beautiful view of an atomic blast. When I was working in Times Square and painting signboards the workmen joked around and said the super center of the super center of the atomic target was around Canal Street and Broadway. That's where the rockets were aimed from Russia; and these guys, the old-timers would say, 'Well, I'm not worried. At least we'll have a nice view right up here against the wall.'"[15] Today, it seems horrific and incomprehensible that around 3,200 soldiers and civilians attended the atomic weapon test in Nevada; hotels and the event organizers advertised it and future tests as tourist attractions (fig. 135). Coated in snow and ice, the beach umbrella from an advertisement for Canada Dry (fig. 107)—a soda that was popular during Prohibition as a mixer for home-brewed alcohol[16]—shows two generations of men "enjoying" the nice view with their drinks, as Rosenquist described it. The advertisement is captioned with the words "Beat the heat," underlining the link between the advertisement's slogan and the visual scenes in *F-111*.

To the right, one can see a diver's air bubbles, the shape of which seems to echo the explosion next to them, but was painted first. Alongside the girl, the diver is the second human figure in the piece. A Polaroid from

an early collage shows him in the spot now occupied by the huge swinging tire, together with the woman from the Coca-Cola advertisement (fig. 128). Rosenquist himself described the scene as: "...an exhaust air bubble that's related to the breath of an atomic bomb. His 'gulp!' of breath is like the 'gulp!' of an explosion. It's an unnatural force, man-made."[17]

At the height of the bomb bay, three pastel-colored lightbulbs—the middle of which is broken—contrast with the red background of the fuselage. Rosenquist recalled: "I was working on top of the Latin Quarter roof in Times Square, painting a 'Join the Navy' sign. Above me five more stories in the iron work were electricians repairing light bulbs in the Canadian Club sign. As a practical joke they dropped four boxes of light bulbs down on me. For about thirty seconds I was showered with breaking light bulbs."[18] Rosenquist recreated this scene in his experimental film work from the 1970s, which was destroyed and can only be guessed at by examining individual film strips and documentary photographs (fig. 136). The lightbulbs came from a Westinghouse advertisement from March 1957 (fig. 105). The Westinghouse Electric Corporation started out as a manufacturer of electric lighting equipment, later covering practically the entire range of electrical and electronic products. In the 1940s, the company was also focused on developing aviation technology, and in 1943, it produced the first operational turbojet for the U.S. Navy. As part of a U.S. government military program, Westinghouse also played an instrumental role in the development of nuclear energy, delivering the first pressurized water reactor in 1957. The company expanded to become a world leader in the field.[19]

137

136

149

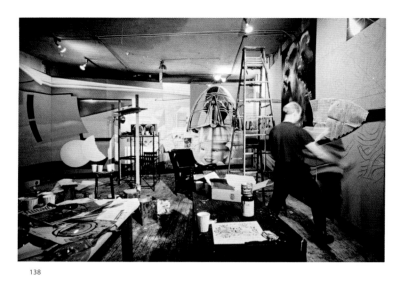

138 James Rosenquist working on the *F-111* spaghetti section, photograph by Hans Namuth, 1965

139 *Source for F-111*, 1964
Magazine clipping and mixed media
5 5/16 × 10 7/8 in. (13.5 × 27.6 cm)

140 *Source for F-111 and Orange Field*, 1964
Magazine clipping on paper
3 13/16 × 5 3/4 in. (9.7 × 14.6 cm)

141
–142 Photographs, taken by Hollis Frampton, for *F-111*, *Spaghetti*, *Spaghetti (Grisaille)*, and *The Friction Disappears*, 1964
Color photograph and mixed media on cardboard; black-and-white photograph and mixed media on cardboard
8 1/2 × 10 15/16 in.; 5 7/16 × 11 15/16 in.
(21.6 × 27.8 cm; 13.8 × 30.3 cm)

143 *Source for F-111*, 1964
Magazine clipping and mixed media on paper
9 3/4 × 11 13/16 in. (24.8 × 30 cm)

144 *Source and Preparatory Sketch for F-111*, 1964
Magazine clipping and mixed media on paper
12 × 11 3/4 in. (30.5 × 29.9 cm)

139–144: The Museum of Modern Art, New York, promised gift of Marie-Josée and Henry R. Kravis

139

141

142

140

143

144

The hurdle in *F-111* is another element that stems from a company that was a leader in its field. A 1948 advertisement from the Texas Company (Texaco) (fig. 108) promotes Sky Chief, a fuel that promises "A quick start—a flashing pace—an extra surge of power." Texaco was the only company to sell motor engine fuel under the same name over many years and across all U.S. states. It was also a member of the Seven Sisters, a group of oil companies that ruled the global market from the 1950s to the 1970s. During World War II, Texaco was ninety-third on the list of U.S. trading partners for military goods.[20] In the original installation, the hurdle is split down the middle, running at a right-angle towards the corner of the room. The base on the left-hand side is made up of aluminum panels, which reflect the opposite half to create the impression of a third element. The perspective is reinforced by the blue triangle which rises out of the corner, also reflected, and by the shadows that run parallel to it. "In the gallery it looked as if a runner would have to jump a triangular hurdle, or one with several alternatives, but they were blind alternatives because the hurdle was in a corner. The runner seemed to hurdle himself into a corner."[21]

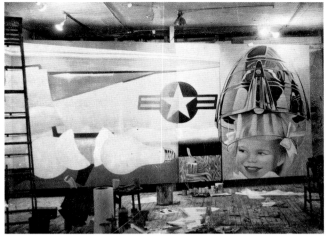
145

Confusion also arises when looking at the Air Force star: in *F-111*, Rosenquist alters the form, counter-form, and color of this multiple times (figs. 145–47). He unevenly splits the axisymmetric star down the middle, giving a different color and outward shape to the left and right sides. In his collage, he notes: "American star becomes N.[orth] Korean star after a small change of color" (fig. 126). Rosenquist was seventeen years old when the Korean War broke out. As a child, he would have experienced the events of World War II indirectly through his parents—the attack on Pearl Harbor forced his father to close a newly opened motel because of a lack of tourists. He also worked in a munitions factory, and in Dayton, Ohio, he serviced B-24 bombers that were flown in combat missions. Rosenquist experienced contemporary events as an adolescent male. Korea, which following World War II was occupied by Soviet soldiers in the north and by the United States in the south, split into the southern Republic of Korea and the northern Democratic People's Republic. On June 25, 1950, North Korean soldiers crossed the demarcation line along the thirty-eighth parallel and triggered the outbreak of war. Three years of conflict saw the Air Force drop around 450,000 tons of explosives and use napalm for the first time to set fire to vast areas. In total, 32,357 tons destroyed entire swathes of land and 2,500,000 civilians met their deaths during the conflict. From an American perspective, the war was not against North Korea, but against communism. The Cold War reached its first peak, driving the conflict—five years after the atomic bomb was dropped on Japan—to the edge of a preemptive atomic strike. Luckily, it didn't come to that, but a massive arms race followed in its wake.[22]

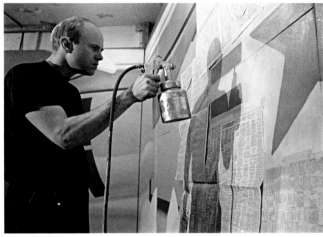
146

With his choice of illustrations in *F-111*, Rosenquist tackles the subject of the nuclear threat, which he reinforces with deliberately chosen advertisements. "Visual metaphors" further enhance the relevance of this topic. Some sections are covered fully or in part with floral patterns, each slightly different but clearly related, which he applied to his canvas and aluminum panels with the help of patterned paint rollers. "I saw the pattern in an elevator lobby [at Richard Brown Baker's apartment] and thought of a solid atmosphere; you walk outside of your apartment into what used to be open air and all of the sudden feel that it has become solid with radioactivity and other undesirable elements."[23] The Sherwin-Williams Company, a U.S.-based chemicals firm producing colors, varnishes, and building materials, introduced the first quick-drying emulsion paint in 1941 with Kem-Tone and the Roller-Koater, a precursor of today's paint roller. The company achieved considerable

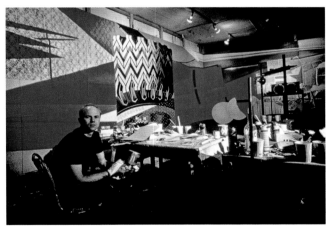
147

145 The U.S. Airforce star in different stages, 1965
–147 (146: Photograph by Hans Namuth)

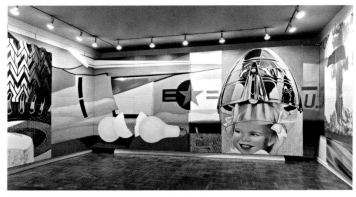

148

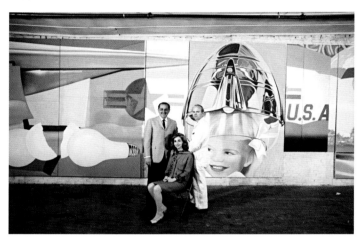

149

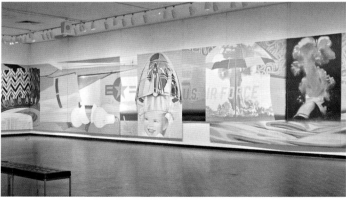

150

148 Installation view of *F-111* at Leo Castelli Gallery, 1965

149 James Rosenquist with Robert and Ethel Scull in
 New York in front of *F-111*. The picture shows
 the U.S.A(irforce) lettering that Rosenquist added
 to the work after the de-installation at Castelli
 on May 13 and the opening at the Jewish Museum
 on June 10, 1965, at this unidentified location.

150 Installation view of *F-111* in the exhibition
 James Rosenquist, The Jewish Museum,
 June 10–September 8, 1965

success with its range of products, because paint for home use was
in high demand after World War II, and supply was limited. One of the
more unusual products was the Super Kem-Tone Applikay (fig. 103),
a double paint roller that Rosenquist also used for his floral patterns.
During World War II, Sherwin-Williams colors were instrumental to the
camouflage of American troops, and the company was listed on the
New York Stock Exchange for the first time in 1964.[24]

The radioactive fallout is also depicted in the spaghetti section, sprayed
in fluorescent dark red alongside an equally fluorescent green meadow
behind the little girl. On the relevant collage, Rosenquist made a note of
"radio active smog" (fig. 139). In contrast to the field of spaghetti, these
come from an advertisement for Franco-American Spaghetti (fig. 111).
Franco-American was founded in 1915 as a sub-brand of the Campbell
Soup Company, whose success with canned products made it one of the
world's largest food manufacturers. In 1942, Campbell made a record
profit of one million U.S. dollars. In 1954, it went on the New York Stock
Exchange and expanded internationally, which rocketed its profits to
five hundred million dollars by 1958.[25]

Rosenquist incorporated spaghetti into many of his early works and
commissioned the photographer and filmmaker Hollis Frampton for
the large-scale illustration in *F-111* (fig. 141). "Late in the Fall of 1964,
a painter friend asked me to make a photographic document of
spaghetti, an image that he wanted to incorporate into a work of his
own. I set up my camera above an empty darkroom tray, opened a
number 2 can of Franco-American Spaghetti, and poured it out. Then
I stirred it around until I saw a suitably random arrangement of pasta
strands, and finished the photograph in short order."[26] Just like the
floral pattern on the left-hand side, the spaghetti is spread across a
quarter of the total surface area of *F-111*. The way the color periodically
fades to silvery gray gives the impression that the base of the entire
piece is made up of aluminum panels. The colored strands of spaghetti
are simply painted in yellow and alizarin, a red that is closer to violet
than to orange. The spaghetti opens up much room for interpretation,
as did the artist himself, who described it as "abstract expressionist
painting."[27] In a conversation in 2012, he casually remarked: "Spaghetti
is merely—I painted it because it's merely … Because we used to be
starving artists. So, a group of us, if everyone paid $0.50, someone
would make a ton of spaghetti, and we'd all eat."[28]

Beneath the front of the fighter jet, the spaghetti flows into the grisaille
of a draped piece of material with a metallic sheen. The Calvert
whisky advertisement, which appeared shortly before Christmas in
1955 (fig. 114), shows the fabric hanging down to the ground, alongside
"America's Smartest Gift Decanter," the shape of which brings to mind
a projectile or a warhead. In 1934, the Calvert Distillers Company was
purchased by the world's largest producer of spirits, Seagram Company
Ltd, and was fully integrated as a subsidiary in 1954. The company
controlled huge volumes of whisky in Canada and its growth sky-rocketed
after the end of Prohibition in the United States. At the end of 1965,
Seagram was present in 119 countries and turned a yearly profit of one
billion U.S. dollars. Rosenquist described the piece of fabric as an
"arabesque" and a "painter's drop cloth." It catches the "residue" that
drops off the canvas. "The idea—his art—is on the wall; the junk or stuff
of paint on the floor is nature, and something else."[29]

On the left-hand side of the cloth, a "missing section" opens up a view
of the installation wall, which is otherwise entirely enclosed. "At first the
missing panel was just to expose nature, that is, the wall wherever it was

hung; and from there of course would be extended the rest of the space wherever it was exhibited."[30] Almost five decades later, Rosenquist explained the significance of the missing panels in a very humorous way: "That one, just to get back to the—to the heating radiator. [Laughing] That entrance to the front of the room ... That was—he [Leo Castelli] had to go back there!"[31]

For the center of the space, Rosenquist planned an installation formed from enormous half-dollar coins, but it was never realized. The associated collage bears the note: "Stacks of Kennedy half dollar aluminum cylinders; DEATH and tapes VANITY" (fig. 151). The silver coin, introduced into circulation in early 1964 as a memorial to the recently assassinated John F. Kennedy, was meant to complete the columns. The idea had to be scrapped because of the scarcity of material caused by the start of the Vietnam War.[32]

The work underwent several stages as Rosenquist searched for, selected, and worked with the motifs. He reacted to every change in the constellation of and dialog between his illustrations as he created, conceived of, and installed the piece. Sections that had already been finished were rethought, painted over, reworked, or altered to fit—including the icicle on the beach umbrella, the insignia, and the U.S. Air Force lettering, which he edited once more in a different location after the exhibition with Castelli. Starting in June 1965, the piece was then exhibited at the Jewish Museum for several months before traveling to Europe. Rosenquist gathered the motifs for *F-111* from advertisements by companies that had played a central role in the production of military goods. Then as now, these companies shaped the consumer world in the United States, and their taxes helped to finance the country's military complex.

Rosenquist took his knowledge, experiences, theories, and visions of the society he grew up in and fed these into his visual world, creating a point of view and projecting them onto a war that had only just begun, the immense scale of which was not yet in sight.

The extensive source material, the advertisements, collages, studio photographs, and Rosenquist's own comments now allow the motifs to be precisely situated and evaluated in the context of contemporary history. They also offer important answers to Henry Geldzahler's original question about the work's "impact" and its temporal relevance. Just as the viewer moves through *F-111*, discovering new constellations with each new angle, the work's own series of contextualizations shift in accordance with experience, points of view, new revelations about historical events, research, and the act of looking both to the past and the future. Rosenquist created this monumental work in the exact same spirit—I would have liked to have met him.

The ambience of the painting is involved with people who are all going toward a similar thing. All the ideas in the whole picture are very divergent ... so it's allowable to have orange spaghetti, cake, light bulbs, flowers ... The picture is my personal reaction as an individual to the heavy ideas of mass media and communication and to other ideas that affect artists.—James Rosenquist[33]

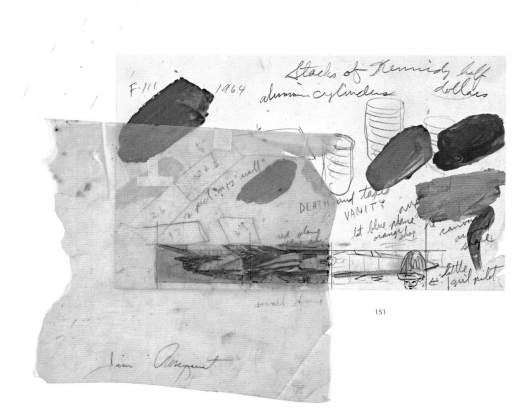

151

151 *Preparatory Study for F-111*, 1964
Mixed media on tracing paper
and paper
10 ¾ × 14 ¼ in. (27.3 × 36.2 cm)
The Museum of Modern Art, New York,
promised gift of Marie-Josée and
Henry R. Kravis

Notes

1 Leah Dickerman, interview with James Rosenquist, The Museum of Modern Art, New York, held on April 17, 2012, http://www.moma.org/docs/learn/archives/transcript_rosenquist.pdf (accessed September 21, 2017).

2 G. R. Swenson, "The F-111: An Interview with James Rosenquist," *Partisan Review* XXXII, Fall 1965: 589–601.

3 Craig Adcock, "An Interview with James Rosenquist," in Susan Brundage, ed., *James Rosenquist, The Big Paintings: Thirty Years*, exh. cat. (New York: Leo Castelli Gallery, 1994), unpaginated.

4 James Rosenquist and David Dalton, *Painting Below Zero: Notes on a Life of Art* (New York: Alfred A. Knopf, 2009), 151.

5 *The Metropolitan Museum of Art Bulletin* 7 (March 1968), 281.

6 See http://www.dtic.mil/dtic/tr/fulltext/u2/a547500.pdf (accessed September 21, 2017).

7 Swenson, "The F-111," 597.

8 *The Metropolitan Museum of Art Bulletin* 7 (March 1968): 282.

9 Rosenquist explicitly mentions his direct contact with Newman in Rosenquist and Dalton, *Painting Below Zero,* 154.

10 Rosenquist and Dalton, 22.

11 On Dow Chemical Co. and Agent Orange see "Geld verdienen mit Napalm … , Wie Dow Chemical ihr Ansehen aufs Spiel setzt," *Die Zeit* 11/1968, March 15, 1968; http://www.dow.com/en-us/about-dow/issues-and-challenges/agent-orange (accessed September 21, 2017); and James Lewes, *Protest and Survive: Underground GI Newspapers during the Vietnam War* (Westport, Connecticut: Greenwood Publishing Group, 2003), 139.

12 Lewes, *Protest and Survive,* 160.

13 *Producing for War, Preparing for Peace* (n.p.: Firestone Tire & Rubber Company, 1944).

14 *Missiles and Rockets*, vol. 15 (Washington, D.C.: American Aviation Publications, 1964).

15 Swenson, "The F-111," 599.

16 Michael Karl Witzel and Gyvel Young-Witzel, *Soda Pop! From Miracle Medicine to Pop Culture* (Oxford, Mississippi, 1998), 68.

17 Swenson, "The F-111," 599.

18 James Rosenquist, "Experiences," in *James Rosenquist*, exh. cat. (Ottawa: National Gallery of Canada, 1968), 88.

19 See http://www.westinghousenuclear.com/About/History (accessed September 21, 2017).

20 Merton J. Peck and Frederic M. Scherer, *The Weapons Acquisition Process: An Economic Analysis* (Cambridge, Massachusetts: Harvard University, 1962), 619.

21 Swenson, "The F-111," 597.

22 Nina Adler (direction/Screenplay), *Korea—Der vergessene Krieg*, three-part television documentary, Germany, 2010.

23 Swenson, "The F-111," 598–99.

24 See http://www.encyclopedia.com/social-sciences-and-law/economics-business-and-labor/businesses-and-occupations/sherwin-williams (accessed September 7, 2017).

25 On the Campbell Soup Company see http://www.encyclopedia.com/social-sciences-and-law/economics-business-and-labor/businesses-and-occupations/campbell-soup (accessed September 21, 2017).

26 Hollis Frampton, "(Nostalgia) Voice-Over narration for a Film of that Name," dated August 1, 1971, in *Film Culture* 53–55, Spring 1972.

27 Rosenquist and Dalton, *Painting Below Zero,* 97.

28 Dickerman, interview.

29 Swenson, "The F-111," 600.

30 Swenson, 595–96.

31 Dickerman, interview.

32 Rosenquist and Dalton, *Painting Below Zero,* 162.

33 Swenson, "The F-111," 595.

152 The word spread quickly that Rosenquist had begun
working on *F-111*, and many curious visitors came to
his Broome Street studio. He documented these visits
with a series of polaroids that also show how the work
was created. In detail:

a) Brooke Hayward
b) Yvonne Mulder
c) John Chamberlain
d) Sir Alex Gregory Hood
e) Thalia and Larry Poons

a

b

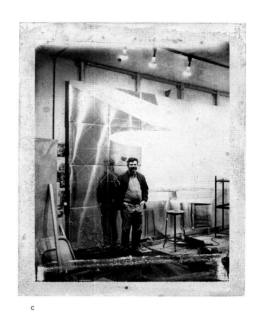

c

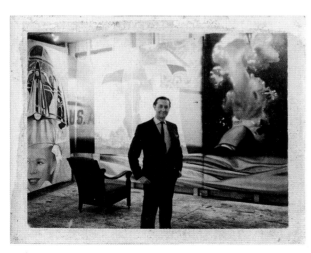

d

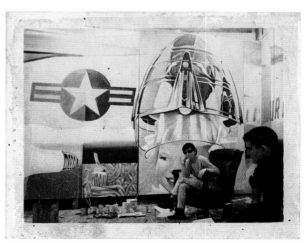

e

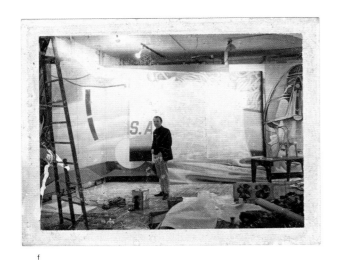

f

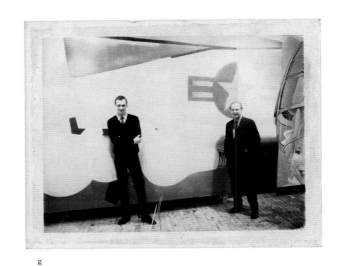

g

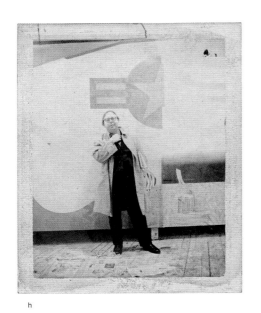

h

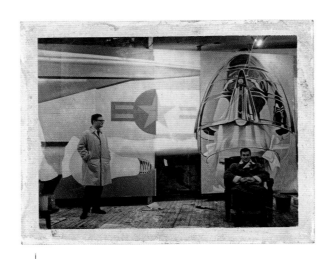

i

j

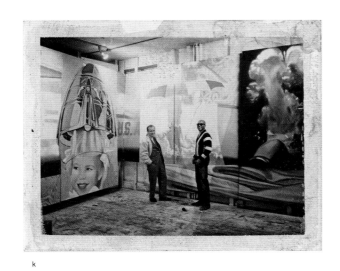

k

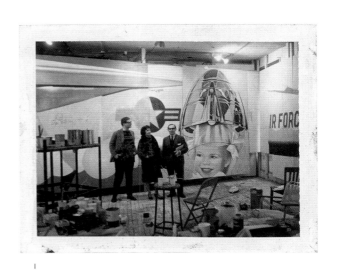

l

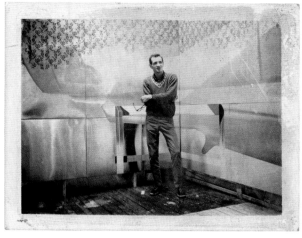

m

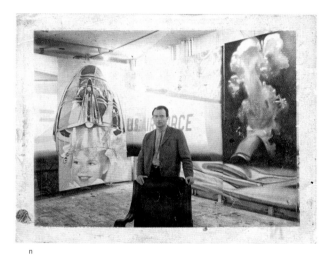

n

f) Gerald Laing
g) Allen Jones, George Cohen
h) Henry Geldzahler
i) Richard Feigen, Tony Curtis
j) Ileana Sonnabend
k) Bruce Hooten, Mel Geary
l) Richard Feigen, Carmen and David Kreeger
m) Unidentified visitor
n) Max Kozloff

o) Charles Henri Ford
p) Richard Smith, Allen Power,
 Bob Gordon, Joe Tilson, Ray Donarski
q) Otto Hahn, Alan Solomon,
 Robert Rauschenberg, Leo Castelli,
 Steven Paxton, Ileana Sonnabend,
 Michelangelo Pistoletto
r) R. Buckminster Fuller, unknown place
 (see fig. 149)

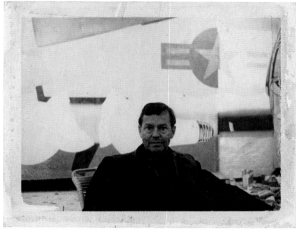

o

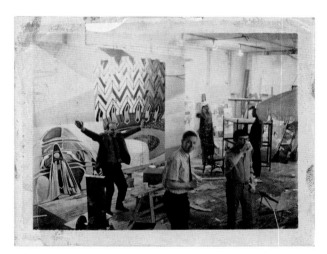

p

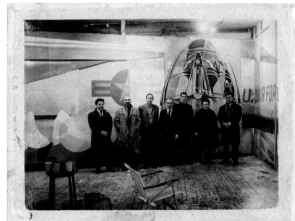

q

r

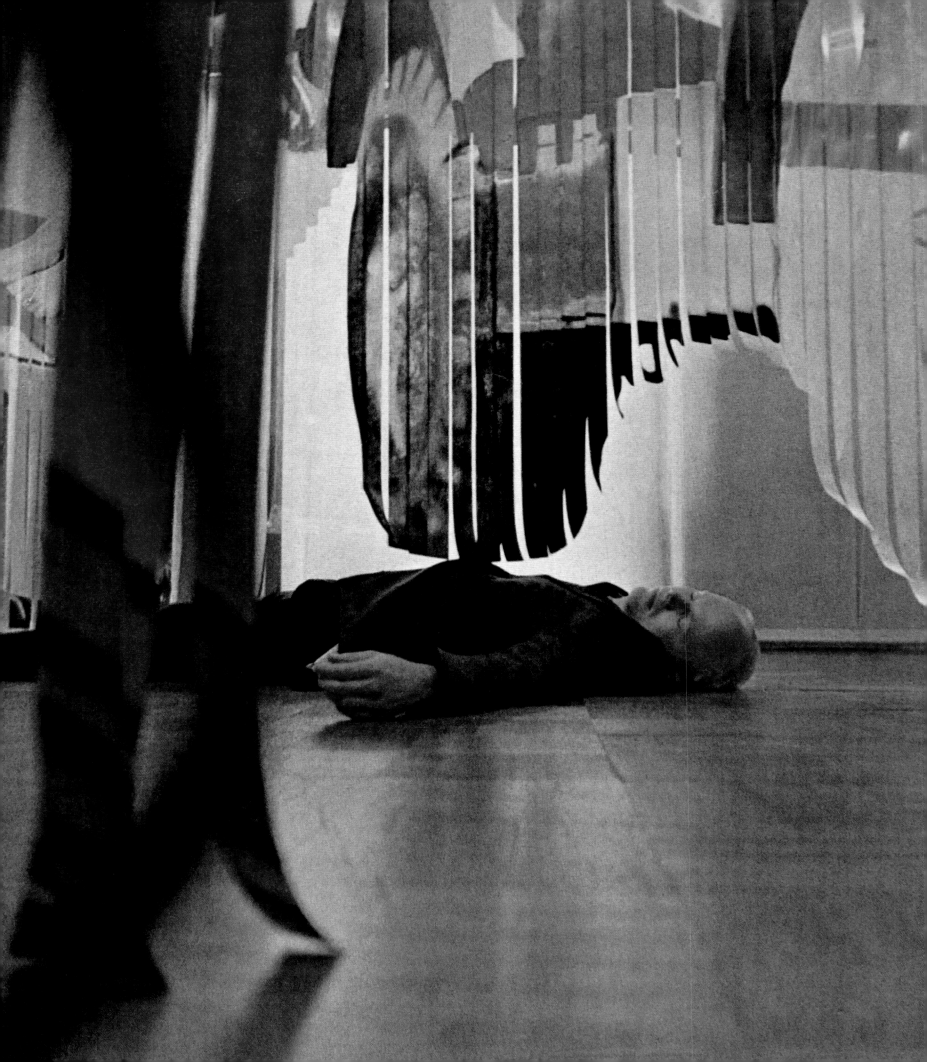

Forest Ranger, 1967

153 Rosenquist with *Forest Ranger*, photographed
 by Manfredi Bellati for *Domus* 455, October 1967

154 Advertisement for Chevrolet
 in *Life* magazine, October 30, 1944, p. 16

155 Advertisement for American Meat Institute
 in *Life* magazine, September 8, 1947, p. 88

156 *Source for Forest Ranger*, 1967
 Magazine clipping and mixed media on paper
 ca. 11 ¾ × 12 ⅛ in. (ca. 29.9 × 30.8 cm)
 Destroyed

157 *Source for Forest Ranger*, 1967
 Magazine clipping and mixed media on paper
 ca. 12 ⅜ × 11 ¼ in. (ca. 31.4 × 28.6 cm)
 Destroyed

154

155

156

157

Horse Blinders, 1968/69

158 *Untitled (Study for Horse Blinders)*, 1968
Oil on canvas
12 × 18 in. (30.5 × 45.7 cm)

159 *Untitled (Study for Horse Blinders)*, 1968
Oil on canvas
12 × 18 in. (30.5 × 45.7 cm)

160 *Untitled (Study for Horse Blinders)*, 1968
Oil on canvas and superimposed Mylar
ca. 12 ¾ × 18 in. (ca. 32.4 × 45.7 cm)

Estate of James Rosenquist

161

158–160

164

162

163

165

166

161

Insights into the Artist's Technique and the Conservation of the Room Installation *Horse Blinders*

Isabel Gebhardt

James Rosenquist's group of works titled *Horse Blinders* (1968–69) comprises an installation made up of a total of twenty-three elements: eleven large-scale paintings and twelve aluminum panels.[1] The piece is owned by the Museum Ludwig in Cologne, and in the past it has been displayed as one of the major works from the Pop-art collection of Irene and Peter Ludwig.

The following presents a few findings from our technical research, the goal being to provide a general overview of the artist's work methods, painting techniques, and selection of materials, while also taking into consideration his statements, sketches, collages, and historical photographs. This should make it possible to imagine the process of designing, constructing, and executing the paintings for this room installation. The final section discusses the condition of *Horse Blinders* and the challenges of preserving it, which ultimately led to the decision to treat the work.

Following the extensive conservation (2015–17), *Horse Blinders* is on display for the first time with two other installations by James Rosenquist, *F-111* (1964–65) and *Horizon Home Sweet Home* (1970), in the context of the exhibition *Painting as Immersion* at the Museum Ludwig.

Room Installations by James Rosenquist: Painting as Immersion, or Diving into the Picture

James Rosenquist began his career painting billboard advertisements. The short distance to the billboard turned reality into an abstract pattern as he worked. Subsequently, his knowledge of this process of dissolution was a crucial influence upon his oeuvre.[2] After the early abstract paintings (*Astor Victoria*, 1959), he took on the visual vocabulary of billboard painting and translated it to paintings on canvas.[3]

Rosenquist developed his concept of panoramic paintings—often known as environmental paintings,[4] wraparound paintings,[5] or surrounding paintings[6]—when he produced the work *F-111* (1964–65); he then continued to work on and vary the concept in other pieces that came afterward (*Horse Blinders*, 1968–69; *Flamingo Capsule,* 1970; *Horizon Home Sweet Home*, 1970; and *The Swimmer in the Econo-mist*, 1997).[7]

Rosenquist's installations, of which *Horse Blinders* is one, were conceived for exhibition inside an closed space. The assembled panels cover all four walls, leaving only enough space for entering and exiting the installation.[8]

Canvas paintings were combined with aluminum and later with metal-foil panels (*Flamingo Capsule*, 1970; *Horizon Home Sweet Home*, 1970) in the corners that reflect the colorful paintings. This makes the space seem boundless and directionless, so that it continues on indefinitely, like a Baroque hall of mirrors.[9]

Surrounded by the harshly bright colors of the Pop paintings, the viewer becomes an integral element of the room installation:[10] "In my eagerness to involve and envelop the viewer, I used ... reflective aluminum panels that could mirror the observer and provoke him to question what he was seeing—and they changed if the person moved."[11] It was this exploration of the phenomena of peripheral vision, inspired by the panorama-sized paintings of Claude Monet, Jackson Pollock, and Barnett Newman, that led Rosenquist to create these installations.[12] Looking at them resulted in a situation in which information from the outermost field of vision still helped to determine the visual impression, regardless of where the eye focused.[13] The title *Horse Blinders* obviously refers to this deliberate visual effect: "... Horse Blinders literally are side shades that block peripheral vision. A horse wearing these will see straight ahead and not be frightened or distracted by anything from left or right."[14]

Working on *Horse Blinders,* and Its Acquisition for the Collection at the Museum Ludwig in Cologne

Horse Blinders was developed over the years 1968 and 1969 at the artist's studio in East Hampton, New York. A photograph (fig. 167) taken while work was still being done on the piece makes it clear how the painting functioned in tandem with the aluminum panels in the corners, creating the desired effect: a reflection of the viewer.[15] Like *F-111* (1964–65) before it, this installation was created specifically for the space at the Leo Castelli Gallery, and it nearly filled the gallery's entire wall space.[16] Again, in this installation, Rosenquist was investigating visual perception, a way of fixing, not the center, but the area around it:[17] "In that sense, as in *F-111,* the painting was about peripheral vision, about looking at something and questioning it because on the peripheries that affect your vision. And like *F-111,* the ten-by-eighty-four-foot *Horse Blinders* wrapped around the walls at the Castelli Gallery."[18] (fig. 169)

After it was completed, the artwork was displayed at the Leo Castelli Gallery from March 29 to April 19, 1969, in a show called *Rosenquist: Horse Blinders*—and was effortlessly sold to the art collector Peter Ludwig. The artist remembered how Ludwig walked into the gallery, took one look at the painting, and liked it right away.[19] At first, the collector thought the asking price of seventy thousand dollars was too high. However, when Ludwig heard that the American architect and critic Philip Johnson was also interested in the piece, he called out impulsively, "It's mine!," and bought the entire group of works on the spot.[20] And so the piece went to the Peter and Irene Ludwig Collection. In the past, the Museum Ludwig in Cologne has presented *Horse Blinders* in spaces equal in size to that of the original room inside the Leo Castelli Gallery. Rosenquist himself supervised the initial installation of *Horse Blinders* in Cologne, for the 1969 show *Art of the Sixties: The Ludwig Collection in the Wallraf-Richartz-Museum Cologne.*[21]

Since then *Horse Blinders* has been almost continuously on display as part of the permanent collection, for it is one of the Ludwig Museum's major pieces from the Pop Art collection. While preparations were underway for a new presentation of the collection, a show called *Not Yet Titled: New and For Always at the Museum Ludwig,* scheduled for summer of 2013, *Horse Blinders* was taken down, which presented an opportunity to begin the extensive research and conservation project.

167

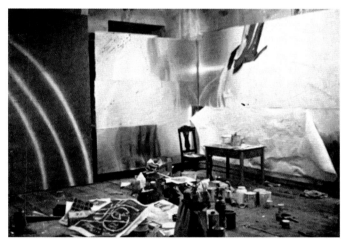

168

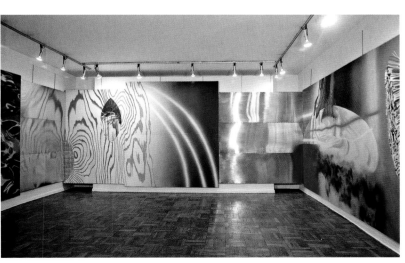

169



167 The gallerist Michael Sonnabend visiting the studio in 1968, during work on *Horse Blinders*, 1968

168 Assembled panels of *Horse Blinders*, in progress in the studio, 1968

169 Horse Blinders, walls 3 and 4, presented at the Leo Castelli Gallery from March 29 to April 19, 1969

170 James Rosenquist installing *Horse Blinders*, 1968–69, Wallraf-Richartz-Museum, Cologne, 1972

170

Artist's Remarks on the Significance of the Motif

Horse Blinders was originally supposed to have been limited to pure color fields, and had no concrete motif.[22] Clearly, the need for a figural motif expanded upon the artist's original intention of using abstract images to manipulate and control the field of vision.[23]

As often is the case in works by Rosenquist, the motifs allude to consumer products and electronic communications devices. Depicted on the canvas are enlarged fragments of ordinary objects—a severed telephone cable, out of which protrudes a bundle of colorful fibers; a bowl of dough and a spoon; a pat of butter in a frying pan; and a stopwatch. In their surprising combination, these seemingly unrelated motifs lose their original meaning and could once again be construed as abstractions, as the artist intended:[24] "The idea of going for a zero nonobjective painting of pure color and pure form obsessed me."[25] None of the individual motifs seem to be part of an overarching theme. This effect must have been precisely what Rosenquist was aiming for. He declared that, at that time, Far Eastern philosophy—especially *The Tale of Genji,* an open-ended, seminal novel in Japanese literary history—greatly influenced the development of *Horse Blinders,* inspiring him to take on this multilayered artistic agenda, which also deliberately evaded obvious interpretation:[26] "I count on the viewer bringing something to the work. Viewers have their own thoughts.... I feel if the images in my painting are powerful enough, they may end up suggesting something beyond the idea I started with. It's my intention to make images that provoke points of departure. I don't write stories with my paintings. I let viewers do that."[27]

One of the central motifs of *Horse Blinders* is the sliced telephone cable, with its ragged, colorful wires. According to the artist, the telephone cord here has the same meaning as the severed Gordian knots in the legends of Alexander the Great.[28] This motif represents ethical questions related to government espionage. Politically, the work was shaped by the McCarthy era, the Vietnam War, and the publishing of the Pentagon Papers.[29] At the time, Rosenquist had become acquainted with young people at the University of South Florida. They were politically active, opposing the government that sent the FBI to spy on private persons and tap telephones.[30]

Next to the telephone cable motif is a painting of a telephone receiver in the upper area of the picture and the fragment of a finger in the lower region. The rainbow colors behind the fingernail could be regarded as the material the artist uses to paint. Beyond that, the motif alludes to the emerging research into DNA analyses, which had been used to identify people ever since Francis Crick and James Watson decoded it in 1953. In the past, people had been identified by fingerprints; in the future, they would do it using DNA, said Rosenquist[31]—and he was proven right.

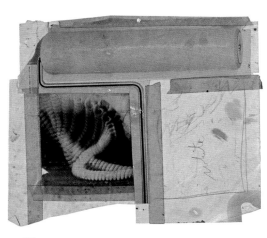

The mostly abstract painting to the right of the entrance again picks up on the theme of communication—here, through the snippet of telephone cord depicted in the lower area of the painting. The painting to the left of the telephone cable is of a spoon, illuminated by various light sources, stirring some white fluid in a bowl, mixing it with some purple fog—supposedly representing the smoke from a rocket shot off during Israel's Six-Day War.[32] Yet another essential motif is the pat of butter in a frying pan, which has its origins in a statement made by his assistant Bill McCain: "You know, existence is like a piece of hot butter in a frying pan."[33] Rosenquist visualizes this idea, painting a piece of butter that comes out of the pan and is immersed in water. He was said to have been fascinated by the process of painting the surface of the water and the rippling lines of light. David Hockney had begun his swimming pool paintings at around the same time, and Rosenquist was obviously enthused, as well as inspired, by them.[34]

The abstract pattern on wall 3 opposite the entrance shows a close-up of wood grain. He has indicated that this motif has to do with Far Eastern philosophical concepts and the notion of the temporality of things: "A stream of consciousness is suggested in the jagged plywood shape and the grain and the patches in the plywood. The implication was that you have one swift race through life. Life is like a quick burn, a quick sizzle. It's an existential idea."[35]

171 *Sources and Preparatory Studies for Horse Blinders*, 1968
Magazine clippings and mixed media on paper
ca. 19 × 83 in. (ca. 48.3 × 210.8 cm) overall
Estate of James Rosenquist

172 *Sketch for Horse Blinders
(Butter as Existence, Melting across
a Hot Pan)*, 1968
Collage and mixed media on paper
22 ¼ × 30 in. (56.5 × 76.2 cm)
Private collection, Houston

Wall 2 with notes from the artist, from
left to right, top: *spray lines on alumi-
num time . . . / stop watch / red finger
nail on green finger / day glo butter;
from left to right, center: aluminum /
aluminum*; from left to right, bottom:
*corner / red hot fry pan & stove dipped
into a pool / Jim Rosenquist.*

This preliminary study is evidence that
the interplay of painting and aluminum
was planned from the start. In the
corner between two adjoining walls,
half the stopwatch is depicted in a
drawing and the rest is reflected in the
adjacent aluminum panel, completing
a picture of the whole. In addition, the
sketch shows that the artist has already
thought out the color scheme for the
background, including a few specific
details as to the choice of materials.

173 Sketch for *Horse Blinders*, 1968
Mixed media and collage on paper
22 ¼ × 29 ⅞ in. (56.5 × 75.9 cm)
Private collection

Without making many changes, this
collage was turned into a painting on
wall 3. Artist's notes, from left to right,
top: *paper boats (?) / spark shower; from
left to right, bottom: screen / from center
into open / dull aluminum reflections
perpendicular to cirrus / scetch [sic!]
for Horse Blinders Jim Rosenquist 1968.*

The collage also demonstrates that he
had already thought to use the reflection
in the aluminum panel as a visual device.

172

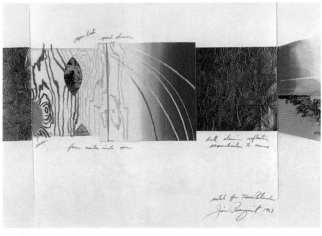

173

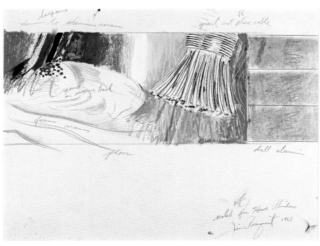

174

174 *Sketch for Horse Blinders*, 1968
Mixed media on paper
18 × 26 in. (45.7 × 66 cm)
Private collection

Wall 4, with artist's notes. Another
preliminary study with notes shows how
the order and selection of individual
motifs in the cut-outs deviate from the
final version on canvas. A larger section
of the cut telephone cord motif runs
horizontally across the surface of the
picture in the actual rendition of *Horse
Blinders.*

175 *Sketch for Horse Blinders*, 1968
Mixed media and collage on paper
14 × 22 ¹⁄₁₆ in. (35.6 × 56 cm)
Estate of James Rosenquist

Panel 5. Artist's notes, from left to right:
scetch [sic!] for Horse Blinders. This
preliminary sketch features the
fragment of a finger, probably taken
from a newspaper clipping. Further-
more, the artist has obviously thought
about the color scheme for the motif,
rendered a sketch, and later reproduced
it in the room installation of *Horse
Blinders*, where it was positioned to
the right of the entrance.

176 *Sketch for Horse Blinders*, 1968
Mixed media on paper
23 × 29 in. (58.4 × 73.7 cm)
Private collection

177 *Sketch for Horse Blinders
(Star Spoons)*, 1968
Mixed media on paper
17 ½ × 29 ¾ in. (44.5 × 75.6 cm)
Private collection

175

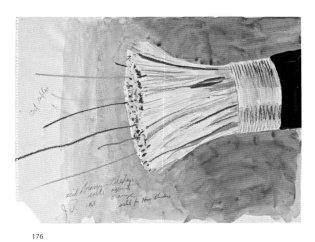

176

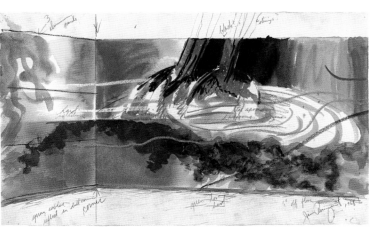

177

178

178 *U-Haul-It*, 1967
Oil on canvas
5 ft. ⅛ in. × 14 ft. 1 ¾ in. (152.7 × 431.2 cm)
Whitney Museum of American Art, New York,
purchase, with funds from Mr. and Mrs. Lester Avnet

179 *Area Code*, 1970
Oil on canvas, Mylar
9 ft. 6 in. × 23 ft. (289.56 × 701 cm)
Collection Walker Art Center, Minneapolis
Gift of The T. B. Walker Foundation, 1971

180 Left: Detail of the source collage with the grid lines
that Rosenquist used to transfer the motif;
right: After completion of the painting Rosenquist
again added on the left a grid that now serves as
a design element.

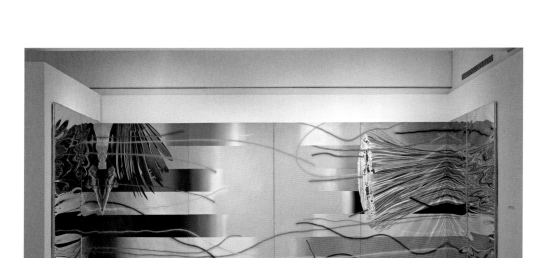

179

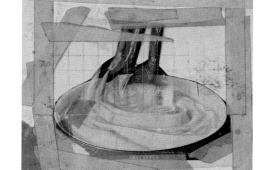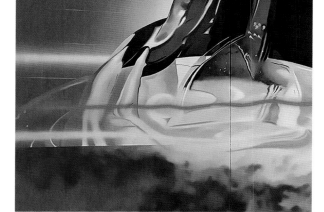

180

On Work Methods, Painting Technique, Selection of Materials, Planning, and Preparation

Before executing his large paintings, Rosenquist produced numerous sketches and collages that helped him in devising ideas and visual concepts.[36] Since, as previously mentioned, he had worked as a billboard painter, he knew how to enlarge small source materials hundreds of times and then transfer them to billboards—and later, to canvases.

He combined the motifs, most of them from *Life* magazine, with each other, and this procedure eventually led to the composition of his paintings.[37] He described the process of spontaneously or randomly assembling and combining individual motifs as being "like listen[ing] to the radio."[38] Changing the station resulted in mixing random fragments of conversations, advertising, news, and music—"a sort of Dada radio station"[39]—in one's mind. Pursuing this work method, he covered the walls and floor of his studio with countless pictures, newspaper clippings, and photographs, which he could use at any time:[40] " . . . my studio floor was a part of me, part of my painting method, because that was the way I intended it, with things strewn all over the floor."[41]

The preliminary studies made for *Horse Blinders* relate clearly to the described working method. The artist's process of creation began with colorful preliminary sketches and collages with individual motifs, or with entire sections of wall, which he enlarged multiple times and then translated into painting. Comparing the preliminary studies with the research into the painting technique shows that there were changes in proportion, the order of individual components, and the color scheme (figs. 173, 174; figs. XI, XII, XIII).

Individual motifs and combinations of motifs are derived from previously completed works. For instance, the pan and the melting pat of butter, along with the fragment of stopwatch, already appear in the painting *U-Haul-It* (1967). Conversely, Rosenquist went back to *Horse Blinders*, slightly altering individual motifs from it for later works. In 1970 he executed *Area Code*, in which he reworks the motif of the severed telephone cable.[42]

Rosenquist composed his works carefully, in the manner of a billboard painter. Initial sketches were made to aid in the process of transferring the motifs to the large canvases with the help of classic transference and enlargement techniques.[43] Using the grid technique, which he called the "Brooklyn Bridge" method,[44] he enlarged his source material. Most likely using a chalk-covered string, he transferred the grid pattern onto the prepared canvas.[45] Hints of this process can also be found on the *Horse Blinders* paintings (fig. VI). The image transfer was then executed square by square. Starting with the collages or sketches, Rosenquist transferred the motif by hand—research shows that he used a dry drawing tool producing broad lines[46]—directly onto the canvas, without the aid of any other technical devices.

The underdrawing is the compositional design on the primed and stretched canvas, and can be considered the first step in the artistic process. The grid and the drawing served as a basis for the process of painting *Horse Blinders*, and with a few exceptions, they are completely over-painted.[47] Despite the precise planning, variations in the painting or later corrections did occur, and examples of that in *Horse Blinders* are described in the following (figs. XI, XII, XIII).

The Technical Composition of the Canvas Paintings of the *Horse Blinders* Installation

Rosenquist's general painting technique can be described as traditional.[48] The artist used stable wooden frames, so-called expansion bolt stretch-ers,[49] and high-quality linen fabric[50] of dense weave,[51] which he skillfully stapled to the frame. (fig. I)[52]

The artist's signature, the date, and the title of the work were scrupulously written on the verso of each individual panel in the group (fig. I). After the composition was defined, as explained above, the actual painting was executed on the sized and primed[53] fabric, probably in a grid pattern, and possibly using individual points of orientation in the composition, as well as rough drawings.[54]

On the whole, the painting was applied in multiple, thin, glazelike layers, some of them wet-on-wet, so there is no impasto whatsoever. As to the order in which the layers of background and motif were applied, it is not possible to discern any uniform process in *Horse Blinders*; layers were applied in various orders, depending upon the image (figs. IX, X).

In selecting the materials, Rosenquist—after some initial experiments with commercial paints for billboards—limited himself to painting on canvas (*Astor Victoria*, 1959), and, later on, to a small selection of oil paints (Winsor & Newton):[55] "I learned to make all of the colors in the universe from eight or ten separate tubes of Winsor & Newton."[56] He used oil paints mixed with boiled linseed oil and thinned with solvents, which made it possible for him to apply thin glazes in the manner of the Old Masters, thereby producing particularly smooth surfaces with soft, flowing color transitions.[57]

In order to produce surfaces without any traces of brushwork, Rosenquist used various brushes and cotton balls to blend and disperse the still-wet paint; he also used spray paint in some places. "I wanted to paint . . . so well that you wouldn't see my brushstroke."[58] In some of his works, as well as in a few sections of *Horse Blinders* (fig. VIII), he worked with daylight fluorescent paint,[59] so-called Day-Glo Colors,[60] applying an extra layer on top of the already completed work to intensify the luminosity of the piece.[61]

Most of the composition was established beforehand. The entire concept shows evidence that the work was planned in advance; there are only a few minor variations on the preliminary studies, and almost nothing was reworked afterward. Nevertheless, in some sections there are hints of later revisions, so-called *pentimenti*.[62] Despite his precise planning, the artist obviously spontaneously decided to make some spontaneous changes to the color and design concept as he developed the work. One particularly noticeable change made afterward can be seen in Panel 3.1 (fig. XIII). Here, the upper ellipsis-shaped, abstract motif was completely overpainted. A comparison of the corresponding collage of Wall 3 (fig. 173) reveals additional minor variations on the composition. The partly depicted ellipsis in the lower part of the picture was completely omitted.

fig. I – Panel 3.1
The artist signed the back of the canvas in black paint.

fig. II – Panel 4.2
In the canvas, which came with selvage, there are unused holes for nails; these hint at the possibility that the canvas had been temporarily stretched once before, so that the sizing and ground layer could be applied.

fig. III – Panel 4.2
The canvas is sized to regulate how much and how deeply the fabric absorbs the ground.

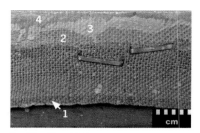

fig. IV – Panel 1.1
Some fabrics have selvage on both sides, marking the points where the weft (1) ends or returns. The sized canvas has a flat, off-white ground (2). A second layer of opaque, brilliant white ground (3), and a layer of paint (4) follow.

1.1 1.2

fig. IV

2.1 2.2 2.3 2.4

fig. XII fig. VIII

fig. IX – Panel 4.3
According to the overlapping sections of paint layers, the cut telephone cord motif was worked out first, followed by the orange background.

fig. X – Panel 3.1
A large section of the wood-grain background and the elliptical motif are drawn onto panel 3.1 (1). As indicated by the paint drips, the elliptical shape was masked out with tape before the ground (2) and the paint (3) were applied.

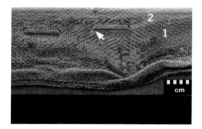

fig. XI – Panel 4.3
On several of the paintings there are traces of different-colored paint along the edge of the fabric (1). This indicates that there was probably a color change during the painting process, resulting in areas of partial and major overpainting (2).

fig. XII – Panel 2.2
According to the artist, he originally considered executing the stick of butter (1) in yellow Day-Glo paint. It was later overpainted in a more muted tone (2).

fig. V – Panel 4.1
In several areas of the painting the white layer of sizing is not completely covered by the paint, but is incorporated into the final composition. The artist took advantage of the light color of the sizing as white accents or for depicting lights and reflexes.

fig. VI – Panel 4.3
By daylight, the unaided eye can perceive dark blue lines that crisscross each other at right angles in sections of the painting with the cut telephone cord where the paint layer is more transparent here than in other parts of the painting. Located beneath the paint, they could be interpreted as a grid pattern that divides up the picture.

fig. VII – Panel 4.1
The spoon motif was drawn on top of the painted layer with a dry medium, probably graphite pencil or charcoal, producing broad lines.

fig. VIII – Panel 2.2
The motif of the glowing burner coil was given a partial coat of fluorescent Day-Glo paint on top of the existing paint, which seems to have been sprayed on.

3.1
3.2
3.3
3.4
4.1
4.2
4.3
4.4
5

fig. I (reverse)
fig. X
fig. XIII

fig. VII
fig. V
fig. II & III
fig. XI
fig. IX
fig. VI
fig. XV
fig. XIV
fig. XVI

fig. XIII – Panel 3.1
The elliptical motif was initially done in green-yellow paint, deviating from the preliminary sketch (1). It was revised later, using a flat layer of ground (2) and a second layer of paint (3).

fig. XIV – Panel 4.4
Before the painting was begun, a layer of white ground was applied to parts of the aluminum surface, probably as a bonding agent.

fig. XV – Panel 4.4
The painting, which was begun on the adjacent painting on canvas, continues on the aluminum surface in the same manner.

fig. XVI – Panel 4.4
The image of the logo with the words "BELL SYSTEM" on *Horse Blinders* is the same as the company's logo design in 1964.

Technical Composition of the Aluminum Panels as Components of the *Horse Blinders* Installation

The *Horse Blinders* installation was completed by installing partially painted aluminum panels in the corners of the room next to the canvas paintings. Simple stretchers were used to mount the aluminum sheets (rolled material).[63] The aluminum surfaces were polished to a very smooth finish and appear to be untreated.

They were mainly left in that state, with only locally applied paint layers. For example, the motif of the severed telephone cable extends from the canvas painting onto the aluminum surface of Panel 4.4. The layer composition is technically similar to the canvas paintings: a white ground layer was partially applied to the aluminum surface first, probably as a kind of bonding agent (fig. XIV). Then the telephone cable motif was painted (fig. XV).

The letters "ATT," which stand for the American telecommunications company AT&T, Inc., were initially outlined in chalk, along with a logo shaped like an abstract bell with the phrase "BELL SYSTEM" written on it; all of this was later painted in black (fig. XVI). A stencil was obviously used for this—a technique that can also be found in other Rosenquist pieces (fig. 132).

Interplay of Painting and Aluminum

Comparing the paintings on canvas with the aluminum panels, it becomes clear that Rosenquist considered them a unit from the start. He arranged their order already while working on them in the studio, obviously taking into consideration the reflective effects of the aluminum surfaces (fig. 168).

Rosenquist, who, up until then had mostly painted on fabric, treated the comparatively new material of aluminum like a canvas. Regardless of the material, the support was mounted to a stretcher with staples. Before the work of painting began, the sized and primed fabric was covered in another layer of white (ground) layer, which can also be found on the partially painted aluminum panels. The paint layers completely cover the canvas and continue onto limited sections of the two aluminum panels.

In understanding the connection between the paintings and the aluminum, the artist's mounting system also provides important clues: all of the panels on a wall are attached to each other on the back with a plug-in system previously specified by the artist (fig. 13).[64] Hence, Rosenquist regarded all panels as interconnected structural components that by covering the walls of the exhibition space completely create a room installation.

Condition of the *Horse Blinders* Installation and Reasons for the Conservation Project

By experimenting with color, reflection, and surface textures, Rosenquist attained an illusory material effect that also became a problem for this work of art: "I used aluminum panels that I painted over to give the effect that aluminum was underneath the entire painting ..."[65] Clearly, the monumental group of works with its reflective aluminum surfaces were fascinating from the start: the artist's friends and acquaintances admired *Horse Blinders* up close while he worked on it in the studio.

Later, museum visitors, who were allowed to move freely around in the space, were so strongly attracted to the interplay of painting and aluminum that they literally wanted to "grasp" it. Much damage can be traced back to frequent touching. Matte fingerprints in particular could be seen on the aluminum surfaces—the results of oxidation and corrosion—and extensive paint cracks on the canvas paintings resulted in a generally very inhomogeneous appearance (figs. XVII, XVIII). Other external influences as well as the artist's concept for mounting the installation caused further damage, such as canvas distortions, scuffs, abrasions, and scratches. After decades, its increasingly deteriorating condition required that ways of conserving and restoring the artwork be explored.

XVII

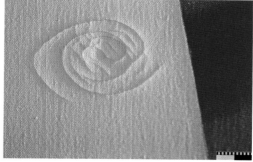

XVIII

Treatment Proposal and Conservation Treatments (2015–2017)

The detailed conservation treatment proposal was based on the findings from technological examinations, scientific analysis, and information from art research. The proposal aimed to regain a well-kept appearance and take preventative measures against any further damage or changes. Restoring the homogeneous appearance of both the aluminum surfaces and the canvas paintings was the main concern. In order to achieve the desired uniformity, it was important to coordinate the treatments of the paintings and the aluminum with each other. Because there were obvious technical limitations in improving the appearance of the aluminum surfaces, preserving and preventative measures were mainly pursued.

This fact predetermined the extent of the treatment for the canvas paintings. Here, the focus was on cleaning the surfaces, the setting down of lifting paint cracks, and the leveling of accompanying canvas distortions.

All of the measures taken to conserve and restore *Horse Blinders* primarily served to maintain the substance and helped considerably in improving the visual appearance of the paintings and therefore the viewer's experience of the installation as a whole. Thanks to the conservation project, the monochrome surfaces of the paintings in particular are again coherent, the motifs are once again legible, and the interplay of painting and aluminum has been reinstated.[66] The extensive treatment has essentially made it possible to exhibit *Horse Blinders* again in a room that is accessible to the public and in accordance with Rosenquist's desire for "painting as immersion."[67]

XVII Matte fingerprints on the aluminum surface, as a result of oxidation and corrosion.

XVIII Paint cracks on a canvas painting, caused by mechanical impact to the front.

Notes

1 The walls were originally numbered by the Leo Castelli gallery, and the gallery's system has been adopted for this article; individual panels are labeled accordingly.

2 Judith Goldman, "An Interview with James Rosenquist," in *James Rosenquist: The Early Pictures 1961–1964*, ed. Judith Goldman (New York: Gagosian Gallery and Rizzoli, 1992), 99.

3 Goldman, 89–90.

4 Peter Schjeldahl, "An Interview with James Rosenquist," *Opus International* 29–30, 1971, 47.

5 Robert Rosenblum, in an interview with James Rosenquist, in *James Rosenquist: The Swimmer in the Econo-mist*, exh. cat. Deutsche Guggenheim, Berlin (New York: The Solomon R. Guggenheim Museum, 1998), 7–11, here 7; Chris Balsiger, "Rooms with a View: Walk-in Paintings," in *James Rosenquist: A Retrospective*, ed. Walter Hopps and Sarah Bancroft, exh. cat. (New York: The Solomon R. Guggenheim Museum, 2003), 148–49.

6 Michaël Amy, "Painting, Working, Talking: Interview with James Rosenquist," *Art in America,* 2004, 108.

7 Judith Goldman, "James Rosenquist: Fragments of Fragments," in *James Rosenquist* (New York, 1985), 11–70, here 41.

8 Horst Richter, *Malerei der sechziger Jahre* (Cologne: DuMont, 1990); Craig Adcock, "James Rosenquist and Pop Art," in *Rosenquist*, exh. cat. (Valencia: Institut Valencià d'Art Modern [IVAM] Centre Julio González, 1991), 191–95, here 195.

9 Balsiger, "Rooms with a View," 148; Evelyn Weiss, "Leben und Werk des Pop Malers James Rosenquist," in *James Rosenquist: Gemälde Räume Graphik*, exh. cat. (Cologne: Wallraf-Richartz-Museum, Kunsthalle Köln, Wallraf-Richartz-Museum Fondation Corboud, 1972), 6–121, here 102.

10 Balsiger, "Rooms with a View," 148; Craig Adcock, "Interface and Overlay in Art of James Rosenquist," in *James Rosenquist*, exh. cat. (Lakeland: Florida State University Gallery and Museum, 1988), 6–46, here 22.

11 James Rosenquist and David Dalton, *Painting Below Zero: Notes on a Life in Art* (New York: Alfred A. Knopf, 2009), 158.

12 Leah Dickerman, interview with James Rosenquist, conducted on April 17, 2012, Museum of Modern Art, New York, http://www.moma.org/docs/learn/archives /transcript_rosenquist.pdf (accessed September 3, 2017), see p. 52; Max Hollein, "Conservation with James Rosenquist," New York, April 1997, http://www.mip.at// attachments/193 (accessed September 3, 2017). See also Tom Holert's observations in this volume, 180.

13 Rosenquist and Dalton, "Painting Below Zero," 196.

14 James Rosenquist, "Statement James Rosenquist 12.12.1968," in *Rosenquist* 1991, 196.

15 Amy, "Painting, Working, Talking," 108.

16 Lawrence Alloway, "Slug-Art," in *The Nation* 5, 1969, 581–82.

17 Judith Goldman, "Swimming in the Mist: Another Time, Another Country," in *James Rosenquist: The Swimmer in the Econo-mist*; Adcock, "Interface and Overlay," 22.

18 Rosenquist and Dalton, "Painting Below Zero," 196.

19 Rosenquist and Dalton, 198.

20 The artist's information about the sales price has varied over the years. See Craig Adcock, "An Interview with James Rosenquist," in *James Rosenquist: The Big Paintings: Thirty Years*, ed. Susan Brundage (New York, 1994), unpaginated; Dickerman, interview, 65–66; and Rosenquist's written information, Stephan Diederich and Luise Pilz, "Statement Rosenquist," in *Ludwig Goes Pop: Essays Statements Interviews*, exh. cat. (Cologne: Museum Ludwig, 2014), 101.

21 Anna Friedrichson, "Einblicke in eine Sammlung—Zur Ausstellung Kunst der sechziger Jahre im Wallraf-Richartz-Museum," in *Ludwig Goes Pop*, exh. cat. (Cologne: Museum Ludwig, 2014), 71–73, here 75.

22 James Rosenquist, in an interview with Scott Rothkopf, in *James Rosenquist*, exh. cat. (London: Haunch of Venison, 2006), 55–62, here 55; Rosenquist and Dalton, *"Painting Below Zero,"* 195.

23 John Loring, "James Rosenquist's Horse Blinders," *Arts Magazine* 47, February 4, 1973, 64–65, here 64.

24 Schjeldahl, "Interview," 47–48; Amy, "Painting, Working, Talking," 106.

25 Rosenquist and Dalton, "Painting Below Zero," 82.

26 Adcock, "Interview," unpaginated; Rothkopf, interview, 61; Rosenquist and Dalton, "Painting Below Zero," 199. Tom Holert's observations in this volume, 180.

27 Rosenquist and Dalton, "Painting Below Zero," 201.

28 Adcock, "Interview," unpaginated; Rosenquist and Dalton, "Painting Below Zero," 197.

29 Adcock, "Interview," unpaginated.

30 Rosenquist and Dalton, "Painting Below Zero," 197.

31 Rosenquist, "Statement"; Rosenquist and Dalton, "Painting Below Zero," 197–98.

32 Rosenquist and Dalton, 198.

33 Adcock, "Interview," unpaginated.

34 Adcock, unpaginated.

35 Rosenquist and Dalton, "Painting Below Zero," 198.

36 Rothkopf, interview, 61; Carter Ratcliff, "Hot Contradictions," in *James Rosenquist*, exh. cat. (London: Haunch of Venison, 2006), 7–16, here 10.

37 Rosenquist, quoted in Adcock, "Interface and Overlay," 10; Mary Anne Staniszewski, "James Rosenquist Interview," *Bomb* 21, 1987, 24–29, here 24–26.

38 For the quote see Julia Blaut, "James Rosenquist: Collage and Painting of Modern Life," in *James Rosenquist: A Retrospective*, ed. Walter Hopps and Sarah Bancroft, exh. cat. (New York: The Solomon R. Guggenheim Foundation, 2003), 16–43, here 18. See also Jane Kinsman, in an interview with James Rosenquist, May 2006, https://nga.gov.au/Rosenquist/Transcripts.cfm?View=2 (accessed September 3, 2017).

39 Rosenquist and Dalton, "Painting Below Zero," 201.

40 G. R. Swenson, in an interview with Stephen Durkee, Jasper Johns, James Rosenquist, and Tom Wesselmann, "What is Pop Art? Part II," *Art News* 62, no. 10, February 1964: 62.

41 Rosenquist and Dalton, "Painting Below Zero," 81.

42 Weiss, "Leben und Werk," 117.

43 Blaut, "Collage and Painting of Modern Life," 20.

44 Sarah Bancroft, "From Abstraction and Back Again, Travelling at the Speed of Light," in *James Rosenquist*, exh. cat. (London: Haunch of Venison, 2006), 107–14, here 111.

45 Rosenquist and Dalton, "Painting Below Zero," 53. Rosenquist's methods are demonstrated in detail in the following video: *James Rosenquist: A Youngstars Masterclass on HBO Trailer, Simon & Goodman Picture Company*, released on May 15, 2013, https://www.youtube.com/watch?v=ESIEJcviMYw (accessed September 3, 2017).

46 Defined in Andreas Siejek, "Identifikation und Rekonstruktion graphischer Mittel auf dem Malgrund," in *Die Unterzeichnung auf den Malgrund: Grafische Mittel und Übertragungsverfahren im 15.–17. Jahrhundert*, ed. Ingo Sandner (Munich, 2004), 13–143.

47 The treatment of the composition in Panel 4.1 is unusual: after completing the painting, Rosenquist added a grid to the upper-left area of the painting, making it into a design element (fig. VI).

48 Amy, "Painting, Working, Talking," 109.

49 This kind of frame has a smooth bolt system that can be used to re-stretch the fabric on all sides and is often part of works of art made by American artists in the late 1950s and 1960s. Steven B. Erisoty, "Expansion Bolt Stretcher," in *PSG Stretchers and Strainer—III. Materials and Equipment,* 2006, http://www.conservation-wiki.com/wiki/PSG_Stretchers_and_Strainers_-_III._Materials_and_Equipment (accessed September 3, 2017), 61–62.

50 A polarization microscopy analysis of the threads showed that the fabric is made of flax fiber.

51 The fabric has seventeen warp threads and fourteen woof threads per square centimeter and is therefore relatively thick. The warp threads are, on average, 0.54 mm, and the woof threads 0.37 mm. According to Rouba's analysis of the fabric's structure, the average fabric fill is approximately 96.82 percent. See J. Bogumila Rouba, "Die Leinwandstrukturanalyse und ihre Anwendung für die Gemäldekonservierung," in *Restauratorenblätter* (Vienna) 13, 1992, 79–90. The threads in both systems have Z-twists. The average angle of the warp threads is 65.87 degrees, and angle of the woof threads is 65.87 degrees.

52 Looking at the results of the fabric structure and thread structure analyses together confirms that the same fabric was used for the entire group of works.

53 "Size" and "primer" are preparatory layers that make the substrate amenable to the paint.

54 Infrared reflectography, or IR, did not provide any clear evidence of this transfer technique. The absence of any traces of underdrawing, however, does not mean that this step was skipped when this work of art was produced. Rather, the results allow us to conclude that certain technical requirements for making the underdrawing visible were not fulfilled—that is, materials and methods were used that cannot be detected by IR.

55 This information was taken from the 2002 correspondence between Tanja Husmann and James Rosenquist. See Tanja Husmann, "'Forest Ranger' von James Rosenquist: Eine großformatige Malerei auf Kunststoff-Folien," unpublished master's thesis, Fachhochschule Köln, Cologne, 2002, 184–85. An investigation of the binding agents conducted through infrared spectroscopy (FTIR) confirmed that the binding agent contained oil. See the analysis report, Dr. Stephan Zumbühl, Kunsttechnologisches Labor, Hochschule der Künste Bern (HKB), Bern, March 30, 2016.

56 Rosenquist and Dalton, "Painting Below Zero," 337. Rosenquist said that he used the following pigments: "cadmium yellow, Winsor red, Winsor blue, phthalo blue and phthalo green (phthalo turquoise), ultramarine blue dark/light, shira rose [sic] (quinacridone red?), alizarin crimson, burnt umber, burnt sienna, black (very little)." James Rosenquist, in an interview with Carol Mancusi-Ungaro, Menil Collection, Houston, October 21, 1993.

57 Christian Rattenmeyer, in an interview with Jeff Koons and James Rosenquist, "If You Get a Little Red on You, It Don't Wipe Off," *Parkett* 58, 2000, 37.

58 Blaut, "Collage and Painting of Modern Life," 19.

59 Daylight fluorescent pigments are made of fluorescent, organic materials mixed into a synthetic resin base. Sarah Eleni Pinchin/Jia-Sun Tsang, Fluor-S-Art, "Northern Lites, DayGlo: Daylight Fluorescent Pigments, Their Development, Use, and Performance," in *Modern Paints Uncovered, Proceedings from Modern Paints Uncovered Symposium* (London, May 16–19, 2006), ed. Thomas J. S. Learner, Patricia Smithen, Jay W. Krueger, and Michael R. Schilling (Los Angeles, 2008), 296–97, here 297. Under UV light, daylight fluorescent pigments can be recognized by their brightly colored fluorescence. Margaret Holben Ellis, Christopher W. McGlinchey, and Ester Chao, "Daylight Fluorescent Colors as Artistic Media," in *The Broad Spectrum: Studies in the Materials, Techniques, and Conservation of Color on Paper*, ed. Harriet K. Stratis and Salvesen Britt (Venice, 2002), 160–66, here 162.

60 In the 1960s, in the wake of the Pop-art movement, Day-Glo fluorescent paints were used more frequently in painting. Holben Ellis et al., "Daylight Fluorescent Colors," 161.

61 Dickerman, interview, 62.

62 On the other hand, in *F-111* (1964–65) at the Museum of Modern Art, New York, in strong raking light a background design with starlike motifs shows up clearly in some areas, due to their plasticity. The artist obviously dismissed the idea later in the process when he overpainted them extensively (New York, March 28, 2017).

63 The X-ray analysis conducted showed that the material is unalloyed aluminum (Al 99.5). See analysis report, Prof. Dr. Gunnar Heydenreich, Kunsttechnologische Untersuchung am Instituts für Konservierungs- und Restaurierungswissenschaft (CICS), Technische Hochschule Köln (TH), Cologne, January 7, 2014.

64 This consists of a carriage bolt (round-head screw) with either a wing or a hexagonal nut, and was also used to mount *F-111* (1964–65), *Star Thief* (1970), and most likely other works.

65 Rosenquist and Dalton, "Painting Below Zero," 159.

66 The conservation and restoration of *Horse Blinders* was made possible by generous support from the federal state of North Rhine-Westphalia in the scope of its restoration program for Fine Arts and from the Wüstenrot Foundation. It was carried out in cooperation with freelance restorers Sandra Schäfer (certified restorer), Diana Blumenroth (M.A.), and Sarah Grimberg (M.A.), in the Conservation Department at the Museum Ludwig from 2015 to 2017.

67 Rosenquist and Dalton, "Painting Below Zero," 155.

Horizon Home Sweet Home / Slush Thrust, 1970

181 *Black and White Corner Study for Slush Thrust*, 1970
Mixed-media sculpture
17 × 10 ¼ × 20 ½ in. (43.2 × 26 × 52.1 cm)
Private collection

182 *Black and White Study for Slush Thrust*, 1970
Mixed media on paper
15 ¾ × 29 ⅛ in. (sheet), 16 ¹⁵⁄₁₆ × 29 ¹⁵⁄₁₆ in. (frame)
(40 × 74 cm [sheet], 43 × 76 cm [frame])
Museum Ludwig, Cologne

183 Detail of *Slush Thrust*, 1970

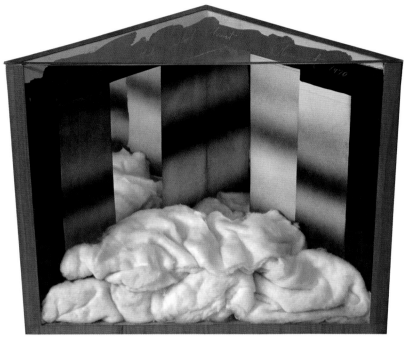

181

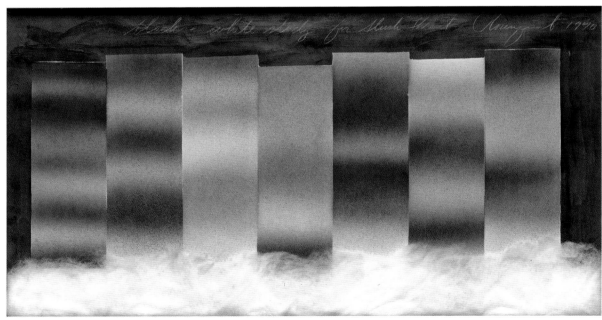

182

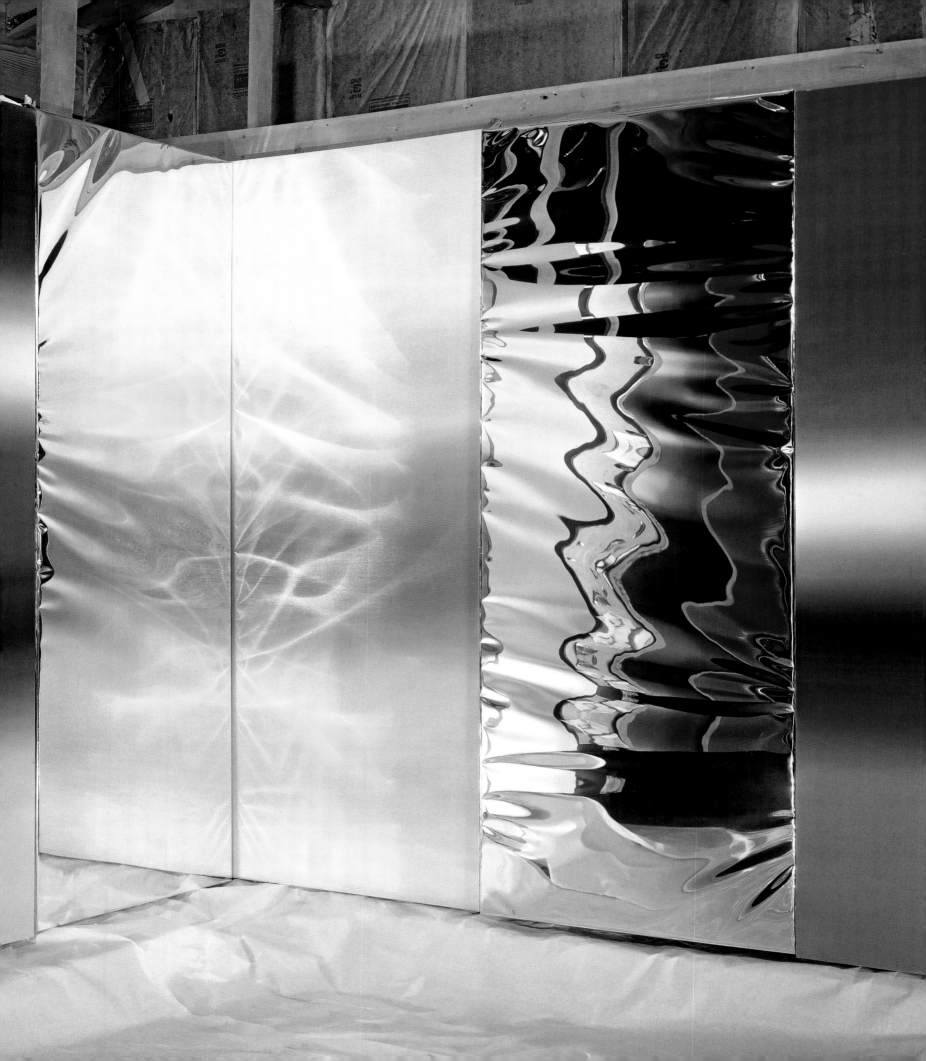

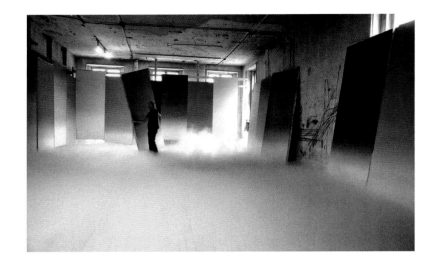 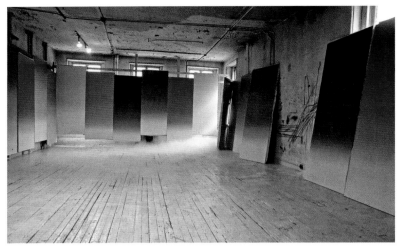

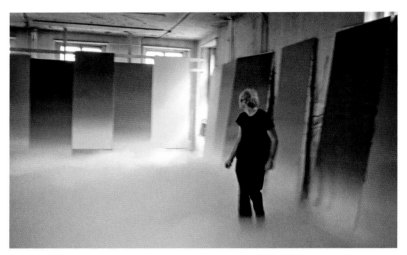 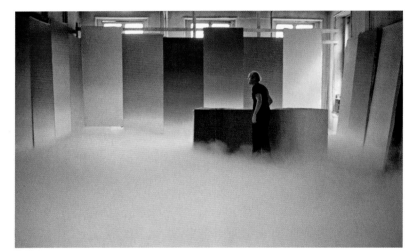

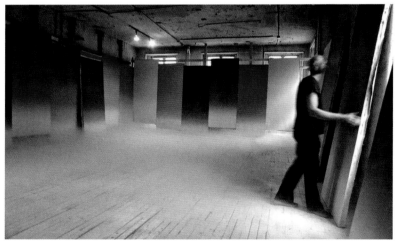 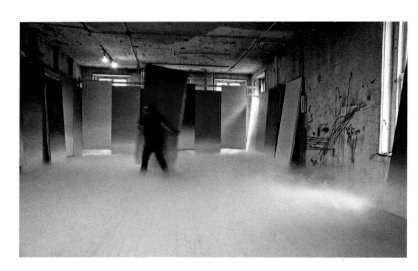

184 a–l

184 a–l Rosenquist working on *Horizon Home Sweet Home*, 1970, panel arrangement, Broome Street studio, New York, 1970

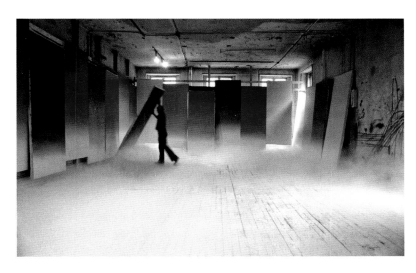
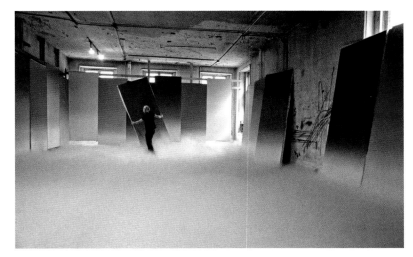
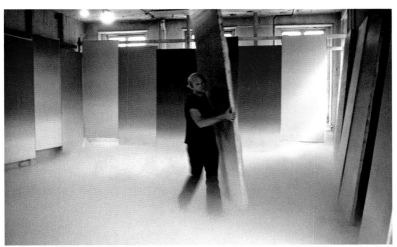
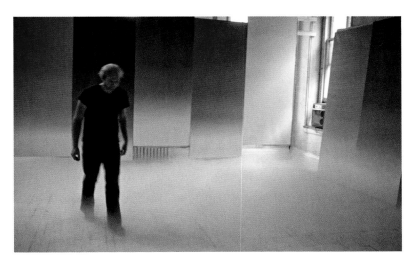
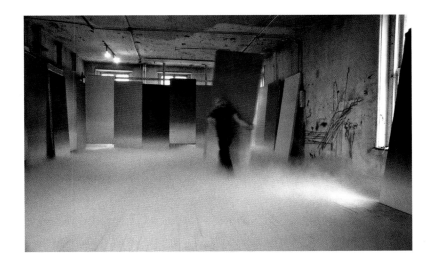
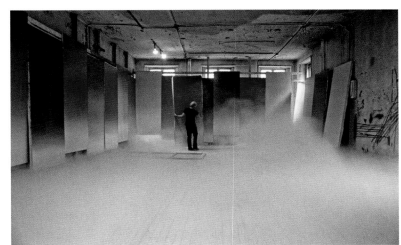

The Peripheral Present:
James Rosenquist's Rooms, ca. 1970

Tom Holert

1. The painter Gerhard Richter was there, as were the performance artist Robert Watts, the collectors Peter Ludwig and Wolfgang Hahn, the art historian Evelyn Weiss, and the curator Rainer Budde of the Wallraf-Richartz-Museum. Nor were they alone, for Cologne's art scene was out in full force when, on Friday, November 13, 1970, Rolf Ricke opened two exhibitions simultaneously at his gallery on Lindenstrasse in Cologne: one on the ground floor by Jo Baer, the other on the fifth floor by James Rosenquist. Ricke was honoring a promise to follow up his exhibition of drawings by contemporary American artists held in the summer of that year with some solo shows. While it was Baer's second appearance there since her 1969 premiere, for Rosenquist it was a first—and as it happened would be his only show at Ricke's.[1]

Slush Thrust, the work with which Rosenquist filled the fifth-floor room assigned to him, was a color-field, metallized-film environment swathed in dry-ice fog. Created in 1970, it belongs to a phase in the artist's career that has received but little attention to date, namely the years 1966 to 1970, when Rosenquist was trying to broaden a repertoire that had hitherto fallen firmly under the heading of "Pop art." To do this, he began experimenting with the sensory perception of space, color, and immersion, invested in the investigation of a range of extreme mental and physical states, and in addition, became preoccupied with the potential of film as a medium.

Some of the projects that he embarked on during this phase ultimately remained unfinished or were never realized at all, but what has survived from this period shows Rosenquist veering away from the formulae that had won him international acclaim as a painter since his first solo exhibition at Richard Bellamy's Green Gallery in 1962. So it was a high-risk new departure, especially since it entailed confounding what audiences, gallerists, and collectors had come to expect of him. Not only was his art indicative of great technical virtuosity and the courage needed to attempt monumental formats, but it was also unmistakably his own, executed in his own signature style.

That Rosenquist was answering the desire for a contemporary iconography and modern-day equivalent of history painting, while at the same time challenging the modern exhibition space with its physical and perceptual determinants and institutional functions was apparent as early as 1964–65 from his twenty-six-meter-long *F-111*. Yet not until the late 1960s, and even more so the start of the new decade, did his project to remodel and reprogram the white cube culminate in those painted installations in which he adapted the artistic genre of the environment (or "room," as Rosenquist himself preferred to call it) for his own purposes. The first of these new works was *Horse Blinders* of 1968–69, followed by *Flamingo Capsule, Area Code, Horizon Home Sweet Home*, and *Slush Thrust,* all of 1970. Largest of all was the piece *47 Dirty Band-Aids*, which despite being installed in the sculpture yard of the Whitney Museum in New York for the 1972 retrospective has unfortunately remained largely undocumented.[2]

A serious car crash in February 1971 unfortunately brought this very promising phase of reorientation to an abrupt end. Rosenquist himself suffered only three broken ribs, whereas his wife, Mary Lou, and their son, John, were much more seriously injured, and after several weeks in a coma had to endure the arduous process of regaining their powers of speech. Plunged into a crisis, Rosenquist for several months was unable to work at all and battled with depression for the remainder of the decade.[3] Only when he began collaborating with Donald Saff of the University of South Florida graphic studio in Tampa and became involved in the preparation and installation of his upcoming retrospectives at the Wallraf-Richartz-Museum in Cologne (the works were actually exhibited at the Kunsthalle) and the Whitney Museum of American Art in New York in the first half of 1972 was he once again able to concentrate on his art.

But he still lacked the energy needed to go ahead with a plan discussed in a letter to Ricke written after the exhibition of *Slush Thrust* and shortly before the accident. The subject was an exhibition to be held at Ricke's gallery just a few months in advance of the Cologne retrospective, the dates for which had by then been fixed: "It could be a large room of hanging aluminum foil and neon shaped at the ceiling, a fantastic light work, solid environment. The show would [be] comprised of very small pieces which you could sell instead of one huge piece. I also have ideas. I'm very busy now here."[4] Rosenquist was in fact revisiting an idea that he had had a few years previously when working together with the experimental filmmaker Stan VanDerBeek (of whom we shall have more to say later on). This letter to Ricke tells us just how hard Rosenquist was then working on opening up his painting and making it more fluid, and how he wanted the gallery "room" that he was planning to be understood as both a "fantastic light work" and a "solid environment." Aware of his gallerist's commercial interests, however, he also took care to conceive his exhibition—as he had done with previous shows—as a temporary, modular whole whose parts could be sold individually at any time.[5] The dogma of the integrity of the work, in other words, was to be dropped in favor of the targeted marketing of its constituent parts, giving rise to a scattered collective of the owners and viewers of the said fragments. The utopia that Rosenquist was positing was at once both aesthetic and political, since his "form of the future" promised to make aesthetic experience available to all social classes in a way that conventionally circulated art did not.[6]

Some of the themes and problems that Rosenquist addressed in environments like *Slush Thrust* created between 1968 and 1972 will be discussed in their larger context in what follows. His eschewal of visual motifs, at least during certain phases, in favor of spaces whose true object was their capacity to provide a phenomenological experience inevitably raises the question of what might have motivated this "voiding." What was it that led the artist to drop, if only temporarily, the very same content and methods that had first brought him to the public's notice in 1962? His notorious impatience and craving for variety, or what Peter Schjeldahl of the *New York Times* called the "obstinately personal, subjective character of Rosenquist's inspiration,"[7] is scarcely explanation enough for his performative and phenomenological work in the field of modern exhibition art. The roots of his inquiry are deeper and more far-reaching than that. Investigating them, moreover, reveals not only how Rosenquist's praxis should be regarded as very much of a piece with the many political and artistic movements springing up around 1970, but also the extent to which it left a very unusual trail in the history of post-1945 art.

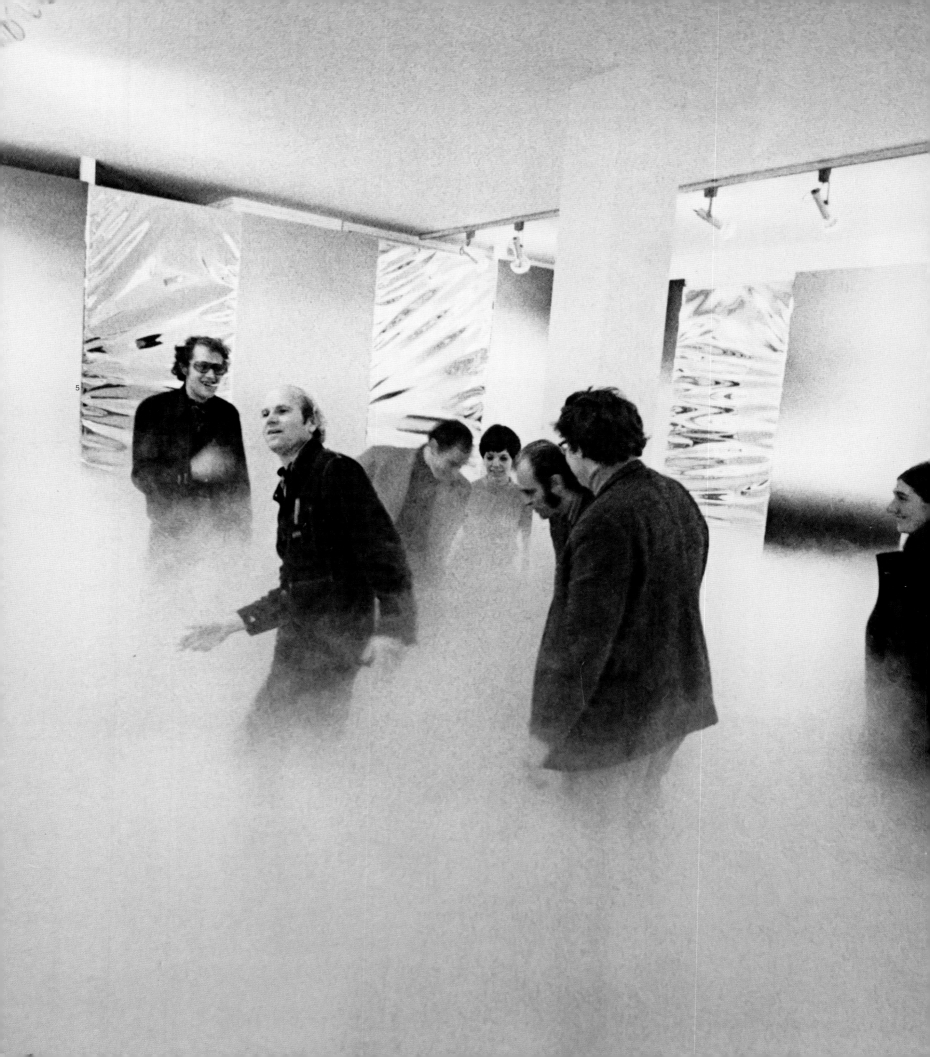

186

185 Previous page: *James Rosenquist: Slush Thrust* exhibition, Galerie Rolf Ricke, Cologne, 1970
Photo: Wolf P. Prange

186 Early configuration of *Horizon Home Sweet Home*, 1970, Wooster Street loft space owned by Richard Feigen, New York, ca. 1970

187 Rosenquist with *Slush Thrust*, 1970, East Hampton, New York, studio ca. 1970

188 *Flamingo Capsule*, 1970
Oil on canvas, with aluminized Mylar
9 ft. 6 3/16 in. × 22 ft. 11 15/16 in.; two Mylar end panels, 9 ft. 6 3/16 in. × 3 ft. each (fixed at a right angle to the painting) (290 × 700.9 cm; two Mylar end panels, 290 × 91.4 cm each [fixed at a right angle to the painting])
Guggenheim Museum Bilbao

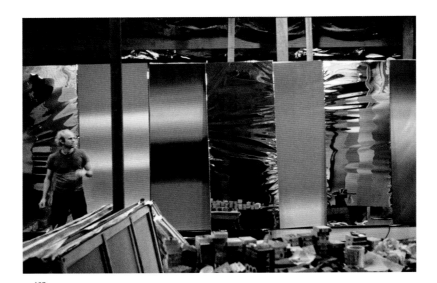

187

188

2. Perhaps it was merely chance, which so often plays a role in exhibition scheduling. But the shows that opened simultaneously at Rolf Ricke's gallery on November 13, 1970, can certainly be rated an exceptionally successful, potentially productive, indeed complementary, combination. The works exhibited by the minimalist painter Jo Baer, who together with fellow artists Brice Marden, Robert Mangold, and Robert Ryman had spent the 1960s reflecting on the painting as object, took the form of white canvases projecting into space, some framed inside a band of black (with or without a thin strip of color or silver inside it), others sandwiched between a band of black along the shorter sides only. While a few of these corpuses were legible as "figures," many required viewers to move around them in order to "inspect" their edges. "Because these paintings are not perceived as static objects, they engage the viewer in a dialogue, making the viewing of them a participatory experience involving discovery," wrote Barbara Haskell in a 1975 essay on the interactive impact of Baer's anti-illusionist, ostensibly self-referential works of the 1960s and early 1970s.[8]

Scarcely anyone would have imagined there to be common ground in the works of Baer and Rosenquist. Here the rather brittle explorer of images and perception, there the experienced billboard painter and cofounder of American Pop art—surely they were poles apart in the world of contemporary art around 1970? As was to be expected, one reviewer did note the "sharp contrast between an exuberant delight in color and bald purism."[9] Yet it is in this same "sharp contrast"—and in the methodological mobilization of the viewer—that the overlaps in the two artists' theoretical preoccupation with edges and peripheries (whether of the painting as object or of the field of vision) are to be found. At the time, both Baer and Rosenquist were working on very different aspects of painting in an attempt to overcome and consolidate it. Despite using radically different means, both were engaged in a critique of the medium from a position of supreme confidence in its potential and relevance. Where they intersect is in their shared interest in outer limits, both of paintings and of perception, about which I shall have more to say toward the end of this essay.

Rosenquist's contribution to the exhibition at Ricke's gallery was so conspicuously at odds with what others had expected of his art that *Slush Thrust* sparked an internecine quarrel. Hans-Jürgen Müller, who ran one of the seven galleries housed in the same building on Lindenstrasse,[10] was so appalled that he proposed that they be allowed to post critiques of each others' exhibitions in their jointly published magazine.[11] The artist famed for his painted Pop-art collages of interlocking or adjoining set pieces from commercial visual culture and modern media communications had installed an imageless environment that not only left the viewer with nothing to latch onto, but on the contrary demanded to be experienced as an aesthetic whole, independent of any iconographic or formal points of reference.

The exhibition at Ricke's gallery opened the day before the final day of a show at Leo Castelli's gallery on New York's Upper East Side. There, two room-length murals, *Flamingo Capsule* and *Area Code*, both of which were "fresh off the press," as it were, and made use of the same metallized polyester film as *Slush Thrust*, were installed on opposite sides of the same gallery. *Slush Thrust,* for which Rosenquist covered the walls of the rectangular, fifty-square-meter gallery space on the fifth floor of Ricke's gallery in Cologne with portrait-format canvases, was in its turn a variation of *Horizon Home Sweet Home*, a work produced earlier in 1970 that had gone on show at Castelli's from May 16 to June 6 (providing yet further proof of the readiness of Rosenquist's gallerists

to support the artist's new "rooms"). Assisted by his team at his New York studio, the artist had painted the vertical panels with horizontal—mainly pastel, but in a few cases quite garish—color runs, daubed on with a broad brush, the idea being to create "a series of slices of sky horizons, atmospheric horizons."[12] Eighteen of these two-meter-high panels were then shunted together and screwed in place at varying heights.

This generated an up-and-down rhythm that was further syncopated by seven (or eight)[13] stretchers loosely spanned with crumpled polyester film and inserted at varying intervals between the panels. The polyester reflected warped mirror images of both the painted panels and visitors, effectively thwarting any impression of duplication that might otherwise have arisen. Rosenquist himself referred to his work as a "funhouse,"[14] which like a cabinet of distorting mirrors—as reminiscent of Andy Warhol's aluminum-foil-clad Factory as it was of the environment *Infinity Mirror Room—Phalli's Field* by Yayoi Kusama, first exhibited in 1965, or the mirror images that Michelangelo Pistoletto produced from the early 1960s—manipulated viewers' ability to navigate space and so forced them to reconsider their perception both of the work and of their own bodies.

3. The weekly news magazine *Der Spiegel* went into raptures over what it called "the most original artist's environment in a long time." The anonymous author of the piece[15] was especially taken with another special effect added to amplify the impact of the warped reflections, namely the dry-ice fog which for a period of twenty minutes every evening transformed the exhibition into a memorable aesthetic experience. Those able to wade through the clouds described the environment as an "immaterial space" that conjured up associations with "space travel."[16]

While the Apollo 11 (on July 16, 1969) and Apollo 12 (on November 19, 1969) moon landings, to say nothing of the ill-fated Apollo 13 mission of April 1970, had perhaps stripped space travel of much of its power to spark flights of fancy, it was still very much in the public consciousness at the start of the new decade; and whether it was viewed critically or as the stuff of utopias, it was definitely central to all imaginings of the future. Rosenquist wanted his *Slush Thrust* to give audiences a somatic experience of weightlessness and the absence of physical barriers that would recall the suspension of gravity in space. Ever since *Horizon Home Sweet Home*, a "room" that he had been working on since 1969 and that like *Slush Thrust* was filled with dry-ice fog, Rosenquist had become increasingly preoccupied with the question of how he might evoke a "feeling of dematerialization" in his viewers; to his mind, therefore, the project was inextricably bound up with the image of astronauts in space "looking in their monitors trying to find their way home."[17]

The artist, moreover, had just discovered BoPET (biaxially oriented polyethylene terephthalate), an extremely lightweight, tough, and tear-proof polyester film that could be laminated and metallized for enhanced temperature stability and gas impermeability. These properties are what brought it to the attention of NASA, which began using Mylar—the name under which the American chemicals giant DuPont patented it—as a material for its satellite balloons and space suits. When Rosenquist wrote to Ricke about the black plastic film in *Flamingo Capsule* in January 1970, he explained that NASA used it as packaging for the capsule whose purpose was to bind astronauts' food to prevent it

dispersing through the spacecraft. He also reported that he had at last received the chromium-coated Mylar from California that he needed "to put this room together."[18]

The six-part wall installation *Flamingo Capsule* features two Mylar-covered panels, which because they jut out at right angles at left and right reflect the painted pictorial space, while at the same time "enveloping" the viewer in front of (or rather inside) it. The reflections and highlights in *Flamingo Capsule* come not just from the Mylar, however; they are also painted on: first in the image of the aforementioned shiny black capsule containing astronaut food, and second in the painted fragment of crumpled Mylar with an American flag worked into it positioned in the middle of the composition.

The fascination of NASA's coolly technical, materially and visually potent space program is conveyed by more than just appearances; feelings of weightlessness, disorientation, and dizziness are also evoked—somatic effects, for which Rosenquist arranged his painted and Mylar-covered panels so that they would create an impression of "floating in space."[19] In the case of *Slush Thrust*, the sense of weightlessness was to have been enhanced by a verticalized impression of space, produced by opening the room to the sky (which could not be done in Cologne), while at the same time making the floor disappear under a cloud of dry ice fog. Rosenquist described how our own body awareness, what the British neuropsychologist and histologist Charles Scott Sherrington called proprioception, is thrown seriously off course by the fog obscuring the floor. The fog alone, in other words, afforded scope for experiments with the viewers' own visibility and corporeality inside the exhibition space: "The floor was eliminated and made opaque by fog so the floor could be as shallow or as deep as you felt like it When I was in it my arches felt like they were falling but my knees felt soft, like—Geez—I can't see my knees. And people could lie down and not be seen."[20]

A few years earlier, media theorist Marshall McLuhan—whom Rosenquist met several times and quoted in interviews from time to time—had hypothesized that the astronauts venturing into space lacked the images and concepts needed to make sense of their experience of space. Artists, he argued, could fill this gap by "defining new dimensions of experience that have no rapport whatever with the previous spaces or modalities of sense perception."[21] Speculative art of this kind, wrote McLuhan, whose wording here recalls that of Gertrude Stein, could lead the artist "to make a space to meet the spaces that he will meet."[22]

Whether McLuhan came to regard Rosenquist as one of the architects of this future understanding of space we shall probably never know; but the artist's implicit demand that the protocol of the white cube be ignored and that viewers be able to literally immerse themselves in one of his "rooms" does raise the question of where painting is headed. For the critic Kenneth Baker, Rosenquist's walk-in "rooms" not only probed "what sort of reality paintings have for us now," but were also inextricably bound up with the "situation of the viewer within the painting" as "the most literal way of forcing the question of how someone who takes this as a painting ought to take himself."[23]

Rosenquist's endgame of painting, his attempt to augment the panel painting still further by incorporating it into the neo-avant-garde format of the environment, picked up where various other spatial painting traditions—from the room-filling fresco programs of the Renaissance to the painted spaces of Modernism starting with El Lissitzky's *Kabinett*

der Abstrakten (Abstract Cabinet, 1926)—had left off. But if by doing so he added a new chapter to painting discourse, it came at a time when this same discourse, faced with contemporary art's conceptual, processual, and performative tendencies, had all but ground to a halt.

So what might be the role of the fog in *Slush Thrust* in such an experimental investigation of painting's possibilities? The machine that Ricke started up every evening used water to heat up solidified carbon dioxide, commonly known as dry ice. In the world of special effects, the low-lying fog thus generated counts as exceptionally thick and white, which is why Rosenquist preferred it over conventional fog machines. As everyone involved was aware, dry-ice fog is an unusual medium—at least for an art gallery. While some of those who visited Ricke's gallery in 1970 might previously have encountered something similar at pop concerts or discos, on the stage, or on screen, the fog that covered the floor in *Slush Thrust* and that aroused sensations of weightlessness or even blindness in many of those who experienced it was undoubtedly an extravagance for an art gallery.

Dry ice was first used in an art context in Judy Chicago's *Disappearing Environments* of 1967, for which the artist, working together with Eric Orr and Lloyd Hamrol, installed a sculpture consisting of nine pyramidal stacks and one row of blocks of white dry ice with integrated lamps in a newly opened shopping mall in Los Angeles. As these sublimated, so the surrounding space became bathed in fog and light, even as the associations with Mesopotamian or Pre-Columbian ziggurats and pyramids lent the architectonic but ephemeral structures an archaic feel. Considered in the larger spatial context of the shopping mall, they could—and indeed should—be read as symbols of transience and mortality.[24]

Chicago's dry-ice environments count among those of her long-term performances that generated and then explored specific "atmospheres." If it makes sense to see her preoccupation with elusive moods and states as similar in thrust and intent to Allan Kaprow's *Fluids* happening, then not just because Chicago herself referenced Kaprow directly. On three consecutive days in October 1967, Kaprow and a group of volunteers erected some twenty architectural structures made of blocks of ice in Los Angeles: all of them self-contained cubes without either doors or roofs, which were left to melt away under California's blazing sun.[25] The happenings were as coordinated as they were clandestine and left all those who saw them wondering who had built these solid-but-soon-to-be-fluid edifices, and above all, why.[26] Kaprow understood the specifically temporary and materially liminal quality of his iceworks in part as a critique of the planned obsolescence in contemporary urban planning: "*Fluids,*" he explained in an interview, "is in a state of continuous fluidity and there's literally nothing left but a puddle of water—and that evaporates. If you want to pursue the metaphor further, it is a comment on urban planning and planned obsolescence."[27] While it is rare for Rosenquist to be associated with this kind of artistic, curatorial attention to what Lucy Lippard and John Chandler, in an article published in early 1968, sought to define as the "dematerialization of art,"[28] it was precisely this same ephemeral quality—of *Slush Thrust* and *Horizon Home Sweet Home*—that was at the heart of his long-term project to dematerialize and spatialize art and to transform painting into different aggregate states: "It was an extension of my concept of dissolving the painting as an object, immersing the viewer in the painting, and making it an environment—color as a state of mind."[29]

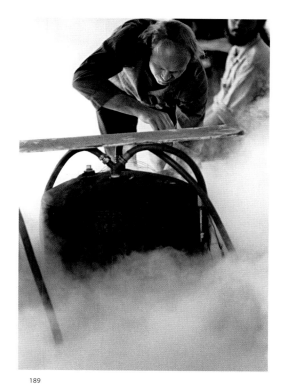

189

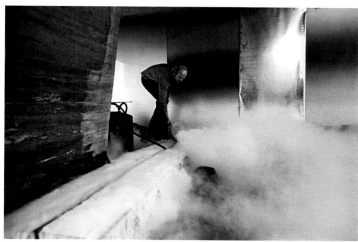

189
–190 James Rosenquist working on the *Horizon Home Sweet Home* fog-machine apparatus for the installation in the retrospective exhibition *James Rosenquist* at the Whitney Museum of American Art, New York, 1972

191
–192 Judy Chicago, *Dry Ice Environment*, installed at Century City Mall, Los Angeles, 1967

190

191

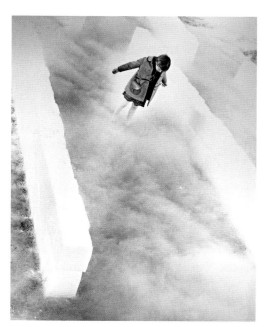

192

185

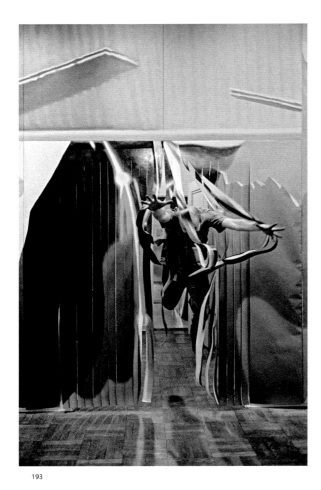

193

193 James Rosenquist jumping through the Mylar strips of *Wind Row*, 1966. The visitiors had to walk through the installation in order to get inside the gallery of Leo Castelli.

194 James Rosenquist working on *Sliced Bologna* in his Broome Street studio, New York, 1966

195 Allan Kaprow, *Yard*, 1961, *Environments, Situations, Spaces*, Sculpture Garden at Martha Jackson Gallery, New York

194

195

4. To prevent any misunderstanding: Rosenquist was not interested in a technological broadening of painting for its own sake, nor was he a conceptualist striving to overcome material reality in pursuit of some Hegelian notion of ideal art. What he called "dissolving the painting as an object" for the most part entailed mobilizing viewers, whether through painterly experiments (that is to say, experiments with painting) or through the subtle reconfiguration of the sensory register determining our perception of images and space. The immersive experiences he offered sometimes took the form of the multimedia activation of the white cube and the multisensory choreography of the viewer's own body, of "Images, reflections, color streaks, wavering patterns, sounds form a syncopated sequence," as Elena and Nicolas Calas wrote of *Horse Blinders* in 1969, noting how "shifts and interruptions act like blinders to force the spectator to a repeated change of vantage point, from frontal to diagonal, back to frontal."[30]

The hanging works that from 1966 onward Rosenquist created out of transparent Mylar, painted and cut into strips, also mobilized the sense of sight, even if they are very different from the "rooms" based on exhibition spaces, like *Horse Blinders* and *Slush Thrust.* These Mylar "curtains"—of which *Forest Ranger* of 1967 and *Sliced Bologna* of 1968 are especially fine examples—first went on show at the *Campo Vitale: Mostra internazionale d'arte contemporanea* exhibition at Palazzo Grassi (in those days the seat of the Centro Internazionale delle Arti e del Costume) in Venice between July and October 1967, followed by the Galerie Ileana Sonnabend in Paris, and the Galleria Gian Enzo Sperone in Turin in November 1968.[31]

The strips of Mylar in *Forest Ranger*, which begin to flutter at the slightest hint of a breeze, are painted with a type M706 armored car, which the U.S. Army made extensive use of in Vietnam. Rosenquist transferred his full-size image of this war machine to polyester film and then had it "sawn" in half by an over life-size handsaw. Despite the unambiguously antiwar message of the work, which puts it in the same category as *F-111*, Rosenquist's contribution to the debate of America's military-industrial complex that preceded it, there are still grounds for doubting the seriousness of the installation. Surely such a heavyweight theme would have warranted rather less breezy treatment? And might not his transfer of a panel painting into space actually undercut any serious engagement with the issues raised? Besides, just how menacing can an M706 painted pale pink and baby blue really be?

Rosenquist himself certainly had doubts at the time of its creation; the images painted onto the Mylar, he said, had taken him to the "limits of set design."[32] Yet he was also confident that stripping the monumental history painting of its weightiness would bring about a change in viewers' behavior. After all, the curtain format invites viewers to explore and probe in a way that resets the relationship between image and space. "What I hoped for was that when people came into the gallery that they would see these configurations and they would think that they had to take a certain path through the room, but actually they could walk directly through the images."[33] Rosenquist, in other words, had prized open pictorial space and by peeling the painting off the wall, which in his book *Experimental Painting* of 1970 Stephen Bann described as "a considered reaction to the final impossibility of representation: to the simultaneous requirement of presence and absence in the pictorial work of art,"[34] had allowed it to be reorganized.

The invitation to experience the Mylar works by physically moving in and out of them, articulated in their representationally reflective ambiguity

of presence and absence, was apparently accepted. The curator André Vigeant, for example, in 1968 spoke enthusiastically of the kinetic plasticity of the curtain paintings, whose structure viewers could "penetrate" in order to become "an additional, aleatory element bringing the work to life."[35] The critic Tommaso Trini described the experience as "oceanic": any intellectual reflection on the Mylar curtains had to be preceded by an actual encounter with them, he wrote, and hence by an experience of such physical immediacy that viewers were liable to be left all at sea. Rosenquist had prepared a reality that above all else cried out to be transgressed, and by doing so he had taken the overlapping and interpenetration of the imaginary and the real, of art and life, to a new extreme.[36]

A photograph by Eric Pollitzer of Rosenquist's studio on Broome Street, presumably taken in 1967,[37] shows the bare-chested artist working on *Forest Ranger* and *Sliced Bologna* at a stage in the production process when the Mylar had not yet been cut into strips. The angle and frame of the photograph convey very vividly what it means to become an "element" of an installation, how the interaction between of art and artist/viewer might look, and how the "animation" of such a work might go hand in hand with a reordering of the senses responsible for the aesthetic reception of the piece.

Rosenquist is shown standing between the sheets of Mylar hanging from the ceiling, which on the photograph appear to collide and overlap to such an extent that *Forest Ranger* and *Sliced Bologna* can no more be told apart from each other than they can from the body of the artist working on them. "Moving through them," wrote Marcia Tucker in the catalogue of the artist's 1972 New York retrospective of the inversion of perception that takes place in these works, "involves the sense of touch ... Touching *Forest Ranger*, however, prevents us from seeing it. The tactile sense, which helps us to perceive detail and distance in relation to ourselves, and the visual sense, which helps us to perceive detail and distance in relation to other objects, are reversed. We must alternate constantly, then, between the ways of perceiving in order to experience the piece."[38]

Rosenquist's redefinition of the relationship between the spatiality, materiality, representation, and function of a work of art as an aesthetic experience prompts further reflection on how he links sight and touch. In fact, it is this same reflection on the relationship between perception and experience that actually constitutes our aesthetic experience. The muddling of the senses amid the strips of Mylar in *Forest Ranger* et al. sparks questions as to these three-dimensional works' function and impact. Rosenquist himself later recalled being inspired by "the idea that one could walk through a wall, could walk through solid substances," and his fascination with holograms was born of the same train of thought.[39]

But such painterly investigations of pictorial space and of the virtuality of representation also bring with them the aforementioned risk of being perceived as mere décor. Painting may enter space, but only by means that raise doubts as to its authority. What becomes of painting when it dispenses with canvas and stretchers as a support? What becomes of it if viewers can simply walk through it or wrap themselves in it? And what is the purpose of fluidizing and spatializing more or less recognizable motifs and themes as part of this process? The physical obstacle presented by a painting or sculpture may be removed and replaced by a movable "grove" of images, but the problem of representation remains unsolved—not least, we might surmise, because

Rosenquist never had any intention of submitting to the late avant-garde pressure to negate all pictoriality, relationality, and theatricality exerted by the dominant strain of 1960s critical discourse.

On the other hand, the Mylar curtains, like the rooms that came later, very obviously belong to the tradition of the environment, a genre which, although relatively new, by 1966–67 was already providing a wealth of material for further discussion, and which did much to escalate the crisis in the modernist debate of the self-referential panel painting. The concept of the "environment," whether in the sense of an enveloping space or a specific aesthetic praxis, was circulating in art discourse even as early as 1961, the year of the canonical show *Environments, Situations, Spaces* (with works by Allan Kaprow, George Brecht, Jim Dine, Walter Gaudnick, Claes Oldenburg, and Robert Whitman) at the Martha Jackson Gallery in New York. The epithet "environmental," moreover, was being used to describe experiences that activated the human senses in an ever more all-inclusive way, but that at the same time involved the interaction of animate beings with their habitat.[40]

Rosenquist's spatial experiments clearly belong in this larger context. They evince important points in common as well as differences with the environment concepts that in those days were setting the trend. Allan Kaprow, who from the late 1950s onward dominated the development of the genre and the discourse generated by it, had a very concise definition of it at the ready: "An Environment is a large assemblage, usually to be physically entered, like a forest or a junk-yard. Those entering an Environment may be encouraged to move its material about, thus changing its composition. As more moves are encouraged, the Environment becomes a Happening. Normally, such an Environment is thrown away after a time and its materials may be perishable, like flowers or food."[41] This triad of concepts, "assemblage," "environment," and "happening," supplied the title of a compendium edited by Kaprow and eventually published—after numerous delays—in 1966. There, following a line of argument whose indebtedness to Marcel Duchamp and John Cage is impossible to overlook, and at a time when many critics believed the concept had had its day,[42] he made the case for the environment's ephemeral qualities, its reliance on throwaway materials and props, its transience as "a semi-intangible entity,"[43] and the close ties it implied between change and chance.

The boundaries separating the assemblage, the environment, and the happening are fluid ones, according to Kaprow. What he also puts up for negotiation, however, is the artist's authorship, and with it the studio, the gallery, and the museum as institutions. "With such a form as the Environment it is patently absurd to conceive it in a studio and then try to fit it into an exhibition hall. And it is even more absurd to think that since the work looks better in the studio because it was conceived there, that it is the best and only place for it. The romance of the atelier, like that of the gallery and museum, will probably disappear in time. But meanwhile, the rest of the world has become endlessly available."[44]

It is here, at the latest, that the differences between the definitions underlying Kaprow's project to flout the conventions and ontologies of art and those informing Rosenquist's experimental broadening of painting as a genre in the direction of the environment are most glaringly apparent. Rosenquist never touched the art world's institutional parameters; his environments were installed in existing, established gallery spaces; the "romance of the atelier" was left unsullied. And even if he had subscribed to the view that "environmental work" implies challenging the notion of art as a commodity and actually enables

"other relationships between art, people, and the artist" that allow it to be viewed almost as "social engineering," as British artist Stuart Brisley put it in 1969,[45] he was still loath to cast his own work as a form of activism in a larger social context, despite being politically engaged.

This explains why not even the studio as the place where art physically and materially comes into being was called into question by his work. After all, it was in the studio that the elements that would later be installed in the gallery or the museum were actually made. Yet the physical, psychological, and perceptual aspects of the work of creating art, like the impact of the end result, were still a matter of concern for Rosenquist—in production as in reception. His phenomenological and psychological interest in corporeality, spatiality, perception, and emotional engagement is reflected in the way he at least allowed his physical presence and work in the studio and in the exhibition space to be recorded in the form of photographs throughout his career, even if he did not actively encourage it.

Showing how the bodies of both artist and viewer behave in relation to an emerging or finished work of art is very much part of the tradition of studio photography as developed by Martha Holmes, Hans Namuth, Tony Vaccaro, and others with Jackson Pollock in the 1940s and 1950s, and as used as a vehicle for self-validation and self-marketing by artists of the 1960s and 1970s. The presence of a photographer, which had the effect of turning the painter's studio into a photographer's studio, seemed not to bother Rosenquist; on the contrary: The work of photographers such as Gianfranco Gorgoni, Ugo Mulas, Claude Picasso, (and again Hans Namuth) throughout the 1960s led to the image of the artist at work in his studio, surrounded by huge canvases and with his source materials strewn carelessly all over the floor, being widely circulated and hence firmly cemented in the public consciousness.

5. *Slush Thrust* is to a large extent a studio piece, even though it was ultimately realized in a gallery. The title alone establishes the connection by highlighting the craftsmanship aspect of the work's creation. Billboard painters, which is what Rosenquist himself was until the early 1960s, use the word "slush" for the brownish, purplish dregs that collect in the bottom of the paint tub.[46] A "slush thrust," or so we could infer, is the action by which these residues of painterly activity are put to good use—by being slapped onto canvases lined up along the walls of a gallery, for example.

The onomatopoeic title is powerfully suggestive of the dynamism of such a gesture and forges a link between Rosenquist's environments and his proto-artistic past as a producer of commercial art on a monumental scale. In the first of his interviews with the critic Gene Swenson in 1964 he lent graphic expression to his disquiet at contemporary America and the oppressive ubiquity of the media and commercially produced visuals, significantly making use of the verb "thrust": "I'm amazed and excited and fascinated about the way things are thrust at us, the way this invisible screen that's a couple of feet in front of our mind and our senses is attacked by radio and television and visual communications, through things larger than life, the impact of things thrown at us, at such a speed and such a force that painting and the attitudes toward painting and communication through doing a painting now seem very old-fashioned."[47]

His aim, presumably, was to harness the onslaught of industrially produced images battering down our defenses—the "invisible screen"

that Rosenquist imagines as a kind of aura surrounding the body—and to channel them into "rooms" like *Slush Thrust* instead; which of course, have premises all their own, even if in pursuit of a very different phenomenological experience. Rosenquist's "rooms" thus became alternative spaces with which to counteract the "space that's put on me by radio commercials, television commercials,"[48] and this made them what Marshall McLuhan called a "counter-environment." In a lecture to Vision 65, the World Congress on New Challenges to Human Communication held at the Southern Illinois University in Carbondale in February 1965, McLuhan argued that since the new electronic media were creating an "invisible environment," art's explicatory, educative role—especially that of Pop art—was now more important than ever. After all, by incorporating the programmed environment of technical communications, art had acquired the capacity to produce "anti-environments or counter-environments" with which the rather more dubious effects of an otherwise quasi-natural, and hence barely perceptible, technical environment (vulgarity, brainwashing, passivity) might be exposed for what they are.[49] For all the sensory overkill that Rosenquist inflicts on his recipients, his environments remain "safe spaces" in which viewers, being relatively well protected from the "thrust" of the media-saturated environment they normally inhabit, can learn, becoming more self-aware, and acquiring a heightened awareness of others in the process. At least up to a point, therefore, these works are educative, learning environments through which we become better able to master and even overcome the capitalist world in which we live.

It is thus only logical that Rosenquist wanted *Slush Thrust* to be understood as a political appeal. The German weekly *Spiegel* paraphrased his message as follows: after two moon landings, American society should "commit the same kind of energy to solving the most pressing problems of everyday life—such as putting an end to the pollution of the environment, racial discrimination, and widespread poverty."[50] In an interview with the *Kölner Stadtanzeiger*, Rosenquist explained how even a work of art with no obvious message or theme might still articulate critique of the squandering of resources, social polarization, and economic inequality. It did so, he said, by providing an ethical-aesthetic intervention at the level of perception: "My room *Slush Thrust* that we are standing in now reminds us to rein in our arrogance. This is the purpose of the intensive impression of color from all sides, of a room that seems to be open on all sides, and of the duplication, mirroring, and color effects of all kinds, all of which have a humbling, chastening effect on us, which is exactly how we should feel if we are to leave the earth in peace rather than plundering what little there is left of it."[51]

According to Rosenquist, the room's openness, its non-linearity, and its built-in feedback would effect a change by touching the emotions of all who entered it, and if possible influencing their behavior thereafter. *Slush Thrust* thus becomes a moral institution, a form of theater or school in which the spectator becomes a spectator of the self and so arrives at new insights. Rosenquist's art ultimately aims to elicit a complex, cathartic sensation of numbness as viewers are engulfed by his tidal wave of colors and images, conveyed to them with almost corporeal immediacy. The word that Rosenquist himself used for this feeling—which has less to do with the aesthetic category of the sublime than with a kind of euphoric exhaustion—was "exhilaration." He was reminded, he said, of his time as a billboard painter in the 1950s and the "numbness that I felt when being immersed in painting large imagery"; when, perched on a scaffold at a dizzying height, he not only lost his bearings but had the Kafkaesque experience of being swallowed up by the monumental images he was painting, since "being reduced to the

size of a fly on a piece of paper does things."[52] The flipside of the aforementioned "exhilaration" was the sense of utter devastation, which is something that Rosenquist likewise felt impelled to share; hence his creation of works that would give people a similarly anaesthetizing experience of vertigo. The iconographic elements, that is to say the images themselves, served him merely as a crutch—as motifs that would drain away into pure color, pure sensation. The goal was not just to negate but actually to eradicate: "no image, nothing image."[53]

6. Rosenquist occasionally spoke of his environments as "fog drawings,"[54] thus ennobling fog to the status of an artistic medium. In a 1972 interview he described the fog in *Slush Thrust* as "white drawing" that evoked unusual sensations and physical states.[55] While Rosenquist did not elaborate on the term "white drawing," we can infer from the associations with the telecommunications concept of "white noise" that he was referring to the entropic dimension of dry-ice fog. After all, cybernetics and information theory were both hot topics among artists, critics, and curators at the time, especially in New York.[56]

Another artist who at the time was pushing the boundaries of semantic, semiotic, and sensory overload, and aesthetic norms was Les Levine, who in the late 1960s was working on the experimental development of the environment format as part of his endeavor to activate the media and communications environment, the aim being to enable people "to involve themselves in a moving environment."[57] His *White Sight* environment was first installed at an exhibition at the Fischbach Gallery in New York in January 1969, and made a second appearance at a charity ball at the Museum of Modern Art later that same year. It featured two, high-intensity, sodium-vapor lamps, whose monochrome light, combined with metallized Mylar, generated a bright yellow atmosphere in which most other colors looked gray and shadows were no longer discernible.

Talking about *White Sight* in 1969, Levine described it as a "totally open system,"[58] while Brian O'Doherty, writing a few years later in *Inside the White Cube,* noted how the visitor entering Levine's environment was forced first to reconstruct the room: "Other viewers became visual cues, points of reference from which to read the space. The audience thus became an artifact. Without sight, turned back on itself, attempted to develop its own content.... So to return to the white space: The twin contexts of anticipation—the gallery and the spectator's mind are fused in a single system, which could be tripped."[59]

The totalization of space enabled on the one hand by the experience of immersion, which is what Levine was aiming for, and on the other by the quasi-systemic fusion of the twin determinants of the Modernist aesthetic experience ("the gallery and the spectator's mind"), which is what O'Doherty argued in his speech, echoes what Rosenquist told the *Kölner Stadtanzeiger* about the motivation behind *Slush Thrust:* "What I really intended with my 'room' was that here people would face each other, the dividing lines would blur, and they would intermingle. And all of that before a colored horizon. If people were going to linger here, then it would have to be like on a film set, where everyone is nice to each other and ready to help."[60]

The importance that Rosenquist here attaches to the social impact of his color and fog environment is surely significant. Underlying his words is the yearning for different forms of encounter, for a different quality of interaction. And an environment in which there are no themes or motifs

196 Les Levine, *White Sight*, 1969

197 James Rosenquist filming inside the installation
–198 *Horizon Home Sweet Home*, 1970

199 Film clips of *Horizon Home Sweet Home*, 1970

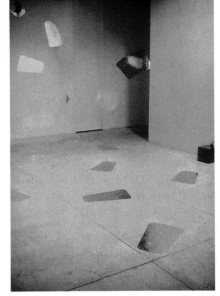

196

197

198

199

that might impair our receptiveness to sensory signals—both those of the colors and those of the other visitors present—is bound to engender a new form of intersubjectivity in which the "I" is subsumed in the collective.

The critic Lawrence Alloway conveyed a similar impression of the sociopsychedelic function of *Horizon Home Sweet Home, Slush Thrust*, and other rooms like them, when, in 1972, he wrote: "This is closer to leisure architecture and science fiction tripping than it is to abstract art."[61] Rosenquist's contemporaries were certainly in no doubt that his "glamorous"—to use Alloway's word—rooms installed in galleries or museums rested on the mentally and physically disorienting, high-tech environments that the entertainment industry had been developing and operating in major urban centers throughout the 1960s, whether as immersive, multimedia spectacles, as stage sets for rock concerts, or as discotheques. The critic Peter Schjeldahl, who was also a personal friend of the artist, considered the "assault on the senses" of *Horizon Home Sweet Home* to be "in the current argot, a 'head trip,' a visit to a charmed space engineered not only to dazzle but also to provoke, to unsettle and, finally, to exhilarate."[62]

That in the year 1970 the word "trip" was associated most readily with the drug culture of the 1960s, and LSD in particular, goes without saying. Nor can there be any doubt that the discussion of artistic environments and psychedelic culture were mutually influential. Among the most important mediators between the psychedelic and the artistic milieu were the multimedia commune USCO, whose light environments supposedly simulated the hallucinations and visions of an LSD trip,[63] and the light artists Jackie Cassen and Rudi Stern, who in 1966 took part in the Trips Festival at the Electric Circus in New York, and whose work, which was neither wholly art nor wholly design, was described by one critic as a "lyrical form which strives for beauty, splendid color, and a display which is never excessive, but characterized by unity and balance."[64]

Rosenquist, in other words, was certainly not alone in his striving for an expansion of consciousness into space; if anything, it seems that he was the one who was inspired by New York's multimedia scene—and to such an extent that in the early 1970s he turned increasingly to film as medium. He had bought a 1950s Mitchell 35-mm camera at a government surplus sale in Cape Canaveral, and in the summer of 1971, just a few months after the momentous car crash, he told Peter Schjeldahl in an interview about a short, "rear-projected environmental film" that he was planning. The basic idea comprised a blacked-out room in which film sequences would be briefly projected onto the walls, which in their turn would eventually appear to topple over backward, revealing a (filmed) landscape in Florida. "What I want to do is present two conditions—something that's astonishing and something that's very *normal*-feeling. I want to create an exhilaration, a dazzlement, but at the same time I want to present very vividly *how it's done*, so no viewer can think, 'Oh, you're trying to fool me.' I want the normal and the unusual to occur at the same time, and that condition should maybe cause some short circuits in people's minds."[65]

The project was to have been called *Vantage Point*, and a sketch made for it along with various photos of the previously exposed film sequences were reproduced in the catalogue of the Whitney retrospective of 1972.[66] And so Rosenquist at least met his own, self-imposed condition that the technical and methodological background of the project be laid bare—even if the project itself was never actually realized. At the same time, *Vantage Point* highlights his proximity both to Cinemascope and Cinerama, and to the immersive, multimedia environments that had featured at various expos of the 1950s and 1960s (at two of which, that in New York in 1964 and that in Montreal in 1967 Rosenquist himself had had large-format paintings on show). Yet the movement with which Rosenquist most obviously entered into a dialogue with his experimental rooms and filmic works of the late 1960s and early 1970s is almost certainly Expanded Cinema, whose spread across North America and Western Europe from the mid-1960s onward is described by Gene Youngblood in his 1970 monograph of the same name.[67]

Not that Rosenquist was a complete newcomer here. After all, he had already collaborated with Stan VanDerBeek, an experimental filmmaker famed for his technical utopias, who between 1963 and 1965 ran an "infinite projection screen" called the Movie Drome in a forest on the outskirts of New York City, and who through that work had become one of the most influential protagonists of an expanded pictorial praxis and information aesthetic. In November 1967, moreover, a sculpture by Rosenquist made of aluminum foil, neon tubes, and chicken wire with films by VanDerBeek incorporated into it was suspended from the ceiling of the Robertson Memorial Field House at Bradley University in Peoria, Illinois.[68] The pairing of the two artists might at first seem surprising, but ultimately was all but inevitable. After all, VanDerBeek's projected 3D collages and Rosenquist's walls and rooms, which were likewise premised on collage principles, had been commenting on each other, at least implicitly, since the early 1960s.

Like Rosenquist, VanDerBeek subscribed to a mission that was at once both ethical and sensorial: "My concern is for a way for the over-developing technology of part of the world to help the underdeveloped emotional-sociology of all of the world to catch up to the 20th century … to counter-balance technique and logic—and to do it now, quickly."[69] His work as an educator rested on "expanded cinema" (a term that VanDerBeek is credited with having coined), on multiple projections of films and slides, and on what he called the "movie mural." This alone might explain the many and various connections to Rosenquist's multiperspective paintings, which in their turn recall the murals of the Mexican Revolution and the WPA program in the United States of the 1930s. But VanDerBeek's visual didactics, his understanding of the presentation as involving—and liberating—both body and mind for all those willing to lie down and let his visual program work its magic on them (or to broaden its compass through dance, as in VanDerBeek's multimedia performances *Variations V* of 1967), share with Rosenquist an interest in the phenomenological activation of seeing, hearing, and touch. The perceptual overload in both cases became an immersive teaching method, whose objective was the development of a subjectivity, which instead of just passively submitting to the "invisible environment" would actively and effectively resist it.

7. If the divide between normality and abnormality, between the familiar and the unknown, was one of the—possibly biographical—driving forces behind the many ideas for filmic environments that Rosenquist had in the summer of 1971, the important role played by the concept of peripheral vision in the development of his visual and experiential spaces and the reception of the same is surely also worthy of mention. Ever since the mid-1960s, theories of perception had provided a conceptual underpinning for both Rosenquist's artistic work in general and his specific approach to painting. The key to his method aimed at opening up pictorial space was the question of how the human sense of

sight, and the visual contemplation of works of art in particular, are shaped by the relationship between focused and peripheral vision. His interest was not just in the relationship between touch and sight, but also in that between the center and the periphery.

Inasmuch as the size, extent, mirroring, or veiling of paintings and pictorial spaces make it harder for us to concentrate on just one point, one motif, one figure that snaps into focus apart from all the rest, much of our experience of art is shaped by our lateral vision—by what we register in the corners of our eyes. An environment that demands peripheral vision makes a change in how we perceive ourselves and makes doubts concerning the integrity of our own identity all the more likely; or as Rosenquist himself put it: "If you surround yourself with color or whatever you look at, you question self-consciousness." [70] For him, therefore, *Horse Blinders* was a typical case of "looking at something and questioning it because of everything else you're seeing, the things on the peripheries that control all those settings." [71]

Rosenquist repeatedly mentioned how, around 1964, he had what for him was a formative conversation with Barnett Newman about peripheral vision and about the "it" that can affect perception as a whole: "What you see through the side of your eyes makes what you think you see, that color for instance. Or color can change other colors, according to the whole surrounding of senses of color, light, dark, everything." [72] Newman seemed to have posed the crucial question—the question of what it was that, say, Claude Monet amid his water lilies or Jackson Pollock hunched over one of his drip paintings laid out on the floor *actually saw:* "Peripheral vision dictated what he saw." [73] Newman's preoccupation with peripheral vision is certainly relevant, [74] and Rosenquist owes much of his own interest in margins, edges, corners, and all the other peripheral zones of perception to him. And to Newman must also be added his experience of the mentally and physically exhausting navigation of oversize pictures acquired in the course of his career as a billboard painter. Ultimately, however, we can follow Lucy Lippard in surmising that it was Rosenquist's period as artist in residence at the Institute for Humanistic Studies in Aspen, Colorado, where he spent several weeks of the summer of 1965 studying the literature and philosophy of the Far East (with a special focus on the Japanese courtly epic *The Tale of Genji*), that led to his "extremely personal project to experiment with the effects of peripheral vision." [75]

The installation of Rosenquist's *Slush Thrust* in close proximity to works by Jo Baer at Rolf Ricke's gallery in November 1970 brought together two specialists in peripheral vision. Baer, who had been conceiving her image objects from the outer margins and edges of the canvas inward for almost a decade by then, engaged the theoretical fundamentals of marginal and borderline phenomena in a complex discourse that was not confined to her own work as an artist, but spilled over into various essays, including one about Mach bands. Named for the philosopher and physicist Ernst Mach, a Mach band is a form of enhanced contrast perceived along the edges of two adjoining blocks of gray. Mach bands, which are a product of the lateral inhibition of the retina, occur at the transition from a light to a dark area so that the human eye detects a lighter band in the light area and a darker band in the dark area at either end of the transition zone.

Shortly before the exhibition in Cologne, Baer had published an article called "Mach Bands: Art and Vision" in the multimedia art journal *Aspen Magazine.* In this complex text she discusses the role of borders and contrasts in visual perception from Clement Greenberg's modernist standpoint, her aim being to introduce artists to the possibilities opened up by the physiology of seeing. While Baer's premises and convictions seem to have little to do with the convictions and leanings that structured Rosenquist's ideas and actions of this period, to judge by what was said about the creation and larger context of *Slush Thrust* and about Rosenquist's other rooms of the early 1970s, it is certainly conceivable that Baer's theoretical exploration of traditional perception theory at least provided a potential basis for discussion: "Since biological preference for illumination qualities, boundaries and sharp changes precede and underlie the more complicated color and sociological factors; and since they are a known, universal visual necessity, it would be well for the proceeding arts to investigate and keep these constants in mind. Perhaps it is now propitious for radical painting's surfaces to mediate new color and value relations between a more closely examined observer and an expanded, more worldly observed." [76] The sources of perception theory may well vary just as much as the art that is premised on them; and "radical painting" need not mean the same thing to all people. Yet there can be no doubt that this is one interest that James Rosenquist and Jo Baer shared: the interest in creating new relationships between color, experience, and the world.

200 *Jo Baer* exhibition, Gallerie Rolf Ricke, Cologne, 1970

201 Rosenquist's untitled installation, 1967, of aluminum foil, chicken wire, and neon. Robertson Memorial Field House, Bradley University, Peoria, Illinois, 1967. Accompanied by a film program by Stan VanDerBeek, who is seated at front with Rosenquist,

202 Josef-Haubrich-Kunsthalle / Wallraf-Richartz-Museum, Cologne, 1972

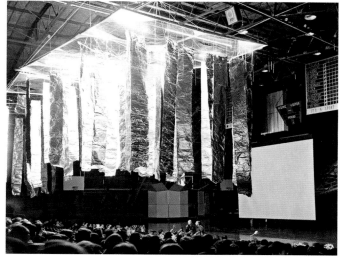

201

200

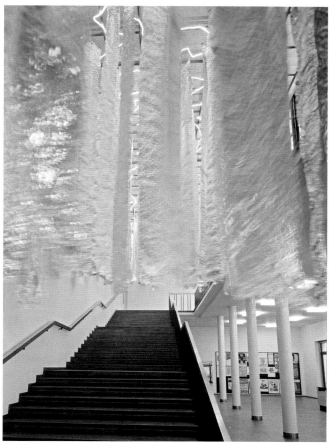

202

Notes

1 While Ricke had had some of Rosenquist's drawings and prints in his program since 1965, their collaboration began in earnest only in 1969–70, after the artist—represented by Leo Castelli in New York—decided to part company with Ileana Sonnabend in Paris.

2 Very little is known about *47 Dirty Band-Aids*, an environment that was never exhibited again after 1972. An unpublished twenty-six-minute video by Hermine Freed (*James Rosenquist Painting "47 Dirty Band-Aids,"* 1972) which was produced for Marcia Tucker of the Whitney Museum of American Art in the spring of 1972 shows Rosenquist virtually doubling both the number and the dimensions of the panels used for previous "wrap-around environments" (as Rosenquist calls them in the video). Lawrence Alloway also mentioned the work, albeit without actually naming it by name, in an article of his published in 1972: "In the Whitney sculpture court is a new piece by Rosenquist, an extension of the glowing color panels of *Slush Thrust*, 1969 [!], and *Horizon Home Sweet Home*, 1969–70. The court has never looked better than it does now, surrounded by tall panels of glamorous color and reflective plastic." (Lawrence Alloway, "Derealized Epic," in *Artforum* 10/10, June 1972: 35–41, esp. 40).

3 See James Rosenquist and David Dalton, *Painting Below Zero; Notes on a Life in Art* (New York: Alfred A. Knopf, 2009), 210–12.

4 James Rosenquist, letter to Rolf Ricke, January 6, 1971, reprinted in Christiane Meyer-Stoll, *Sammlung Rolf Ricke / Rolf Ricke Collection: Ein Zeitdokument / A Document of the Times* (Ostfildern: Hatje Cantz, 2008), 283. The concept envisioned here was eventually realized—though in a somewhat modified form and not at Rolf Ricke's gallery—as *Aurora Boralis*, a work that Rosenquist created for his retrospective at the Kunsthalle Köln in 1972. An assemblage of disused neon tubes and strips of aluminum foil, it was suspended from the ceiling of the foyer like an oversized chandelier (for more on the history of this work, see Christiane Meyer-Stoll, "Ganz nah dran: Gespräche mit Rolf Ricke," in Meyer-Stoll 2008, 20–201, esp. 69).

5 The fifty-one-panel *F-111* of 1964–65, for example, was to have been sold piecemeal: "Yes, the whole thing was actually sold in pieces for about $54,000 but Bob Scull [Robert C. Scull, who ran a successful taxi business in New York and was an avid collector of Pop art, TH] came along and bought it all, thinking he was saving it so that it wouldn't get scattered to the winds I thought, I'm going to do a painting and divide it up into panels so that each panel isolated might look like something. Each piece would be only a fragment that would be scattered about and then later some piece might assume an identity of style." (Jeanne Siegel, "An Interview with James Rosenquist," in *Artforum* 10/10, June 1972: 30–34, esp. 34).

6 "And then, if the painting was ever to be shown again, people would have to get together and loan them and they could be shown as one piece again. But I thought originally that . . . the look of it would be or could be the form of the future, of the fragments—not of the complete whole." (Siegel, 34.)

7 Peter Schjeldahl, "A 'Trip' with Rosenquist," in *The New York Times*, May 31, 1970, 77. (The piece is a review of the exhibition of *Horizon Home Sweet Home* at Leo Castelli's gallery, 1970).

8 Barbara Haskell, *Jo Baer* (New York: Whitney Museum of American Art, 1975), unpaginated.

9 Günter Pfeiffer, "James Rosenquist/Jo Baer, Galerie Ricke, Köln," *das kunstwerk: Zeitschrift für bildende Kunst* 24/1, 1971: 79.

10 In addition to Müller and Ricke, Heiner Friedrich, Reinhard Onnasch, Hans Neuendorf, Dieter Wilbrand, and M. E. Thelen also had galleries there. See Brigitte Jacobs van Renswou, "Porträt Galeriehaus Köln, Lindenstraße 18–22," website of the Zentralarchiv des internationalen Kunsthandels e.V. (ZADIK), http://www.artcontent .de/zadik/default.aspx?s=1061 (accessed August 16, 2017).

11 See Gila Strobel, "Chronik der Galerie Rolf Ricke 1963–2004," in Meyer-Stoll, *Sammlung Rolf Ricke*, 19–201, esp. 74.

12 Siegel, "Interview," 34.

13 The exact number of panels and ratio of painted panels to those covered in polyester film vary depending on the source: according to Judith Goldman (*James Rosenquist* [New York: Viking, 1985], 46) *Slush Thrust* consisted of fourteen of each, a figure which is impossible to verify on the basis of the surviving photos; Evelyn Weiss, who is known to have seen the work in person, speaks of eighteen painted and seven covered panels (Evelyn Weiss, *James Rosenquist: Gemälde—Räume—Graphik*, exh. cat. Wallraf-Richartz-Museum in der Kunsthalle Köln [Cologne: Wallraf-Richartz-Museum, 1972], 108); an article about Rosenquist in *Spiegel* ("Rosenquist: Licht vom Mond," *Der Spiegel* 50, 1970: 188), however, arrived at a ratio of eighteen to nine.

14 Siegel, "Interview," 34. The "funhouse" look of Rosenquist's environments was also noted by contemporary critics (see Kenneth Baker, "James Rosenquist, Castelli Gallery," in *Artforum* 9/5, January 1971: 74–75, among others).

15 It was probably Alfred Nemeczek, who between 1967 and 1973 was an arts and culture editor at *Spiegel* and who is known to have been among those present at the opening of the exhibitions in Cologne on November 13, 1970.

16 "Rosenquist: Licht vom Mond," 188.

17 Rosenquist and Dalton, *Painting Below Zero*, 206.

18 James Rosenquist, letter to Rolf Ricke, January 24, 1970, reprinted in Meyer-Stoll, *Sammlung Rolf Ricke*, 283.

19 Meyer-Stoll, 283

20 Siegel, "Interview," 34.

21 Marshall McLuhan and Harley Parker, *Through the Vanishing Point. Space in Poetry and Painting* (New York, Evanston and London: Harper & Row, 1968), 30.

22 McLuhan and Parker, 30.

23 Kenneth Baker, "New York: James Rosenquist, Castelli Gallery," in *Artforum* 9/5, January 1971: 74–75.

24 See, among others, Suzanne Lacy and Jennifer Flores Sternad, "Voices, Variations and Deviations From the LACE Archive of Southern California Performance Art," in *Live Art in LA Performance in Southern California, 1970–1983*, ed. Peggy Phelan (New York: Routledge, 2012), 61–114, esp. 64.

25 Rebecca Choi, "Allan Kaprow's *Fluids*: An Architectural Happening in Los Angeles," The Mediated City Conference Architecture_MPS; Ravensbourne; Woodbury University, Los Angeles, October 1–4, 2014, http://architecturemps.com/wp-content /uploads/2013/09/CHOI-REBECCA_ALLAN-KAPROW%E2%80%99S-FLUIDS_AN -ARCHITECTURAL-HAPPENING-IN-LOS-ANGELES.pdf (accessed August 16, 2017).

26 See the section on *Fluids* in *Allan Kaprow. Art as Life*, ed. Eva Meyer-Hermann, Andrew Perchuk, and Stephanie Rosenthal (London: Thames & Hudson, 2008), 188–95.

27 Allan Kaprow, in Richard Schechner, "Extensions in Time and Space. An Interview with Allan Kaprow," in *The Drama Review: TDR* 12/3, Spring 1968: 154–55; Chicago's and Kaprow's atmospheric installations, at once both architectural and performative, coincided with the wave of kinetic art in Europe and Latin America, which Willoughby Sharp, curator and founder of the Kineticism Press, had been publicizing in North America since the mid-1960s, in part as a contribution to the 1968 Olympic Games in Mexico City. Writing about *Kinetic Environment*, an open-air show in New York's Central Park in October 1967, when five artists, including Hans Haacke and Gilles Larrain, experimented with air, fire, fog, ice, smoke, and water, Sharp expressed his "strong feeling of confidence in the ability of the new art to reconstruct the world kinetically." (Willoughby Sharp, "Luminism and Kineticism," in *Minimal Art. A Critical Anthology*, ed. Gregory Battcock [New York: Dutton, 1968], 317–58, esp. 358). A few months after the performances involving dry ice and ice by Chicago and Kaprow, Sharp conceived and curated the exhibitions *Air Art* (University Art Museum, Berkeley, CA, and five other venues, 1968–69) and *Kineticism: Systems Sculpture in Environmental Situations* (Mexico City, 1968), thus according the tendency to appreciate art in terms of categories such as volatility, interactivity, and immateriality (as "absence" and "invisibility") institutional recognition (see Willoughby Sharp, "Air Art," in *Studio International* 175/900, May 1968: 262–64, esp. 263). A six-part series of shows called simply *Environments* hosted by New York's Architectural League between 1966 and 1968 likewise featured a number of works that operated with media such as light, water, and vibrations.

28 Lucy R. Lippard and John Chandler, "The Dematerialization of Art," *Art International* 12/2, February 1968; reprinted in Lucy R. Lippard, *Changing: Essays in Art Criticism* (New York: Dutton, 1971), 255–76.

29 Rosenquist and Dalton, *Painting Below Zero*, 206.

30 Elena and Nicolas Calas, "James Rosenquist Vision in the Vernacular," in *Arts Magazine* 44/2, November 1969, here quoted from idem, *Icons and Images of the Sixties* (New York: E. P. Dutton, 1971), 122.

31 Also worthy of mention in this connection are the works *Wall Dog* (formerly *Windrows*), 1966; *Stellar Structure*, 1966; *Hat*, 1967; *Avalanche*, 1967; *Sauce*, 1967; *Scrub Oak*, 1968; *For Lao Tse*, 1968; and *Mayor Daley*, 1968.

32 This is how Evelyn Weiss paraphrases the artist (in German) in Weiss, *James Rosenquist: Gemälde—Räume—Graphik*, 96.

33 Siegel, "Interview," 32.

34 Stephen Bann, *Experimental Painting. Construction, Abstraction, Destruction, Reduction* (London: Studio Vista, 1970), 124.

35 André Vigeant, "James Rosenquist. Temps-Espace-Mouvement," in *Vie des arts* 51, 1968: 58–61, esp. 61.

36 See Tommaso Trini, in an essay in a brochure published to mark the opening of the show of Mylar works at the Galerie Ileana Sonnabend in Paris on April 25, 1968 (*Rosenquist*, with texts by Tomasso Trini and James Rosenquist [Paris: Éditions Galerie Ileana Sonnabend, 1968], unpaginated).

37 The photograph was first reproduced in the aforementioned brochure published by Ileana Sonnabend, 1968; see also Marcia Tucker, *James Rosenquist* (New York: Whitney Museum of American Art, 1972), 98–99.

38 Tucker, 20.

39 See Michaël Amy, "Painting, Working, Talking," [Interview with James Rosenquist], in *Art in America* 92/2, February 2004: 104–09, esp. 109. Rosenquist's interest in holograms was shared by several other artists, including Bruce Nauman, who in 1970 exhibited his *Studies for Holograms* at Ricke's gallery in Cologne (September 11 – October 9, 1970).

40 For an in-depth analysis of the relationship between the "environment" as a concept of art theory and the "environment" in the sense of our natural (or indeed technical or industrial) surroundings, see James Nisbet, *Ecologies, Environments and Energy Systems in Art of the 1960s and 1970s* (Cambridge, MA, and London: MIT Press, 2014), esp. 23.

41 Allan Kaprow, "Definition of an Environment" (statement provided by the Allan Kaprow Studio in 2004), here quoted from Paul Schimmel, "'Only memory can carry it into the future': Kaprow's Development from the Action-Collages to the Happenings," in *Allan Kaprow: Art as Life*, 8–19, esp. 11.

42 See David Antin, "Art and Information 1: Grey Paint, Robert Morris," *Art News* 65/2, April 1966: 22–24, esp. 24: "There are tides of fashion in the art world, and it was only a few years ago that everybody was making environments. But environment is a pretty dead word now ... sculptors would sooner be caught dead than making them." (see also Nisbet, *Ecologies*, 62–63).

43 Allan Kaprow, "Assemblage, Environments & Happenings," in *Assemblage, Environments & Happenings*, ed. Allan Kaprow (New York: Abrams, 1966), 168.

44 Kaprow, 183.

45 Stuart Brisley, "Environments," in *Studio International* 177/912, June 1969: 269–99, esp. 267.

46 Siegel, "Interview," 34; in another interview of 1972, Rosenquist explained that he had used the word "slush"—which according to him is slang for a complete mishmash of colors—merely as a joke (Werner Krüger, "Interview mit James Rosenquist," in *Kölner Stadtanzeiger*, November 13, 1970, quoted from Meyer-Stoll, *Sammlung Rolf Ricke*, 285).

47 Gene R. Swenson, "What Is Pop Art? Answers from Eight Painters. Part II: James Rosenquist," in *Art News* 62/10, February 1964: 40–43, 62–67, esp. 63. For more on this passage of the interview, see Caroline A. Jones, *Machine in the Studio: Contructing the Postwar American Artist* (Chicago and London: The Chicago University Press, 1996), 357–58 and Stephen Monteiro, "'Smashing Images in Your Face': Mobile Perception and Urban Media in James Rosenquist's Pop," *The Senses & Society* 10/3, 2016: 298–320, 306ff. In the 1972 *Artforum* interview Rosenquist repeated what he had said back in 1964 almost word for word: "Things, billboard signs, everything thrust at me ..." (Siegel, "Interview," 32).

48 Siegel, 32.

49 See Marshall McLuhan, "Address at Vision 65," in *The American Scholar* 35/2, Spring 1966: 196–205; McLuhan, "The Invisible Environment—The Future of an Erosion," in *Perspecta* 11, 1967: 163–67, esp. 165.

50 "Rosenquist: Licht vom Mond," 188.

51 Krüger, "Interview mit James Rosenquist."

52 Siegel, "Interview," 30.

53 Siegel, 30.

54 In a letter to Rolf Ricke dated June 3, 1970 Rosenquist mentions a "photo of fog drawing at Leo's." The reference is to the *Horizon Home Sweet Home* exhibition at Leo Castelli's gallery in New York held that same year (Meyer-Stoll, *Sammlung Rolf Ricke*, 283).

55 Siegel, "Interview," 34.

56 Especially worthy of mention among the many exhibitions of the year 1970 are two which back then were controversial, but which have long since become canonical: *Information* (Museum of Modern Art, curated by Kynaston McShine) and *Software: Information Technology: Its New Meaning for Art* (Jewish Museum, curated by Jack Burnham).

57 Thelma R. Newman, "The Artist Speaks: Les Levine," *Art in America* 57/6, November–December 1969: 86–93, esp. 87.

58 Newman, "The Artist Speaks," 93.

59 Brian O'Doherty, *Inside the White Cube: The Ideology of the Gallery Space; Expanded Edition* (Berkeley and Los Angeles: University of California Press, 1986), 97.

60 Krüger, "Interview mit James Rosenquist."

61 Alloway, "Derealized Epic," 40.

62 Schjeldahl, "A 'Trip' with Rosenquist," 77.

63 See Nan R. Piene, "Light Art," *Art in America* 55/3, May–June 1967: 24–47, 45; for more on USCO see also Nisbet, *Ecologies*, 55–57.

64 Barry N. Schwartz, "The Kinetic Scope of Cassen and Stern," *Arts in Society* (Tenth Anniversary Issue) 6/1, Spring–Summer 1969, 95–102, esp. 100; for more on Cassen and Stern, see also Nisbet, *Ecologies*, 58–60.

65 Peter Schjeldahl, "An Interview with James Rosenquist," *Opus International* 29–30, December 1971, 114–15, esp. 114 (the interview took place in East Hampton, Long Island, on September 13, 1971).

66 All the materials on *Vantage Point*, including film copies dating from the years 1971 to 1972, were destroyed in a devastating fire at Rosenquist's studio complex in Aripeka, southern Florida, in 2009.

67 Gene Youngblood, *Expanded Cinema*, with an introduction by R. Buckminster Fuller (New York: Dutton, 1970); see also Gloria Sutton, *The Experience Machine: Stan VanDerBeek's Movie-Drome and Expanded Cinema* (Cambridge, MA, and London: MIT Press, 2015), 19–49, passim, and *X-Screen: Filmische Installationen der Sechziger- und Siebzigerjahre,* ed. Matthias Michalka and Museum Moderner Kunst Stiftung Ludwig Wien, Vienna (Cologne: Verlag der Buchhandlung Walther König, 2004).

68 The work is clearly related to the suspended sculpture *Aurea Borealis*, created for the 1972 retrospective at the Kunsthalle Köln (see note 4); other versions of the same work were included in the touring exhibition *New York 13* of 1969, which was shown at three different museums in Canada as well as at a party organized by Rosenquist in Robert Rauschenberg's studio in New York in 1970. Both Rosenquist and VanDerBeek had previously had works of theirs exhibited in the American pavilion at Expo '67 in Montreal, the famous geodesic dome designed by Buckminster Fuller. There, Rosenquist showed the painting *Fire Slide*, and VanDerBeek the computer graphics film *Man and His World,* which was a coproduction with the physicist Kenneth C. Knowlton of Bell Laboratories.

69 Stan VanDerBeek, "Culture-Intercom. A Proposal," *Film Culture* 40, Spring 1966: 15–18, esp. 18; for more on VanDerBeek generally, see, most recently, Sutton, *The Experience Machine.*

70 Cheryl Kaplan, "A Life Flower, a Painting, and a Shrunken Head" (interview with James Rosenquist), *db artmag* 13, October 31, 2003, http://db-artmag.de/archiv /2003/e/13/4/134.html (accessed August 16, 2017).

71 Craig Adcock, "An Interview with James Rosenquist," in *James Rosenquist: The Big Paintings; Thirty Years Leo Castelli*, ed. Susan Brundage (New York: Rizzoli, 1994), unpaginated (the interview took place on June 11, 1994).

72 "Interview: James Rosenquist; Pop Art Master," *Academy of Achievement*, March 18, 1991, Aripeka, Florida, http://www.achievement.org/achiever/james-rosenquist /#interview (accessed August 25, 2017).

73 See Max Hollein, "Conversation with James Rosenquist," *museum in progress*, http://www.mip.at/attachments/193 (accessed August 16, 2017; the interview took place in New York in April 1997).

74 See Yve-Alain Bois, "Newman's Laterality," in *Reconsidering Newman. A Symposium at the Philadelphia Museum of Art*, ed. Melissa Ho (New Haven and London: Yale University Press, 2005), 29–45, esp. 34, 36.

75 See Lucy R. Lippard, "James Rosenquist: Aspects of a Multiple Art," *Artforum* 4/4, December 1965, here quoted after Lucy R. Lippard, *Changing: Essays in Art Criticism* (New York: Dutton, 1971), 97. That these *effects* can also occur as *affects* should not be ruled out. In his psychoanalytical theory of the artistic imagination, *The Hidden Order of Art,* published in 1967, Anton Ehrenzweig writes about the special significance of peripheral perception as a site of dreams and fantasies. To be able to probe this dimension, however, the eyes' focusing powers first have to be immobilized or obscured as only then can the forms perceived on the periphery appear as dream figures (Anton Ehrenzweig, *The Hidden Order of Art. A Study in the Psychology of Artistic Imagination* [Berkeley, Los Angeles, and London: University of California Press, 1967], 273–74).

76 Jo Baer, "Mach Bands: Art and Vision," *Aspen Magazine* 8 (The Fluxus Issue), Autumn–Winter 1970, http://www.ubu.com/aspen/aspen8/machBands.html (accessed August 16, 2017).

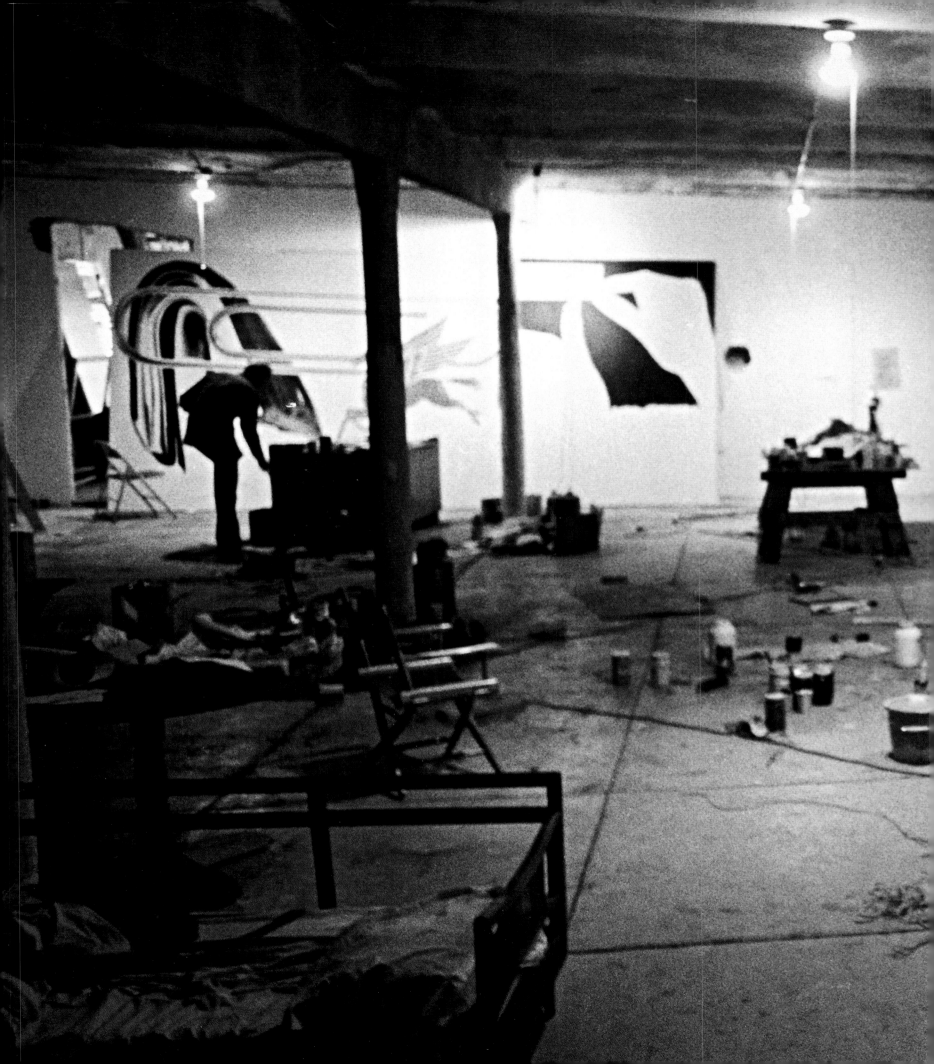

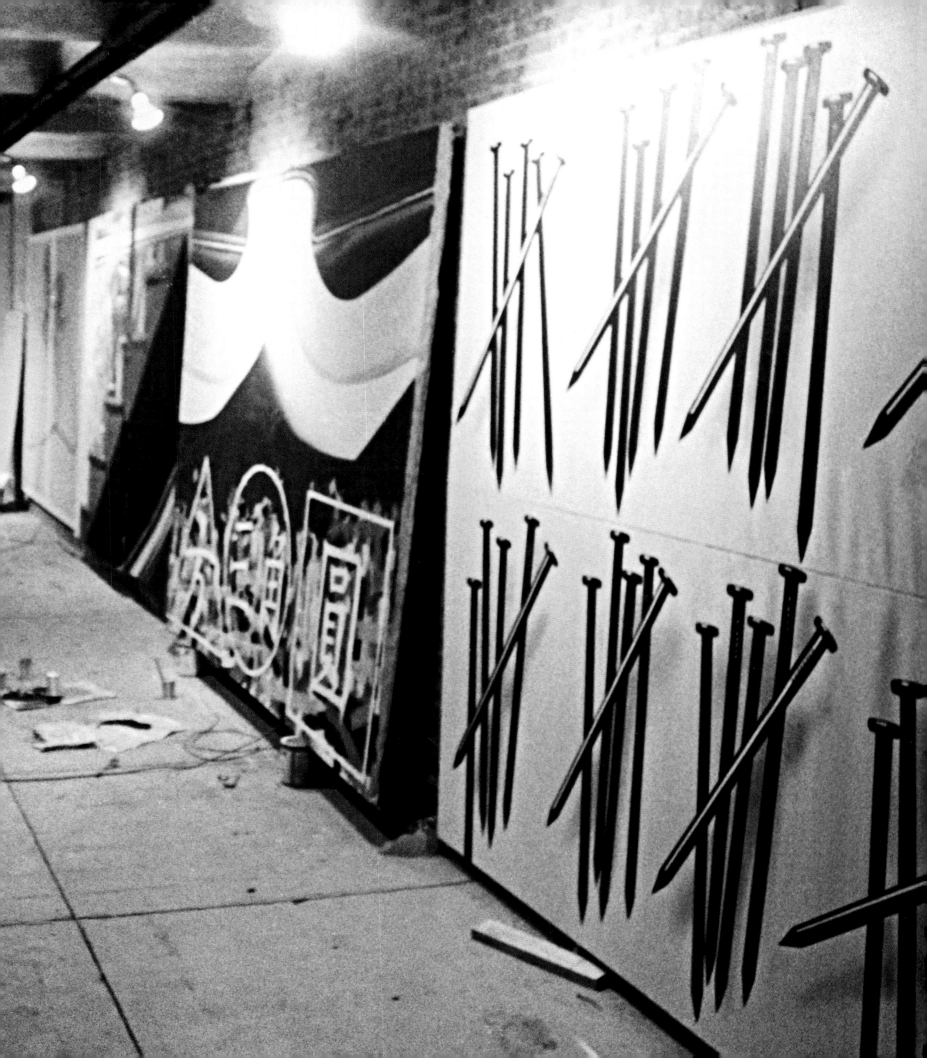

A Pale Angel's Halo and **Slipping Off the Continental Divide**, 1973

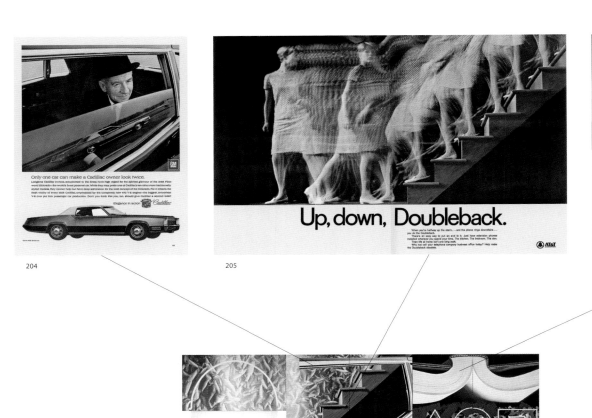

204

205

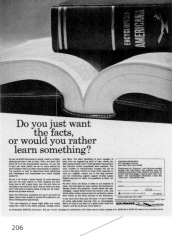

206

209

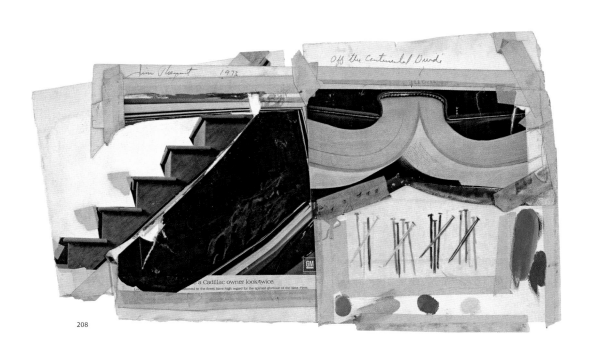

208

210

203 Previous spread: Rosenquist at work in his Bowery studio, New York, ca. 1973. Works pictured (left to right): *Paper Clip*, *Windscreen*, *Slipping Off the Continental Divide*, *Snow Fence I / Snow Fence II*, all 1973

204 Advertisement for General Motors
in *Life* magazine, date unknown (ca. December 1967)

205 Advertisement for AT&T
in *Life* magazine, November. 17, 1967, pp. 6–7

206 Advertisement for Encyclopedia Americana
in *Life* magazine, May 28, 1965, p. 13

207 Advertisement for Sears
in *Life* magazine, March 29, 1968, pp. 64–65

208 *Source and Preparatory Sketch for*
–209 *Slipping Off the Continental Divide*, 1973
Collage and mixed media on paper
Book endpaper, 8 ¼ × 6 ⁵⁄₁₆ in. (21 × 16 cm);
collage element, 13 ⁵⁄₁₆ × 25 ⅜ in. (33.8 × 64.5 cm)
Destroyed

210 Original preparatory sketch element for
Source for Off the Continental Divide, 1973
Pencil on paper
11 ¼ × 5 ¼ in. (28.6 × 13.3 cm)

211 *Off the Continental Divide*, 1973–74
Multicolor lithograph
42 ¹⁵⁄₁₆ × 79 ³⁄₁₆ in. (109.1 × 201.1 cm)
Publisher: Universal Limited Art Editions, Inc.
Printer: Universal Limited Art Editions, Inc.
Edition: 43 + 5 APs, 8 HCs, 4 TPs, 2 PPs
Estate of James Rosenquist

212 *Sketch for Slipping Off the Continental Divide*, 1972
Mixed media on paper
43 × 77 ½ in. (109.2 × 196.9 cm)

207

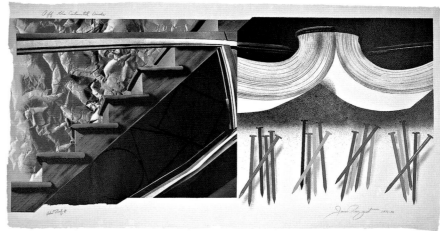

211

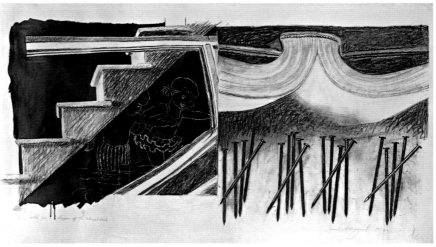

212

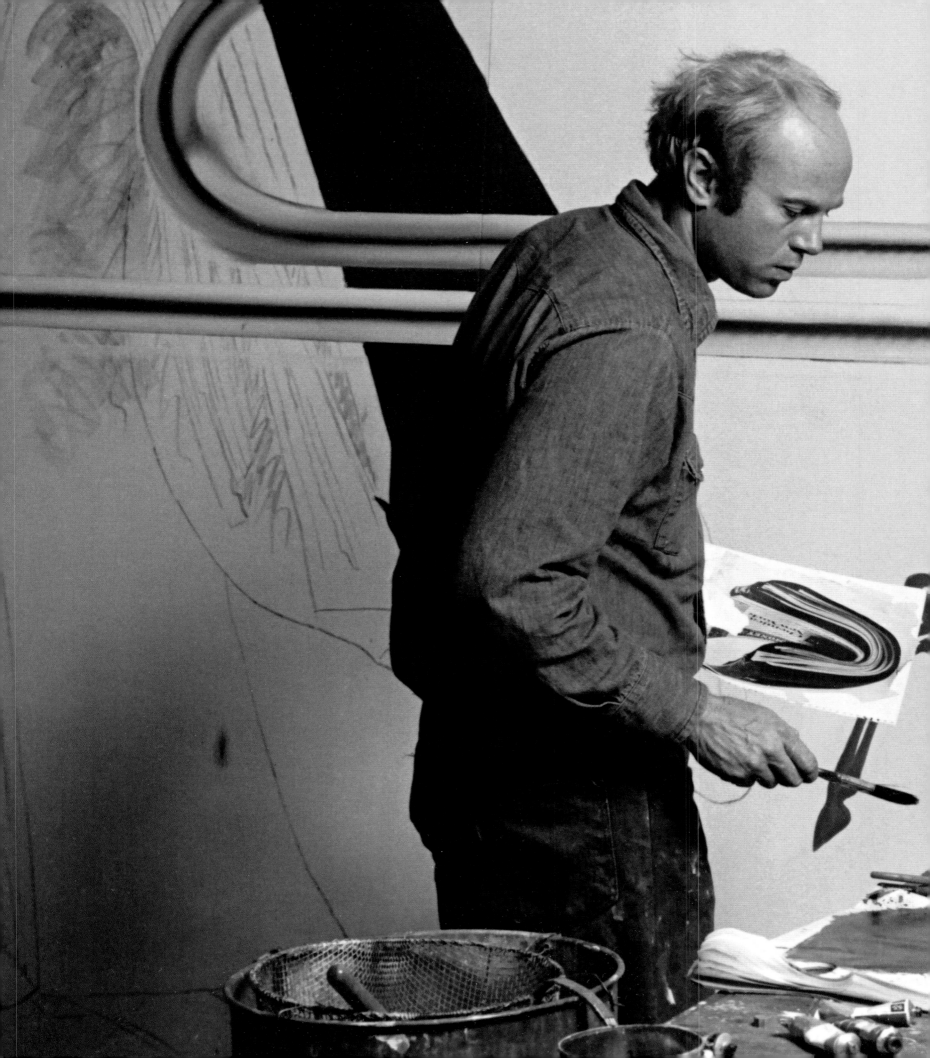

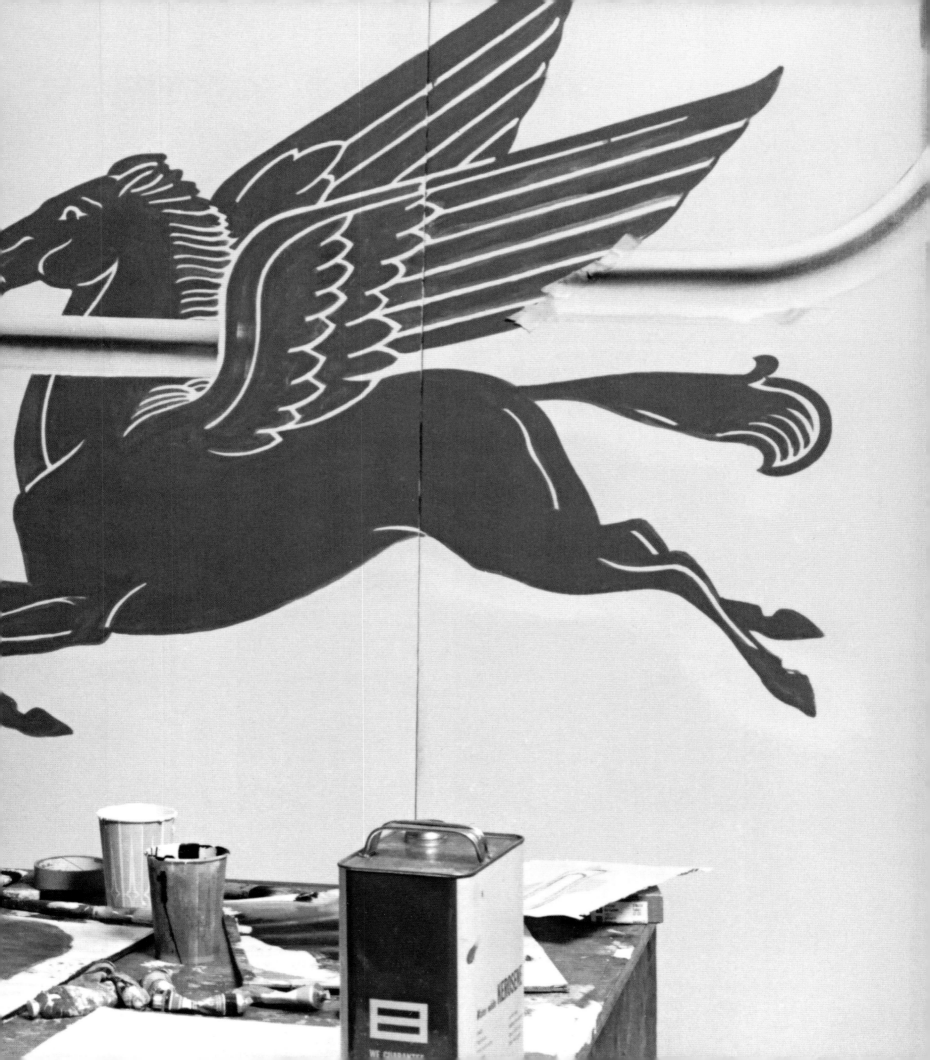

214

215

216

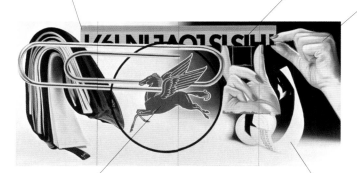

217

218

Paper Clip, 1973

213 Previous spread: James Rosenquist working on
Paper Clip, Bowery Street studio, New York, 1973

214 Advertisement for General Electric
in *Life* magazine, March 16, 1962, pp. 72–73

215 Advertisement for Menley & James
in *Cosmopolitan*, May 1971, p. 143

216 Advertisement for Winston
in *Life* magazine, February 24, 1961, back cover

217 Advertisement for Mobilgas
in *Life* magazine, August 2, 1948, pp. 28–29

218 Advertisement for Olivetti
in *Life* magazine, March 1, 1968, p. 53 (foldout)

219 *Source for Paper Clip*, 1973
Magazine clipping and mixed media on paper
ca. 16 ⅜ × 10 ¾ in. (ca. 41.6 × 27.3 cm)
Destroyed

220 *Source for Paper Clip*, 1973
Magazine clippings and mixed media on paper
17 × 27 in. (43.2 × 68.6 cm)
Destroyed

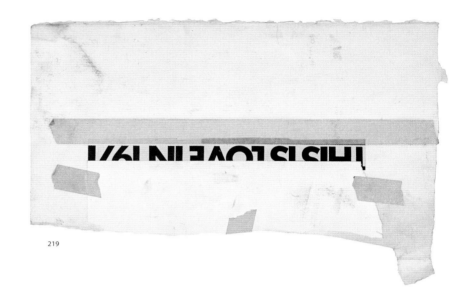

219

220

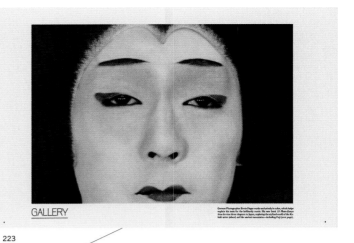

221

222

223

Terrarium, 1977

221 Advertisement Sealy Posturepedic
in *Life* magazine, August 16, 1968, inside cover

222 Advertisement for Hunt
in *Life* magazine, December 13, 1963, p. 116

223 "Gallery about the German Photographer Erwin Fieger,"
Life magazine, October 17, 1969, pp. 8–9

224 *Source for Terrarium*, 1977
Magazine clippings and mixed media on paper
14 3/16 × 27 13/16 in. (36 × 70.6 cm)
Private collection

225 James Rosenquist in front of *Terrarium*, Aripeka,
Florida 1977

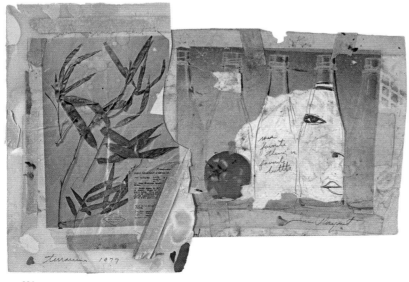

224

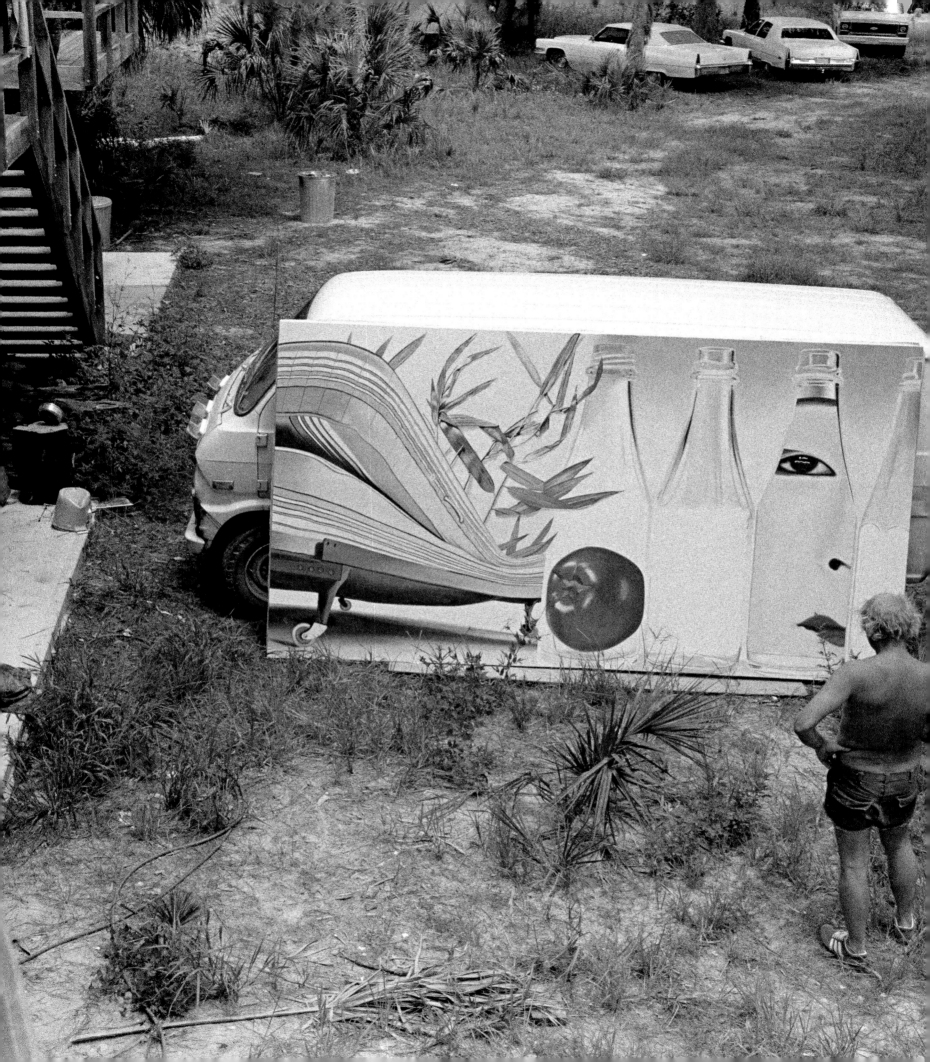

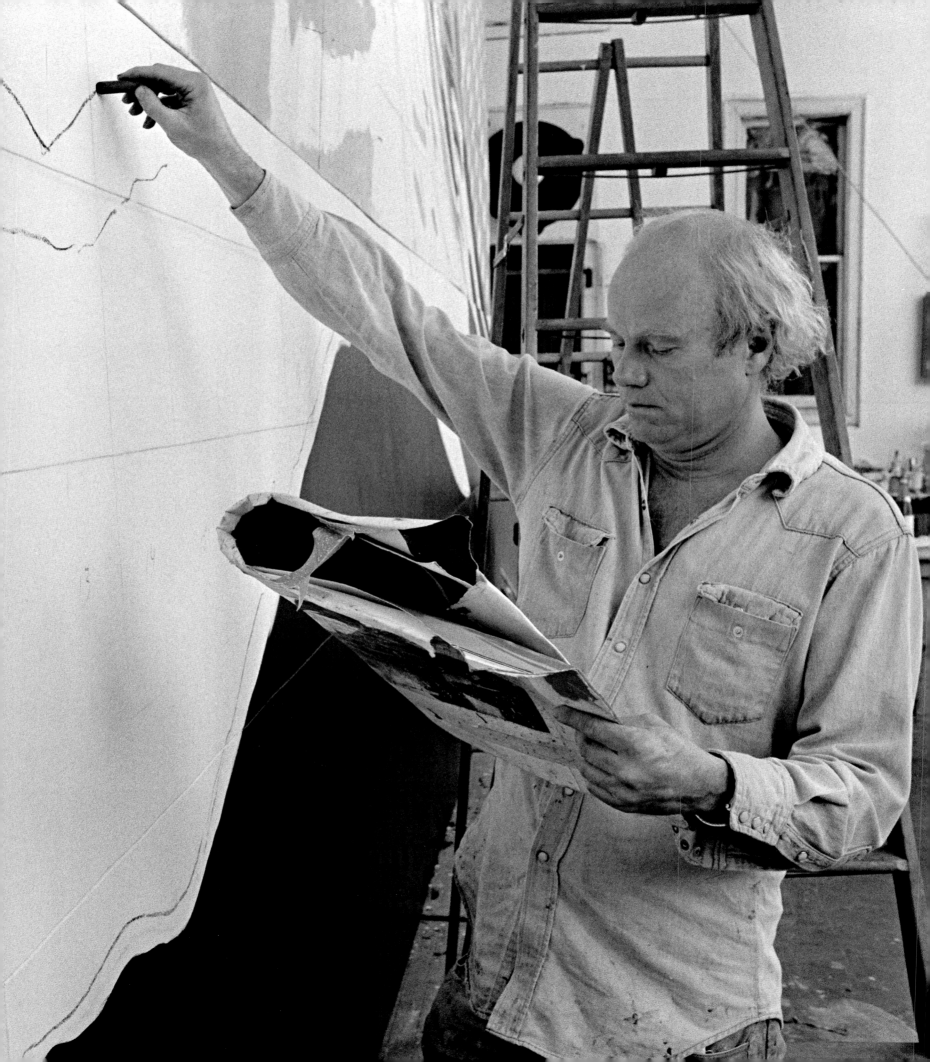

227

Star Thief, 1980

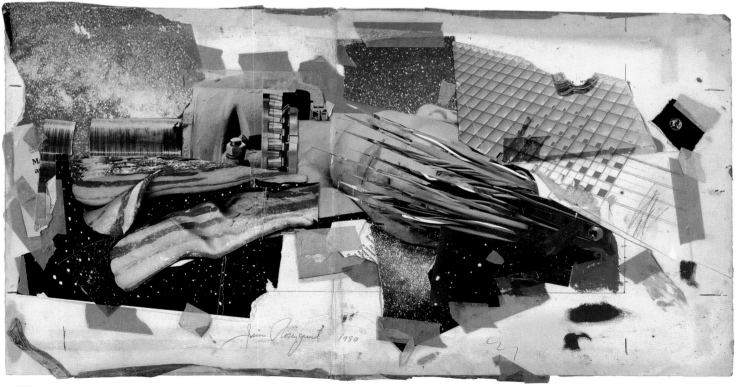

228

229 James Rosenquist working
–242 on *Star Thief*, 1980,
236–238 photographs by Hans Namuth

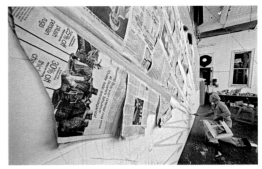

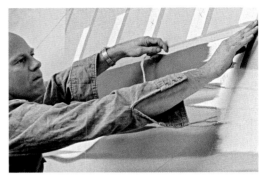

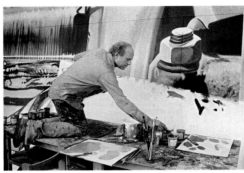

230–233

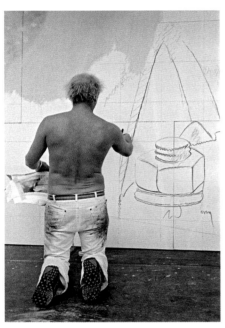

229

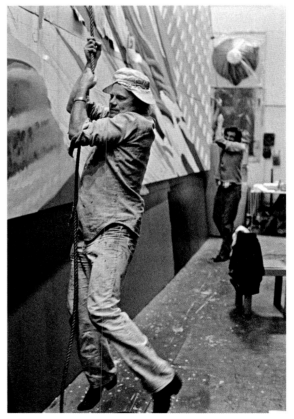

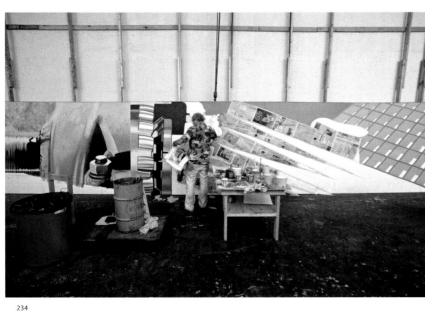

234

235

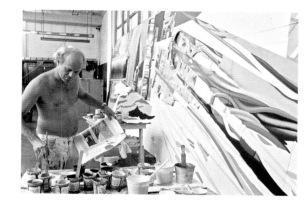

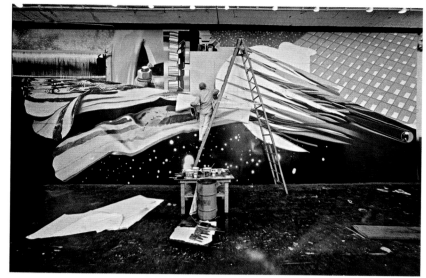

239

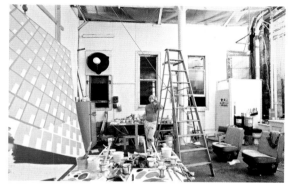

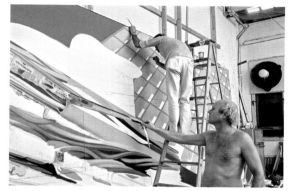

236–238

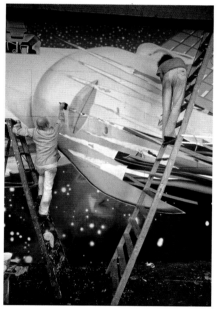

240

241

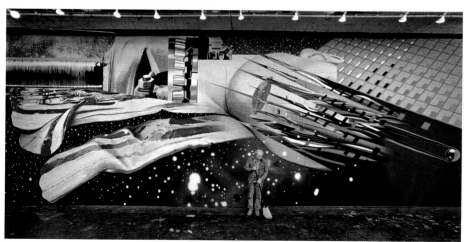

242

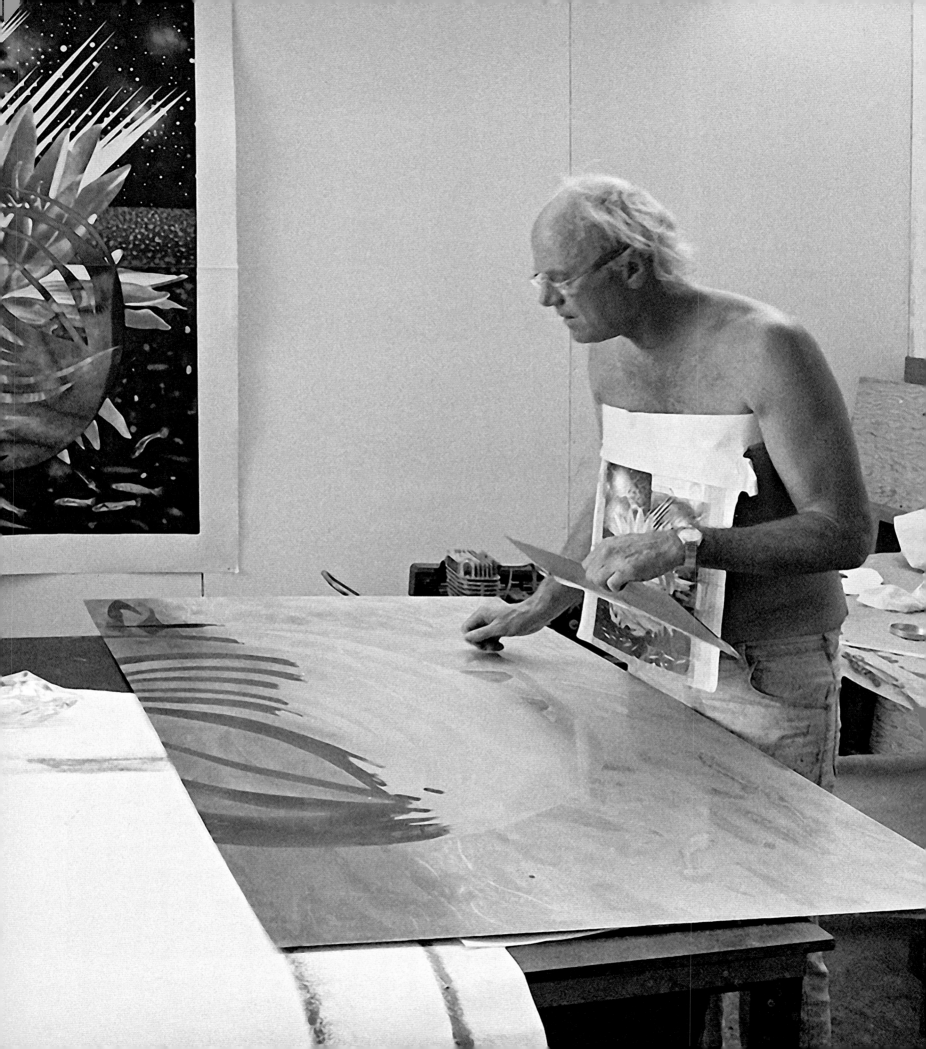

The Prickly Dark, 1987

243 *Source for The Prickly Dark*, 1987
Magazine clippings and mixed media on book clipping
9 11/16 × 8 ½ in. (24.6 × 21.6 cm)
Estate of James Rosenquist

Welcome to the Water Planet, 1987

244 James Rosenquist working on
Welcome to the Water Planet, 1987

245 *Source for Welcome to the Water Planet*, 1987
Magazine clippings, unidentified clippings,
and mixed media on paper
14 3/16 × 13 ¼ in. (36 × 33.7 cm)
Private collection

243

245

Through the Eye of the Needle to the Anvil, 1988

246 *Source for Through the Eye of the Needle to the Anvil*, 1988
Photocopies, photographs, magazine clippings,
printed paper, and mixed media on plywood
18 ½ × 36 ⅜ in. (47 × 92.4 cm)
Estate of James Rosenquist

247 Detail of the open box above the shoes
(in the middle of the plant leaves), with the inscription
"after all in awe of itself is death."

248 James Rosenquist working on
Through the Eye of the Needle to the Anvil, 1988

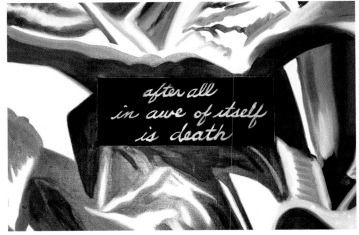

247

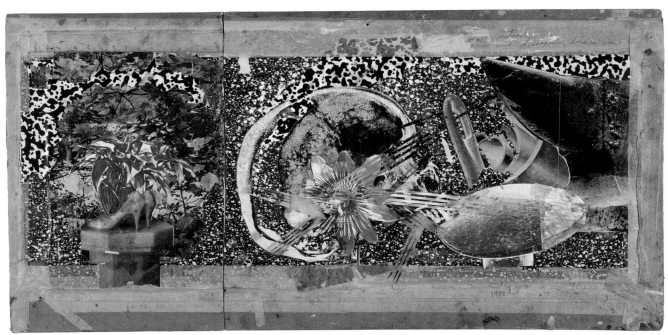

246

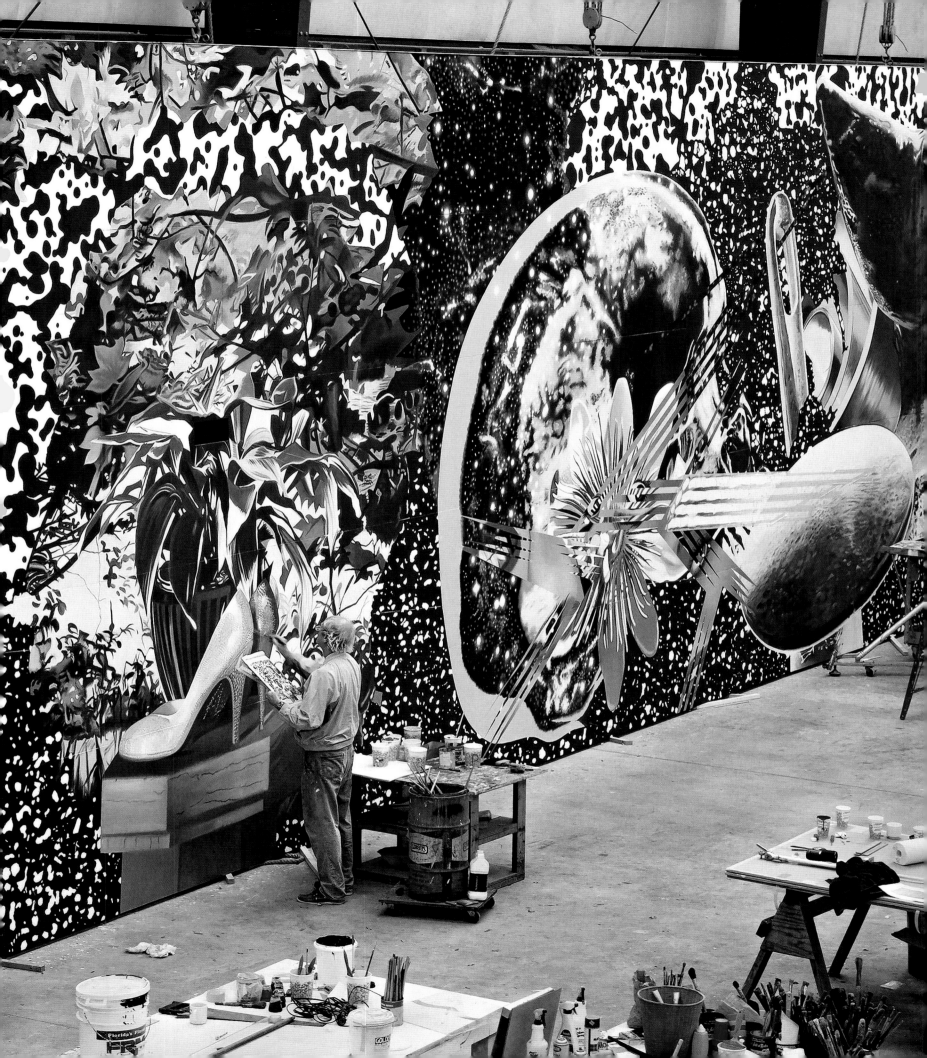

The Bird of Paradise Approaches the Hot Water Planet, 1989

249 James Rosenquist in paper mill studying newly made colored paper pulp sheet for his *The Bird of Paradise Approaches the Hot Water Planet* from the *Welcome to the Water Planet* series with collage colored paper pulp proof mounted on cardboard in the background, Tyler Graphics Ltd., Mount Kisco, New York, 1988

250 *Source for The Bird of Paradise Approaches the Hot Water Planet and Untitled*, 1988
Magazine clippings, photocopy, and mixed media on unidentified clipping
11 ⅝ × 10 in. (29.5 × 25.4 cm)
Private collection

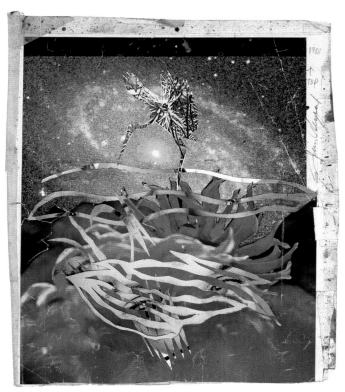

250

251

252

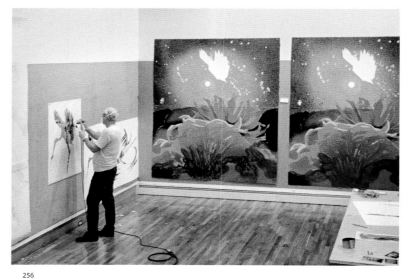

253

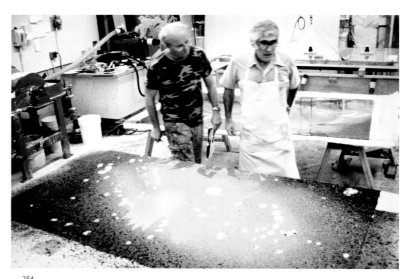

254

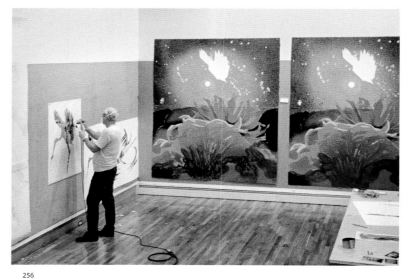

255

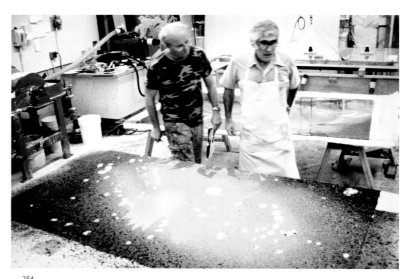

256

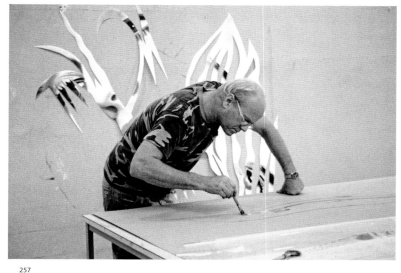

257

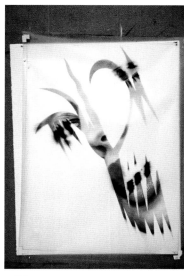

258

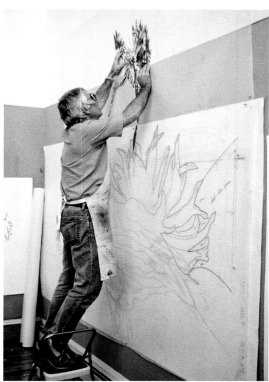

259

Development of *The Bird of Paradise Approaches the Hot Water Planet* from the *Welcome to the Water Planet* series, paper mill, Tyler Graphics Ltd., Mount Kisco, New York, 1988

251 Kenneth Tyler removing plastic stencils from newly colored wet paper pulp sheet

252 Paul Imboden and John Fulton assisting James Rosenquist spraying colored paper pulp with pattern pistol through plastic stencil onto wet paper pulp sheet

253 Paul Imboden assisting James Rosenquist spraying colored paper pulp with pattern pistol through Lexan plastic stencil onto wet paper pulp sheet

254 Kenneth Tyler and James Rosenquist in paper mill checking newly colored paper pulp sheet

255 Paul Imboden in paper mill adding blue pulp to wet paper pulp sheet

256 James Rosenquist in artist studio air brushing Mylar for lithography element, and two proofs pinned on workshop wall

257 James Rosenquist drawing with lithographic tusche on aluminum plate for lithography collage element in the artist studio with printed lithography elements pinned on the wall

258 Printed Mylar sheets with lithographic collage elements pinned on workshop wall

259 Kenneth Tyler attaching printed collage element to artist studio wall above key line drawing

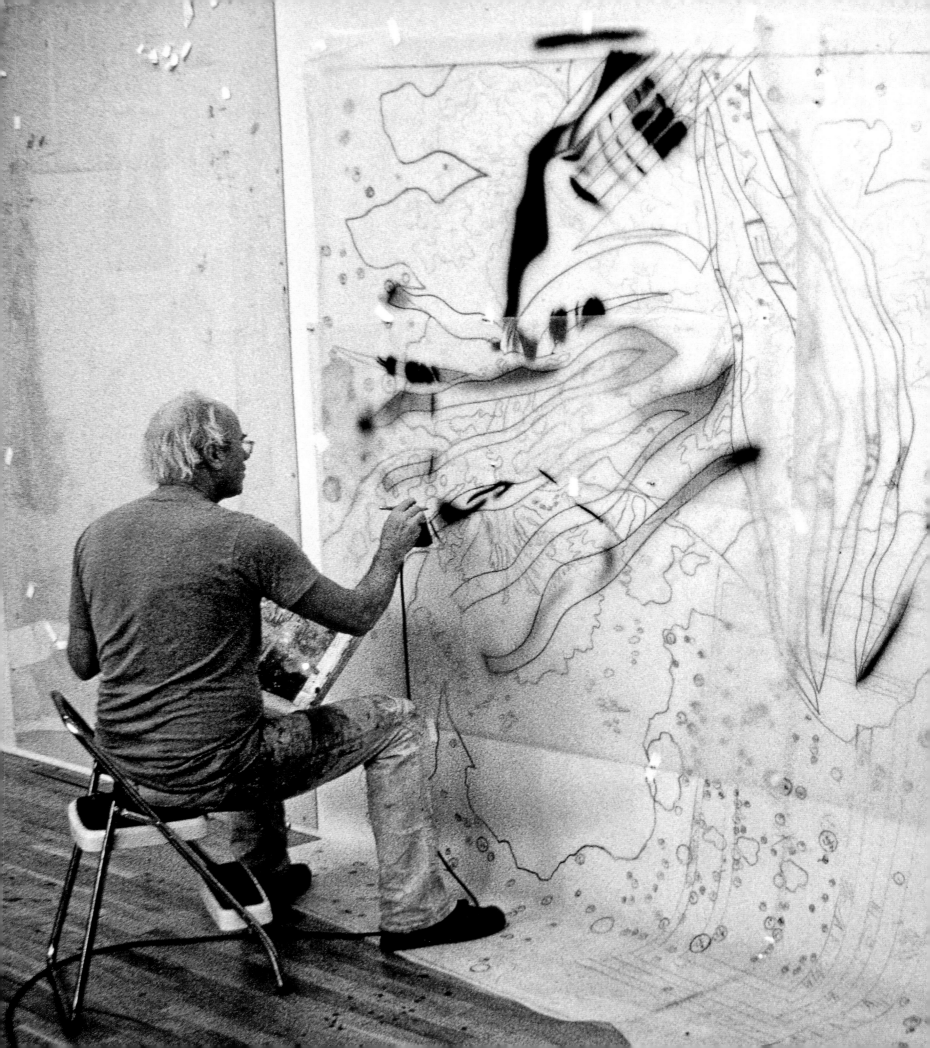

Time Door Time D'Or, 1989

260 James Rosenquist air-brushing Mylar for lithography collage element on artist studio wall for *Time Door Time D'Or* from *Welcome to the Water Planet* series, Tyler Graphics Ltd., Mount Kisco, New York, 1989

261 Kenneth Tyler and Doug Humes in paper mill removing plastic stencil from newly sprayed colored paper pulp sheet

262 *Source for Time Door Time D'or*, 1989
Magazine clippings, unidentified clippings, and mixed media on corrugated cardboard
16¼ × 18½ in. (41.3 × 47 cm)
Estate of James Rosenquist

261

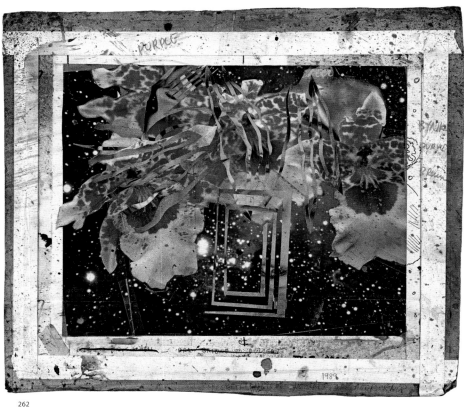

262

221

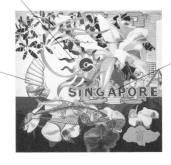

264

263

265

Untitled, 1995

263 Singapore five-dollar banknote, 1988

264 Singapore ten-dollar banknote, 1988

265 *Source for Untitled*, 1995
Color photocopies and mixed media on plywood
16 9/16 × 14 13/16 in. (42.1 × 37.6 cm)
Estate of James Rosenquist

266 Exhibition *Singapore, Three Large Paintings*,
at Galerie Thaddaeus Ropac, Paris, 1997

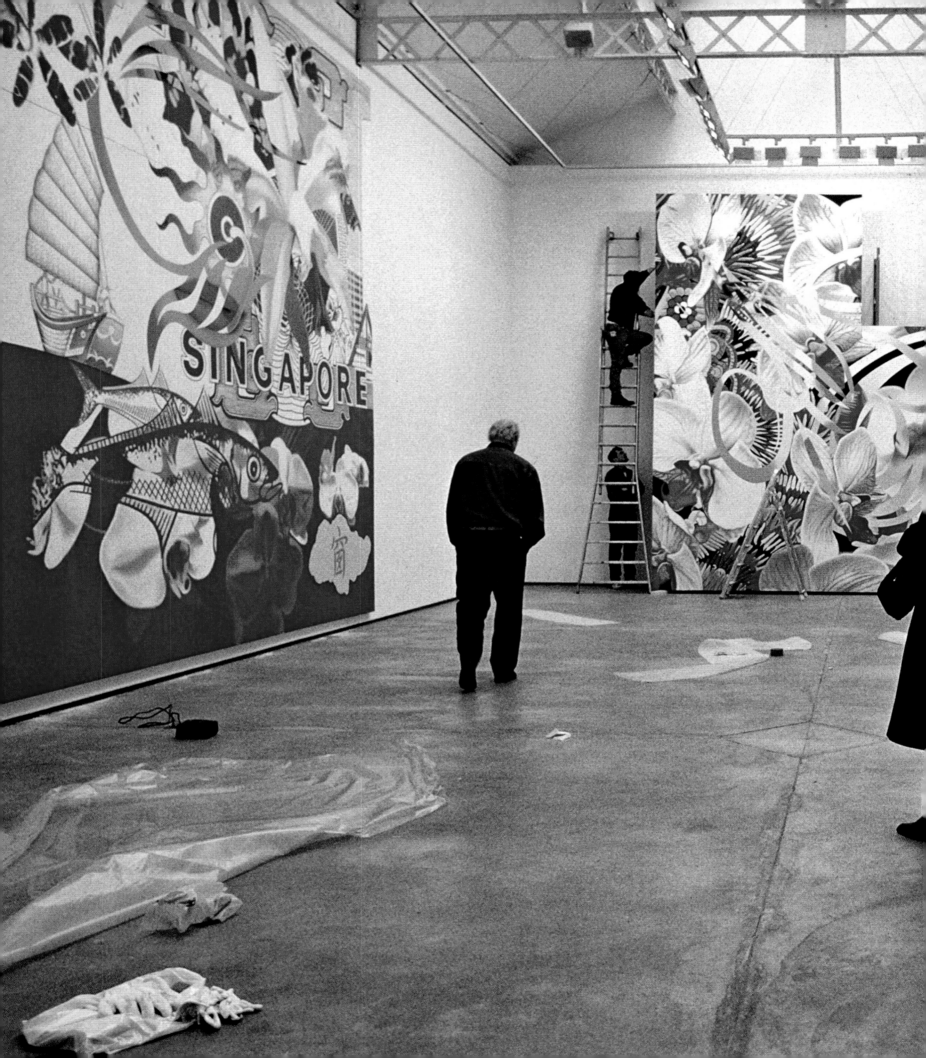

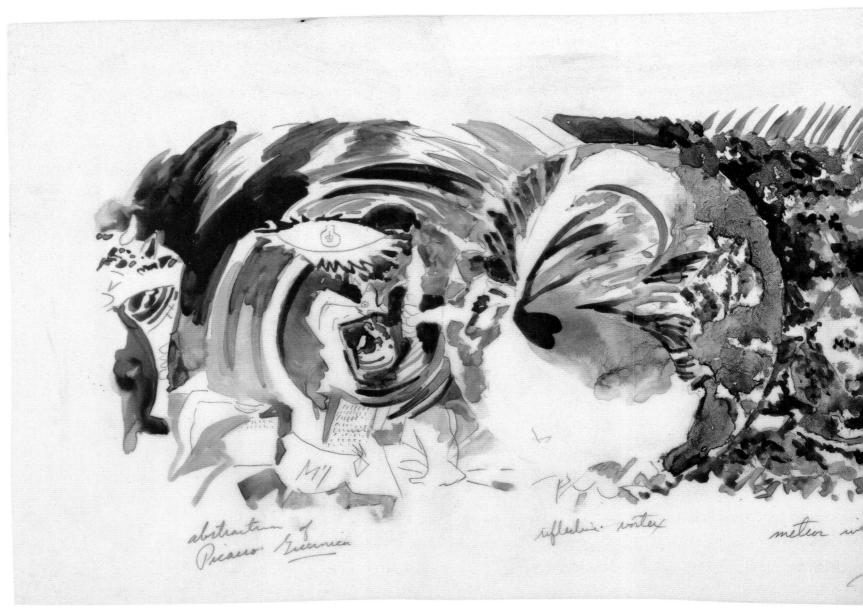

267

267 *Study for The Swimmer in the Econo-mist #1*, 1996—97
Lithographic ink and pencil on Mylar
16 ¼ × 45 ¾ in. (41.3 × 116.2 cm)
Sammlung Deutsche Bank AG

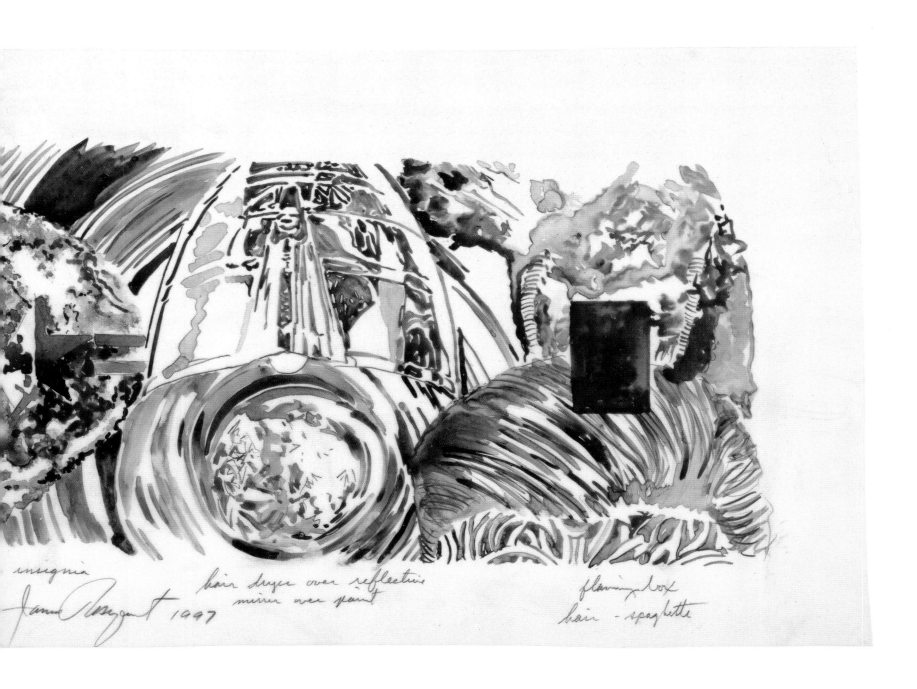

insignia

James Rosenquist 1947

hair dryer over reflective
mirror over paint

flamingo box
hair – spaghette

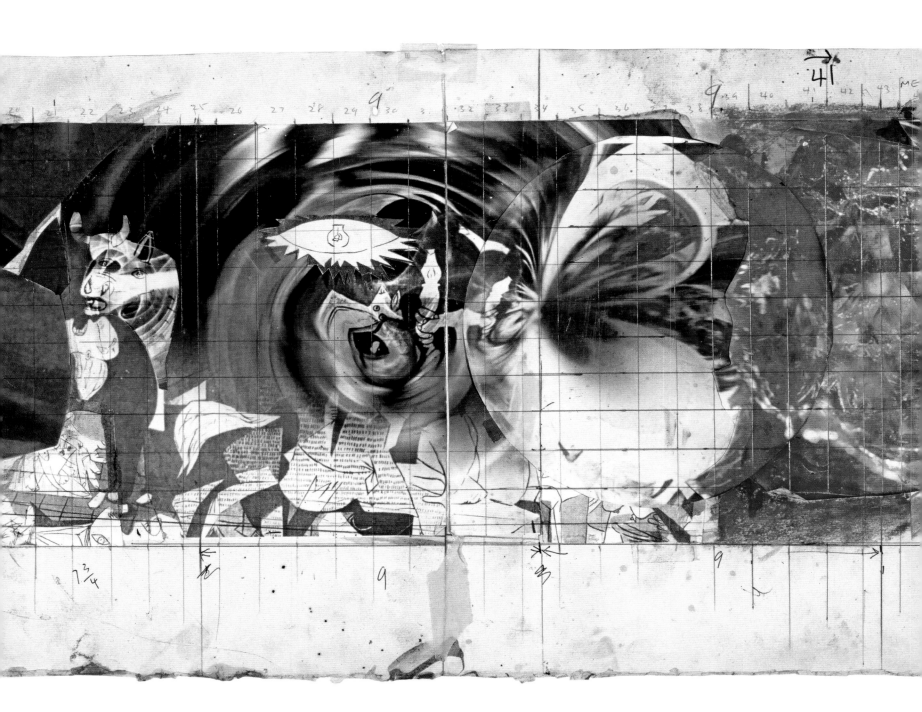

276

268 *Study for The Swimmer in the Econo-mist #1*, 1997
Lithographic ink and pencil on Mylar
15 ¾ × 45 ⅞ in. (40 × 116.5 cm)

269 *Study for The Swimmer in the Econo-mist #1*,
1996–97
Lithographic ink and pencil on Mylar
16 ⅝ × 36 ¼ (42.2 × 92.1 cm)

270 *Study for The Swimmer in the Econo-mist #1*, 1997
Mixed media on paper
18 ½ × 37 ½ in. (47 × 95.3 cm)

271 *Study for The Swimmer in the Econo-mist #2*, 1997
Lithographic ink and pencil on Mylar
20 ⅛ × 26 ¼ in. (51.1 × 133 cm)

272 *Study for The Swimmer in the Econo-mist #3*, 1997
Lithographic ink and pencil on Mylar
20 ⅛ × 26 ¼ in. (51.1 × 66.7 cm)

273 *Study for The Swimmer in the Econo-mist #3*, 1997
Mixed media on Mylar
20 × 25 ¾ in. (50.8 × 65.4 cm)

274 *Study for The Swimmer in the Econo-mist #1* and *#3*,
1996–97
Lithographic ink and colored ink on Mylar
16 × 27 ¾ in. (40.6 × 70.5 cm)

275 *Study for The Swimmer in the Econo-mist #1* and *#3*,
1997
Pencil on paper
21 ¾ × 49 ¾ in. (55.2 × 126.4 cm)

Sammlung Deutsche Bank AG

268

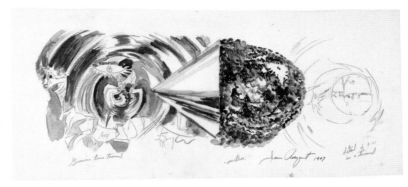

269

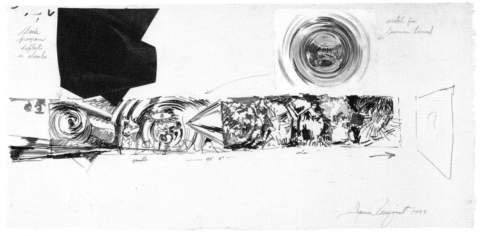

270

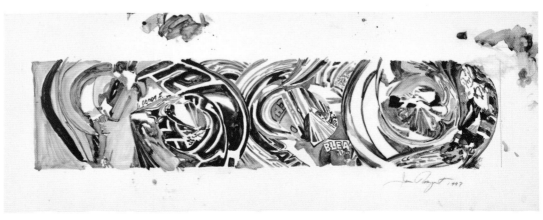

271

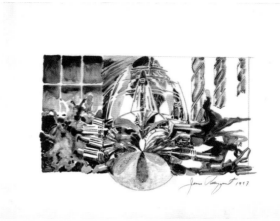

272

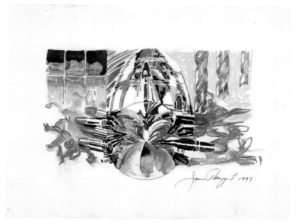

273

274

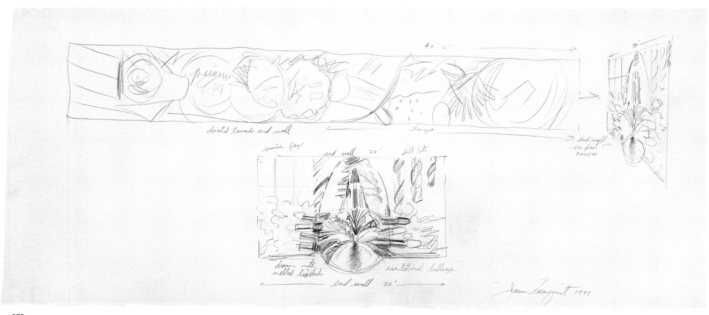

275

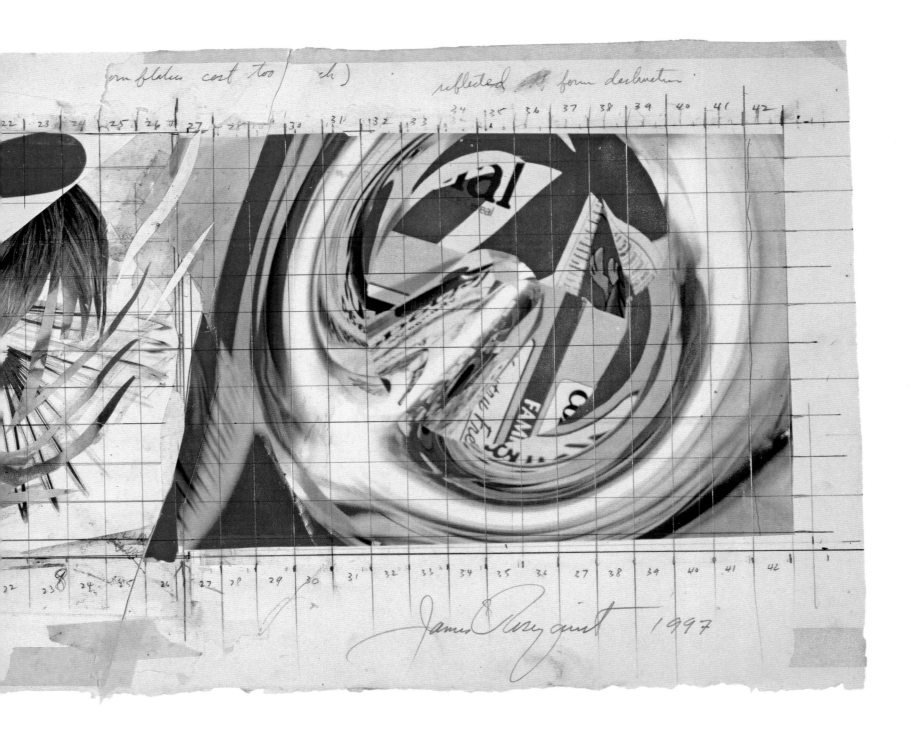

(corn flakes cost too much) reflected [x] form destruction

22 | 23 | 24 | 25 | 26 | 27 | 28 | 30 | 31 | 32 | 33 | 34 | 35 | 36 | 37 | 38 | 39 | 40 | 41 | 42

22 | 23 | 24 | 25 | 26 | 27 | 28 | 29 | 30 | 31 | 32 | 33 | 34 | 35 | 36 | 27 | 38 | 39 | 40 | 41 | 42

James Rosenquist 1997

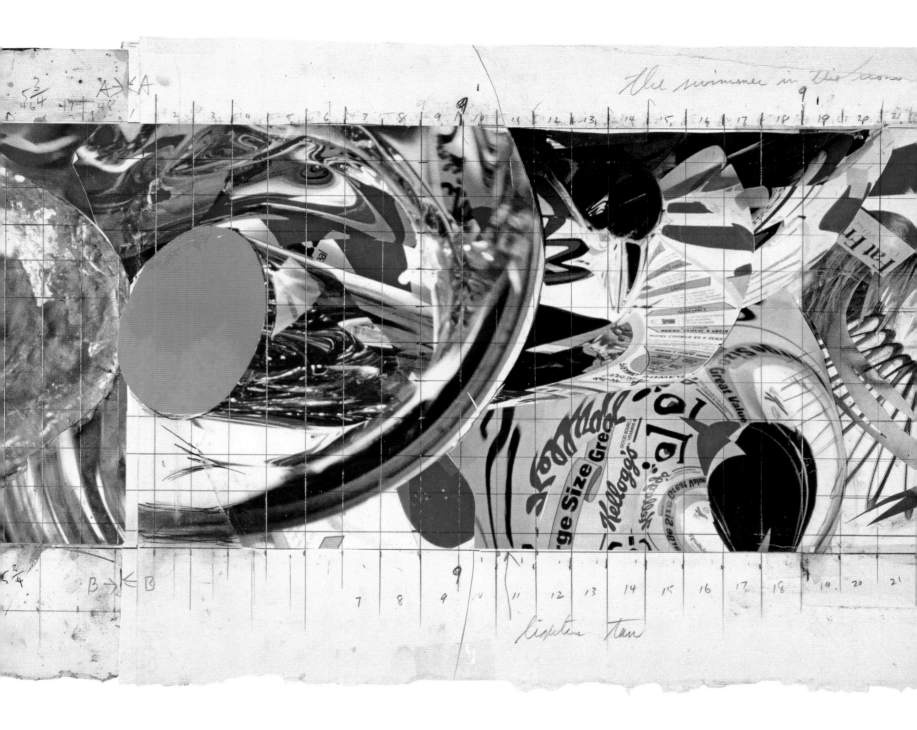

276 *Source for The Swimmer in the Econo-mist #1*, 1997
Mixed media on paper
15 ¾ × 90 ⁹⁄₁₆ in. (40 × 230 cm)
Sammlung Deutsche Bank AG

277

277 *Source for The Swimmer in the Econo-mist #1*, 1997
 Color photocopy and mixed media on cardboard
 11 ⅝ × 18 ¼ in. (29.5 × 46.4 cm)
 Estate of James Rosenquist

278 *Source for The Swimmer in the Econo-mist #2*, 1997
 Mixed media on paper
 14 × 47 ⅝ in. (35.6 × 121 cm)
 Sammlung Deutsche Bank AG

279 *Source for The Swimmer in the Econo-mist #1*, 1997
 Color photocopy and mixed media on cardboard
 11 ⅞ × 17 ⅞ in. (30.2 × 45.4 cm)
 Estate of James Rosenquist

280 *Source for The Swimmer in the Econo-mist #3*, 1997
 Mixed media on paper
 17 × 23 ¼ in. (43.2 × 59.1 cm)
 Sammlung Deutsche Bank AG

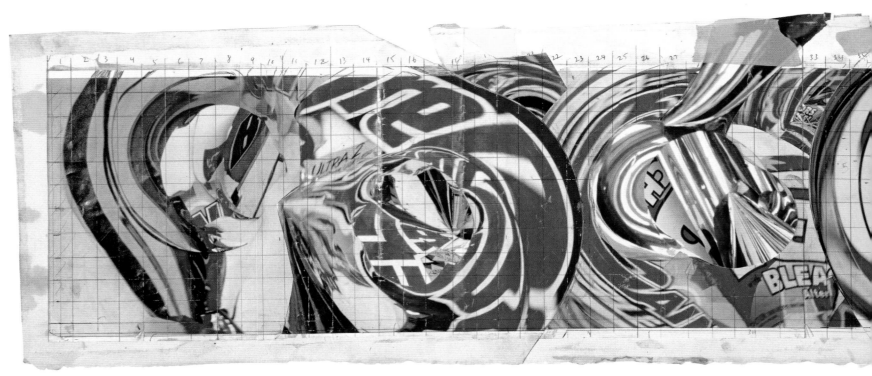

278

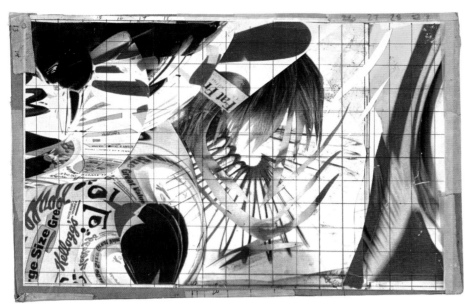

279

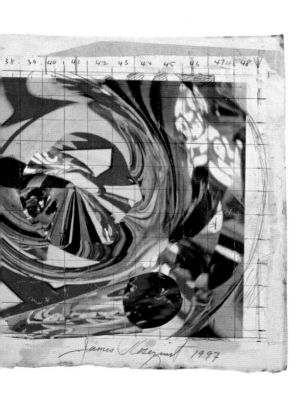

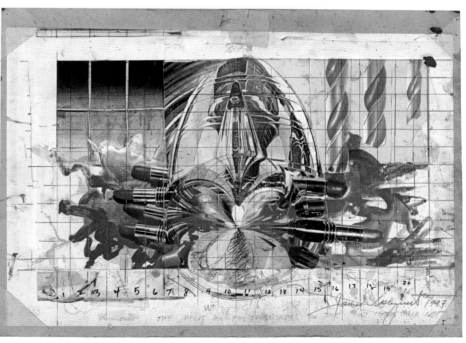

280

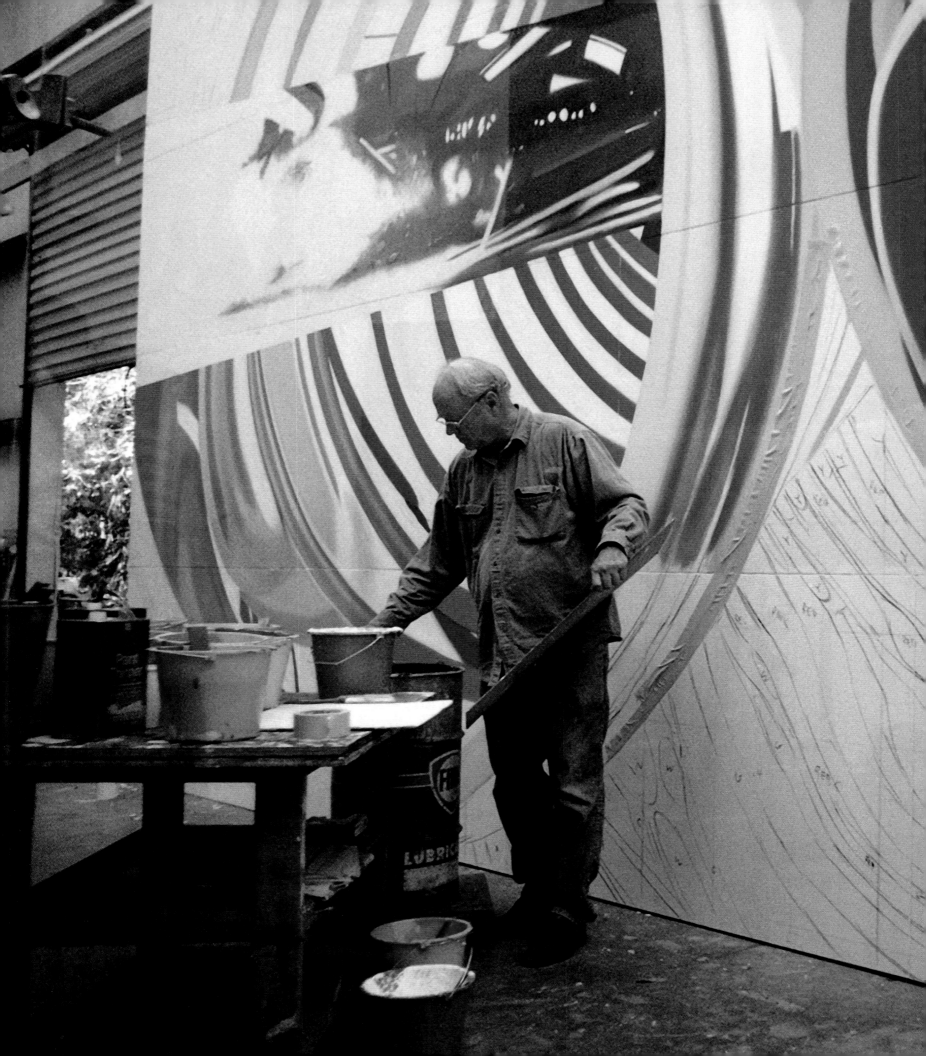

The Stowaway Peers Out at the Speed of Light, 2000

281 Rosenquist painting *The Stowaway Peers Out at the Speed of Light* (2000)
in his Aripeka, Florida, studio, ca. 2000

282 *Source for The Stowaway Peers Out at the Speed of Light*, 2000
Color photocopies and mixed media on plywood
14 × 29 ½ in. (35.6 × 74.9 cm)
Estate of James Rosenquist

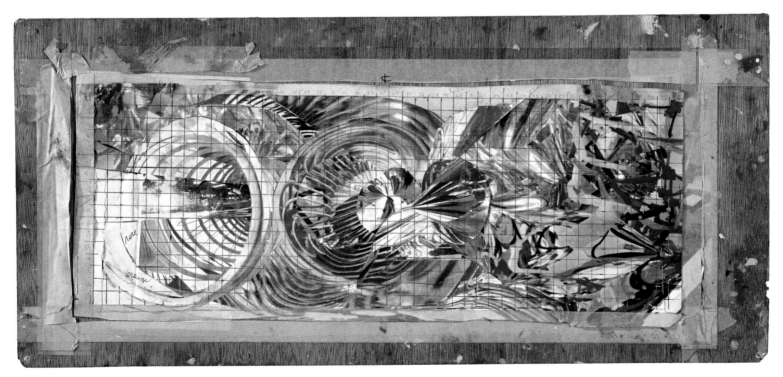

282

The Geometry of Fire, 2011

283 *Source for The Geometry of Fire*, 2011
Color photocopies and mixed media on cardboard
13 ⅜ × 29 ¼ in. (34 × 74.3 cm)
Estate of James Rosenquist

284 *Source for The Geometry of Fire*, 2011
Color photocopies and unidentified clippings on paper
15 ¾ × 31 1/16 in. (40 × 78.9 cm)
Estate of James Rosenquist

Opposite page: Detail of *Source for The Geometry of Fire*, 2011

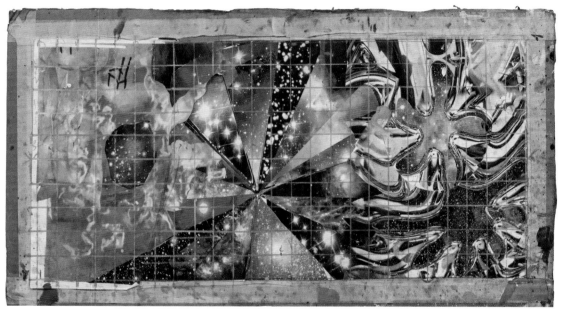

283

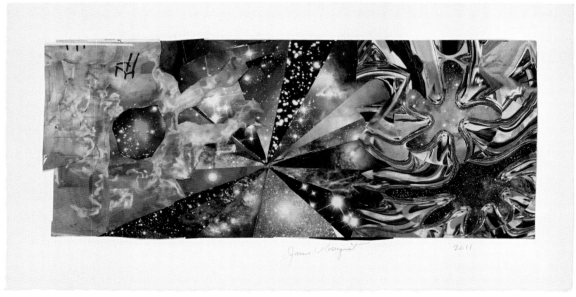

284

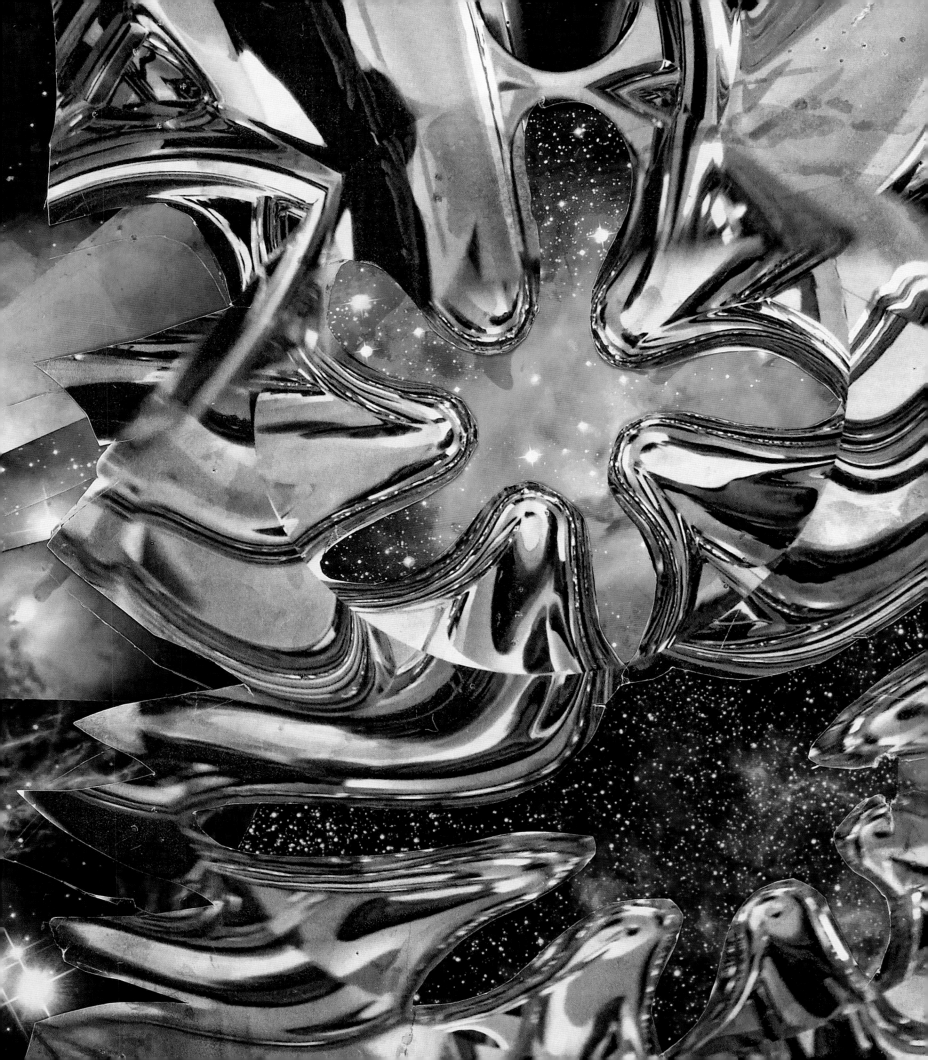

Pop and Politics in the Work of James Rosenquist

Yilmaz Dziewior

285

It's not that I'm apolitical—I feel very strongly about civil rights and moral issues and I've done many paintings in protest against stupid wars, stupid laws, ruthless politicians, and greedy entrepreneurs— it's simply that I don't think artists should preach.[1]

From an art-historical perspective, James Rosenquist's images are as paradigmatic for Pop art as the work of Lichtenstein and Warhol, corresponding to Lawrence Alloway's characterization of the movement.[2] A critic and curator known due to his texts and exhibitions as one of the initiators and supporters of Pop art, Alloway describes the movement's classical characteristics in his catalogue for the now-legendary exhibition *Six Painters and the Object* at New York's Guggenheim Museum in 1963: "the use of objects drawn from communications network and the physical environment of the city."[3] Rosenquist's motifs, adapted from magazine advertisements, are precisely this: situations and objects drawn from the communication circuits of everyday urban life. But it is not only what his images portray that corresponds to the world of advertising and consumption; it is also how they are painted. For Rosenquist's large-scale, realistic technique is that of the billboard painter transferred to canvas, to an artistic context. Often his images are visual excerpts that in some cases can be recognized only at a distance as iconic images laden with meaning, like the laughing face of a woman or the hood of a car.

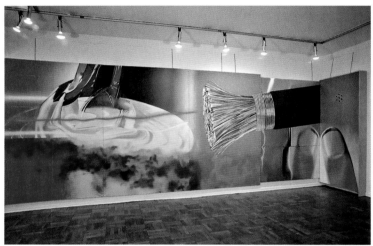

286

Although the application of the Pop-art label to his work by curators such as Alloway or Gene Swenson[4] was certainly no disadvantage to the spread of his work in the New York of the early 1960s, Rosenquist's strong reservations about any classification of his work and the inevitable accompanying generalizations and simplifications are entirely understandable. The Pop-art label was one that he particularly disliked. He did note in his autobiography that what united him with Warhol, Oldenburg, and Lichtenstein was a shared aversion to "the drip, the splash, the schmear"—in short, to Abstract Expressionism—combined with an ironic attitude toward the banality of American consumer culture, but his ultimate conclusion was that "If anything, you might say we were *anti*pop artists."[5] This self-assessment may also have to do with the fact that Pop art was sometimes understood to take an affirmative approach to its themes as its starting point, an assumption that ignores any critical potential or political stance. This essay is concerned with exactly these aspects, namely, to what extent Rosenquist adopted a decidedly political and socially critical stance.[6] That Rosenquist certainly would not have described himself as an explicitly political artist makes the main thrust of this essay no easy task.[7] His evasive answers to specific questions posed by Max Hollein about the degree of political engagement in his art or whether he intended his works to have political meaning at all clearly reflect this as well.[8] At the same time, Judith Goldman, who has written several books about Rosenquist, reports that he often spoke about politics in public lectures, sometimes unexpectedly. This happened, for example, at Beersheba University in Israel, where, to the surprise of his audience, he spoke for twenty minutes solely about Livingston Biddle, the author of the statutes of the National Endowment for the Arts (NEA) under Jimmy Carter.[9]

285 Mary Lou, James, and Ruth Rosenquist at the Guggenheim exhibition *Six Painters and the Object*, New York, 1963

286 *Horse Blinders*, presentation at Leo Castelli Gallery, March 29–April 19, 1969

I. Technique and Effect

In his autobiography Rosenquist describes the dominance of Abstract Expressionism during the early days of his own artistic career. Despite his personal appreciation for William de Kooning and Franz Kline and his own early abstract compositions, he writes, he had to seek out a different path for himself. At the same time, he characterizes his artistic approach as a response to the cacophony of commercial images that surrounded him, whether on billboards, on television, or in newspapers and magazines. The latter—in particular those images found in magazines like *Life*—formed the basis for most of his early figurative paintings. Here the driving force was not a predilection for the world of goods as such, with which Andy Warhol liked to flirt; rather, what interested Rosenquist was the strategy and suggestive formal power with which advertising contrives to generate attention.[10] That he turned to the medium of collage as a technique for making his paintings is significant. For this very technique has a long tradition of political and social criticism in the hands of artists like John Heartfield, Hannah Höch, and the Russian Constructivists.[11] No less politically charged is the other major reference for his work: Mexican mural painting, as made by artists like Diego Rivera and David Alfaro Siqueiros, in whose creations Rosenquist was interested particularly in relationship to his own knowledge of billboard painting.[12] But it is above all the combination of found images through collage to which Rosenquist had immediate proximity; Jasper Johns and Robert Rauschenberg, for example, used similar approaches when they sometimes would arrange discrete objects to make a work, as Rauschenberg did in his Combines. While the collages of Johns and Rauschenberg were themselves intended for exhibition, for Rosenquist the strategy of collaging was only a means to an end, and collage served merely as a starting point for his paintings.[13] Just as he relegated his source material to the background at the beginning of his career, the additional thematization of societal aspects seemed to him of lesser importance. More important to him was the invention of a new formal language, which operated by means of fragmentation, enlargement, and the resulting alienation.

II. Blind Spots

An example of the way the artist himself denies any direct political interpretation of his work can be seen in his own comments on *Horse Blinders* in December 1968, that is, during the time he was still creating the work. For the catalogue *Art of the Sixties in the Wallraf-Richartz-Museum*, Rosenquist composed a short text in which he writes associatively about odd radio programs and other relatively cryptic incidents, ending with a play on words that expresses a wish for a fish commonly found in Arkansas, the catfish, to sprout legs.[14] He waxes concrete only when he concerns himself with the formal reception of his work, for instance, when he says that he is interested in "the speed with which one recognizes color in space."[15] And it is precisely these moments of aesthetic reception that are highlighted early on in Rosenquist's work by critics such as Lucy Lippard. In an essay about the artist in the December 1965 issue of *Artforum*, she describes how the depicted objects and people are robbed of their identity by this particular kind of painting. One could almost believe that the artist himself is speaking when Lippard writes, "To Rosenquist it makes no difference what things are called. What they look like counts."[16] He himself expresses it like this: "It seemed an almost absurd idea to use objects as abstractions, but that was what I was beginning to think about."[17] Though the two quotations from Lippard and Rosenquist are not expressly referring to *Horse*

Blinders, they provide quite a good characterization of the effect of most of Rosenquist's works produced in the 1960s and 1970s. This reception results not least from the artist's avoidance of the political dimension of his pictorial subjects. It would be almost thirty years before Rosenquist himself in his autobiography made clear the way that the subjects used in *Horse Blinders* were anchored in a socio-political context. In hindsight he describes the environment as a "political pun" and describes the repertoire of images he uses as a reaction to the election of Richard Nixon.[18] It is true that, in his 2009 description, he also refers to the idea of aesthetics by emphasizing the painting's size and the way this leads to peripheral and simultaneous perception of the subjects, but it should also be noted that he unequivocally interprets the loose ends of the telephone cable as a Gordian knot that has been cut through. According to his own account, he here separates—as Alexander the Great once did the impossibly knotted ropes—the phone cables of the Bell company (forerunner of the monopoly giant AT&T), which, he points out, was particularly hated in leftist circles in the 1960s because of its surveillance activities. In a similar vein, Rosenquist interprets the fingertip in the image as an expression of individual DNA and means of identification used by authorities. Often, however, these descriptions also betray an ambivalence between the visual appearance of the representations, which are described both in terms of their formal effects, for example their reflectiveness, and their immediate political reference, such as the purple swathes of smoke from Israel's Six-Day War that appear on the adjacent panel. In contrast to some consumer articles and other images that Rosenquist deliberately extracted from their temporal context, by choosing, for example, a Ford from the 1950s for his 1961 *I Love You with My Ford* in order to create emotional distance for the viewer, in this undeniably political work he uses an image that was barely one year old.[19]

Horse Blinders demonstrates Rosenquist's complex approach of composing politically connotative imagery using a combination of everyday objects (electric cables, butter in pan, et cetera) and military motifs (smoke clouds). Here, he increases the menacing mood evoked by the smoke clouds by means of the electric cables that jut aggressively into the pictorial space and the precarious tilting of the pan on the red-hot stovetop. At the level of aesthetic reception, too, he is able to confront the viewer with the vehemence of approaching objects in extreme colors from which, because they encompass all walls of the room, there is no escape. Lucy Lippard speaks of an "elephantine trompe-l'oeil" that encases the viewer and continues, in her above-mentioned text: "Where other Pop artists have used scale to overpower but not to attack, holding the image on the picture plane on an arrogant withdrawal, Rosenquist uses his gigantism as an assault on normality: this is the first aspect of his work."[20] Without knowing the actual concrete social and military references, Lippard grasps their impact through formal analysis of the work alone.

III. Clarity through De-Clarification

In *Forest Ranger* from 1967, Rosenquist uses a subject borrowed from the military in combination with an everyday object to create an installation with all-encompassing force. This catalogue features, for the first time, a reproduction of the original advertisement culled from the October 30, 1944, issue of *Life* magazine showing the "Chevrolet-Built Armored Car," a special vehicle presented as a secret weapon of the Allies, with special attention given to its armor plating and the fact that its weight is an astonishing fourteen tons.[21] By combining this object

with a meat saw, Rosenquist created an installation whose aggressive bluntness is lent a disconcerting lightness through the handling of subject matter and material. Rosenquist painted the pictures with oil paint on a surface of thick Mylar (polyester) sheets cut into strips, through which the viewer is meant to move. If in his room-scaled images viewers are able to tackle what is portrayed through the work's sheer size and appellative effect, in works like *Forest Ranger* they become physically active recipients whose loss of physical and emotional distance to the content is even greater. In this work, Rosenquist further advanced his basic ideas of immersion that had already been laid out in his large-scale and sometimes room-filling works. It seems as if, through his almost playful approach, he intended to make the drastic nature of the topics and subject matter he negotiated in it more bearable. It is this contradiction between, on the one hand, the Pop-like attributes and sometimes cheerful, bright colors of his works and, on the other, the sometimes abysmally dark content that, from my perspective, is a unique feature of his work. The contradiction gives rise to a certain accessibility that has undoubtedly contributed to the artist's great popularity, but has at the same time obscured the critical and resistive potential in the work and so pushed it to the background.

How little the latter is given focus even by those who knew Rosenquist, Marcia Tucker illustrates in her reading of the work *Early in the Morning*, 1963.[22] Her interpretation, in which she describes at length a story from Rosenquist's time as a billboard painter, and in which she names time and space as essential features of the painting, has nothing to do with the artist's own intention, as he himself says in his autobiography. Even if Rosenquist does not write more specifically

about his intention, the article from February 7, 1949, in *Life* magazine, published here for the first time in connection with *Early in the Morning*, documents the origins of the barefooted boy in an explicitly political environment. The article luridly describes the aggression of black South Africans towards their fellow citizens who are ethnically Indian. Rosenquist, in his preparatory collage and the resulting painting, covered the upper body of the black South African young man with the illustration of an orange, which he transposed, in reverse, from an advertisement for J. William Horsey's orange juice. This obscures the figure's ethnicity. At the same time, Rosenquist underscored the threatening mood of his source material by combining the image with a stormy sky (conceived and rendered by himself and not a direct visual citation).[23] The fact that Rosenquist was also concerned with formal aspects here is shown by his note on the source collage that reads "orange and blue feet." In contrast to the picture *Red Race Riot*, also created in 1963, in which Warhol reproduced the source image using a silkscreen-printing process several times on the canvas for viewers to see clearly, Rosenquist preferred a more open approach to his subject. While Warhol could be accused of reinforcing, through repetition, the victim status of the depicted African-Americans suffering police violence, and could even perhaps be accused of using them to gain cultural and economic capital,[24] Rosenquist avoids stereotypical attributions in *Early in the Morning* in favor of an image that may be less overtly critical, but nevertheless expresses the threatening mood of his source. Rosenquist's interest in this problem is illustrated by his painting *Painting for the American Negro* (1962–63), which was made shortly before *Early in the Morning*. He painted it during the Civil Rights protests and it illustrates, according to his own statement, the discrimination against a black middle class and the problem that the perception of African-Americans is still determined by stereotypes.[25]

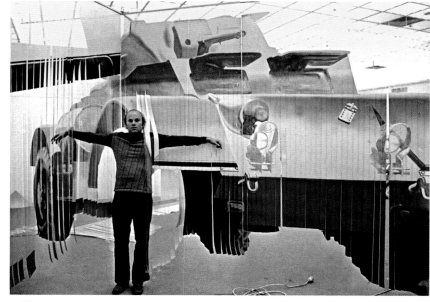

287

287 Rosenquist with *Forest Ranger* during the installation of the exhibition *James Rosenquist: Gemälde—Räume—Graphik* at the Josef-Haubrich-Kunsthalle Köln/Wallraf-Richartz-Museum, Cologne, 1972

288 Andy Warhol
 Red Race Riot, 1963
 Silkscreen on canvas
 137.8 × 82.7 in. (350 × 210 cm)
 Museum Ludwig, Cologne,
 Donation from the Ludwig Collection 1976

289 *Early in the Morning*, 1963
 Oil on canvas and plastic
 95 × 56 in. (241.3 × 142.2 cm)
 Virginia Museum of Fine Arts, Richmond,
 Gift of Sydney and Frances Lewis

290 *Painting for the American Negro*, 1962–63
 Oil on canvas
 6 ft. 8 in. × 17 ft. 6 in. (203.2 × 533.4 cm)
 National Gallery of Canada, Ottawa

288

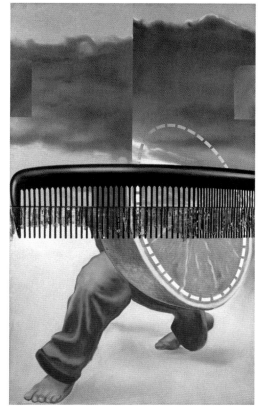

289

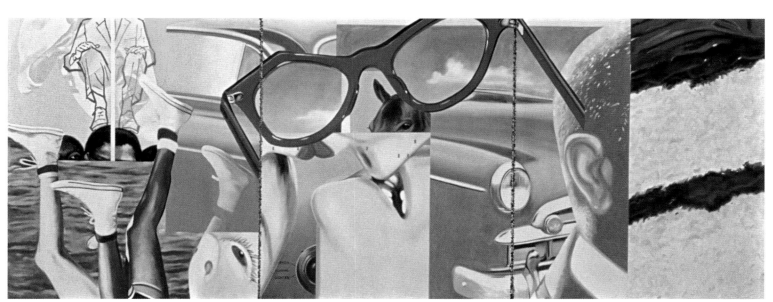

290

291

292

293

IV. Lived Politics

Rosenquist's reflections on the political and social conditions of his time were not only reflected in some of his major works, but also led to concrete actions, such as his participation in antiwar demonstrations protesting the military action of the United States in Vietnam. For one of these protest marches in New York in 1967, he painted his (now lost) *Fruit Salad on an Ensign's Chest*, which was mounted on a truck that was used as a speaker's podium. The picture showed a woman's hand with a saltshaker over a collection of geometric war decorations. Previously, Rosenquist had already participated in the exhibition *The Collage of Indignation* as part of "Angry Arts," a week of protest against the Vietnam War (January 29 to February 8, 1967). In turn, this was closely linked to the *Tower of Protest* or "Peace Tower" installed in Los Angeles in 1966, to which Rosenquist also contributed.[26] This gigantic yellow-and-purple painted steel structure was conceived by the sculptor Mark di Suvero and the architect Kenneth H. Dillon and adorned with 418 specially designed works by artists. Forty years later, in 2006, the tower was revived by di Suvero, Irving Petlin, and Rirkrit Tiravanija at the Whitney Museum in New York as a protest against the Iraq War. To this iteration, too, Rosenquist gave a piece of work, this time a panel of chrome-plated barbed wire, on which were scattered fragments of the American flag along with the words "Chrome Barbwire for the Military Industrial Complex."[27]

291 *Fruit Salad on an Ensign's Chest*, 1967
 Oil on canvas and fiberboard
 9 × 24 ft. (274.3 × 731.5 cm)
 Destroyed
 The title of the painting, which was destroyed during the protest, is slang for the military medals and service ribbons worn on a soldier's dress uniform.

292 Mark di Suvero, *Artists' Tower for Peace*, 1966

293 On the right, second row from bottom:
 Body Count, Rosenquist's contribution to the *Artists' Tower for Peace*

294 Artists' rights Senate subcommittee hearing, Washington, D.C., 1974. Left to right, seated: Congressman John Brademas, Congressman Edward Koch, Senator Jacob Javits, Marion Javits, and Senator Claiborne Pell; and standing: Rosenquist and Robert Rauschenberg

295 Letter from the White House, September 26, 1978

294

THE WHITE HOUSE
WASHINGTON

September 26, 1978

Dear Mr. Rosenquist:

The President is seriously considering you for appointment to the National Council on the Arts.

In order to proceed with the appointment process, I am enclosing a packet of forms for you to complete and return to me at your earliest convenience. If you have any questions regarding these forms, please do not hesitate to call my office. Roberta Adams will be able to answer your questions (202-456-7165).

Please do not discuss this with anyone yet. The FBI and financial investigations will probably take about two months. Once this has been completed, the White House Press Office will issue an announcement.

With best wishes,

Sincerely,

Peggy Rainwater
Associate Director
Presidential Personnel

Mr. James A. Rosenquist
46 Springs-Fireplace Road
East Hampton, NY 11937

Enclosures

295

296

297

(7)

During the time I've taken to write this, the current acceleration of the
change of events regarding government support for the arts, business support
for the arts and the fate of the National Endowment for the Arts under the
new Reagan-Bush administration drastically has changed. The new government
senses a need for extreme budget cuts in every area except military spending.
In the New York Times, during the height of the Vietnam conflict, the annual
government military contracts to major corporations were published. If one
added up all the arts activities in the United States for the same year,
including dance, museums, theatre and even large Hollywood films, it wouldn't
compare as a drop in the bucket to the enormous military expenditures for
Vietnam.

On Sunday, April 28, 1981, in a United States chamber of commerce program,
the panelists seem to agree that art should become a business to be able to
make it on its own. Mr. Herb Schmerz, of Mobil Oil, stated that art groups
should be able to make it as a business. Mr. Schmerz was happy to announce
that art finance should be left to the private sector and will happily be
taken over by big business. One member said that art in America is alive and
healthy and always was, in spite of government support. Mr. Marshall said to
write your views to your congressman.

I remember a time not long ago when art barely existed in New York, and the
future of art in America doesn't look good now. With big business support, I
sense

The United States is a great country. Let's encourage the arts and letters,
and new forays into art. Let's build one or two less missles and provide the
National Endowment for the Arts- with its history of a hands-off attitude-
with a healthy, growing budget. Let's not let large corporate control solely
lead us into 1984.

 James Rosenquist
 April 1981

298

Beginning at the latest in 1978, Rosenquist supported Joan Mondale,[28] wife of Walter (Fritz) Mondale, the vice president under Jimmy Carter, in her cultural and political activities by not only making his own studio available for events,[29] but also by accepting her invitation to the board of the National Council on the Arts. A letter from the White House from September 26, 1978, which states not only that the president was considering his nomination, but also that the FBI must first obtain information about him, can still be found among the documents in his studio. The letter goes on to request that he not discuss this with anyone yet. In his autobiography, we learn that Rosenquist contacted Joan Mondale to tell her that he had been imprisoned because of his anti-Vietnam War activities, but that she did not see this as an obstacle to his appointment.[30] Of the planned six years on the National Council on the Arts he served only five, among other things because he was no longer willing to accept the increasing budget cuts under Ronald Reagan. In the studio archive is a manuscript page written by the artist in April 1981, only four months after Reagan took office as president, in which Rosenquist strongly criticizes the severe budget cuts in the cultural sector in favor of military spending. The last two sentences are indicative of Rosenquist's succinct yet to-the-point way of expressing himself: "Let's build one or two less missles [sic] and provide the National Endowment for the Arts—with its history of a hands-off attitude—with a healthy growing budget. Let's not let large corporate control solely lead us into 1984." For precisely this—the sole financing of art by corporate sponsorship—was Reagan's idea, whose first term of office would last until 1984. From a contemporary perspective, it is disheartening to see how the influence of large companies and their CEOs on cultural institutions in the United States has expanded since when Rosenquist wrote these lines. That his clear position on the political circumstances remains relevant today is shown by the resignation of the entire Committee on the Arts and Humanities, the organization that succeeded the National Council on the Arts, in protest of the behavior of President Trump.[31]

Rosenquist writes in his autobiography that the United States presidential election had inspired him to create certain works. *F-111* came about when Lyndon B. Johnson was elected, *Horse Blinders* was a response to Richard Nixon, *Star Thief* to Ronald Reagan and *Masquerade of the Military Industrial Complex* (fig. 302) to Bill Clinton.[32] Unfortunately, we cannot know what James Rosenquist might have painted today. Not alone for this reason is his absence sorely felt.

Notes

1 James Rosenquist and David Dalton, *Painting Below Zero: Notes on a Life in Art* (New York: Alfred A. Knopf, 2009), 115.

2 Alloway, originally from Great Britain and living in New York since 1961, was also one of the leading members of the Independent Group and in this context took part in the 1956 exhibition *This is Tomorrow*. Richard Hamilton designed his famous collage *Just what is it that makes today's homes so different, so appealing?* for the exhibition's catalogue, and it served as a template for one of the exhibition posters.

3 Lawrence Alloway, *Six Painters and the Object,* exh. cat. (New York: Guggenheim Museum, 1963), unpaginated. In addition to Rosenquist, Jim Dine, Jasper Johns, Roy Lichtenstein, Robert Rauschenberg, and Andy Warhol were represented in the exhibition. Comprising only thirty-two pages, the entire catalogue is available in the digital archives of the Guggenheim Museum: https://archive.org/stream /sixpaintersobjec00allo#page/2/mode/2up (accessed September 19, 2017).

4 Gene Swenson was another of Pop art's major proponents, and in his series "What Is Pop Art?" for *ARTnews* he interviewed Jim Dine, Stephen Durkee, Robert Indiana, Jasper Johns, Roy Lichtenstein, James Rosenquist, Andy Warhol, and Tom Wesselmann, among others, in November 1963 and February 1964. Cf. Scott Rothkopf, "Banned and Determined," *Artforum,* Summer 2002, 142–45 and 194. How important Swenson was for Rosenquist, the latter makes clear in his autobiography, in which he calls Swenson his "aesthetic collaborator"; cf. Rosenquist and Dalton, *Painting Below Zero,* 116.

5 Rosenquist and Dalton, 100.

6 His use of the Kennedy portrait and the F-111 fighter jet (see fig. 7 and 16 in this catalogue) are detailed here as first examples of his political iconography and are only two of many such references. His engagement in the cultural-political sphere was just as diverse, as the following text shows. In 1974, for example, he and Robert Rauschenberg took the initiative to rally the Senate for artists' rights to share in the profits from the resale of their works.

7 In the extensive literature on James Rosenquist, there is little writing that engages deeply with his relationship to political themes. Sarah Bancroft does so in a highly condensed form in "Modern Issues and Current Events," in *James Rosenquist: A Retrospective*, ed. Walter Hopps and Sarah Bancroft, exh. cat. (New York: Solomon R. Guggenheim Museum, 2003), 126–27. Michael Lobel wrote a comprehensive monograph on this topic in relation to the artist's early work, titled *James Rosenquist: Pop Art, Politics, and History in the 1960s* (Berkeley, Los Angeles, and London: University of California Press, 2009). Cf. also the article by Tim Griffin in this catalogue, 248.

8 Museum in Progress, Portraits of Artists 42, Max Hollein, Conversation with James Rosenquist, New York, April 1997, http://www.mip.at/attachments/193 (accessed September 19, 2017). Thanks to Tino Grass for calling my attention to this interview.

9 *James Rosenquist*, ed. Judith Goldman, exh. cat., Denver Art Museum and five other locations in the United States (New York, 1985), 15: "In fact, in public his conversation often turns to politics."

10 Rosenquist and Dalton, *Painting Below Zero*, 89.

11 Rosenquist relates himself to the Surrealists in connection with his collages, but also explicitly mentions John Heartfield, cf. Rosenquist and Dalton, 302–03.

12 Rosenquist mentions that at this time, that is, in the 1950s, no one else was interested in this, also because these artists had been branded as Marxists, cf. Rosenquist and Dalton, 49.

13 While it is true that among Rosenquist's work are paintings that contain objects, these are the exception.

14 James Rosenquist in *Art of the Sixties in the Wallraf-Richartz-Museum*, ed. Gert von der Osten and Horst Keller (Cologne, 1969), here 5th revised edition (Cologne 1971), insert between pages 165 and 166.

15 Rosenquist in *Art of the Sixties in the Wallraf-Richartz-Museum.*

16 Lucy Lippard, "James Rosenquist: Aspects of a Multiple Art," *Artforum,* December 1965, 41–44.

17 Rosenquist and Dalton, *Painting Below Zero*, 79.

18 For *Horse Blinders*, cf. Rosenquist and Dalton, 196–99, all following quotations and interpretations of *Horse Blinders* are taken from these pages.

19 Rosenquist's surprising statement that the clouds of smoke are a visual reference to Israel's Six-Day War can now be attested for the first time with the matching illustration from *Life* magazine ("Israeli Thrust—The Astounding 60 Hours," *Life*, June 16, 1967, 26–27), showing a direct correlation between the two; see this catalogue on p. 161. Rosenquist painted the image upside down.

20 Lucy Lippard, "James Rosenquist: Aspects of a Multiple Art," *Artforum*, December 1965: 41–44, 41.

21 *Life*, October 30, 1944, 16.

22 Cf. Marcia Tucker, *James Rosenquist*, exh. cat. Whitney Museum of American Art, New York (New York, 1972), 20. A long version of the text can be found at: https://archive.org/stream/srosenquist00rose/srosenquist00rose_djvu.txt (accessed September 19, 2017). Rosenquist mentions that the points raised in Tucker's interpretation were not what he intended in making this picture, but he very much likes the potential his images contain for just such considerations, cf. Rosenquist and Dalton, *Painting Below Zero*, 219–20.

23 Rosenquist has written the note "juxtaposed storm sky" on the collage.

24 Cf. in relation to this theme the discussions around the work by Sam Durant Sam, *Scaffold*, in the sculpture garden of the Walker Art Center in Minneapolis and the image *Open Casket* (2016) that Dana Schutz showed in this year's Whitney Biennial. In both cases there were violent protests in which the artists were accused of profiting from the suffering of African-Americans.

25 Rosenquist and Dalton, *Painting Below Zero*, 188.

26 Cf. for these events: Francis Frascina, *Art, Politics and Dissent: Aspects of the Art Left in Sixties America* (Manchester and New York: Manchester University Press, 1999), 108–10.

27 Cf. for the version from 2006, "Peace Tower: Irving Petlin, Mark di Suvero, and Rirkrit Tiravanija," *Artforum*, March 2006, 252–57, with an illustration of Rosenquist's work on p. 256.

28 Joan Mondale, known due to her exceptional commitment to the arts as "Joan of Art," also wrote a remarkable book on art and politics: cf. the obituary by Anita Gates in *The New York Times*, February 3, 2014, A14.

29 There are several photos of Mondale in Rosenquist's studio, one also in conversation with Mark di Suvero from 1978, who had twelve years prior to this been politically engaged against the Vietnam War and whom Rosenquist at the time also supported with an image.

30 Rosenquist and Dalton, *Painting Below Zero*, 247ff.

31 Cf. Robin Pogrebin, "Arts Committee Resigns In Protest of Trump," *The New York Times*, August 19, 2017, C3.

32 Rosenquist and Dalton, *Painting Below Zero*, 313.

299 James Rosenquist, Chambers Street Studio, New York, 1980

General Dynamics

Tim Griffin

It was deep in the summer of 2004—when that year's United States presidential election between George W. Bush and John F. Kerry was at perhaps its most fevered pitch—that my fellow editors and I at the American art magazine *Artforum* decided we had no choice but to devote a special issue to the theme of Art and Politics. True enough, historically speaking, this particular publication's writings typically had a more circumscribed perspective on art, notwithstanding a few significant exceptions such as critic Barbara Rose's important series of columns on the subject of political art during the late 1960s and early '70s. But against the backdrop of America's most recent bombing and invasion of Iraq (regarding which this election seemed a referendum), any sense of a public role or stakes for contemporary art in our eyes absolutely necessitated an explicitly contrapuntal stance with respect to developments in larger society. This impulse, we knew, was nevertheless bound to be awkward in its articulation. In terms of artistic context alone, the culture wars and street activism of the late 1980s and early '90s were no longer so prominent in artistic circles; the critique of institutions had itself become somewhat institutionalized, when it came to any reflexivity in art about ideology and power; and nascent anti-globalist movements within art at the turn of the millennium had been, for the time being, largely swept aside by the events of September 11 and subsequent "War on Terror." In other words, although politics in art was in fashion, art's political efficacy—or better, the shape that engaged and reflexive art should take—remained in question.[1] Indeed, any political position put forward in the art world also risked seeming the stuff of privilege and, perhaps worse, of merely preaching to the choir—something with symbolic importance, yes, but dubious in terms of its wider impact. (The artistic language wanted for this specific hour was, simply put, not immediately clear let alone practiced.) Acknowledging as much, we knew we had to be thoughtful regarding the artists and writers we invited to contribute—particularly when it came to anyone asked to participate in the issue's special portfolio of new artworks meant to reflect on what seemed such a momentous political moment. What should art do in the face of cultural developments that recalled protest eras of decades past, yet seemed to suggest an entirely new cultural logic? (A question I would sometimes ask myself: What happens to an avant-garde in a so-called war without borders?) Looking back today, I am not surprised that the very first artist who came to our minds was James Rosenquist.

In truth, there could hardly have been a figure more appropriate for the time. If the first years of the new millennium in American culture were being defined by exponential militarization, Rosenquist had specifically taken up the American military-industrial complex (as Eisenhower had coined the term) on multiple occasions since the 1960s. The artist even included the moniker openly in the title of one epic canvas, *Masquerade of the Military Industrial Complex Looking Down on the Insect World*, 1992, whose composition features the iconographies and synthetic hues of laundry-detergent packaging interwoven with (and partially eclipsed by) the abstruse-by-design geometries of stealth bombers, in addition to so many other altered yet recognizable figures like a blackened American flag and stack of luridly colored pencils. By such a measure, we thought, Rosenquist's very presence in this special issue would clearly place the immediate cultural situation in historical perspective and, as important, provide an incisive take on a deeper substrate of American society.

Even very early in Rosenquist's career, critics remarked on how his montage-like compositions brought together singular images from throughout visual culture, putting ostensibly disparate pictures forward in active relation and, more precisely, as if they were to be understood within functioning and continuous systems and infrastructures.[2] Regarding the character of the latter, one of the most astute observations about the artist's work stemmed from a reflection on the mid-twentieth-century clippings from *Life* magazine that frequently provided Rosenquist with a material basis for his famous collage studies: in the words of scholar Peter Bacon Hales, that particular publication's editorial perspective, which guided the arrangement and juxtapositions of pictures and texts during the 1950s and '60s, sought to provide "a context of normalcy" in which a "duality . . . of violence [was] set against the reassuring safety of the everyday." Tearing this imagery out of the magazine pages, Rosenquist's arrangements made such a deep duality unfamiliar again in his canvases. By 2004, his capacity to bring new visibility to such frequently overlooked (or taken for granted) relationships among different cultural sectors seemed uniquely prescient and, in fact, incredibly well suited for our grappling with the cognitive dissonance being staged in the American mass media between a burgeoning economy and entertainment industry at home and a war largely being conducted, as if by remote control and viewing, a world away.[3]

Yet saying as much also asks for a deeper consideration of Rosenquist's particular standing within the historical genre of Pop art. Indeed, few artists—of the Pop generation or after—have been so attuned to the internal contradictions of American culture with respect to its abstractions and realities, and most pointedly, its self-imaging. One of his most famous works to engage politics overtly, *President Elect*, 1960–61/1964, remains striking for its usage of John F. Kennedy's visage next to renderings of a car and piece of cake—as one of so many different things meant, in their respective presentational modes, for consumption. (As Rosenquist would say of the work's inspiration during the 1960 Presidential election, "The face was from Kennedy's campaign poster. I was very interested at that time in people who advertised themselves. What did they put on an advertisement of themselves? So that was his face. And his promise was half a Chevrolet and a piece of stale cake.")[4] Regarding the roots of such an approach in culture more broadly, the artist frequently remarked on the importance of deploying commercial visual language in his work, saying, for example, that his use of collaged advertisements was necessarily "very quick [because i]t's about contemporary life,"[5] adding elsewhere that his compositions on canvas—whose power was frequently amplified through their outsize scale—subsequently provided a "visual antidote to the power and pressure of the other side of our society."[6] However, most revealing when it comes to Rosenquist's conscious grasp of the influence of commercial imagery over American society—and, more specifically, of how such commerce-driven image production instilled a fundamental shift in public and private life, rendering it increasingly subject to a kind of televisual abstraction—might be the artist's 1961 canvas *Reification*. Titled after the art-critical term describing capitalist production and consumption's objectification of human relations (making of them a kind of commodity in themselves), the work features bright, artificial hues of orange, red, and yellow—along with electric lights spelling out the term's first three letters—and offers a discursive foundation for Rosenquist's later grand, montaged compositions whose fields play host to proliferations of luminous yet disparate objects and images all spilling into one another. As art historian Hal Foster would observe of Pop more generally, while using language that seems custom-tailored for Rosenquist's compositions throughout his career: "In this condition, reification . . .

300　Front cover and inside page with *The Xenophobic Movie Director or Our Foreign Policy* in *Artforum*, September 2004, in the article "Electoral Collage: A Portfolio," pp. 227–41

300

comes to look like its apparent opposite, that is to say, less a becoming thing-like than a becoming liquid or light, as though what Karl Marx and Friedrich Engels had only imagined in *The Communist Manifesto* (1848) about the capitalist dynamic at large—'all that is solid melts into air'—had actually come to pass."[7]

In this respect, even when it came to our fears about the efficacy of any critical gesture from the art world within a larger political landscape, Rosenquist offered the perfect "antidote." One recalls Lippard's discussion of his exhibition of *F-111*, 1965, in *Artforum*, which framed Rosenquist's thinking in terms that had lost none of their resonance in a booming wartime cultural economy half a century later: "[The work] was entirely devoted to a social theme, that of the artist's position in today's society, the insignificance of the easel painting in an era of immensity, of jet war machines and *nouveaux collectionneurs* buying wholesale."[8] In fact, Lippard would observe that General Dynamics—the corporation that made the F-111 aircraft—could be found everywhere within the artist's canvas. Yet one could say that Rosenquist engaged with such powerful branding in a redirection that made such "general dynamics" in society plainer to see. For any reflection on questions of art's place with respect to the politics of our day, Rosenquist was, and would remain, a pivotal figure.

Even so, Rosenquist's level of commitment to the project surprised all of us. While our timeline was short (we offered artists only a month to develop artwork for the occasion), he not only accepted our invitation but also expressed his desire to make an entirely new painting—in a single week. True, his reputation for working quickly certainly preceded him, having been an established part of the lore around his transition at the start of the 1960s from the high scaffolding of Times Square to his artist's studio on Lower Manhattan's Coenties Slip. (The fast technique and material facility of the billboard painter stayed with him throughout his career.) Yet his fervent embrace of our invitation was probably all the more startling given how so many other artists with whom we spoke were, from the start, uncertain of how best to proceed. At a pluralist moment in art, there was a pervasive sense among artists—especially from a younger generation—that "political art" was illustrative and redundant, given that all art is necessarily "political." For them, one could only too easy find oneself grasping for appropriate terms for critical engagement in the context of an artistic field whose discourse seemed so atomized. (More than a few artists, including the elder statesperson Richard Serra, would then say as well that their contributions were not artworks but instead simply efforts to "get the message out.")[9] Yet within days, we received in the mail a crinkled drawing that seemed akin to Rosenquist's famed "ideagrams" of the past—a rendering in pencil and pastel featuring the most elemental contours of the painting as it was being conceived. And within a month of our first correspondence, we received a professional photograph of the work—shot in his Aripeka studio with the paint still wet, I had been told—ready for reproduction as one of the most ambitious projects to appear in that issue.

The final work, titled *The Xenophobic Movie Director or Our Foreign Policy*, was nothing if not enigmatic when its reproduction arrived at the office—strongly evoking the cultural moment through its dreamlike montage and atmosphere, but puzzling, paradoxically enough, for a relatively stable narrative emerging from its assemblage of parts. At the center of the three-panel painting, one sees the lower torso of a golfer—hips slightly turned, completing a swing in a classic pose—whose white shoes and pants conjure both the leisurely attire of the country club and a nearly apparitional distance from the world this figure inhabits. (If previous works by Rosenquist similarly contain truncated bodies in order to mirror the objectification—and fetishization—of the human figure and its symbolic power in advertising, here one cannot help but think of the figure of the film director as an abstract, larger-than-life agent who choreographs and colors, or gives image to, the world from without. In a sense, his influence is an abstraction within figuration—like policy—and the world is his game.) Strongly tipping his hand regarding the golfer's identity, the artist wraps an American flag around a tree stump, on which rests the white skull of a Longhorn.

(When it comes to creating a constellation of signifiers for the day's Texas-bred President—and let's not forget that golf is the premier of all presidential pastimes—Rosenquist all but brands the letter W onto the canvas surface.)

In juxtaposition with these images, and with the flag ensconced amid two figures devoid of life, the figure of the golfer becomes nearly ghostly. More significant, however, is that the golfer's swinging club is obscured by a light bulb, set radically in the foreground of the picture, adorned by Arabic writing taken from the second line of the Qu'ran: "Praise Allah, Lord of the World." The language is immediately noteworthy for being indecipherable to the vast majority of Western audience members who would see the painting. Even while it is a source of light, the object, removed from its socket, becomes merely a sign for a lack of illuminated knowledge, both for the director and audience member who cannot read the words. At the same time, within the context of Rosenquist's paintings across the decades, the bulb remains a kind of commodity: whatever else it might represent, it is also a symbol of an economic infrastructure driving policy. (If General Dynamics lurks in the background of *F-111* during the Vietnam era, perhaps General Electric assumes an analogous subliminal presence here during this war in Iraq). More precisely in this respect, the bulb is a potential source of light for any film director who would seek to render a picture of the world onscreen and convince a public to embrace his foreign policy by seeing the world his way. Perhaps most poignant in turn, the painting's lower portion is populated by a "rough" consisting of jumbled numbers, whose stenciled contours conjure yesteryear's Pop, yet appear here devoid of the very rationalist order Pop artists of previous generations sought to dissemble. A game is being played in this painting—and a forceful stroke has been executed—but the landscape is overgrown, denoting a collapse of strategy. Both director and viewer are set within a kind of hazard, from which it will be difficult to escape.

Such disorder—or maybe better, disorientation—is emblematic of Rosenquist's work throughout his life. The artist himself would often comment on the disarming effect of radical decontextualization and shifts of scale in his paintings, for example, observing to curator Walter Hopps that "[i]f I can take a fragment of something realistic, and put the fragment in space at a certain size, I could make a painting where people would recognize something at a certain rate of speed. The largest fragment would be the closest, and the hardest to recognize. Therefore, I could make a mysterious painting."[10] Such pauses in viewer's assimilation of imagery—a play, in effect, between figuration and abstraction in his work[11]—is but a step away from a spatial play that arises from his selections of material. In the words of Lippard, "Light

301 *Reification*, 1961
Oil on canvas and chromed steel,
with electric lights and sockets
24 × 30 in. (61 × 76.2 cm)
Estate of James Rosenquist

302 *Masquerade of the Military Industrial Complex
Looking Down on the Insect World*, 1992
Oil and acrylic on shaped canvas,
with metal screen, pencils, clock hands,
and battery-powered clock mechanism
7 ft. 6 in. × 29 ft. 2 in. (228.6 × 889 cm)
The Detroit Institute of Arts, Founders Society
Purchase, gift of Mrs. George Kamperman,
by exchange

301

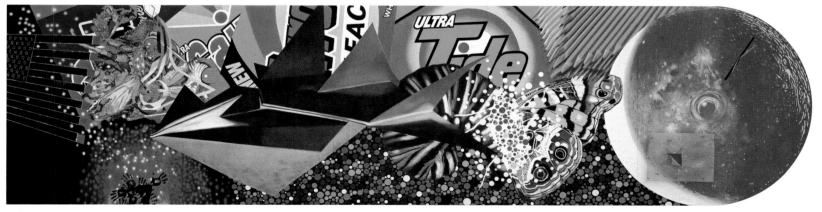

302

and clear plastics [used by Rosenquist] share with [his] iconography a quiescent immateriality, the ability to destroy conventional space and define further levels or 'vantage points' from or through which an object might be seen."[12] The great critic of Pop, Lawrence Alloway, would make a similar observation regarding the artist's *Horse Blinders*, 1968, noting how reflective sheets of aluminum were set at right angles in a room's corners to distort both imagery and, in turn, the viewer's sense of the installation space itself. Every figure would be seen in juxtaposition with its redirected image on another reflective plane, rendering the picture's dimensionality more ambiguous—creating a visual correspondence between object and image that seems analogous with the socioeconomic dynamics alluded to by his earlier reference to "reification." (While some of his paintings would move sculpturally into three dimensions, such disorientation is also amplified in the images rendered in Rosenquist's later works on canvas, whose compositional vortices are often generated as the artist paints what he sees when looking at pictures through a reflective cylinder. And, in many works from his final decades, the artist paints figures within abstract shapes, which then variously seem superimpositions on and cutaways from the overall composition across the canvas surface. The kind of push-pull effect usually attributed to abstract painting here arises in figurative work instead.) Time and again, in other words, such taut correspondences seem clearly entwined with a larger sociological context, which then extend all the more provocatively to eroded distinctions between natural and artificial, real and synthetic. Along these lines, it remains striking today how Rosenquist's earliest critics, such as Edward F. Fry (writing in a catalogue for Ileana Sonnabend Gallery in 1964) would look at repetitions in his renderings of suburban landscapes and pose the question: "He is asking us the question, how real is nature under such repeated, standardized conditions?"[13] The sentiment is echoed as well by Lippard, who describes the artist's *Capillary Action* II, 1963, by noting how even "a piece of torn newspaper hints the artifice of reality itself."[14] In this vein, most observers of the artist's works immediately grasp how the intense colors of Day-Glo paint and other bright hues imbue the most figurative passages in his canvases with a sense of entirely synthetic material composition. Per Alloway: "He paints the world in all those episodes in which we lose our grip on it."[15]

Rosenquist's early exposure to the culture of Happenings famously influenced his decision to make paintings as entire room installations, yet the pronounced role of such disorientation in his work—which, as seen above, is at the service of his underscoring objects' imbrication within larger, abstract socioeconomic fields—makes it more tempting to look not at the artist's precedents but instead at work by subsequent generations of artists. For example, one thinks of scholar Juliane Rebentisch's observation that the rise of immersive installations in art during the 1990s paralleled a rise of globalist discourses in art and, more precisely, a redrawing of the geopolitical map in the years immediately following the ostensible close of the Cold War. Just as individuals in the larger political context were newly uncertain of their position in the larger social landscape, so audiences were made cognizant of their ambiguous position within art institutions. Indeed, if some in the West were arguing that the 1990s saw an "end of history," immersive installations—particularly those employing large-scale, looped video projections—were noteworthy at the time for belying any sense among audiences of the most fundamental protocols for viewing, including simply when they should enter or leave a space.[16] The very sense of chronology was unsettled, recalling for us in the present context how any rational order of numbers is disrupted in Rosenquist's *Movie Director*.

A consideration of Rosenquist's own immersive works in terms of these enveloping contemporary "screens" is perhaps even more instructive, particularly if we extend some longstanding dialogues about the artist in this vein. To bring up the example of one other American artist who has similarly delved deeply into the language of advertising on a grand scale, a number of art historians in the past have distinguished Rosenquist from the likes of Ed Ruscha by comparing the latter's devotion to frontality to the former's immersive work. In this context, Ruscha himself has said, "Los Angeles to me is like a series of store-front planes that are all vertical from the street, and there's almost like nothing behind the façades," and one may subsequently observe that his own canvases mimic such verticality and staging.[17] (Among others, Eleanor Antin would also note how many of his canvases and artist books were made from the vantage of a car, with his windshield or side windows effectively acting as a kind of screen through which the world was seen and rendered.)[18] By contrast, Rosenquist's immersive installations, three-dimensional canvases, and montage-like compositions clearly lack such frontality or, for that matter, single perspective. And in this light—and bearing in mind the likes of Ruscha and Rebentisch's observations about immersive installations—Rosenquist seems remarkably contemporary in his approach.

Among the most clarifying comparisons with more recent artists might be one with Belgian artist Michel Majerus. Similar to Rosenquist (and in all likelihood inspired partly by him), Majerus would frequently place images from popular culture alongside appropriated passages from modern artworks; at the same time, he would blow up such pictures to massive scale, sometimes bending them to seem like skateboard ramps (imagine Rosenquist's curling images set in physical space) or designer architectures. Yet by the time Majerus arrived on the scene during the 1990s, such endeavors were recognized to be directly in dialogue with recent developments in technology and, more precisely, the phenomenology of online design. His paintings and sculptural elements, in other words, were made using the screen itself as a conceptual model. As artist and critic John Kelsey would say of his first encounter with Majerus in Cologne during the late 1990s: "This was painting in a moment when much of the culture we cared about was for the first time being distributed and consumed on digital formats like discs, and users and players were interfacing with and controlling content on screens. Culture was beginning to speed up, and Majerus's painting was speeding up in relation to it. I got the impression of a very fast and ambitious painting, going for blown-out scale and linking itself to a new PlayStation speed of attention [It was] painting that involve[d] itself in the power of media—becoming billboard-like and screen-like, restaging media space in painterly terms."[19]

These words resonate strongly with Rosenquist's stated desire to work within the language of the media of his day, but they are more provocatively so when one considers how the artist would similarly move from scale to scale—demonstrating a kind of malleability that anticipates the screen time and space of painters of our own era, to say nothing of the images they would circulate so freely. In fact, at least one aspect of Rosenquist's work that was considered a deficiency during the 1960s becomes especially compelling. Critics who sought to undercut the artist's stature as a fine artist—disdaining his use of color (even Lippard would describe flaws she saw in this respect), for example, or taking issue with an assertion by many that quality was "beside the point" in his work—would argue that Rosenquist's original idea to allow the panels of *F-111* to be sold individually was indicative of his fundamental inability to appreciate the importance of formal composition. By contrast,

today we might see such a willingness to have his masterwork atomized to be in keeping with the disorienting media-sphere Rosenquist sought to capture. The painting itself would pass into the abstraction of the culture that made it possible, displaying the mutability of its screen even while (if not by virtue of) becoming one with it.

Perhaps true to such words, many years later I would finally see a physical iteration of Rosenquist's *Movie Director*—at Art Basel, of all places. The size had increased stunningly from what I had seen on a couple pages of a magazine: Larger than any billboard—to my uneducated eye it seemed at least fifty yards across in length—it was all but impossible to assimilate. It was as big and abstract as the problem it sought to represent. Yet a greater irony for me, looking back at *Movie Director* now, is that the canvas is roughly as removed from today as the advertisements and other images were from Rosenquist when he typically used them—roughly fifteen years. Or, as he might put it, not quite old enough to generate romantic nostalgia, but far enough away to allow us to see them as objects no longer functioning as they should. His canvases, even when creating a critical disorientation, offered some reflexivity by dwelling on the "just past." And by that measure, Rosenquist's canvas gives us remarkable perspective on our own day and its general dynamics, as it were—offering a pathway forward for contemporary artists engaging contemporary media and, most important, seeking a political position within its vast syntax.

Notes

1 Writing in an introduction to the issue, I specifically touched on the question of politics' fashionability at the time, wondering, more urgently, whether the "mere appearance of politics in art … is often taken to be enough, leaving open the question of whether the work is at all meaningfully and effectively 'political'—before prompting in turn the more compelling question: What else could art possibly *do*?" Rosenquist's engagement with politics throughout his career—particularly in large-scale installation work—offers a remarkable testament to how shifts in the physical parameters of art might alter in turn the potential for art's political agency. See "The Art of Politics," *Artforum* (September 2004): 205. Rosenquist's painting made in response to our request would be reproduced as part of "Electoral Collage: A Portfolio," 227–41.

2 In this vein, Rosenquist would famously argue to critic Lucy R. Lippard that one must consider the figures in his canvases in relation to one another. As he said, "One thing, the subject isn't popular images …. It isn't that at all." See Lucy R. Lippard, "James Rosenquist: Aspects of a Multiple Art," *Artforum* (December 1965), in Steven Henry Madoff, ed., *Pop Art: A Critical History* (Berkeley: University of California Press, 1997), 246.

3 See Peter Bacon Hales, "Imagining the Atomic Age: Life and the Atom," in Erika Doss., ed., *Looking at Life Magazine* (Washington, D.C.: Smithsonian Institution Press, 2001), 107. A remarkable perspective on Rosenquist's practice was also offered by collector Robert C. Scull on the occasion of the painting *F-111* being exhibited at the Metropolitan Museum of Art: "It presents the essence of the United States' relationship to the world, displaying the equation of the good life of peace, with its luxuries and aspirations, and our involvement with the potential for war and final annihilation." See Robert C. Scull, "Re The *F-111*: A Collector's Notes," *Metropolitan Museum of Art Bulletin* (March 1968): 282–83.

4 See Walter Hopps, "Connoisseur of the Inexplicable," *James Rosenquist: A Retrospective*, Walter Hopps and Sarah Bancroft, eds. (New York: Solomon R. Guggenheim Foundation, 2003), 9.

5 Hopps, 17.

6 Lippard, "Aspects of a Multiple Art," 247. His words recall Walter Benjamin's assertions that advertising was remarkably revealing when it came to the deep structures of culture. As he wrote, using words that resonate strongly with Rosenquist's montage-like works: "Today, the most real, mercantile gaze into the heart of things is the advertisement. It tears down the stage upon which contemplation moved, and all but hits us between the eyes with things as a car, growing to gigantic proportions, careens at us out of a film screen … What, in the end, makes advertisements so superior to criticism? Not what the moving red neon says—but the fiery pool reflecting it in the asphalt." "One Way Street," in Michael Jennings and Marcus Bullock, eds., *Selected Writings, vol. 1, 1913–1926* (Cambridge, MA: Harvard University Press, 1996), 476.

7 Rosenquist's specific assertion that he provides an antidote to "pressure of the other side of our society" brings to mind Hal Foster's description of Pop art's heightened attention to "the pressures of modern life," which, although discernable in many artists' works, is made emblematic for Foster in Rosenquist's *Reification*. As Foster writes, in a manner to which my own discussion here is indebted: "Pop shows us how, in a consumerist economy, objects and images tend to become serial and simulacral, and how commodities tend to operate like signs and vice versa. Indeed, Pop works to capture a shift in appearance whereby the commercial world appears as a second nature shot through with photographic, filmic, and televisual visualities." See Hal Foster, *The First Pop Age: Painting and Subjectivity in the Art of Hamilton, Lichtenstein, Warhol, Richter, and Ruscha* (Princeton: Princeton University Press, 2012), 13.

8 Lippard, "Aspects of a Multiple Art," 247.

9 See "Electoral Collage," 228.

10 Hopps, "Connoisseur of the Inexplicable," 6.

11 By many accounts, this particular play is likely rooted in his colossal billboard work, for which the cheek of a movie star, say, might be dozens of feet tall.

12 Lippard, "Aspects of a Multiple Art," 249.

13 Edward F. Fry, *James Rosenquist* (Paris: Ileana Sonnabend Gallery, 1964) in Madoff, 242–43. The writer continues in his essay by addressing the "abstractions" of what seem real cultural objects— artificial butter, for example—before saying that Rosenquist deals in canvases like *Taxi*, 1964, with "Nature and Machinery, the one ironically neither more nor less natural than the other."

14 Lippard, "Aspects of a Multiple Art," 249.

15 Lawrence Alloway, "Art," *The Nation* (May 5, 1969), 582.

16 See Juliane Rebentisch, *Aesthetics of Installation Art* (Berlin: Sternberg Press, 2012).

17 Gary Conklin, "L.A. Suggested by the Art of Edward Ruscha," film transcription in *Leave Any Information at the Signal*, ed. Alexandra Schwartz (Cambridge, MA: MIT Press, 2002), 223–24.

18 See Eleanor Antin, "Reading Ruscha," *Art in America* (November–December 1973): 64–71.

19 Kelsey's conversant Daniel Birnbaum would similarly observe: "[The] impossibility [of translating the visual world generated by digital devices] is acknowledged in Majerus's works, and yet almost every large work tries to perform the act of translation in spite of its impossibility. This results in strangely empty works in which the pictorial elements float around in a rather disconcerting way. On one level it is hard to make spatial sense of his paintings; on the other hand every computer screen displays similar features." See Daniel Birnbaum and John Kelsey, *Michel Majerus* (New York: Matthew Marks Gallery, 2014), 14–33.

This Chronology by Sarah Bancroft was first published in *James Rosenquist: A Retrospective* (New York: The Solomon R. Guggenheim Museum, 2003), and updated by Bancroft for the James Rosenquist Studio website in 2017 and for the catalogue *James Rosenquist: Painting as Immersion.*

Chronology

1933–50 James Albert Rosenquist is born on November 29, 1933, in Grand Forks, North Dakota, to Ruth Hendrickson Rosenquist and Louis Rosenquist, who are of Norwegian and Swedish descent respectively.

During Rosenquist's childhood, his family moves from one Midwestern city or farming community to another, including Atwater, Perham, and Minneapolis in Minnesota, and Tipp City and Vandalia in Ohio. Rosenquist's father works at a series of jobs, including a motor-court and gas-station operator, airplane mechanic, and other positions in the aviation industry. Rosenquist's mother and his paternal uncle, Albert, have experience as pilots. By age eight Rosenquist has become an avid maker of model airplanes. In 1941 he visits the Minneapolis Institute of Arts with his mother, an amateur painter. When he shows an aptitude for sketching at an early age, she encourages him.

By 1944 his family has settled down in Minneapolis, purchasing a house on Nokomis Avenue. In his teenage years Rosenquist paints portraits and landscapes. He submits a painting of a sunset and wins a scholarship in junior high school for four Saturdays of art classes at the Minneapolis School of Art at the Minneapolis Institute of Arts. At the institute Rosenquist is first exposed to quality art supplies—such as Arches and Strathmore papers, which he will use throughout his career—and takes classes with older students and teachers who have studied in Paris and across Europe on the GI Bill.

303 Rosenquist and his mother, Ruth, Grand Forks, North Dakota, ca. 1935

304 Rosenquist and Duane Solmenson on motorcycle, Perham, Minnesota, 1940

305 Rosenquist as a child

306 Rosenquist's sixth birthday, November 29, 1939

307 Rosenquist with his aunt, Dolores Hendrickson

308 Rosenquist with his pet skunk

309 Rosenquist camping with scouts, ca. 1946

310 Rosenquist in scout uniform with model airplane, ca. 1946

305

303

304

306

307

308

310

309

1951–54 In 1951 Rosenquist and his father travel by car to visit California and the Pacific Northwest. While in Southern California, they cross the border into Mexico. In spring 1952 Rosenquist graduates from Roosevelt High School in Minneapolis. With the encouragement of his mother, he enrolls in art classes at the University of Minnesota, Minneapolis. He attends the university from fall 1952 until spring 1954, learning oil painting, egg tempera, and Renaissance underpainting from painter Cameron Booth.[1] Booth—who had studied with the painter Hans Hofmann and taught at the Art Students League, New York, in the mid-1940s—becomes Rosenquist's mentor. Booth takes Rosenquist and another student to view Impressionist and old master paintings at the Art Institute of Chicago.

During the summer of 1953, Rosenquist works for the commercial painting contractor W. G. Fischer. He travels across the Midwest as part of a Fischer crew, painting Phillips 66 signs, gasoline and storage tanks, refinery equipment, and grain elevators. After leaving the University of Minnesota with an associate's degree in studio art, Rosenquist paints billboards in Minneapolis and Saint Paul for General Outdoor Advertising, including promotional signs for the movie *Davy Crockett, King of the Wild Frontier*, advertisements in Saint Louis for Corby's Whiskey, and advertisements in Minneapolis for Northwest Airlines and Coca-Cola. He travels to Florida and Cuba.

311 Rosenquist painting portrait of Tom Tone Jr.

312 *Portrait of Mother*, Minnesota, 1954

313 Rosenquist's high school graduation picture, 1952

314 Rosenquist riding his motorcycle, Atwater, Minnesota, ca. 1953

315 Rosenquist with the speedboat he built from *Popular Mechanics* magazine plans, ca. 1952

316 Rosenquist with his father, Louis, September 1955

317 Rosenquist traveling, ca. 1951

318 Rosenquist in Tijuana, where he drove with his father in 1951

311

313

312

260

314

315

316

317

318

1955 Encouraged by Cameron Booth, Rosenquist applies to the Art Students League, New York. He receives a scholarship, which includes a year's tuition but nothing for room and board. Rosenquist arrives in New York with a few hundred dollars as well as Booth's letter of introduction and his list of affordable restaurants. At the Art Students League, Rosenquist studies under Will Barnet, Edwin Dickinson, Sydney E. Dickinson, George Grosz, Robert Beverly Hale, Morris Kantor, and Vaclav Vytlacil. Rosenquist frequents the Cedar Tavern, where he meets painters Willem de Kooning, Franz Kline, and Milton Resnick. Diagnosed with pneumonia before the end of the academic year, Rosenquist is treated in the welfare ward at Roosevelt Hospital in Manhattan.

1956 Rosenquist leaves the Art Students League, New York, after the 1955–56 academic year. He works as a chauffeur and bartender for Roland and Joyce Stearns and also minds their children at the family's Irvington, New York, estate. There he works on small abstract oils and drawings in an octagonal studio space on the top floor of the Stearns home. In September he meets artists Jasper Johns, Ray Johnson, and Robert Rauschenberg in New York. He also meets Robert Indiana, Ellsworth Kelly, and Jack Youngerman this year.

1957 Rosenquist quits his job with the Stearns family and moves back to Manhattan. He lives for a time in a loft at Sixty-third Street and Amsterdam Avenue, which he shares with Takeshi Asada, Alice Forman, Chuck Hinman, Peggy Smith, and Joan Warner. Rosenquist joins Local 230 of the International Brotherhood of Painters and Allied Trades union and begins painting billboards in New York. His first assignment is to paint a Hebrew National Salami sign on Flatbush Avenue in Brooklyn for A. H. Villepigue Company. The firm lets him go shortly after this task. He then paints signs in Brooklyn for General Outdoor Advertising but is subsequently laid off. Rosenquist travels home to Minnesota, retaining his studio in New York. In Minneapolis he paints promotional signs on a freelance basis, including a number of automobile advertisements on building exteriors. He subsequently returns to New York, where he begins painting billboards for Artkraft Strauss Sign Corporation. He lives briefly in a studio at Broadway and Twenty-seventh Street. In his spare time Rosenquist attends drawing classes with Claes Oldenburg and Henry Pearson. The sessions are organized by Robert Indiana and Jack Youngerman, whose wife, Delphine Seyrig, serves as a model. Simultaneously, Rosenquist creates abstract pieces, including a nine-by-seventeen-foot drawing, anticipating the large scale of his future art.[2]

319

320

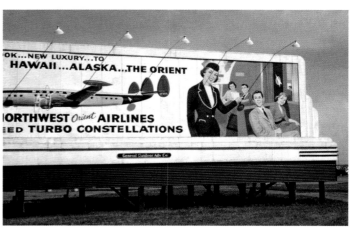

321

322

323

324

325

1958 As a commercial artist, Rosenquist paints billboards in Manhattan and Brooklyn, including signs in Times Square for the Astor Theatre, Victoria Theater, and Morosco Theatre, all located at Broadway and Forty-fifth Street. He moves to an apartment and studio at Second Avenue and Ninety-fourth Street, where he continues to create abstract paintings and works on paper. He also begins looking for a separate studio space. In the spring Rosenquist's abstract painting *Passing before the Horizon* (1957) is included in the *1958 Biennial: Paintings, Prints, Sculpture* at the Walker Art Center, Minneapolis.

326

327

328

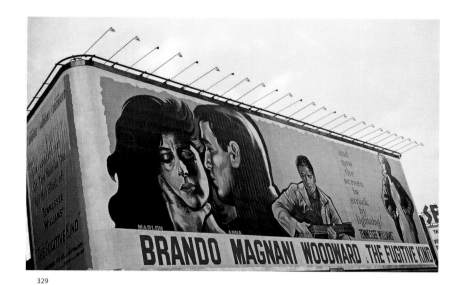

329

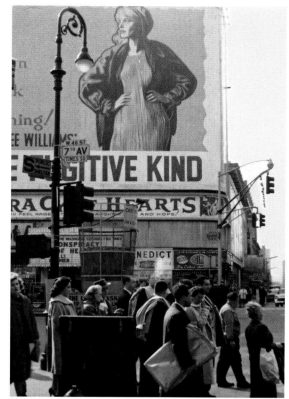

330

331

332

1959 At age twenty-five Rosenquist becomes head painter at Artkraft Strauss Sign Corporation. He meets Gene Moore, head window designer at Tiffany & Co., Bonwit Teller, and other stores, who hires him periodically over the next two years to design displays and paint backdrops for store windows on Fifth Avenue in Manhattan.

333 Rosenquist's notebook page featuring backdrop sketches and notes for Bonwit Teller window-display backgrounds, ca. 1961

334 "Speaking of Pictures . . . Paris Recalls Building of 'Loathsome' Eiffel Tower," *Life* magazine, July 3, 1950, pp. 2–3

335 "Eiffel Tower" Bonwit Teller window display backdrop in Coenties Slip studio, with (left to right) Ruth Rosenquist, Mary Lou Rosenquist, Louis Rosenquist, and Chuck Hinman, ca. early 1961. A portion of the painting *Zone* (1960–61) can be seen in the lower left corner.

336 Bonwit Teller window display with Rosenquist's Gay Nineties–inspired painted and drawn backdrop, 1961

333

334

335

336

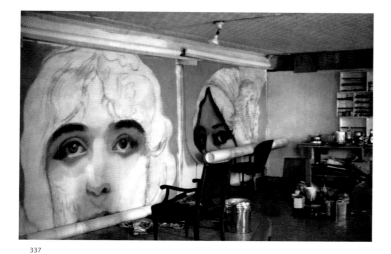

337

337 Gay Nineties–inspired window display backdrops in Coenties Slip studio, ca. 1960

338 Bonwit Teller window displays with Rosenquist's Gay Nineties–inspired painted and drawn backdrops, 1961

339 Bonwit Teller window display with Rosenquist's "Statue of Liberty" painted backdrop, 1961

340 Bonwit Teller window displays with Rosenquist's "Great Sphinx of Giza" and "Elephant Tower of Fatehpur Sikri" painted backdrops, 1961

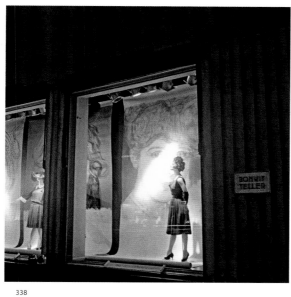

338

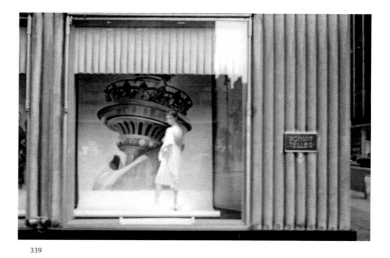

339

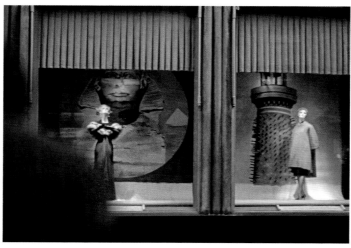

340

1960 In June, Rosenquist marries textile designer Mary Lou Adams, whom he had met while painting Times Square billboards. He is featured in the United Press International article "Billboard Painter, Local 230, Is Broadway's Biggest Painter." Ray Johnson introduces him to painters Agnes Martin and Lenore Tawney, who live and work in Lower Manhattan. Rosenquist quits working for Artkraft Strauss Sign Corporation after two fellow painters fall from scaffolding and die. He rents the studio that had been Martin's at 3–5 Coenties Slip, near the workspaces of Robert Indiana, Ellsworth Kelly, and Jack Youngerman, and commits himself to a career in fine art. He shares his studio space with Charles Hinman for part of the year. At Coenties Slip, Rosenquist begins creating paintings, such as *Zone* (1960–61), that incorporate commercial sign-painting techniques as well as images of people and products derived from advertisements and photographs. With the financial backing of Robert and Ethel Scull, Richard Bellamy—who will become Rosenquist's first dealer—opens the Green Gallery in New York in October with the exhibition *Mark di Suvero*.

1961 Several art dealers pay visits to Rosenquist's Coenties Slip studio, including Richard Bellamy, Leo Castelli with his gallery manager Ivan Karp, Ileana Sonnabend, and Allan Stone. Henry Geldzahler, a curator at the Metropolitan Museum of Art, New York, and several private collectors also come. Stone offers Rosenquist an exhibition with Robert Indiana, which both artists turn down. Rosenquist makes his first sale with Robert Scull's purchase of *The Light That Won't Fail II* (1961). Scull is president and owner of a large fleet of New York taxicabs: Super Operating Corporation. He will become one of the largest private collectors of 1960s Pop art and a Rosenquist enthusiast. In October a photograph of Rosenquist painting *The Light That Won't Fail I* (1961) appears on the cover of the *St. Louis Post-Dispatch Sunday Pictures* magazine. Rosenquist meets critic Gene Swenson, whose sympathetic interviews with him and others associated with Pop art will help legitimize their work within the art world.

341 Advertisement for a German car brand, Rosenquist in the top left corner on the truck

342 Advertisement for a swimsuit in *McCall's* magazine. The desert landscape was painted completely by Rosenquist.

343 Rosenquist outside his studio at 3–5 Coenties Slip (third-floor corner), New York, 1960

344 Rosenquist in Coenties Slip studio he shared with Charles Hinman, New York, ca. 1960

345 Cover and double-page spread from the December 31,1961, issue of the *St. Louis Post-Dispatch/Pictures* publication (Paul Berg, "About-Face from the Abstract," *St. Louis Post-Dispatch/Pictures*, December 31, 1961, cover, 10–11)

342

341

343

344

345

1962 In many works painted this year, such *as Untitled (Two Chairs)*, *Capillary Action*, and *Untitled (Blue Sky)*, Rosenquist attaches small rectangular or circular canvases to the surface of the larger paintings. He produces his first print, *Certificate,* a small photoengraving and etching for inclusion in the fifth volume of Italian gallerist Arturo Schwarz's portfolio *International Anthology of Contemporary Engraving: The International Avant-garde: America Discovered.* Billy Kluver selects the works for the portfolio.

The Green Gallery, New York, presents Rosenquist's first solo show, opening in January, for which the artist designs a poster featuring his painting *Pushbutton* (1961). The exhibition, organized by Richard Bellamy, sells out. Count Giuseppe Panza di Biumo, an early collector of Pop art, purchases three paintings: *Pushbutton*, *Air Hammer* (1962), and *Waves* (1962). In March, *Art International* publishes Max Kozloff's "'Pop' Culture, Metaphysical Disgust, and the New Vulgarians," one of the first articles linking Jim Dine, Roy Lichtenstein, Claes Oldenburg, and Rosenquist together as a group. In April, Rosenquist's *Shadows* (1961) is included alongside works by Dine, Jasper Johns, Lichtenstein, Oldenburg, and Robert Rauschenberg in the exhibition *1961* organized by Douglas MacAgy at the Dallas Museum for Contemporary Arts. In September, Gene Swenson's article "The New American Sign Painters" is published in *Art News*, which associates Rosenquist with Dine, Robert Indiana, Lichtenstein, and Andy Warhol. In the fall Rosenquist's work is included in *Art 1963: A New Vocabulary*, organized by Billy Kluver for the Fine Arts Committee of the Philadelphia YM/YWHA Arts Council; other artists represented include Dine, Johns, Lichtenstein, Oldenburg, Rauschenberg, George Segal, and Jean Tinguely. Instrumental in recognizing the significance of the young artists who will be identified as "Pop artists," Kluver, a scientist at Bell Labs, will organize several early exhibitions featuring their work. Rosenquist's work is represented in seminal exhibitions at the Sidney Janis Gallery in New York and the Dwan Gallery in Los Angeles. The title of the exhibition at the Sidney Janis Gallery, *International Exhibition of the New Realists*, galvanizes the name "New Realists" for the American and British artists, who are represented alongside the work of the continental Europeans known as the Nouveaux Realistes. "New Realism" would shortly be replaced by "Pop art," a term critic Lawrence Alloway had used to identify the work of several British artists who incorporated the imagery of advertising and popular culture into their work in the late 1950s. The Dwan Gallery exhibition, *My Country 'Tis of Thee*, includes Rosenquist's *Hey! Let's Go for a Ride* (1961) and also features other young artists such as Indiana, Lichtenstein, Oldenburg, Warhol, and Tom Wesselmann.

In December the Museum of Modern Art, New York, hosts the Symposium on Pop Art, moderated by Peter Selz, Curator of Painting and Sculpture. The panel of speakers includes art historian and critic Dore Ashton; Metropolitan Museum of Art curator Henry Geldzahler; critic and professor Hilton Kramer; critic and author Stanley Kunitz; and critic and professor Leo Steinberg.[3] Both Rosenquist and Marcel Duchamp are in attendance at the symposium.

346

347

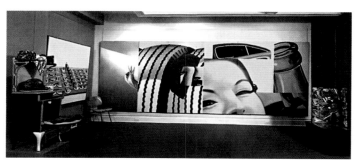

348

349

346 Poster designed by Rosenquist showing *Pushbutton*, 1961, for his exhibition at Green Gallery, New York, January 30 – February 17, 1962

347 Rosenquist looking at wall with *James Rosenquist* Green Gallery exhibition poster, ca. 1962

348 *International Exhibition of the New Realists*, Sidney Janis Gallery, New York, 1962. Works shown, left to right: Claes Oldenburg, *The Stove*; Wayne Thiebaud, *Salads, Sandwiches, and Desserts*; James Rosenquist, *Silver Skies*; and Arman, *Accumulation of Faucets*, all 1962

349 Rosenquist in his studio, photographed by Hollis Frampton, Palm Sunday, 1963

350 *Americans 1963*, Museum of Modern Art, New York, 1963. Rosenquist's parents, Ruth and Louis, in front of *Marilyn Monroe I*, 1962, and *Above the Square*, 1963

351 *Sketch for Marilyn Monroe I*, 1962
Mixed media on paper
11 15/16 × 8 15/16 in. (30.3 × 22.7 cm)
Private collection

351

350

362

363

365

364

362 Polaroid of Rosenquist and Polaroid of Rosenquist holding a similar Polaroid of himself, standing in front of Andy Warhol's *Tunafish Disaster*, 1963, at Warhol's Lexington Avenue townhouse, New York, 1963

363 Claes Oldenburg, Tom Wesselmann, Roy Lichtenstein, Jean Shrimpton, James Rosenquist, and Andy Warhol at the Factory, New York, 1964

364 Dwan Gallery announcement for its *Dealer's Choice* group exhibition, Los Angeles, 1963

365 The Pace Gallery announcement/poster for its *Stock Up for the Holidays* group exhibition, Boston, 1962

366 *Pop art américain*, Galerie Ileana Sonnabend, Paris, 1963. Works shown, left to right: Andy Warhol, *Marilyn Monroe in Black and White*, 1962; Claes Oldenburg, *Giant Ice Cream Cone*, 1962; James Rosenquist, *Vestigial Appendage*, 1962; and John Chamberlain, *Butternut*, 1963

367 Mary Lou Rosenquist, Ruth Rosenquist, and other visitors at the Solomon R. Guggenheim exhibition *Six Painters and the Object*, New York, 1963. Rosenquist works pictured, from left to right: *4-1949 Guys* (1962), *Mayfair* (1962), and *The Lines Were Deeply Etched on the Map of Her Face* (1962)

1963 Rosenquist continues to experiment with including objects and three-dimensional elements in many of the paintings he creates this year; incorporating wood (in *Nomad*), chairs (in *Candidate and Director*), and painted Mylar or plastic sheets (in *Morning Sun and Nomad*). He also begins experimenting with freestanding, multimedia constructions and neon, in works such as *AD, Soap Box Tree* (1963), *Untitled (Catwalk)* (1963), and *Untitled* (reconstructed as *Tumbleweed*; 1963–66). Rosenquist will eventually destroy *AD, Soap Box Tree* and *Untitled (Catwalk)*, along with most of his other early constructions.

Rosenquist receives the Norman Wait Harris Bronze Medal and one-thousand-dollar prize for *A Lot to Like* at the *66th Annual American Exhibition* at the Art Institute of Chicago. In February, Rosenquist is among seventy prominent artists to donate paintings and sculptures to benefit the Foundation for the Contemporary Performance Arts. He donates the painting *The Promenade of Merce Cunningham* (1963). The works are featured in a weeklong exhibition at Allan Stone Gallery, New York, with all proceeds supporting FCPA grants to short-run, avant-garde performances of music, dance, and theater in New York. (Dancer and choreographer Cunningham is slated to receive a grant from the foundation to stage a dance performance downtown.)[4]

Rosenquist's work is represented in the Solomon R. Guggenheim Museum's exhibition *Six Painters and the Object*, curated by Lawrence Alloway and including works by Jim Dine, Jasper Johns, Roy Lichtenstein, Robert Rauschenberg, and Andy Warhol. The works by Rosenquist exhibited are *Zone* (1960–61), *4-1949 Guys* (1962), *The Lines Were Deeply Etched on the Map of Her Face* (1962), *Mayfair* (1962), and *Untitled (Blue Sky)* (1962). The show travels to the Los Angeles County Museum of Art, where it is presented in conjunction with *Six More*, featuring six West Coast artists. In April, *Shadows* (1961), *Halved Apricots* (1962), and *The Promenade of Merce Cunningham* (1963) appear in *Pop! Goes the Easel* at the Contemporary Arts Museum, Houston, curated by Douglas MacAgy. *I Love You with My Ford* (1961), *Look Alive (Blue Feet, Look Alive)* (1961), *Tube* (1962), and *Morning Sun* (1963) are included in *The Popular Image Exhibition*, a large-scale compendium of Pop and Fluxus art curated by Alice Denney, at the Washington Gallery of Modern Art, Washington, D.C. Rosenquist's painting *Vestigial Appendage* (1962) is included in the group exhibition *De A à Z 1963: 31 peintres americains choisis par The Art Institute of Chicago*, one of the first European exhibitions to include his work, presented at the Centre Culturel Américain, Paris.

Rosenquist is also one of fifteen painters and sculptors included in Dorothy Miller's *Americans 1963* exhibition at the Museum of Modern Art, New York. On view are Rosenquist's paintings *The Light That Won't Fail I* (1961), *Pushbutton* (1961), *Air Hammer* (1962), *Marilyn Monroe I* (1962), *Portrait of the Scull Family* (1962), *Waves* (1962), *1, 2, 3, Outside* (1963), and *Above the Square* (1963). His second solo exhibition is advertised by the Green Gallery, New York, in the spring, but is postponed until the following year, as several works for the exhibition are on loan to the Guggenheim Museum's *Six Painters and the Object* and the Museum of Modern Art's *Americans 1963*.

In June, Charles Henri Ford brings Rosenquist, Robert Indiana, and Andy Warhol to Joseph Cornell's studio on Utopia Parkway in Queens, where they meet the artist.[5] In September, Rosenquist's work is represented by the painting *The Space That Won't Fail* (1962) in *Pop Art USA* at the Oakland Museum, California, which includes work from both East and West Coast artists. In October, the Institute of Contemporary Arts, London, presents *The Popular Image*, one of the first European overviews of American Pop art. Included is Rosenquist's *Rainbow* (1962). *Nomad* (1963) is included in the fall exhibition *Mixed Media and Pop Art* at the Albright-Knox Art Gallery, Buffalo. The Albright-Knox acquires the painting, one of the first Rosenquist works to enter a museum collection. In the fall Rosenquist moves his studio from Coenties Slip to the third floor of 429 Broome Street.

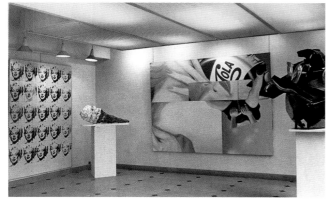

366

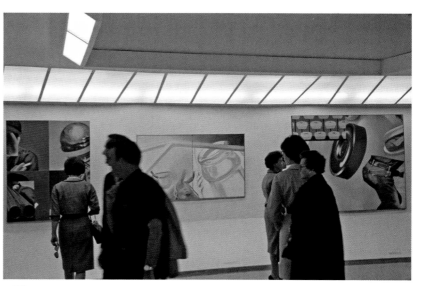

367

1964 Rosenquist's work is represented in *Four Environments by Four New Realists* at the Sidney Janis Gallery, New York, by the works *Capillary Action II* (1963), *Doorstop* (1963), and *Untitled (Catwalk)* (1963). Green Gallery, New York, hosts the second solo exhibition of his work. Works shown include *AD, Soap Box Tree* (1963, destroyed), *Binoculars* (1963, destroyed), *Candidate* (1963; repainted as *Silo*, 1963–64), *Capillary Action* (1963), *Early in the Morning* (1963), *He Swallowed the Chain* (1963), *Nomad* (1963), *1, 2, 3, Outside* (1963), *Untitled (Two Chairs)* (1963), and *Untitled* (1963; reworked as *Tumbleweed*, 1963–66). The opening is filmed and Rosenquist's dealer, Richard Bellamy, as well as Sidney Janis and collector Robert Scull are interviewed about Pop art for a half-hour news segment, "Art for Whose Sake?" to be broadcast during the *Eye on New York* program on WCBS Channel 2 on March 17 and 21. In February, Gene Swenson's "What Is Pop Art? Part II: Stephen Durkee, Jasper Johns, James Rosenquist, Tom Wesselmann," which includes an interview with Rosenquist, is published in *Art News*.

In the spring Rosenquist's work is featured in the *Amerikansk pop-konst* exhibition organized by the Moderna Museet, Stockholm. He travels to Europe for the first time, crossing the Atlantic by boat, for the opening of his solo show at Galerie Ileana Sonnabend in Paris and the Venice Biennale, both of which begin in June. André Breton, Alberto Giacometti, Joan Miró, and Barnett Newman, along with his wife Annalee, attend the Sonnabend opening. In Paris, Rosenquist visits the Louvre. During his stay in Italy, he meets artist Mimmo Rotella.

In September, Rosenquist's son, John, is born in New York. Rosenquist serves as a visiting art lecturer at Yale University, New Haven, during the first semester of the 1964–65 school year at the invitation of Jack Tworkov. In the fall he travels to Los Angeles for the opening of his solo show at the Dwan Gallery, and is also featured in a solo show in Turin, Italy, at the Galleria Gian Enzo Sperone. Commissioned by architect Philip Johnson, Rosenquist's *World's Fair Mural* (1963–64), a twenty-by-twenty-foot oil painting on Masonite, is featured on the Theaterama building at the New York State Pavilion of the 1964–65 New York World's Fair. Rosenquist becomes affiliated with the Leo Castelli Gallery.

Rosenquist gathers photographs and information about the F-111 fighter bomber being developed for the United States military, and begins painting *F-111* (1964–65), which will measure ten by eighty-six feet when complete. With word spreading about the monumental painting, a succession of artists and members of the art world visit the Broome Street studio, where Rosenquist documents them in a series of Polaroid photographs. At the suggestion of Jasper Johns, Rosenquist begins working with Tatyana Grosman at Universal Limited Art Editions—a printmaking workshop located at Grosman's home in West Islip, Long Island. Between 1964 and 1966, he produces seven lithographs at ULAE, including *Spaghetti and Grass* (1964–65), *Campaign* (1965), and *Circles of Confusion I* (1965). Rosenquist continues to work with ULAE over the course of the next forty years.

1964 GREEN GALLERY-WED., JAN 15-FEB 8

368

369

370

368 Green Gallery announcement/poster for the exhibition *James Rosenquist*, New York, 1964

369 Dick Bellamy and James Rosenquist standing in front of *Untitled (Two Chairs)* (1963) at the opening of *James Rosenquist*, Green Gallery, 1964

370 Roy Lichtenstein, James Rosenquist, and Ivan Karp standing in front of *Untitled (Two Chairs)* (1963) at the opening of *James Rosenquist*, Green Gallery, 1964

371 Andy Warhol, Robert and Ethel Scull, and James Rosenquist at the opening of *James Rosenquist*, Green Gallery, New York, 1964. Rosenquist works partially pictured, on the left: *Nomad* (1963); on the right, foreground: *AD, Soap Box Tree* (1963, destroyed); on the right, background: *Candidate* (1963; reworked as *Silo*, 1963–64)

372 Visitors including, on the right, Gordon Hyatt talking with Robert and Ethel Scull at the opening of *James Rosenquist*, Green Gallery, New York, 1964. Rosenquist works partially pictured, on the left, foreground: *Untitled* (1963; reworked as *Tumbleweed*, 1963–66); on the right, foreground: *AD, Soap Box Tree* (1963, destroyed); and in background: *Nomad* (1963)

373 Cover of the February 9, 1964, issue of the *St. Louis Post-Dispatch/Pictures* publication. Rosenquist works pictured, in foreground: *Untitled* (1963; in progress, reworked as *Tumbleweed*, 1963–66); in background: *Candidate* (1963; reworked as *Silo*, 1963–64). (Paul Berg, "Far Out, but No Laughing Matter," *St. Louis Post-Dispatch/Pictures*, February 9, 1964, 2–5.)

372

371

373

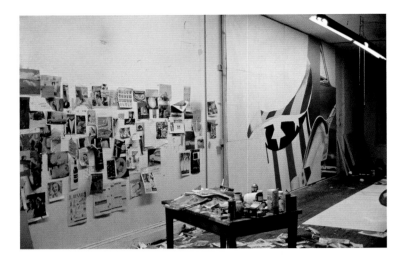

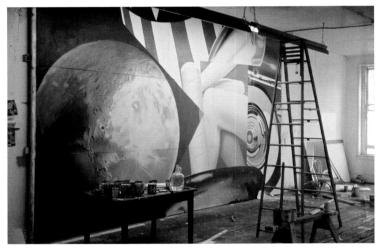

374–376

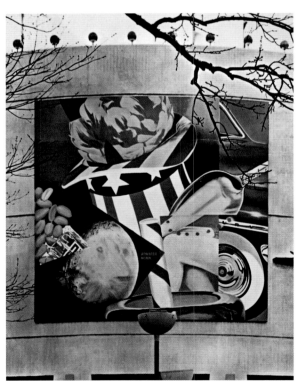

377

374 *World's Fair Mural* (1963–64) in progress, Broome
–376 Street studio, New York, ca. 1963–64

377 Rosenquist's *World's Fair Mural* (1963–64) installed
on the exterior of Philip Johnson's Theaterama building,
New York State Pavilion. New York World's Fair 1964,
1964

378 Dwan Gallery announcement/poster for the exhibition
James Rosenquist, Los Angeles, 1964

379 John Romaine at the opening of *James Rosenquist*,
Dwan Gallery, Los Angeles, 1964. Rosenquist
works pictured, left to right: *3 Peanuts* (1964);
Orange Field (1964); *Silo* (1963–64)

380 Visitors at the opening of *James Rosenquist*, Dwan
Gallery, Los Angeles, 1964. Rosenquist works pictured,
on the left: *Untitled (Joan Crawford Says . . .)* (1964);
on the right, partially obscured: *Wrap II* (1964)

381 Ileana Sonnabend and visitors at the opening of
Rosenquist, Galerie Ileana Sonnabend, Paris, 1964.
Rosenquist work pictured: *Front Lawn* (1964)

382 Cover of the exhibition catalogue for *Rosenquist*,
Galerie Ileana Sonnabend, Paris, 1964

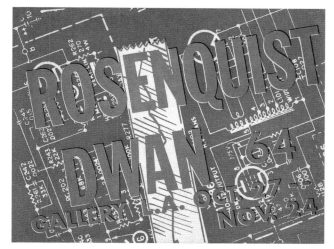

378

380

379

381

382

1965 Rosenquist is one of five artists (the others are Roy Lichtenstein, Claes Oldenburg, Andy Warhol, and Tom Wesselmann) featured in lavish studio pictorials in one of the first major books on the movement, *Pop Art*, with text by John Rublowsky and photographs by Ken Heyman. He is also included (along with the four artists in Rublowsky's *Pop Art* and Jasper Johns) in Dorothy Herzka's *Pop Art One*, a small-format portfolio of reproductions issued by the Publishing Institute of American Art. This portfolio includes Rosenquist's *Silver Skies* (1962), *Dishes* (1964), *Lanai* (1964), and *Untitled (Joan Crawford Says…)* (1964). In the spring the painting *F-111* (1964–65) is featured in the exhibition *Rosenquist* at the Leo Castelli Gallery, New York. The work is installed along the four walls of the gallery's front room. Rosenquist intends to sell the fifty-one panels of *F-111* separately. The day after the exhibition closes, however, Robert Scull buys the entire work. The purchase is featured in an article in *The New York Times*, in which Scull is quoted: "We would consider loaning it to institutions because it is the most important statement made in art in the last fifty years."[6]

In the summer Rosenquist studies Eastern philosophy and history at the Institute of Humanist Studies in Aspen, Colorado, where he is an artist-in-residence along with Allan D'Arcangelo, Friedel Dzubas, and Larry Poons. He meets artist Marcel Duchamp at the New York home of Yvonne Thomas. *F-111* is exhibited at the Jewish Museum, New York, in Rosenquist's first solo museum exhibition. He is awarded the Premio Internacional de Pintura at the Instituto Torcuato di Tella, Buenos Aires, for *Painting for the American Negro* (1962–63). In September he travels to Stockholm for the exhibition *James Rosenquist: F-111* at the Moderna Museet, and from there flies to Leningrad, where he meets Evgeny Rukhin, a Russian artist with whom he has been corresponding. *James Rosenquist: F-111* will tour to major venues across Europe over the course of the next year. In the fall the Green Gallery closes.

Three of Rosenquist's multicolor screenprints are included in Rosa Esman's portfolio *11 Pop Artists*, published by Original Editions. One of the screenprints, *Whipped Butter for Eugen Ruchin* (1965), is dedicated to Rukhin. The planes of distinct, flat blue, yellow, and red within this work are reminiscent of Soviet propaganda posters of the 1930s.

1966 Rosenquist commissions the fashion designer Horst to tailor a brown-paper suit with paper donated by the Kleenex Company. He wears the suit to gallery and museum openings throughout the year, which attracts media attention, generating, among other pieces, an interview by Doon Arbus in *New York* magazine.[7] Rosenquist contributes a twenty-four-by-twenty-four-inch panel to the *Peace Tower* ("The Artists' Tower of Protest") that is dedicated on February 26 in protest against the Vietnam War. The tower, organized by artists Mark di Suvero and Irving Petlin, is a fifty-eight-foot-tall structure covered with artwork contributed by over four hundred artists that is installed on an empty lot on Sunset Avenue in Hollywood, California, and remains on view for three months.[8] When the lease on the site expires and is not renewed, the tower is dismantled and the panels sold in a fund-raising effort by the Los Angeles Peace Center to raise money for the cause.[9] Rosenquist participates in a panel discussion, "What about Pop Art?," with critic Gene Swenson and media theorist Marshall McLuhan at the Art Gallery of Ontario, Toronto. He is commissioned by *Playboy* magazine to create a painting that "transforms the idea of the Playmate into fine art."[10] Larry Rivers, George Segal, Andy Warhol, Tom Wesselmann, and other artists are also asked to participate. In response Rosenquist paints *Playmate*, which he identifies as a pregnant playmate suffering from food cravings. This work will be reproduced in an article in the January 1967 issue of *Playboy*. In October, Rosenquist travels to Japan for the *Two Decades of American Painting* exhibition organized by the Museum of Modern Art, New York, and hosted by the National Museum of Modern Art, Tokyo. He wears the brown-paper suit to the opening. He then tours Japan for a month, before traveling to Alaska, France, and Sweden. In November the first edition of the major contemporary monograph *Pop Art* by Lucy Lippard is published. Its cover design, by Rosenquist, features the title of the book in neon tubes overlaying an image of his lithograph *Spaghetti and Grass* (1964–65).

384

383

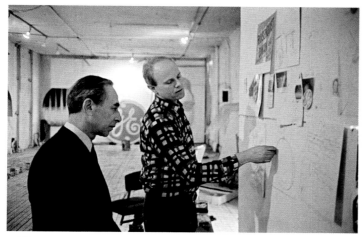

385

386

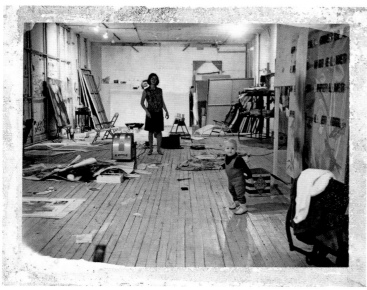

387

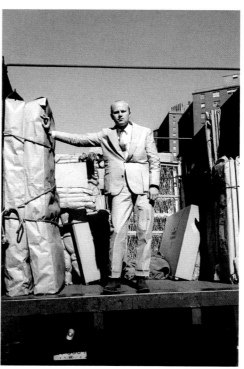

388

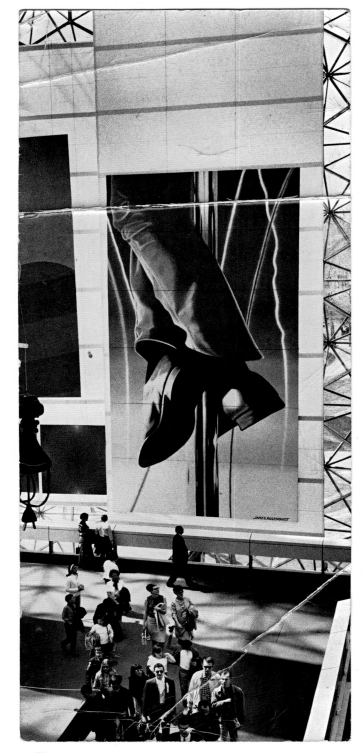

389

389 Fire Slide, 1967, installed in Buckminster Fuller's geodesic dome, United States Pavilion, Expo 67, Montreal, 1967

390 Visit in in East Hampton, from left to right (standing): Robert and Ethel Scull, Mary Lou Rosenquist, and Dick Bellamy

391 Rosenquist and his toddler son, John, in wading pool in Dallas, Texas, 1968

392 Catalogue of the exhibition *James Rosenquist,* National Gallery of Canada, Ottawa, January 24–February 25, 1968

393 James Rosenquist (in paper suit), Mary Lou Rosenquist, Jane and Brydon Smith interact with Rosenquist's *Stellar Structure* (1966) at the opening of *James Rosenquist*, National Gallery of Art, Ottawa, Canada, 1968

390

391

280

1967 In March, Rosenquist moves his family's primary residence from Manhattan to East Hampton, New York, where he also builds a studio. In it he installs a Griffin lithography press custom made by Reynaldo Terrazas. Rosenquist retains his studio on Broome Street. He makes and contributes a nine-by-twenty-four-foot painting, *Fruit Salad on an Ensign's Chest*, to the Spring Mobilization against the War in Vietnam rally in New York, in which several thousand demonstrators march from Central Park to the United Nations. The painting's imagery features a woman's hand shaking salt from a saltshaker onto a field of combat medals, known in military parlance as "fruit salad." The painting—positioned atop a flatbed truck, which also carries poets who are reading aloud from their work—is destroyed during the procession. Rosenquist's thirty-three-by-seventeen-foot painting *Fire Slide* (1967) is installed in the United States Pavilion—a geodesic dome designed by R. Buckminster Fuller—at Expo 67, the Montreal World's Fair.[11] Rosenquist's installation *Forest Ranger* (1967) is presented at Palazzo Grassi, Centro Internazionale delle Arti e del Costume, Venice, in the exhibition *Campo Vitale: Mostra internazionale d'arte contemporanea*. The Mylar paintings in this installation—which includes a work with the same title created the previous year—are cut into vertical strips that hang like banners from the ceiling. The artist intends the viewers to walk through their openings. A condensed version of *F-111* (1964–65) is included in *Environment U.S.A.: 1957–1967*, the American component of the ninth São Paulo Biennial exhibition in Brazil. In November he creates a large-scale installation work of aluminum foil and neon tubing, which hangs from the ceiling of the field house at Bradley University, Peoria, Illinois. (Rosenquist makes at least two additional versions of this work, one of which is constructed and installed this year in Robert Rauschenberg's studio space in a former chapel on Lafayette Street in Manhattan.) The Peoria installation also includes a film program by the experimental filmmaker Stan VanDerBeek. In the late 1960s and early 1970s, Rosenquist himself experiments with a number of film projects, which he abandons before completion. He is among sixteen artists featured in the oversized book of photographs by Italian Ugo Mulas *New York: The New Art Scene*, with text by Alan Solomon, Director of the Jewish Museum, New York. In December, Rosenquist's painting *Marilyn Monroe I* (1962) is included in the exhibition *Homage to Marilyn Monroe* at the Sidney Janis Gallery, New York.

1968 Organized by curator Brydon Smith, Rosenquist's first retrospective, with thirty-two works, opens at the National Gallery of Canada, Ottawa, in January. The National Gallery of Art acquires two Rosenquist paintings at this time: *Painting for the American Negro* (1962–63) and *Capillary Action II* (1963). *F-111* (1964–65) is featured in the exhibition *History Painting: Various Aspects* at the Metropolitan Museum of Art, New York. *F-111* is exhibited alongside three paintings from the museum's permanent collection: *The Death of Socrates* (1787) by Jacques-Louis David, *The Rape of the Sabine Women* (ca. 1633–34) by Nicolas Poussin, and *Washington Crossing the Delaware* (1851) by Emanuel Leutze.[12] Henry Geldzahler, Curator of Contemporary Art, writes an essay in defense of the installation of *F-111* at the museum in the March issue of *The Metropolitan Museum of Art Bulletin*, in the face of mounting criticism. Galerie Ileana Sonnabend, Paris, presents a solo exhibition featuring Rosenquist's *Forest Ranger* installation. The artist travels to France for the opening, returning to the United States after the outbreak of student protests in Paris. Rosenquist's work is represented in documenta 4 in Kassel, West Germany, beginning in June. In November, Galleria Gian Enzo Sperone in Turin presents a solo show that includes several paintings on Mylar.

393

392

1969 Leo Castelli Gallery, New York, presents a solo exhibition featuring Rosenquist's *Horse Blinders* (1968), a room-sized installation that fills the walls of the front gallery space. His work is presented in the Smithsonian Institution's *The Disappearance and Reappearance of the Image: Painting in the United States since 1945*, which opens at the Slovak National Gallery, Bratislava, Czechoslovakia, and travels to Prague, Brussels, and three Romanian cities. Rosenquist's work is also included in Henry Geldzahler's exhibition *New York Painting and Sculpture: 1940–1970* at the Metropolitan Museum of Art, New York. As a participant in the Art and Technology Program at the Los Angeles County Museum of Art, Rosenquist visits American companies and manufacturing plants, including Container Corporation of America, Ampex, and RCA.[13] He decides against creating a work of art for the program and instead considers the merits of an "invisible sculpture."[14]

1970 In the spring Leo Castelli Gallery, New York, presents Rosenquist's recent room installation *Horizon Home Sweet Home* (1970). Like *F-111* (1964–65) and *Horse Blinders* (1968), it is installed along the four walls of the gallery's front room. The work contains no representational imagery. It comprises twenty-seven panels (twenty-one are colored, and six have reflective silver Mylar film loosely stretched over them) staggered along the walls of the gallery space, with dry-ice fog hovering along the floor. The six panels with Mylar (a material also incorporated in *Area Code* [1970] and *Flamingo Capsule* [1970]) distort the reflections of the colored panels and the spectators in the room. Prior to the exhibition Rosenquist had developed and experimented with the *Horizon Home Sweet Home* installation in his Broome Street studio as well as in a loft space on Wooster Street owned by art dealer Richard Feigen. In the fall Castelli exhibits the paintings *Area Code* and *Flamingo Capsule*. Rosenquist travels to Germany in November with his wife for a solo show at Galerie Rolf Ricke, Cologne, featuring *Slush Thrust* (1970), another room installation. He is awarded the Friend of Japan Award from Kokusai Bunka Shinkokai (Japanese Society for International Cultural Relations), and designs a poster for the 1970 New York Film Festival.

394 Poster/announcement for the exhibition *Rosenquist: Horse Blinders*, Leo Castelli Gallery, New York, 1969

395 Rolf Ricke, his wife, and Rosenquist in front of *Area Code*, 1970, in progress, East Hampton studio, New York, 1970

396 Poster/announcement for the exhibition *James Rosenquist: Horizon Home Sweet Home*, Leo Castelli Gallery, New York, 1970

395

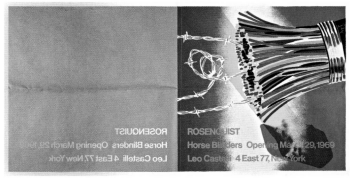

394

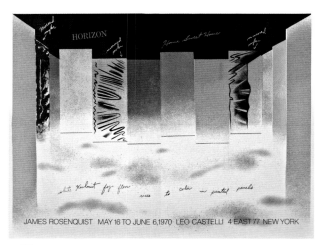

396

397

398

397 James Rosenquist and photographer Jack Mitchell experiment with photographing balloon motion under strobe lights, April 1970

398 Rosenquist working on *Flamingo Capsule*, 1970, East Hampton studio, New York, 1970

399 *Flamingo Capsule*, at Leo Castelli Gallery, New York, 1970

400 Poster/announcement for the exhibition *James Rosenquist: Two Large Paintings*, Leo Castelli Gallery, New York, 1970

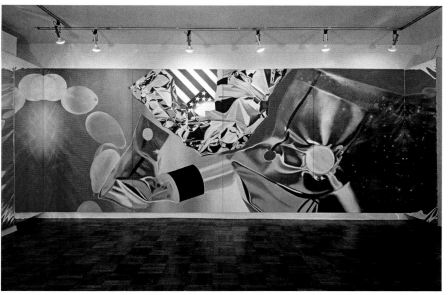

399

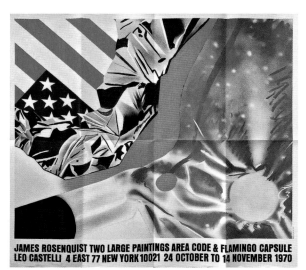

400

401

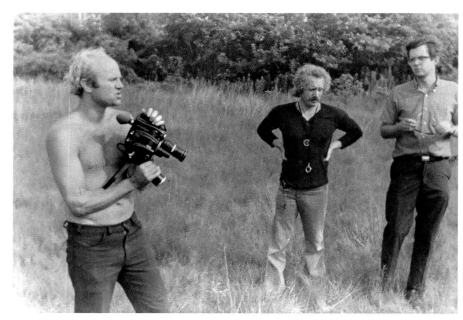

402

401 Strips of film from *Empty Chairs* (destroyed);
Peter Schjedahl shooting

402 James Rosenquist filming *Empty Chairs*
(photo courtesy of Gordon Hyatt)

403 Poster designed by Rosenquist for the Eighth New York
Film Festival, Lincoln Center, New York, 1970

404 Sketch for *Vantage Point*, 1971

405 35mm film clips from four-screen film environment
Vantage Point, 1971

405

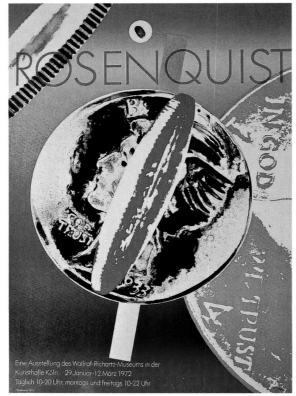

406

407

406 Poster for the exhibition *James Rosenquist: Gemälde—Räume—Graphik* at Josef-Haubrich-Kunsthalle Köln / Wallraf-Richartz-Museum, Cologne, 1972

407 James Rosenquist and Evelyn Weiss at Wallraf-Richartz-Museum, 1972

408 Installation views of the exhibition *James Rosenquist:*
–410 *Gemälde—Räume—Graphik* at Josef-Haubrich-Kunsthalle Köln / Wallraf-Richartz-Museum, Cologne, 1972

411 Cover designed by Rosenquist for the exhibition catalogue *James Rosenquist* by Marcia Tucker, Whitney Museum of American Art, New York, 1972

412 Exhibition announcement for the exhibition *James Rosenquist*, Amerika Haus, Berlin, 1973

408

409

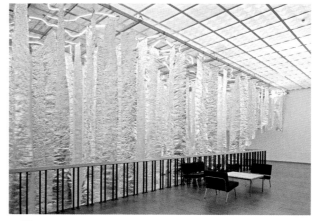

410

1971 In February, Rosenquist, his wife, and their son are seriously injured in an automobile accident in Florida. While his wife and son convalesce in a Tampa hospital, Rosenquist travels back and forth between Tampa and New York, renting a two-story studio on Wall Street in Lower Manhattan. He begins collaborating with Donald Saff at Graphic studio/University of South Florida, Tampa, where he produces the print series *Cold Light Suite* (1971).

1972 The Wallraf-Richartz-Museum, Cologne, and the Whitney Museum of American Art, New York, each host a Rosenquist retrospective this year. Evelyn Weiss organizes the retrospective *James Rosenquist: Gemälde—Räume—Graphik* for the German museum, which is installed at the Kunsthalle Köln. The Whitney presents the painting retrospective *James Rosenquist*, organized by Associate Curator Marcia Tucker, which travels to the Museum of Contemporary Art, Chicago. The Whitney show is negatively reviewed by John Canaday in *The New York Times*, who likens Rosenquist's work to a corpse and the exhibition to a wake. In a letter to *The New York Times*, Rosenquist protests the critic's choice of words in light of the 1971 accident that permanently injured his wife and son. "I know more about death than Mr. Canaday. I prefer life. Long live artists, long live art collectors, long live art dealers, long live art critics, but damn a person like Mr. Canaday," he writes.[15]

Rosenquist demonstrates in Washington, D.C., against the Vietnam War, and is arrested and jailed for one night. He travels to London to work at Petersburg Press, where he produces several prints based on early paintings, such as *Hey! Let's Go for a Ride* (1961) and *Pushbutton* (1961). In New York he produces the four panels of the lithograph and screenprint *Horse Blinders* at Styria Studio with Marion Goodman, relating to the 1968 painting of the same name. Rosenquist will come to consider *Horse Blinders* to be his most important monumental print of the 1970s.[16]

411

412

1973 Rosenquist rents two storefronts, at 1724 and 1726 Seventh Avenue in Ybor City, Florida, to use as a studio. Founded at the end of the 1800s by Cuban immigrants, Ybor City is part of east Tampa. By 1973 he is also renting a studio on the Bowery in downtown Manhattan, as he continues to work in both Florida and New York. In the Bowery studio he returns to large-scale painting with such works as *Paper Clip* and produces experimental hanging works, one of which incorporates the Coca-Cola logo and is made from Tergal polyester fabric. The latter work hangs dipped into a trough of colored ink, which is gradually absorbed into the fabric through capillary action.[17] Rosenquist's work is represented in the exhibition *Contemporanea* in the fall at the Villa Borghese, Rome.

1974 Rosenquist's work is included in the exhibition *American Pop Art*, curated by Lawrence Alloway, at the Whitney Museum of American Art, New York. He completes the lithograph *Off the Continental Divide* (1973–74), the largest print ULAE has produced up to this point. This print addresses the flow of water from the Midwest to the East, reflecting Rosenquist's own trajectory from Minnesota to New York.[18] He attends a Senate subcommittee hearing with fellow artist Robert Rauschenberg to lobby for legislation regarding artists' estate inheritance taxes and resale royalties.

1975 In January, Rosenquist and the artists' rights advocate Rubin Gorewitz address several hundred artists in Chicago about artists' royalty legislation.[19] Rosenquist designs a set for *Deuce Coupe II*, a dance choreographed by Twyla Tharpe and performed by the Joffrey Ballet at City Center, New York, in the spring. Rosenquist and his wife, Mary Lou, divorce.

1976 Rosenquist continues to travel back and forth between Tampa and New York, eventually purchasing land in Aripeka, Florida, forty-five miles north of Tampa on the Gulf of Mexico, on which he begins building a house with the assistance of architect Gilbert Flores. Shaped like a bow, the house is propped atop eighteen-foot-high stilts, which accommodate an open-air studio beneath the house.[20] Rosenquist continues to acquire land adjacent to the original property, maintaining the natural state of dense, tropical vegetation.

Rosenquist works on *Calyx Krater Trash Can*, a limited-edition sculpture commissioned by the New York jeweler Sid Singer. This artwork is a small, hand-wrought, solid-gold garbage can that is fabricated and colored with oil paint by Rosenquist and etched by Donald Saff. It registers opposition to the Metropolitan Museum of Art's decision to deaccession works from its permanent collection to finance the purchase of a Greek calyx-krater. Rosenquist is commissioned to create a mural for the new Florida State Capitol in Tallahassee. After Rosenquist's friend Russian artist Evgeny Rukhin dies (allegedly assassinated by the KGB), Rukhin's wife moves to the United States and asks Rosenquist to store her late husband's canvases, which he does at his New York studio.

In June Rosenquist lobbies Congress with Marion Javits—wife of New York Senator Jacob Javits—and Robert Rauschenberg for legislation to permit artists to take deductions on their taxes for the market value of their artworks donated to nonprofit, educational, and other institutions; Rosenquist and Rauschenberg also attend a press conference organized by Senator Javits on the issue. In August the Senate passes Javits's amendment to the 1969 Tax Reform Act, allowing artists to receive equitable tax credit for their donations valued at up to twenty-five thousand dollars.[21]

1977 At the invitation of Joan Mondale, the incoming Vice President's wife, Rosenquist attends the inauguration of President Jimmy Carter. Rosenquist purchases a five-story building on Chambers Street in New York, which he converts into studio and residential space. He produces the etching series *Calyx-Krater Trash Can Suite* at Pyramid Arts, Ltd., in Tampa, which relates to *Calyx Krater Trash Can* from 1976. Rosenquist begins working with Gemini G.E.L. in Los Angeles, producing three lithographs, two of which include attached elements.

413

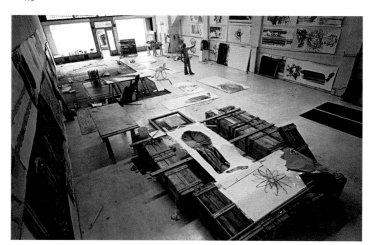

414

413 Ybor City, Florida, 1975

414 Rosenquist working on a series of drawings using an experimental technique of applying a blend of acrylic paint with a screenprint squeegee, Ybor City studio, Florida, 1974

415 Rosenquist working in his Bowery studio, New York, 1973. Works shown, left to right: *Paper Clip*, *Capillary Action III*, and *Slipping Off the Continental Divide*, all 1973, 1973

416 Rosenquist and Bill Molnar cleaning etching plates, Aripeka, Florida, ca. 1978

417 Rosenquist working on *Star Pointer* (1977), assisted by Tony Zepeda, at Gemini G.E.L., Los Angeles, 1977

418 Rosenquist working in original ground floor studio of his home in Aripeka, Florida, 1977. Works shown, left to right: *Evolutionary Balance*, *Gears*, and *Highway Trust,* all 1977

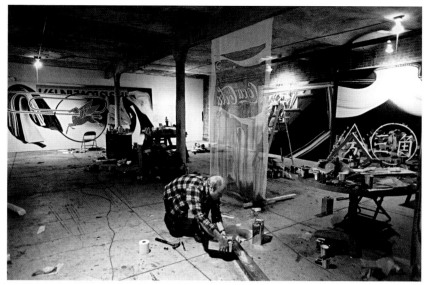

415

417

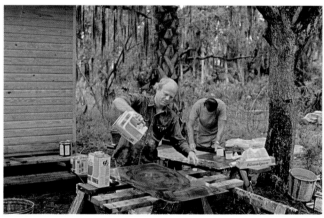

416

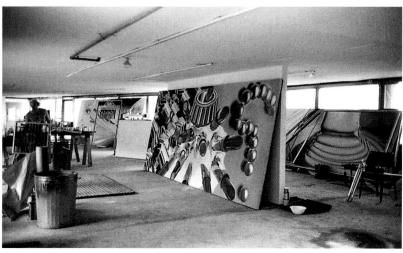

418

419

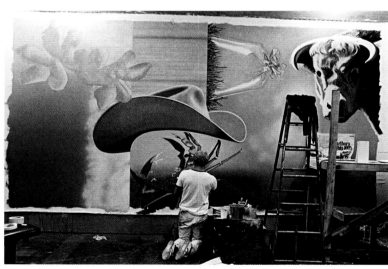

420

421

1978 Joan Mondale asks Rosenquist to serve on the National Council on the Arts. He is appointed by President Jimmy Carter to a six-year term at the organization, which advises the National Endowment for the Arts. He travels to Venice to attend the thirty-eighth Venice Biennale, in which *F-111* (1964–65) is installed. Rosenquist completes a monumental diptych titled *Tallahassee Murals* (1976–78), featuring symbols of Florida's industry, economy, and natural environment including the state seal, the state bird (the mockingbird), a monarch butterfly, an alligator, a phosphate rock, palm and pine trees, cattle, crustaceans, and a cowboy hat.[22]

1979 Rosenquist designs posters for the Institute of Arts and Urban Resources in Queens, New York (P.S.1); the Associates of the American Friends of the Israel Museum; and the inauguration of President John Brademas of New York University. The John and Mable Ringling Museum of Art in Sarasota, Florida, hosts *James Rosenquist Graphics Retrospective*, the first comprehensive survey of Rosenquist's prints.

1980 Rosenquist participates in a conference, the Business of Art and the Artists, at the American Museum of Natural History, New York, sponsored by the National Endowment for the Arts and the Small Business Administration. He travels to Israel with Judith Goldman and Carolyn Alexander to give a lecture on printmaking at an exhibition sponsored by the United States Information Agency: *Print Publishing in America*.[23] At his Chambers Street studio, Rosenquist paints *Star Thief*, whose dimensions, seventeen-by-forty-six feet, will become a standard for a number of later Rosenquist works. The creation of the painting—from blank canvas to completed work—is documented by photographer Bob Adelman over a period of five weeks; in February 1981 the photographs will be featured in an eleven-page color article in *Life* magazine entitled "Evolution of a Painting."

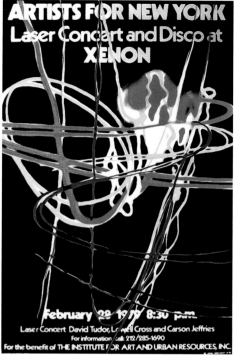

422

423

424

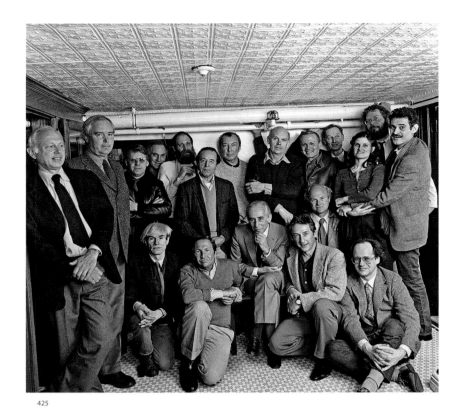

425 Reunion of artists represented by Leo Castelli, basement of Odeon restaurant, New York, 1982. Left to right, sitting: Andy Warhol, Robert Rauschenberg, Leo Castelli, Edward Ruscha, James Rosenquist, and Robert Barry; and standing: Ellsworth Kelly, Dan Flavin, Joseph Kosuth, Richard Serra, Lawrence Weiner, Nassos Daphnis, Jasper Johns, Claes Oldenburg, Salvatore Scarpitta, Richard Artschwager, Mia Westerlund Roosen, Cletus Johnson, and Keith Sonnier, photograph by Hans Namuth

426 Rosenquist working on *Fahrenheit 1982°* (1982) in his Chambers Street studio, New York, 1982. Background: partial view of *Four New Clear Women* (1982)

427 Rosenquist with *Flowers, Fish and Females for the Four Seasons*, 1984, while it is being transported into the Seagram Building, New York, 1984

428 James Rosenquist and his future wife, Mimi Thompson, in front of *Four New Clear Women*, 1982, in progress, Chambers Street studio, New York, photograph by Hans Namuth, 1982

429 Installation of *Four New Clear Women*, 1982, at Leo Castelli Gallery, 1983

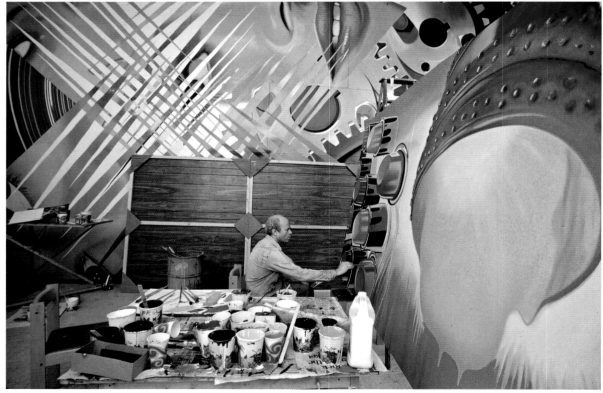

426

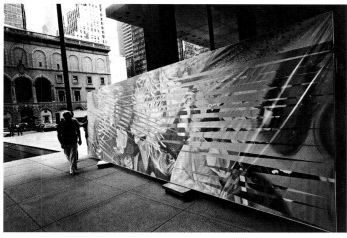

427

428

1981 In January, *Star Thief* (1980) is exhibited at the Leo Castelli Gallery, New York, and is subsequently selected by the Dade County Art in Public Spaces Committee for installation in Terminal Two of Miami International Airport. The painting is not installed in the concourse due to resistance from Eastern Airlines—the main tenant of Terminal Two—when Frank Borman, former astronaut and chairman of Eastern Airlines, strongly rejects the painting. A private collector in Chicago (Burton Kantor, a tax attorney) will eventually purchase the painting for an undisclosed sum. (The painting is ultimately acquired by the Museum Ludwig in Cologne, Germany, for the permanent collection.) Rosenquist receives an Honorary Doctorate of Fine Arts from the University of South Florida, Tampa. He produces *The Glass Wishes* series of aquatints at Gemini G.E.L.

1982 The La Jolla Museum of Contemporary Art in California presents *Castelli and His Artists: Twenty-five Years*, which is organized by the Aspen Center for the Visual Arts, Colorado, and features work by eighteen artists including Rosenquist, Roy Lichtenstein, Robert Rauschenberg, and Andy Warhol. In New York the Leo Castelli Gallery mounts *New Works by Gallery Artists*, which includes paintings by Rosenquist.

1983 In March construction is complete on a large, naturally lit studio on Rosenquist's property in Aripeka, Florida. His lithograph *Ice Point*—which incorporates a slivered image of a woman's face on a starry white background—is published by Visconti/Laxo Vujic in the portfolio *Art and Sport* to commemorate the upcoming 1984 Winter Olympics in Sarajevo, Yugoslavia.

1984 Alex von Bidder, Paul Kovi, and Tom Margittai, owners of the Four Seasons restaurant in the Seagram Building, New York, commission Rosenquist to create a painting in honor of the restaurant's twenty-fifth year of service. The resulting seven-and-one-half-by-twenty-four-foot painting *Flowers, Fish and Females for the Four Seasons* (1984) is installed in the east corner of the Pool Room, the restaurant's main dining room. The French automobile manufacturer Renault Automobile Co. commissions Rosenquist to paint a mural for the Fondation l'Incitation, Paris; *Eau du Robot* (1984) is Rosenquist's response.

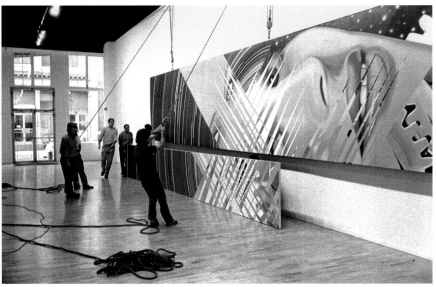

429

1985 The Denver Art Museum organizes the retrospective *James Rosenquist: Paintings 1961–1985*, curated by Dianne Perry Vanderlip. The exhibition travels to the Contemporary Arts Museum, Houston; the Des Moines Art Center; the Albright-Knox Art Gallery, Buffalo; the Whitney Museum of American Art, New York; and the National Museum of American Art, Smithsonian Institution, Washington, D.C. Rosenquist completes *Sunshot,* a mural commissioned for the lobby of the Ashley Tower in Tampa, Florida.

1986 The Scull Collection, including Rosenquist's *Portrait of the Scull Family* (1962) and *F-111* (1964–65), is sold at Sotheby's Contemporary Art Auction on November 11 and 12. Sold for just over two million dollars, the highest amount ever paid for a Rosenquist work at auction up to that point, *F-111* is subsequently installed in the lobby of the Society Bank tower in downtown Cleveland. Rosenquist creates the mural *Ladies of the Opera Terrace*, which is a commission for the Opera Terrace, a ballroom located within the Operakällaren restaurant at Stockholm's opera house.[24] He is also commissioned to paint a mural for AT&T Headquarters in Manhattan. When the painting, *Animal Screams* (1986), is finished, AT&T abandons the commission, and the work is sold to a group of businessmen in Sweden.

1987 Rosenquist finishes the print series *Secrets in Carnations*, at Graphic-studio/University of South Florida, Tampa. Begun in 1986, the series comprises five prints—including *The Kabuki Blushes*—that incorporate interspliced or "crosshatched" images of women and plants. In April, Rosenquist marries painter and writer Mimi Thompson. Representing the Florida Department of State and the Florida Arts Council, Secretary of State George Firestone presents Rosenquist with the Florida Arts Recognition Award on May 6. Rosenquist completes the mural *Welcome to the Water Planet*, which is a commission for the Corporate Property Investors building in Atlanta. He begins working on a related series of nine lithographic and handmade-paper-pulp works at Tyler Graphics Ltd. in Bedford Village, New York. At Graphicstudio he likewise creates the related large-scale aquatints *Welcome to the Water Planet* and *The Prickly Dark*, which use a grisaille palette to great effect.

1988 Rosenquist receives the Golden Plate Award from the American Academy of Achievement, Nashville, on July 2. To fulfill a commission from McDonald's Swedish Corporation, Rosenquist paints the mural *Welcome to the Water Planet III*. Leo Castelli Gallery features Rosenquist's seventeen-by-forty-six-foot painting *Through the Eye of the Needle to the Anvil* (1988) in an exhibition of the same name.

1989 In November, Rosenquist's daughter, Lily, is born in New York. He completes the *Welcome to the Water Planet* series with Kenneth Tyler at Tyler's new studio, Tyler Graphics Ltd., in Mount Kisco, New York. On Rosenquist's property in Aripeka, Florida, construction is completed on his second naturally lit studio, which incorporates steel girders and corrugated-metal walls approaching industrial scale. He adapts a mobile hydraulic lift to work at various heights on large-scale canvases.

430 Rosenquist working on *The Bird of Paradise Approaches the Hot Water Planet*, 1989, Tyler Graphics Ltd., Mount Kisco, New York, 1989

431 Rosenquist and Bill Goldston working on *The Persistence of Electrons in Space* at Universal Limited Art Editions, West Islip, New York, 1987

432 Rosenquist on the front porch of his home, Aripeka, Florida, ca. 1988

433 Rosenquist and his wife, Mimi Thompson, with their newborn daughter, Lily, Chambers Street studio, New York, 1989

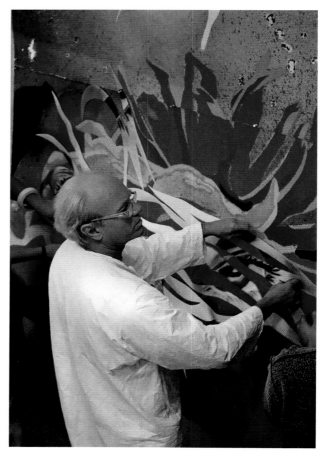

430

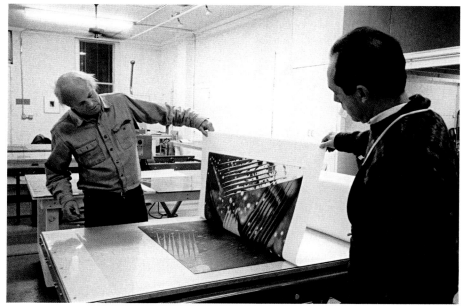

431

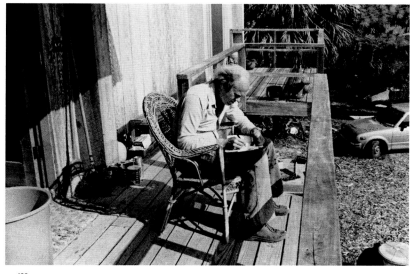

432

433

1990 Vandals slash a Rosenquist painting as well as a Roy Lichtenstein painting on view in art dealer Leo Castelli's booth at the International Art Fair FIAC in Paris. Castelli does not press charges. *F-111* (1964–65) is included in *High and Low: Modern Art and Popular Culture* at the Museum of Modern Art, New York, which is curated by Kirk Varnedoe and Adam Gopnik.

1991 In February the State Tretiakov Gallery, Central House of Artists, Moscow, hosts *Rosenquist: Moscow 1961–1991*, an exhibition organized by Donald Saff. This major retrospective is one of the first post–Cold War exhibitions in Russia of work by an American artist. IVAM Centre Julio González, Valencia, Spain, presents the large-scale painting exhibition *James Rosenquist*. Rosenquist's work is represented in *The Pop Art Show* at the Royal Academy of Arts, London. Works included in the exhibition are *Hey! Let's Go for a Ride* (1961), *I Love You with My Ford* (1961), *Look Alive (Blue Feet, Look Alive)* (1961), and *Star Thief* (1980). Rosenquist is awarded the Florida Prize by *The New York Times* Regional Newspapers on June 27.

1992 Rosenquist is awarded the Chevalier dans l'Ordre des Arts et des Lettres by Jack Lang, French Minister of Culture. Gagosian Gallery, New York, hosts the exhibition *James Rosenquist: The Early Pictures 1961–1964*, in which Rosenquist for the first time displays a small number of his preparatory collages for paintings. The collages are also published for the first time, in the exhibition's catalogue. He is represented in the exhibition *Hand-Painted Pop: American Art in Transition, 1955–62* at the Museum of Contemporary Art, Los Angeles. A limited number of Rosenquist's preparatory collages are shown in this exhibition as well, and are reproduced in the accompanying catalogue. Rosenquist begins painting the series *Gift Wrapped Dolls* (1992–93),[25] which the artist describes as a response to the AIDS crisis. In the fall the *Gift Wrapped Dolls* paintings are featured in the exhibition *James Rosenquist: Recent Paintings* at Galerie Thaddaeus Ropac, Paris. He completes the monumental print *Time Dust*, measuring approximately seven by thirty-five feet.

434 Rosenquist's staff and studio assistants, left to right: Tony Caparello, James Dailey, Beverly Coe, Bill Molnar, Paul Simmons, Tim Merrill, Cindy Hemstreet, and Michael Harrigan, Aripeka, Florida, 1990

435 Poster designed by Rosenquist for *Rosenquist: Moscow 1961–1991*, Moscow, U.S.S.R., 1991

436 *Rosenquist: Moscow 1961–1991*, State Tretiakov Gallery, Central House of Artists, Moscow, 1991

434

435

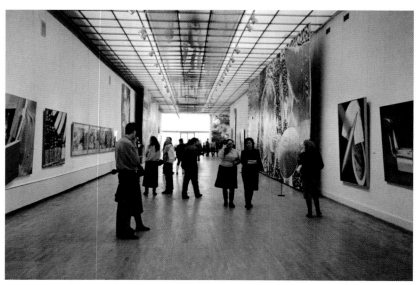

436

437 Rosenquist standing in the door of his studio,
Aripeka, Florida, 1992. Background: partial view of
The Persistence of Electrical Nymphs in Space (1985)

438 Rosenquist wearing the mask he designed for the
Outsiders Masked Ball benefit auction, Los Angeles
County Museum of Art, Los Angeles, California, 1992

439 Kenneth Tyler and others assisting James Rosenquist
on top of moveable trolley spraying colored paper pulp
from a pattern pistol onto seven colored paper pulp
sheets on platform in workshop driveway for *Time Dust*,
Tyler Graphics Ltd., Mount Kisco, New York, 1990

437

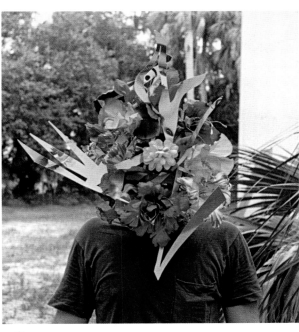

438

439

440

441

442

440 Rosenquist working on *Time Dust*, 1992,
 Tyler Graphics Ltd., Mount Kisco, New York, 1992

441 Cover of the exhibition catalogue/catalogue raisonné
 *Time Dust, James Rosenquist: Complete Graphics,
 1962–1992* by Constance Glenn, 1993

442 Rosenquist and Roy Lichtenstein at showing of
 Time Dust, 1992, Gagosian Gallery, New York, 1993

443 *The Swimmer in the Econo-mist*, 1997–98,
 in progress in the studio, Aripeka, Florida, 1997

1993 Organized by Constance Glenn at the University Art Museum, California State University, Long Beach, the exhibition *James Rosenquist: Time Dust, The Complete Graphics, 1962–1992*, opens at the first of its ten venues: the Walker Art Center, Minneapolis. It is accompanied by an exhibition catalogue that includes a catalogue raisonné of Rosenquist's graphic works and also illustrates many of his preparatory collages. On March 13 hurricane-strength winds and a tidal surge on the Gulf of Mexico from a tropical storm flood Rosenquist's Aripeka, Florida, studio and office. Much of the artist's archives, including documentation, photographs, and works on paper, is damaged or lost. In the spring Leo Castelli Gallery, New York, features Rosenquist's series *Gift Wrapped Dolls* (1992–93), along with his painting *Masquerade of the Military Industrial Complex Looking Down on the Insect World* (1992), in a solo show. Rosenquist's *Gift Wrapped Dolls* are also featured in solo shows at Akira Ikeda Gallery, Tokyo, and Feigen, Inc., Chicago.

1994 Rosenquist receives the Skowhegan Medal of Painting from the Skowhegan School of Painting and Sculpture, Maine. In the fall Leo Castelli Gallery, New York, celebrates its long connection with Rosenquist by presenting *James Rosenquist: The Thirtieth Anniversary Exhibition*.

1995 The exhibition *James Rosenquist Paintings* is shown at the Seattle Art Museum. Rosenquist's recent work is also featured in Italy in *James Rosenquist: Gli anni novanta*, a solo show at the Civico Museo Revoltella, Galleria d'Arte Moderna, Trieste.

1996 Rosenquist's collaboration with Graphicstudio/University of South Florida, Tampa, is honored in the exhibition *James Rosenquist: A Retrospective of Prints Made at Graphicstudio 1971–1996*, installed at the College of Fine Arts, University of South Florida. In the spring Rosenquist is featured in a solo show at the Leo Castelli Gallery, New York. He creates a series of twenty-six gun paintings, which are featured in the spring in the exhibition *Target Practice: Recent Paintings by James Rosenquist* at Feigen, Inc., in Chicago.

Rosenquist designs a set of six espresso cups and saucers for Italian coffee-maker Illycaffè, which are introduced in late April as the Italian Riviera collection. The cups are decorated with a motif of colorful paper strips, described by the artist as "colored pieces from a straw hat."[26] In November he begins discussions with the Solomon R. Guggenheim Foundation, New York, for a mural commission of "an updated version of *F-111*."[27]

1997 Rosenquist receives an Honorary Doctorate of Fine Arts degree from Bard College, Annandale-on-Hudson, New York, on May 24. The Center for Contemporary Graphic Art and Tyler Graphics Archive Collection of Fukushima, Japan, host *The Graphics of James Rosenquist*. In the fall, in New York, he is included in the celebratory Leo Castelli Gallery exhibition *Forty Years of Exploration and Innovation: The Artists of the Castelli Gallery 1957–1997, Part One*. He begins the Guggenheim commission—requested for the new Deutsche Guggenheim Berlin exhibition space—in his Aripeka, Florida, studio and completes one of the three paintings that constitute this three-part installation work entitled *The Swimmer in the Econo-mist* (1997–98).

Rosenquist's *Horizon Home Sweet Home* is shown in the exhibition *Home Sweet Home/Einrichtungen/Interieurs/Möbel* at the Deichtorhallen Hamburg from June 20 to September 28.

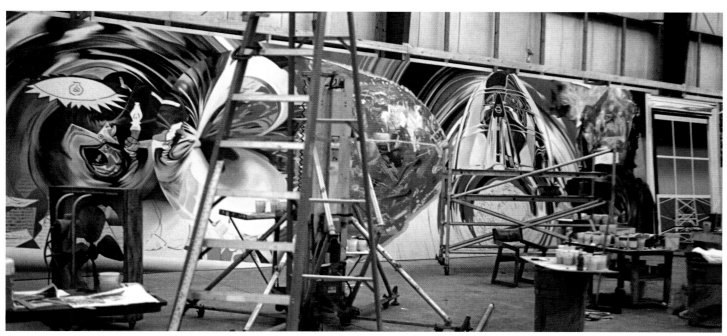

443

444 *Sketch for Borderline Freedom*, ca. 2010
Marker on paper
19 × 24 in. (48.3 × 61 cm)
Estate of James Rosenquist

445 *Sketch for Borderline Freedom*, ca. 2010
Mixed media on paper
24 × 19 in. (61 × 48.3 cm)
Estate of James Rosenquist

446 Rosenquist applying painted footprints to the 24-by-133-foot painting *Celebrating the Fiftieth Anniversary of the Signing of the Universal Declaration of Human Rights by Eleanor Roosevelt*, 1998, with help from studio assistant Darren Merrill, Aripeka studio, Florida, 1998

447 Rosenquist walking on *Celebrating the Fiftieth Anniversary of the Signing of the Universal Declaration of Human Rights by Eleanor Roosevelt* (1998), Guggenheim Museum Soho, New York, ca. 1999. The exhibition *Andy Warhol: The Last Supper* is on the walls.

445

444

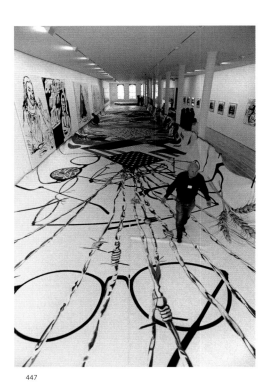

447

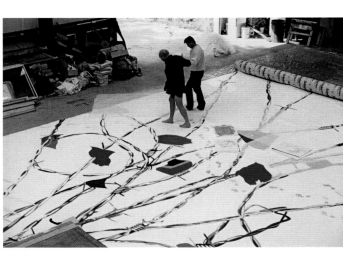

446

1998 Rosenquist paints *Celebrating the Fiftieth Anniversary of the Signing of the Universal Declaration of Human Rights by Eleanor Roosevelt* in response to a commission from the city of Paris for a mural to mark the anniversary; it is intended for installation on the ceiling of the Palais de Chaillot, a government building, but remains in the artist's collection after a change in city leadership. He completes the three-painting suite *The Swimmer in the Econo-mist* (1997–98), which is installed in the spring at Deutsche Guggenheim Berlin as the institution's first commissioned work and second show. The exhibition space is located on Unter den Linden, in former East Berlin, on the ground floor of Deutsche Bank's offices, and the exhibition celebrates the cooperative endeavor between Deutsche Bank and the Solomon R. Guggenheim Foundation. The subjects of *The Swimmer in the Econo-mist* are industry, consumerism, and the turbulent nature of the economy as a whole. The painting also refers to the wars that shaped the twentieth century, as the images borrowed from *F-111* (1964–65) and Pablo Picasso's *Guernica* (1937) suggest. Hugo Boss designs and produces an edition of 250 "Rosenquist" paper suits in conjunction with the show.

1999 In the fall Rosenquist is represented in the exhibition *The American Century: Art and Culture 1900–2000* at the Whitney Museum of American Art, New York. He begins relatively abstract paintings for the *Speed of Light* series, which he will work on until 2001. At ULAE he produces a related series of prints with imagery derived from the paintings.

2000 In June, with wife Mimi Thompson and daughter Lily, Rosenquist attends the Friends of Art and Preservation in Embassies reception hosted by Hillary Clinton at the White House, along with fellow artists Ellsworth Kelly, Joel Shapiro, and Frank Stella. Rosenquist's seven-color lithograph *The Stars and Stripes at the Speed of Light* (2000) is unveiled at the reception. He donates the edition of fifty to American embassies around the world. Among the artists participating in the program are Louise Bourgeois, Roy Lichtenstein, Maya Lin, Robert Rauschenberg, and Stella.

2001 In the spring Rosenquist travels to Paris, where his work is included in the exhibition *Les Années Pop: 1956–1968* at the Musée National d'Art Moderne, Centre Georges Pompidou. Gagosian Gallery, New York, hosts the solo show *James Rosenquist: The Stowaway Peers Out at the Speed of Light* at its Chelsea space, which features paintings from the *Speed of Light* (1999–2001) series. He is also represented in the Gagosian exhibition *Pop Art: The John and Kimiko Powers Collection* at the gallery's Madison Avenue location. In June at the Tampa Museum of Art, Rosenquist is inducted into the Florida Artists Hall of Fame. The thirtieth artist or performer thus honored, he joins a group including Jimmy Buffett, Ray Charles, Ernest Hemingway, Zora Neale Hurston, Robert Rauschenberg, Burt Reynolds, and Tennessee Williams.

448

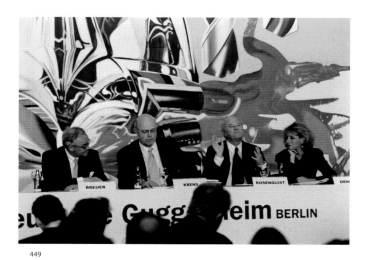

449

2002 Rosenquist donates a large sculpture to the All Children's Hospital, University of South Florida, Saint Petersburg. Affixed to the outside of the hospital's state-of-the-art Children's Research Institute, the aluminum and fiberglass sculpture, shaped like an adhesive bandage, is decorated with a colorful motif of a rainbow, a tic-tac-toe game, and various figures and numbers.[28] Dedicated in a ceremony on April 23, the sculpture is the second public art project Rosenquist has completed in Florida. He receives an Honorary Doctorate of Humane Letters from the University of Minnesota, Minneapolis, on May 19. In June the Fundación Cristóbal Gabarrón of Valladolid, Spain, confers upon him its annual international award for art in recognition of his great contributions to universal culture. In the fall he is included in *Surrounding Interiors: Views inside the Car*, organized by Judith Hoos Fox at the Davis Museum and Cultural Center at Wellesley College, Massachusetts. Rosenquist signs the "Not In Our Name Statement of Conscience" petition coordinated by the Bill of Rights Foundation to protest the military actions of the United States government in response to the events of September 11, 2001. Among the forty thousand signatories are prominent actors, artists, and political activists. The statement is published throughout the fall and winter in major newspapers across the United States and abroad, including *The New York Times*, *Chicago Tribune*, *San Francisco Chronicle*, *Los Angeles Times*, *The Guardian* (London), *The Daily Star* (Beirut), and *La Jornada* (Mexico City).

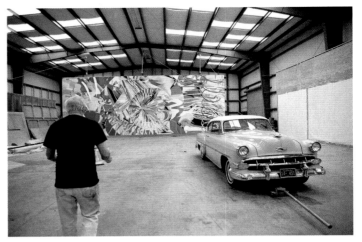

450

2003 In the spring the full-career exhibition organized by the Guggenheim Museum, *James Rosenquist: A Retrospective*, opens at The Menil Collection and The Museum of Fine Arts in Houston, Texas, and travels to the Solomon R. Guggenheim Museum, New York; the Guggenheim Museum Bilbao, Spain; and Kunstmuseum Wolfsburg, Germany, through 2005. Writer Ingrid Sischy profiles Rosenquist in a ten-page article, "Rosenquist's Big Picture," in the May issue of *Vanity Fair*. Rosenquist receives an Honorary Doctorate in Fine Arts Degree from Montserrat College of Arts, Beverly, Massachusetts. He designs a second limited-edition ceramic coffee cup collection for Italian coffeemaker Illycaffè titled *Coffee Flowers Ideas*; this design features a cappuccino cup with imagery of women's smiling faces interspliced with red coffee beans and white coffee flowers. The exhibition *Pop³: Oldenburg, Rosenquist, Warhol* opens at the Walker Art Center, in Minneapolis, Minnesota.

2004 Rosenquist's work is included in two Pop art exhibitions in Europe: *Das Grosse Fressen: Von Pop bis Heute* at the Kunsthalle Bielefeld, Germany, and *Pop Classics* at ARoS Aarhus Art Museum, Denmark. In the fall, his painting *Untitled* (1987) is featured in the exhibition *The Flower as Image*, at Louisiana Museum of Modern Art, in Humlebæk, Denmark.

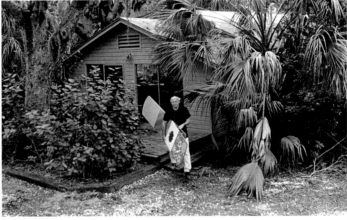

451

2005 Rosenquist receives the Legends Award from Pratt Institute, Brooklyn, New York on April 19. He is bestowed an Honorary Doctorate in Fine Arts Degree from North Dakota State University, Fargo, on May 13. The exhibition *James Rosenquist: Ten Paintings, 1965–2004; Collage, 1987* opens at Givon Art Gallery, Tel Aviv, Israel. His painting *Untitled* (1987) is included in the exhibition *Flower Myth: Van Gogh to Jeff Koons* at the Fondation Beyeler, in Riehen/Basel, Switzerland. Rosenquist's second paper suit (released as a limited edition by Hugo Boss in 1998 in dyed Tyvek) is featured in the exhibition *Pattern Language: Clothing as Communicator* at Tufts University Art Gallery in Medford, Massachusetts, and travels to four subsequent venues.

452

453

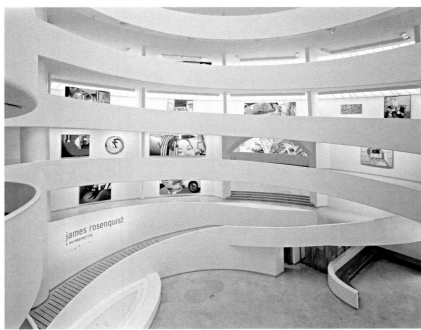

454

455

2006 Rosenquist receives the Lifetime Achievement Award from Polk Museum of Art, Lakeland, Florida, on March 21, where his work is also featured in the exhibition *Pop Art 1956–2006: The First 50 Years*. The exhibition *Welcome to the Water Planet: Paperworks by James Rosenquist* opens at the National Gallery of Australia, Canberra, in the summer. His work is featured in London, England, in the show *James Rosenquist*, which opens at the Haunch of Venison gallery in the fall. Rosenquist donates a painting to the collaborative sculpture project *The Peace Tower, 2005–2006*, created by Rirkrit Tiravanija and Mark di Suvero for the 2006 Whitney Biennial. The sculpture project is a reconception of the original 1966 *Peace Tower* (officially titled "The Artists' Tower of Protest") to which Rosenquist and more than four hundred artists contributed artworks in protest to the Vietnam war.

2007 Rosenquist's work is included in the exhibition *Art in America: Three Hundred Years of Innovation*, co-organized by the Solomon R. Guggenheim Museum and the Terra Foundation, which opens in February at the National Art Museum in Beijing, China, and travels to Shanghai, and then to Russia and Spain. He begins a new body of work—the *Time Blades* series—in which he contemplates the concepts of time and existence. Works from the series are featured in *James Rosenquist: Time Blades*, at Acquavella Contemporary Art, Inc., New York. His work is included in the exhibition *Pop Art Portraits* at the National Portrait Gallery, London, England, which travels to the Staatsgalerie Stuttgart, Germany.

2008 Rosenquist's work is included in the exhibition *The Story Goes On: Contemporary Artists in the Wake of Van* Gogh at MODEM Centre for Modern and Contemporary Arts, Debrecen, Hungary, and in *Fernand Léger: Paris–New York* at the Fondation Beyeler, Riehen/Basel, Switzerland, in the summer. His painting on slit Mylar, *Daley Portrait* (1968), featuring an image of Chicago Mayor Richard J. Daley, is shown in the exhibition *1968: Art and Politics in Chicago* at DePaul University Museum in Chicago, Illinois. The early painting *Coenties Slip Studio* (1961) is presented in the exhibition *Circa 1958: Breaking Ground in American Art* at Ackland Art Museum, The University of North Carolina at Chapel Hill.

456 Rosenquist working on *Celebrating the Fiftieth Anniversary of the Signing of the Universal Declaration of Human Rights by Eleanor Roosevelt* (1998), Basel, Switzerland, 2006

457 *Celebrating the Fiftieth Anniversary of the Signing of the Universal Declaration of Human Rights by Eleanor Roosevelt* (1998) exhibited at Art Unlimited, *Art 37 Basel*, Switzerland, 2006

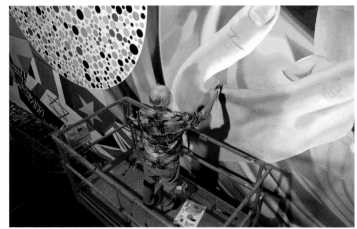

456

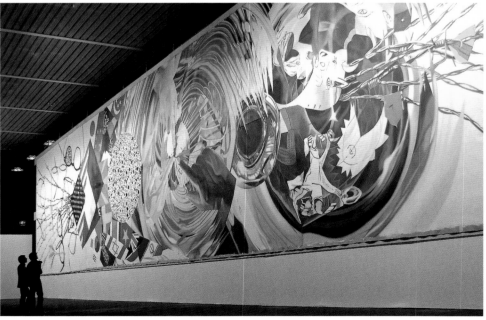

457

458

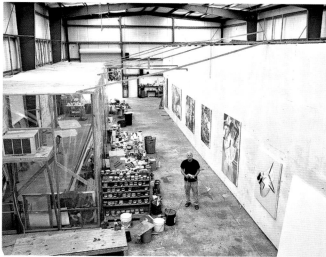

459

460

461

458 Party invitation for Rosenquist's seventy-fifth birthday, Aripeka, Florida, 2008

459 Rosenquist in studio with *Time Blades* series of paintings, Aripeka, Florida, 2007

460 James Rosenquist with Frank Stella at the opening of *James Rosenquist: Time Blades* at Acquavella Contemporary Art, Inc., New York, 2007

461 Opening of *James Rosenquist: Time Blades* at Acquavella Contemporary Art, Inc., New York, 2007

2009 On April 25 a brush fire spreads across Rosenquist's property in Aripeka, Florida, consuming sixty-two of his acres and destroying his house, office, studio, and other buildings. His print archives and numerous paintings are consumed by the flames. Rosenquist moves his office and work space to a stilt-house on the property (located across a road from the area destroyed by fire). He encloses the area under the house to create a studio in which he begins painting again. In October Rosenquist's memoir, *Painting Below Zero: Notes on a Life in Art*, is published by Alfred A. Knopf to positive reviews. The Salvador Dalí Museum in St. Petersburg, Florida, honors him with The Order of Salvador, on November 5. Rosenquist's painting *Tosca—Music, Murder and Mayhem* (2009) is shown in the exhibition *Something About Mary* at The Metropolitan Opera, New York; for the exhibition, he is one of sixteen contemporary artists invited to create work inspired by composer Giacomo Puccini's 1900 opera *Tosca*, which opens the The Metropolitan Opera's 2009–10 season. In sketches and preparatory works on paper, Rosenquist develops the collage *Red, White and News* for the cover of the holiday 2009 issue of *The New York Times Style Magazine*.

2010 Rosenquist's latest series of work is featured in the exhibition *James Rosenquist: The Hole in the Middle of Time and The Hole in the Wallpaper* that opens in February at Acquavella Contemporary Art, Inc., in New York City. The exhibition features seven paintings as well as a selection of motorized works, with attached mirrors, that spin. In the spring, he receives an honorary doctorate degree from the Corcoran College of Art, Washington, D.C. Rosenquist's work is shown in two exhibitions opening at the Museum of Modern Art, New York, in September: *Counter Space: Design and the Modern Kitchen*, and *On to Pop*. He receives the inaugural Hermitage Museum Foundation Award at the Hermitage Museum Foundation's first Hermitage Dinner at Christies in New York City on November 6.

2011 Rosenquist begins a new body of work, the *Multiverse* series, which features imagery of nebulae, star systems, and galaxies and that he will continue through 2015. Two years after the devastating fire on his Florida property, Rosenquist completes the painting *The Geometry of Fire* (2011), a meditation on the destruction; "The title is ultimately nondescriptive, because there is no such thing as geometry in fire, it's just wild, totally reckless, an accidental illumination an immolation. Humans always want to inject geometry and meaning into nature, but it's a mystery."[29] He is recognized as an Alumni of Notable Achievement by the College of Liberal Arts, University of Minnesota, Minneapolis on March 31. Rosenquist's work is included in the exhibition *Ileana Sonnabend: An Italian Portrait* at the Peggy Guggenheim Collection, Venice, Italy, and in the exhibition *Homage to Leo Castelli—9 Works by 9 Artists* at the Fundación Juan March in Madrid and in Palma de Mallorca, Spain. The Minneapolis College of Art and Design bestows upon him a Lifetime Achievement Award on September 17. Rosenquist paintings once owned by lifelong friend Robert Rauschenberg—including *Spaghetti* (1965) and *Waiting for Bob* (1979)—are featured in Gagosian Gallery's show, *The Private Collection of Robert Rauschenberg*, opening in November in New York City.

462
–463 Aftermath of the fire on Rosenquist's property that destroyed the studio, office, house, and other buildings, in Aripeka, Florida, 2009

464 Cover of *Painting Below Zero: Notes on a Life* in Art by James Rosenquist, with David Dalton, 2009

465 Rosenquist conversing with Marvin Ross Friedman at the James Rosenquist Talk and Book Signing, The Wolfsonian, Florida International University, Miami Beach, 2009

466 Diploma, The Degree of Doctor of Fine Arts Honoris Causa, Corcoran College of Art and Design, Washington, D.C., 2010

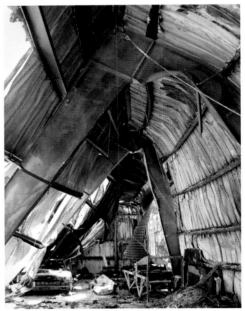

462

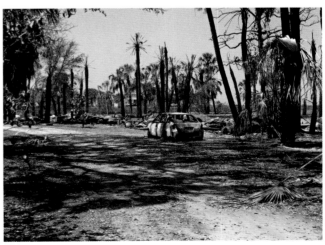

463

464

465

467 *Sketch for Red, White and News*, 2009
Ink and marker on paper
5 ⅞ × 5 ¼ in. (14.9 × 13.3 cm)
Estate of James Rosenquist

468 *Red White and Blue Fit to Print*, 2009
Color photocopy on paper
15 ⅛ × 11 in. (38.4 × 27.9 cm)
Estate of James Rosenquist

466

467

468

2012 The Museum of Modern Art in New York dedicates an exhibition, *James Rosenquist: F-111*, to Rosenquist's room installation and historic painting *F-111* (1964–65). He completes two prints with etched and rotating mirrors (and with imagery related to the *Multiverse* series of paintings) at ULAE. Rosenquist's latest series is featured in the show, *James Rosenquist: Multiverse You Are, I Am*, that opens in September at Acquavella Contemporary Art, Inc., in New York City. Rosenquist receives the Isabella and Theodor Dalenson Lifetime Achievement Award as part of the National Arts Awards organized by Americans for the Arts in New York City on October 15. His iconic painting, *I Love You with My Ford* (1961), is included in the Vitra Design Museum's exhibition, *Pop Art Design* that travels internationally.

2013 Rosenquist is presented with the ASF Cultural Award at the Spring Gala of the American-Scandinavian Foundation at the Pierre Hotel, in New York City, on April 26 in recognition as one of the founders of American Pop art. North Dakota Museum of Art hosts *James Rosenquist: An Exhibition Celebrating His 80th Birthday* in Grand Forks, North Dakota, which opens in August. A friend and correspondent to the late artist Ray Johnson, Rosenquist's work is included in the exhibition, *Correspondents of Ray Johnson*, at the Krannert Art Museum, University of Illinois at Urbana-Champaign. His work is also featured in the fall exhibition *Made in U.S.A.: Rosenquist/Ruscha* at the Museum of Art, Washington State University in Pullman. Having exhibited with the gallerist in the 1960s and 1970s, Rosenquist's early work *Volunteer* (1964) is included in the exhibition *Ileana Sonnabend: Ambassador for the New* that opens in December at the Museum of Modern Art, New York.

2014 Writer Daniel Kunitz and Rosenquist discuss the *Multiverse* series of works in the article "In the Studio: Master of Space and Time," in the February issue of *Art + Auction*. In March, Rosenquist and wife Mimi Thompson purchase a house in Miami, Florida, and set up a working studio there, where he continues working on the *Multiverse* series. In the spring, Rosenquist's work is included in the exhibition *Witness: Art and Civil Rights in the Sixties* at the Brooklyn Museum, New York, which travels to two venues in the United States. A selection of paintings from the *Multiverse* series are shown in the exhibition *James Rosenquist: All Things are Devoid of Intrinsic Existence* at Wetterling Gallery, in Stockholm, Sweden. Featuring loans from the former collection of the German industrialists Peter and Irene Ludwig borrowed from six different institutions, Rosenquist's work is presented in the exhibition *Ludwig Goes Pop* that opens at the Museum Ludwig in Cologne in October, and travels to Museum Moderner Kunst Stiftung Ludwig Wien in Vienna, Austria, in 2015. In November, the focused survey exhibition *James Rosenquist: Illustrious Works on Paper, Illuminating Paintings* opens at Oklahoma State University Museum of Art, Stillwater, and travels to Syracuse University Art Galleries, Syracuse, New York, in 2015.

2015 Rosenquist is honored as the inaugural recipient of the Spirit of Tomorrow Award by the Women of Tomorrow, Mentor and Scholarship Program, Miami, Florida on March 7. His work is presented in the exhibition, *The New York School, 1969: Henry Geldzahler at the Metropolitan Museum of Art*, at Paul Kasmin Gallery, in New York City. Rosenquist's painting *Zone* (1961) is included in the *International Pop* exhibition that opens at Walker Art Center, Minneapolis, Minnesota and travels to the Dallas Museum of Art, Texas, and the Philadelphia Museum of Art. Rosenquist completes *An Intrinsic Existence* (2015), the last painting produced as part of his final body of work, the *Multiverse* series.

469 Rosenquist with his daughter, Lily, and his wife, Mimi, 162 Chambers Street, New York, January 2013

470 Rosenquist with Marjorie Corbett in his Bedford Studio

471 Installation view *James Rosenquist: Multiverse You Are, I Am* exhibition, Acquavella Galleries, New York, 2012. Works pictured, on the left: *The Geometry of Fire* (2011); on the right: *Sand of the Cosmic Desert in Every Direction* (2012)

472 Rosenquist, New York

473 *An Intrinsic Existence*, 2015 Oil on canvas, with a painted and rotatable mirror 81 × 67 in. (205.7 × 170.2 cm) Private collection

469

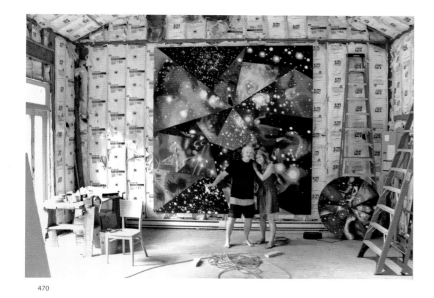

470

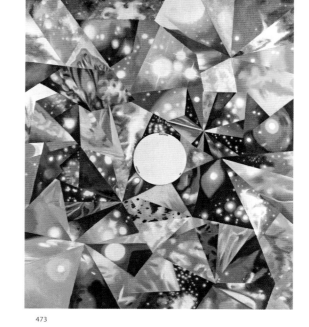

473

471

472

2016 Rosenquist's painting and room-installation *F-111* (1964–65) is the sole work to represent the year 1964 in the Museum of Modern Art's year-long exhibition, *From the Collection: 1960–69*, opening in March. On March 31, Rosenquist receives the Lifetime Achievement in Printmaking Award from SGC International during the SGCI Printmaking Conference in Portland, Oregon. In the spring, Rosenquist is the first living artist given a special exhibition at the Judd Foundation in New York City. The exhibition, *James Rosenquist*, is curated by Flavin Judd and features the paintings *Shadows* (1961), *Yellow Applause* (1966), and *Time Dust—Black Hole* (1992), and the prints *Horse Blinders (east)* (1972) and *Horse Blinders (west)* (1972). Rosenquist's grandchild, Oscar, is born on October 14 to daughter Lily Rosenquist and son-in-law Andrés Altamirano in New York City. In November, Galerie Thaddaeus Ropac in Paris opens the survey exhibition *James Rosenquist: Four Decades 1970–2010* at the gallery's Pantin location, and *James Rosenquist: The Collages 1960–2010* at their Marais location.

2017 James Rosenquist dies on March 31 in New York City. The Museum of Modern Art in New York hosts a memorial service in celebration of his life and artistic achievement on June 26, with speakers including Glenn Lowry, Judith Goldman, Richard Feigen, Frank Stella, John Rosenquist, Agnes Gund (in Gund's absence, comments are read by her personal curator), Thaddaeus Ropac, Gianfranco Gorgoni, Hilton Als, and Ann Temkin. The survey exhibition *James Rosenquist: Painting as Immersion* opens at the Museum Ludwig in Cologne, Germany, in November and travels to ArOS Aarhus Art Museum in Denmark in spring 2018. University of South Florida Contemporary Art Museum in Tampa organizes the tribute exhibition, *James Rosenquist: Tampa*, presenting prints Rosenquist produced at Graphicstudio/University of South Florida and at other local presses including Flatstone Press, Topaz Editions, and Pyramid Arts Ltd, with additional works borrowed from private collections. The museum hosts a memorial service for Rosenquist in commemoration of his life and recognition of his artistic contributions in Florida and beyond on December 2, with speakers that include Sarah Bancroft, Ruth Fine, Peter Foe, Gail Levine, Patrick Lindhardt, Margaret Miller, John Rosenquist, and Don Saff.

474 View of exhibition *James Rosenquist*, Ground floor 101 Spring Street, New York, 2016

475 *James Rosenquist, Bedford, New York*, 2012. Photo © Annie Leibovitz

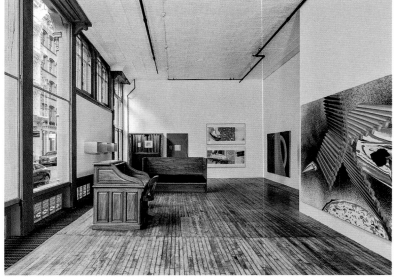

474

Notes

1 See "Biography" in *James Rosenquist*, exh. cat (Ottawa: National Gallery of Canada, 1968), 74.

2 See Peter Schjeldahl, "The Rosenquist Synthesis," *Art in America* 60, no. 2 (March–April 1972): 57.

3 See "Special Supplement: A Symposium on Pop Art," *Arts Magazine* 37, no. 7 (April 1963): 36.

4 See "Artists for Artists," *New Yorker* 39, no. 3, March 9, 1963, 33.

5 Joseph Cornell recorded the visit in a note dated June 25, 1963. See Cornell Papers, Archives of American Art, Smithsonian Institution, Washington, D.C., microfilm, 1056:845.

6 Scull, quoted in Richard F. Shepard, "To What Lengths Can Art Go?" *New York Times*, May 13, 1965, 39.

7 Doon Arbus, "The Man in the Paper Suit," *New York/The World Journal Tribune Magazine*, November 6, 1966: 7–9.

8 See Therese Schwartz, "The Politicalization of the Avant-Garde," *Art in America* 59, no. 6 (November–December 1971): 97–105.

9 Schwartz, "The Politicalization of the Avant-Garde."

10 "The Playmate as Fine Art," *Playboy* 14, no. 1 (January 1967): 141.

11 Although this work is often referred to as *Fire Pole*, that is actually the name of the study erroneously attributed to the larger work.

12 The title and date of Nicolas Poussin's painting have since been revised by the Metropolitan Museum of Art to *The Abduction of the Sabine Women* (probably 1633–34).

13 See Maurice Tuchman, *Art and Technology: A Report of the Art and Technology Program of the Los Angeles County Museum of Art 1967–1971* (Los Angeles: Los Angeles County Museum of Art, 1971), 297.

14 Rosenquist, conversation with the author, February 2003.

15 Rosenquist, "Art Mailbag: James Rosenquist Replies," *New York Times*, May 14, 1972, 23–24.

16 See Constance W. Glenn, "Time Dust," in Glenn, *Time Dust, James Rosenquist: The Complete Graphics, 1962–1992*, exh. cat. and catalogue raisonné (New York: Rizzoli in association with the University Art Museum, California State University, Long Beach, 1993), 66.

17 This work, *Capillary Action III*, is nonextant.

18 See Glenn, "Time Dust," 62.

19 See Roy Bongratz, "Writers, Composers and Actors Collect Royalties—Why Not Artists?" *New York Times*, February 2, 1975, sec. 2, 1, 25.

20 See Judith Goldman, "James Rosenquist: Fragments of Fragments," in Goldman, *James Rosenquist*, exh. cat. (New York: Viking Penguin, 1985), 67.

21 See Joan Young with Susan Davidson, "Chronology," in *Robert Rauschenberg: A Retrospective*, exh. cat. (New York: Guggenheim Museum, 1997), 574.

22 See *James Rosenquist's Commissioned Works* (Stockholm: Painters Posters in association with Wetterling Gallery, 1990), 17.

23 See Deborah Jordy, "Brief Chronology," in Goldman, *James Rosenquist*, 77.

24 See Craig Adcock, "James Rosenquist Interviewed by Craig Adcock, March 25, 1989," in *James Rosenquist's Commissioned Works*, 20, 27–28.

25 Rosenquist's complete title for these works is *The Serenade for the Doll after Claude Debussy, Gift Wrapped Dolls*.

26 Rosenquist, quoted in Elaine Louie, "Espresso with an Artist," *New York Times*, late edition, May 2, 1996, sec. C, 5.

27 Judith Goldman, "Swimming in the Mist: Another Time, Another Country," in *James Rosenquist: The Swimmer in the Econo-mist*, exh. cat. (New York: Guggenheim Museum, 1998), 31–32.

28 See Mary Ann Marger, "One Man's Healing Vision," *St. Petersburg Times*, Feb. 10, 2002, sec. F, 8, 10.

29 Rosenquist in conversation with the author, summer 2014; originally published in Sarah Bancroft, "Six Decades of Artmaking," *James Rosenquist: Illustrious Works on Paper, Illuminating Paintings*, exh. cat (Stillwater: Oklahoma State University Museum of Art, 2014), 9.

Appendix

Select Solo Exhibitions

1962
· Green Gallery, New York, *James Rosenquist*

1964
· Green Gallery, New York, *James Rosenquist*
· Galerie Ileana Sonnabend, Paris, *Rosenquist*
· Dwan Gallery, Los Angeles, *James Rosenquist*
· Galleria Gian Enzo Sperone, Turin, *James Rosenquist*

1965
· Leo Castelli Gallery, New York, *Rosenquist*
· The Jewish Museum, New York, *James Rosenquist: F-111*, traveled to Moderna Museet, Stockholm; Stedelijk Museum, Amsterdam; Staatliche Kunsthalle, Baden-Baden; and Galleria Nazionale d'Arte Moderna, Rome

1966
· Leo Castelli Gallery, New York, *James Rosenquist*

1968
· National Gallery of Canada, Ottawa, *James Rosenquist*
· Galerie Ileana Sonnabend, Paris, *Rosenquist*
· Galleria Gian Enzo Sperone, Turin, *James Rosenquist*

1969
· Leo Castelli Gallery, New York, *Rosenquist: Horse Blinders*

1970
· Leo Castelli Gallery, New York, *James Rosenquist: Horizon Home Sweet Home*
· Leo Castelli Gallery, New York, *James Rosenquist: Two Large Paintings: Area Code and Flamingo Capsule*
· Galerie Ricke, Cologne, *James Rosenquist*
· Castelli Graphics, New York, *Rosenquist: Recent Lithographs*

1972
· Josef-Haubrich-Kunsthalle (organized by Wallraf-Richartz-Museum, Cologne), *James Rosenquist: Gemälde—Räume—Graphik*
· Whitney Museum of American Art, New York, James Rosenquist, traveled to Museum of Contemporary Art, Chicago
· Margo Leavin Gallery, Los Angeles, *James Rosenquist: Lithographs*

1973
· Leo Castelli Gallery, New York, *James Rosenquist*
· Amerika Haus Berlin, *James Rosenquist*
· Portland Center for the Visual Arts, Portland, Oregon, *James Rosenquist*
· Stedelijk Museum, Amsterdam, *James Rosenquist*
· Jack Glenn Gallery, Corona del Mar, California, *Rosenquist*

1974
· Max Protetch Gallery, Washington, D.C., *Rosenquist*
· Castelli Graphics, New York
· Scottish Arts Council Gallery, Edinburgh, *Rosenquist Prints*, traveled to Art Gallery and Museum, Aberdeen, and City Museum and Art Gallery, Dundee
· Jared Sable Gallery, Toronto, *James Rosenquist*
· Norrköpings Konstmuseum, Norrköping, Sweden, *James Rosenquists Litografier, summer.*
· Mayor Gallery, London, *James Rosenquist: An Exhibition of Paintings 1961–1973*

1975
· The New Gallery, Cleveland, *James Rosenquist: Recent Work*
· Knoedler Contemporary Prints, New York, *James Rosenquist: Recent Mural Prints*
· Leo Castelli Gallery, New York, *Rosenquist: Drawings*
· Castelli Graphics, New York
· Margo Leavin Gallery, Los Angeles, *James Rosenquist: Paintings*

1976
· Greenberg Gallery, St. Louis, *James Rosenquist*
· Mayor Gallery, London, *James Rosenquist: New Paintings*

1977
· Sable-Castelli Gallery, Toronto, *James Rosenquist*
· Institute of Modern Art, Brisbane, Australia, *James Rosenquist: Nine Large Drawings*
· Leo Castelli Gallery, New York, *James Rosenquist*
· Getler/Pall, New York, *James Rosenquist: New Prints*
· Jacksonville Art Museum, Jacksonville, Florida, *Jim and Bob: The Florida Connection*

1978
· Multiples/Goodman, New York, *James Rosenquist: Hand-Colored Etchings*
· Mayor Gallery, London, *James Rosenquist: Recent Paintings*

1979
· The John and Mable Ringling Museum of Art, Sarasota, *James Rosenquist Graphics Retrospective*, traveled to Fort Lauderdale Museum of Arts
· Galerie Sonnabend, Paris
· Albright-Knox Art Gallery, Buffalo, *Recent Prints by James Rosenquist*
· Plains Art Museum, Moorhead, Minneapolis, *James Rosenquist: Seven Paintings*

1980
· Castelli-Feigen-Corcoran Gallery, New York, *Rosenquist*
· Texas Gallery, Houston, *James Rosenquist*

1981
· Leo Castelli Gallery, New York, *James Rosenquist*
· Castelli-Goodman-Solomon Gallery, East Hampton, N.Y., *James Rosenquist: Selected Prints*
· Dolly Fiterman Art Gallery, Minneapolis, *High Technology and Mysticism: A Meeting Point*
· I. Irving Feldman Gallery, Sarasota, *James Rosenquist*

1982
· Castelli-Feigen-Corcoran Gallery, New York, *James Rosenquist: House of Fire*
· Gloria Luria Gallery, Bay Harbor Islands, Florida, *James Rosenquist: Major New Works*
· Metropolitan Museum and Art Center, Coral Gables, Florida, *F-111 and Flamingo Capsule*
· Mayor Gallery, London, *James Rosenquist: Paintings from the Sixties*
· Castelli-Feigen-Corcoran Gallery, New York, *James Rosenquist: Reflector-Deflector*

1983
· Center for the Fine Arts, Miami, *James Rosenquist*
· Van Straaten Gallery, Chicago, *James Rosenquist: Paintings and Works on Paper*

Thordén Wetterling Galleries, Göteborg, Sweden,
· Thordén Wetterling Galleries, Göteborg, Sweden, *James Rosenquist*
· Leo Castelli Gallery, New York, *James Rosenquist*

1984
· SVC Fine Arts Gallery, University of South Florida, Tampa, *Rosenquist*
· Thordén Wetterling Galleries, Stockholm, *James Rosenquist: New Paintings*
· Smith College Museum of Art, Northampton, Massachusetts, *James Rosenquist and Maurice Sanchez: Artist and Printer, A Decade of Collaboration*

1985
· Leo Castelli Gallery, New York, *James Rosenquist: The Persistence of Electrical Nymphs in Space*
· The Denver Art Museum, *James Rosenquist: Paintings 1961–1985*, traveled to Contemporary Arts Museum, Houston; Des Moines Art Center; Albright-Knox Art Gallery, Buffalo; Whitney Museum of American Art, New York; and National Museum of American Art, Smithsonian Institution, Washington, D.C.
· Catherine G. Murphy Gallery, St. Paul, *James Rosenquist Prints*

1986
· Heland Thordén Wetterling Galleries, Stockholm, *James Rosenquist Prints: Ladies of the Opera Terrace*

1987
· Heland Thordén Wetterling Galleries, Stockholm, *James Rosenquist: One Painting and One Print*
· Galerie Daniel Templon, Paris, *James Rosenquist*
· Heland Thordén Wetterling Galleries, Stockholm, *James Rosenquist: Paintings 1987*

1988
· Florida State University Gallery and Museum, Tallahassee, *James Rosenquist*, traveled to The University Gallery at Memphis State, Memphis, and Polk Museum of Art, Lakeland, Florida
· Leo Castelli Gallery, New York, *James Rosenquist: Through the Eye of the Needle to the Anvil*
· Richard L. Feigen & Company, Chicago, *James Rosenquist: New Work*
· USF Art Museum, College of Fine Arts, University of South Florida, Tampa, *James Rosenquist at USF*

1989
· Richard L. Feigen & Company, Chicago, *James Rosenquist: Flashlife*
· Richard L. Feigen & Company, London, *James Rosenquist: New Paintings*
· Heland Wetterling Gallery, Stockholm, *Welcome to the Water Planet*

1990
· Universal Limited Art Editions, New York, *James Rosenquist— Never Mind: From Thoughts to Drawing*
· The Museum of Modern Art, New York, *James Rosenquist: Welcome to the Water Planet*, traveled to Laguna Gloria Art Museum, Austin, Texas; University of Missouri, Kansas City; The Art Museum, University of California, Santa Barbara; Center for the Arts, Vero Beach, Florida; and University of Kentucky Art Museum, Lexington
· Erika Meyerovich Gallery, San Francisco, *James Rosenquist, Welcome to the Water Planet and House of Fire*, traveled to Glenn-Dash Gallery, Los Angeles, and Richard L. Feigen & Company, Chicago
· Leo Castelli Gallery, New York, *James Rosenquist*

1991

· Tretiakov Gallery, Central House of Artists, Moscow, *Rosenquist: Moscow 1961–1991*

· IVAM Centre Julio González, Valencia, *James Rosenquist*

1992

· Gagosian Gallery, New York, *James Rosenquist: The Early Pictures 1961–1964*

· Galería Weber, Alexander y Cobo, Madrid, *James Rosenquist: Paintings 1990–1992*

· Galerie Thaddaeus Ropac, Paris, *James Rosenquist: Recent Paintings*

1993

· Walker Art Center, Minneapolis (organized by University Art Museum, California State University, Long Beach), *James Rosenquist: Time Dust, The Complete Graphics, 1962–1992*, traveled to Honolulu Academy of Arts; Sarah Campbell Blaffer Gallery, University of Houston; Samuel P. Harn Museum of Art, University of Florida, Gainesville; Montgomery Museum of Fine Arts; Huntsville Museum of Art, Huntsville, Alabama; Elvehjem Museum of Art, Madison; Joslyn Art Museum, Omaha; Neuberger Museum of Art, State University of New York at Purchase; San Diego Museum of Art; and Davenport Museum of Art, Davenport, Iowa

· Leo Castelli Gallery, New York, *James Rosenquist: The Serenade for the Doll after Claude Debussy or Gift Wrapped Dolls and Masquerade of the Military Industrial Complex Looking Down on the Insect World*

· Alyce de Roulet Williamson Gallery, Art Center College of Design, Pasadena, California, *James Rosenquist: Recent Paintings*

· Galerie Thaddaeus Ropac, Salzburg, *James Rosenquist: Recent Paintings*

· Akira Ikeda Gallery, Tokyo, Japan, *James Rosenquist: The Serenade for the Doll after Claude Debussy or Gift Wrapped Dolls*

· Richard L. Feigen & Company, Chicago, *James Rosenquist: Gift Wrapped Dolls or Serenade for the Doll after Claude Debussy*

1994

· Richard L. Feigen & Company, London, *James Rosenquist: Gift Wrapped Dolls*

· Leo Castelli Gallery, New York, *James Rosenquist: The Thirtieth Anniversary Exhibition*

· Wetterling Teo Gallery, Singapur, *James Rosenquist—Paintings*

· Wetterling Teo Gallery, Singapur, *Flower Paintings*

· Portland Art Museum, Portland, Oregon, *James Rosenquist: Recent Work*

1995

· Pyo Gallery, Seoul, *James Rosenquist: The Big Paintings*

· Seattle Art Museum, *James Rosenquist Paintings*

· Civico Museo Revoltella, Galleria d'Arte Moderna, Trieste, *James Rosenquist: Gli anni novanta*

1996

· Indigo Galleries, Boca Raton, *James Rosenquist: New Paintings and Constructions*

· Graphicstudio Gallery, University of South Florida, College of Fine Arts, Tampa, *James Rosenquist: A Retrospective of Prints Made at Graphicstudio 1971–1996*

· Leo Castelli Gallery, New York, *James Rosenquist, 4 E 77 St 1970 Revisited and New Paper Constructions from Gemini G.E.L.*

· Galerie Thaddaeus Ropac, Paris, *James Rosenquist: Target Practice*

· Richard L. Feigen & Company, Chicago, *Target Practice: Recent Paintings by James Rosenquist*

· Gemini G.E.L., Los Angeles, *New Paper Constructions*

1997

· Galerie Thaddaeus Ropac, Paris, *James Rosenquist: Three Large Paintings*

· Heland Wetterling Gallery, Stockholm, *Target Practice*

· Center for Contemporary Graphic Art and Tyler Graphics Archive Collection, Fukushima, Japan, *The Graphics of James Rosenquist*

· Wetterling Teo Gallery, Singapur, *James Rosenquist: New Works 1996*

1998

· Deutsche Guggenheim Berlin, *James Rosenquist: The Swimmer in the Econo-mist*

· Feigen Contemporary, New York, *James Rosenquist/After Berlin: New Paintings*

1999

· Baldwin Gallery, Aspen, Colo., *James Rosenquist/Meteors: New Paintings*

· Museum of Fine Arts, St. Petersburg, Florida, *Robert Rauschenberg and James Rosenquist: Images From Everywhere, News From Nowhere*

2000

· Salvador Dalí Museum, St. Petersburg, Florida, *James Rosenquist Paintings/James Rosenquist Selects Dalí*

2001

· Gagosian Gallery, New York, *James Rosenquist: The Stowaway Peers Out at the Speed of Light*

· Tampa Museum of Art, *James Rosenquist: The Florida Years 1976–2001*

2003

· The Menil Collection and the Museum of Fine Arts, Houston, *James Rosenquist: A Retrospective*, traveled to Solomon R. Guggenheim Museum, New York; Guggenheim Museum, Bilbao; and Kunstmuseum Wolfsburg

· McClain Gallery, Houston, *James Rosenquist: Recent Paintings*

· Leo Castelli Gallery, New York, *James Rosenquist: Selected Works on Paper*

· Jim Kempner Fine Art, New York, *James Rosenquist Prints: A Mini-Retrospective*

· AXA Gallery, New York, *James Rosenquist*

· Robert Miller Gallery Temporary Annex Space, New York, *James Rosenquist*

· Jacobson Howard Gallery, New York, *James Rosenquist: Collages*

· Barbara Gillman Gallery, Miami, *Rosenquist in Florida: Major Prints*

2004

· Godt-Cleary Projects, Las Vegas, *James Rosenquist: Prints from the '80s and '90s*

· Galerie ArtPoint der Ferratec AG, Rudolfstetten, Switzerland, *James Rosenquist: Welcome to the Water Planet*

2005

· Givon Art Gallery, Tel Aviv, *James Rosenquist: Ten Paintings, 1965–2004 Collage, 1987*

· Acquavella Contemporary Art, Inc., New York, *James Rosenquist: Monochromes*

2006

· Miami Art Museum, Miami, *James Rosenquist*

· National Gallery of Australia, Canberra, *Welcome to the Water Planet: Paperworks by James Rosenquist*

· Art Unlimited/Art Basel, *James Rosenquist: Celebrating the Fiftieth Anniversary of the Signing of the Universal Declaration of Human Rights by Eleanor Roosevelt*

· Carl Solway Gallery, Cincinnati, *James Rosenquist: Print Retrospective, 1965–2005*

· Haunch of Venison, London, *James Rosenquist*

2007

· Silvermine Guild Arts Center, New Canaan, Connecticut, *James Rosenquist: The Speed of Light and Beyond*

· Acquavella Contemporary Art, Inc., New York, *James Rosenquist: Time Blades*

2008

· Jablonka Galerie, Berlin, *James Rosenquist: The Hole in the Center of Time*

2009

· DaFeng Gallery, Beijing, *James Rosenquist: Speed of Light Lithograph Series*

2010

· Acquavella Contemporary Art, Inc., New York, *James Rosenquist: The Hole in the Middle of Time and the Hole in the Wallpaper*

2012

· The Museum of Modern Art, New York, *James Rosenquist: F-111*

· Leslie Sacks Contemporary, Santa Monica, *James Rosenquist*

· Acquavella Contemporary Art, Inc., New York, *James Rosenquist: Multiverse You Are, I Am*

2013

· North Dakota Museum of Art, Grand Forks, *James Rosenquist: An Exhibition Celebrating His 80th Birthday*

· Richard L. Feigen and Co., New York, *James Rosenquist: A Pale Angel's Halo and Slipping off the Continental Divide, 1973*

· Boca Raton Museum of Art, Florida, *James Rosenquist's "High Technology and Mysticism: A Meeting Point"*

2014

· Wetterling Gallery, Stockholm, *James Rosenquist: All Things are Devoid of Intrinsic Existence*

· Senior and Shopmaker Gallery, New York, *James Rosenquist: F-111 (South, West, North, East) and Drawings from the 70s*

· Oklahoma State University Museum of Art, Stillwater, *James Rosenquist: Illustrious Works on Paper, Illuminating Paintings*, traveled to Syracuse University Art Galleries, New York

2015

· The Heckscher Museum of Art, Huntington, New York, *James Rosenquist: Tripartite Prints*

2016

· Museum of Contemporary Art Jacksonville, University of North Florida, *Time Zones: James Rosenquist and Printmaking at the Millennium*

· Pacific Northwest College of Art Center for Contemporary Art and Culture, Portland, Oregon, *Lifetime Achievement Award Exhibition: James Rosenquist*

· Judd Foundation, New York, *James Rosenquist*

· Honolulu Museum of Art, *James Rosenquist's House of Fire: A Masterwork of American Pop Art*

· Galerie Thaddaeus Ropac, Paris Marais, Paris, *James Rosenquist: The Collages, 1960–2010*

· Galerie Thaddaeus Ropac, Paris Pantin, Paris, *James Rosenquist: Four Decades, 1970–2010*

Select Group Exhibitions

1958

· Walker Art Center, Minneapolis, *1958 Biennial: Paintings Prints Sculpture*

1962

· The Dallas Museum for Contemporary Arts, *1961*

· Nelson Gallery-Atkins Museum, Kansas City, *Popular Art: Artistic Projections of Common American Symbols*

· Art Council of the YM/YWHA, Philadelphia, *Art 1963: A New Vocabulary*

· Sidney Janis Gallery, New York, *International Exhibition of the New Realists*

· Dwan Gallery, Los Angeles, *My Country 'Tis of Thee*

1963

· The Art Institute of Chicago, *Sixty-sixth Annual American Exhibition: Directions in Contemporary Painting and Sculpture*

· Cinéma Ranelagh, Paris, *Vues Imprenables*

· The Allan Stone Gallery, New York, *Exhibition for the Benefit of the Foundation for Contemporary Performance Arts*

· Solomon R. Guggenheim Museum, New York, *Six Painters and the* Object, traveled to Los Angeles County Museum of Art

· The Kootz Gallery, New York (organized by The Poses Institute of Fine Arts, Brandeis University, Waltham, Massachusetts), *Recent Acquisitions: The Gevirtz-Mnuchin Collection and Related Gifts*, traveled to The Rose Art Museum, Brandeis University, Waltham, Massachusetts

· Contemporary Arts Museum, Houston, *Pop! Goes the Easel*

· The Washington Gallery of Modern Art, Washington, D.C., *The Popular Image Exhibition*

· Nelson Gallery-Mary Atkins Museum of Fine Arts, Kansas City, *Popular Art*

· Galerie Ileana Sonnabend, Paris, *Pop art américain*

· Centre Culturel Américain, Paris, *De A à Z 1963: 31 peintres américains choisis par The Art Institute of Chicago*

· The Museum of Modern Art, New York, *Americans 1963*, traveled to National Gallery of Canada, Ottawa

· Oakland Art Museum (organized by California College of Arts and Crafts), *Pop Art USA*

· Jerrold Morris International Gallery, Toronto, *The Art of Things*

· Institute of Contemporary Arts, London (organized by Ileana Sonnabend Gallery, Paris), *The Popular Image*

· Tate Gallery, London, *Dunn International Exhibition*

· Albright-Knox Art Gallery, Buffalo, *Mixed Media and Pop Art*

· Munson-Williams-Proctor Institute, Utica, New York (organized by the Institute of Fine Arts, Brandeis University, Waltham, Massachusetts), *New Directions in American Painting*, traveled to Isaac Delgado Museum of Art, New Orleans; Atlanta Art Association; The J. B. Speed Art Museum, Louisville; Art Museum, Indiana University, Bloomington; Washington University in St. Louis; and Detroit Institute of Arts

· Des Moines Art Center, *Signs of the Times*, traveled to Addison Gallery of American Art, Phillips Academy, Andover, Massachusetts

· Whitney Museum of American Art, New York, *Annual Exhibition 1963: Contemporary American Painting*

1964

· Sidney Janis Gallery, New York, *Four Environments by Four New Realists*

· Green Gallery, New York, *James Rosenquist*

· Dwan Gallery, Los Angeles, *Boxes*

· Moderna Museet, Stockholm, *Amerikansk pop-konst*, traveled to Louisiana Museum of Modern Art, Humlebæk, Denmark as *Amerikansk Popkunst*, and Stedelijk Museum, Amsterdam, as *American Pop Art/De Nieuwe Amerikaanse Kunst*

· Tate Gallery, London, *Painting and Sculpture of a Decade 54/64*

· New York State Pavilion, New York World's Fair

· Whitney Museum of American Art, New York, *The Friends Collect: Recent Acquisitions by Members of the Friends of the Whitney Museum of American Art; Seventh Friends Loan Exhibition*

· Musée d'art moderne de la Ville de Paris, *XXe Salon de Mai*

· Whitney Museum of American Art, New York, *Between the Fairs: Twenty-five Years of American Art, 1939–1964*

· Museum of Art, Rhode Island School of Design, Providence, *Paintings and Constructions of the 1960's Selected from the Richard Brown Baker Collection*

· Bianchini Gallery, New York, *American Supermarket*

· Museum of Art, Carnegie Institute, Pittsburgh, *The 1964 Pittsburgh International: Exhibition of Contemporary Painting and Sculpture*

· Sidney Janis Gallery, New York, *A Selection of Twentieth Century Art of Three Generations*

· Oakland Art Museum, *Pop Art U.S.A.*

1965

· Palais des Beaux-Arts, Brussels, *Pop Art, Nouveau Réalisme, Etc....*

· Worcester Art Museum, Worcester, Massachusetts, *The New American Realism*

· Milwaukee Art Center, *Pop Art and the American Tradition*

· The Larry Aldrich Museum, Ridgefield, Connecticut, *Art of the 50's and 60's: Selections from the Richard Brown Baker Collection*

· Leo Castelli Gallery, New York, *James Rosenquist*

· Instituto Torcuato di Tella, Buenos Aires, *International Prize Exhibition*

· De Waters Art Center, Flint Institute of Arts, Flint, Michigan, (organized by American Federation of Arts), *The Drawing Society National Exhibition*, traveled to University of Massachusetts, Amherst; Oklahoma Art Center, Oklahoma City; Atlanta Art Association; Museum of Art, University of Kansas, Lawrence; Colorado Springs Fine Arts Center; Frederick & Nelson, Seattle; Long Beach Museum of Art; Honolulu Academy of Arts; M. H. de Young Memorial Museum, San Francisco; and National Collection of Fine Arts, Smithsonian Institution, Washington, D.C.

· Sidney Janis Gallery, New York, *Pop and Op*

1966

· Institute of Contemporary Art, University of Pennsylvania, Philadelphia, *The Other Tradition*

· Queens College, City University of New York, *New York International*

· Museum of Art, Rhode Island School of Design, Providence, *Recent Still Life*

· Galerija Suvremene Umjetnosti, Zagreb, *Pop Art*

· The Jewish Museum, New York, *The Harry N. Abrams Family Collection*

· The Art Institute of Chicago, *Sixty-eighth American Exhibition*

· The Larry Aldrich Museum, Ridgefield, Connecticut, *Selections from the John G. Powers Collection*

· Sidney Janis Gallery, New York, *Erotic Art '66*

· The National Museum of Modern Art, Tokyo (organized with the International Council of The Museum of Modern Art, New York), *Two Decades of American Painting*, traveled to The National Museum of Modern Art, Kyoto; Lalit Kala Academy, New Delhi; National Gallery of Victoria, Melbourne; and Art Gallery of New South Wales, Sydney

· William Rockhill Nelson Gallery of Art, Kansas City, *Sound, Light, Silence*

· Flint Institute of Arts, Flint, Michigan, *Flint Invitational*

· Galleria la Bertesca, Genoa, *American Pop Artists*

1967

· State University College, Oswego, N.Y. (organized by The Museum of Modern Art, New York), *Contemporary American Still Life*, traveled to Wabash College, Crawfordsville, Indiana; Texas Technological College, Lubbock; Cummer Gallery of Art, Jacksonville, Florida; San Francisco State College; Kresge Art Center, Michigan State University, East Lansing; Mercer University, Macon, Georgia; and University of Maryland, College Park

· Leo Castelli, New York, *Leo Castelli: Ten Years*

· Städtische Kunstausstellung, Gelsenkirchen, *Original Pop Art*

· Krannert Art Museum, University of Illinois, Champaign, *Contemporary American Painting and Sculpture 1967*

· U.S. Pavilion, Expo '67, Montreal World's Fair, *American Painting Now*, traveled to Horticultural Hall, Boston

· Art Gallery, University of California, Irvine, *A Selection of Paintings and Sculptures from the Collections of Mr. and Mrs. Robert Rowan*, traveled to San Francisco Museum of Art

· New Jersey State Museum, Trenton, *Focus on Light*

· The Museum of Modern Art, New York, *The 1960's: Painting and Sculpture from the Museum Collection*

· Palazzo Grassi, Centro Internazionale delle Arti e del Costume, Venice, *Campo Vitale: Mostra Internazionale d'arte contemporanea*

· Palazzo dei Congressi, San Marino, *Nuove Tecniche d'Immagine*

· Museu de Arte Moderna de São Paulo, *Environment U.S.A.: 1957–1967* (part of *IX Bienal de São Paulo*)

· The Washington Gallery of Modern Art, Washington, D.C., *Art for Embassies Selected from the Woodward Foundation Collection*

· Whitney Museum of American Art, New York, *1967 Annual Exhibition of Contemporary Painting*

· Frankfurter Kunstverein, Frankfurt am Main, *Kompass, New York: Paintings after 1945 in New York*, traveled to Stedelijk van Abbemuseum, Eindhoven

· Sidney Janis Gallery, New York, *Homage to Marilyn Monroe*

1968

· The Museum of Modern Art, New York, *Three Generations of Twentieth-Century Art: The Sidney and Harriet Janis Collection*, traveled to Minneapolis Institute of Arts; Portland Museum of Art, Portland, Maine; Pasadena Art Museum; San Francisco Museum of Art; Seattle Art Museum; Dallas Museum of Fine Arts; Albright-Knox Art Gallery, Buffalo; and The Cleveland Museum of Art

· The Metropolitan Museum of Art, New York, *History Painting: Various Aspects*

· Dayton's Gallery 12, Minneapolis, *Contemporary Graphics Published by Universal Limited Art Editions*

· Fine Arts Center, University of Wisconsin, Milwaukee, *Art 1968: Hang Ups and Put Downs*

· Kassel, documenta 4

· Guild Hall, East Hampton, New York, *American Printmaking 1670–1968*

· The National Museum of Modern Art, Tokyo, *The Sixth International Biennial Exhibition of Prints in Tokyo 1968*

· San Francisco Museum of Art, *Untitled 1968*

· The Museum of Modern Art, New York, *The Machine as Seen at the End of the Mechanical Age*

· Galerie Ricke, Cologne, *Querschnitt*

1969

· Art Gallery, University of Notre Dame, South Bend, Ind., *Richard Brown Baker Collection*

· Pennsylvania Academy of the Fine Arts, Philadelphia, and Philadelphia Water Color Club, *The One Hundred and Sixty-Fourth Annual Exhibition*

· Vancouver Art Gallery, *New York 13*, traveled to The Norman MacKenzie Art Gallery, Regina, Saskatchewan, and Musée d'art contemporain, Montréal

· The Winnipeg Art Gallery, *OK America*

· Neuen Nationalgalerie, Berlin, *Sammlung 1968 Karl Ströher*, traveled to Städtische Kunsthalle, Düsseldorf, and Kunsthalle Bern

· Art Gallery, University of California, Irvine, *New York: The Second Breakthrough, 1959–1964*

· Galleria Civica d'Arte Moderna, Turin, *New-Dada e Pop Art Newyorkesi*

· Slovak National Gallery, Bratislava, Czechoslovakia (organized by the Smithsonian Institution, Washington, D.C.), *The Disappearance and Reappearance of the Image: Painting in the United States since 1945*, traveled to National Gallery, Prague; Palais des Beaux-Arts, Brussels; Sala Dalles, Bucharest; Museul Banatului, Timisoara, Romania; and Galeria de Arte, Cluj, Romania

· The Jewish Museum, New York, *Superlimited: Books, Boxes and Things*

· Dayton's Gallery 12, Minneapolis, *Castelli at Dayton's*

· York University, Toronto, *American Art of the Sixties in Toronto Private Collections*

· Hayward Gallery, London, (organized by The Arts Council of Great Britain), *Pop Art*

· The Metropolitan Museum of Art, New York, *New York Painting and Sculpture: 1940–1970*

· The Metropolitan Museum of Art, New York, *Prints by Five New York Painters: Jim Dine, Roy Lichtenstein, Robert Rauschenberg, Larry Rivers, James Rosenquist*

· Denver Art Museum, *American Report: The Sixties*

· Fort Worth Art Center Museum, *Drawings: An Exhibition of Contemporary American Drawings*

· Whitney Museum of American Art, New York, *Contemporary American Painting: 1969 Annual Exhibition*

1970

· Contemporary Arts Center, Cincinnati, *Prints by Nine New York Painters: Jim Dine, Helen Frankenthaler, Jasper Johns, Roy Lichtenstein, Robert Motherwell, Barnett Newman, Robert Rauschenberg, Larry Rivers, James Rosenquist*

· Kunsthalle Basel, Sidney and Harriet Janis Collection, traveled to Akademie der Künste, Berlin, and Kunsthalle Nuremberg

· Indiana University Art Museum, Bloomington, *The American Scene 1900–1970*

· Galerie Ricke, Cologne, *Zeichnungen amerikanischer Künstler*

· Virginia Museum of Fine Arts, Richmond, *American Painting 1970*

· Princeton University Art Museum, *American Art since 1960*

· The Brooklyn Museum, New York, *Seventeenth National Print Exhibition*

· Kunsthalle Nürnberg, Nuremberg, *Das Ding als Objekt*

· Fondation Maeght, Saint-Paul-de-Vence, France, *L'Art vivant aux Etats-Unis*

· Contemporary Arts Center, Cincinnati, *Monumental Art*

· Emily Lowe Gallery, Hofstra University, Hempstead, New York, *Graphics in Long Island Collections from the Studio of Universal Limited Art Editions*

· Whitechapel Art Gallery, London, *3 → ∞: New Multiple Art*

· Mayfair Fine Art Gallery, London, *Pop! '70*

1971

· The Nelson-Atkins Museum of Art, Kansas City, *Communications '71: An Exhibition of Prints, Banners, and Posters*

· Philadelphia Museum of Art, *Multiples: The First Decade*

· Palais des Beaux-Arts, Brussels, *Métamorphose de l'Objet, Art et Anti-Art 1910–1970*, traveled to Museum Boijmans Van Beuningen, Rotterdam; Nationalgalerie, Berlin; Palazzo Reale, Milan; Kunsthalle Basel; and Musée des Arts décoratifs, Paris

· Emily Lowe Gallery, Hofstra University, Hempstead, N.Y., *Art Around the Automobile*

· The Metropolitan Museum of Art, New York, *Summer Loan 1971 Paintings from New York Collections: Collection of Kimiko and John Powers*

· Albright-Knox Art Gallery, Buffalo, *¿Kid stuff?*

· Whitney Museum of American Art, New York, *Oversize Prints*

1972

· Emily Lowe Gallery of Hofstra University, Hempstead, New York, *The Green Gallery Revisited*

· High Museum of Art, Atlanta, *The Modern Image*

· Multiples, New York, *June Exhibition*

· Grand Palais, Paris, *Festival d'Automne à Paris*

· La Jolla Museum of Contemporary Art, La Jolla, California, *Dealer's Choice*

· Leo Castelli Gallery, New York, *Drawings*

1973

· Whitney Museum of American Art, New York, *American Drawings 1963–1973*

· Galerie Sonnabend au Musée Galliera, Paris, *Aspects de l'art actuel*

· San Francisco Museum of Art, *A Selection of American and European Paintings from the Richard Brown Baker Collection*, traveled to Institute of Contemporary Art, University of Pennsylvania, Philadelphia

· Yale University Art Gallery, New Haven, *American Drawing 1970–1973*

· Moderna Museet, Stockholm, *The New York Collection for Stockholm*

1974

· Whitney Museum of American Art, *Downtown at Federal Reserve Plaza, New York, Nine Artists/Coenties Slip*

· Sidney Janis Gallery, New York, *Twenty-five Years of Janis*

· Whitney Museum of American Art, New York, *American Pop Art*

· Contemporary Arts Center, Cincinnati, *The Ponderosa Collection*

· Leo Castelli Gallery, New York, *In Three Dimensions*

· The Museum of Modern Art, New York, *Works from Change, Inc.*

· Leo Castelli Gallery, New York, *Drawings*

1975

· Denver Art Museum, *American Art Since 1960: The Virginia and Bagley Wright Collection*

· Kennedy Galleries, New York, *Hundredth Anniversary Exhibition of Paintings and Sculptures by One Hundred Artists Associated with the Art Students League of New York*

· Art Students League of New York, *One Hundred Prints by One Hundred Artists of the Art Students League of New York, 1875–1975*

· Yale University Art Gallery, New Haven, *Richard Brown Baker Collects!*

· Davison Art Center, Wesleyan University, Middletown, Connecticut, Recent American Etching, traveled to Grey Art Gallery and Study Center, New York University, New York; National Collection of Fine Arts, Washington, D.C.; and Gibbes Art Gallery, Charleston

1976

· The New Gallery of Contemporary Art, Cleveland, *American Pop Art and the Culture of the Sixties*

· University Art Museum, California State University, Long Beach, *The Lyon Collection: Modern and Contemporary Works on Paper*

· Contemporary Art Society of the Indianapolis Museum of Art, *Painting and Sculpture Today*

· Allentown Art Museum, Allentown, Pennsylvania, *The American Flag in the Art of Our Country*

· Guild Hall, East Hampton, Artists and East Hampton: *A Hundred-Year Perspective*

· The Metropolitan Museum of Art, New York, Contemporary American Prints: *Gifts from the Singer Collection*

· Fendrick Gallery, Washington, D.C., *Prints from the Untitled Press*

· Alberta College of Art Gallery, Calgary, *The Art of Playboy: From the First Twenty-five Years*

· The Cleveland Museum of Art, *Materials and Techniques of Twentieth-Century Artists*

· The Brooklyn Museum, New York, *Thirty Years of American Printmaking*

1977

· Galerie Bucholz, Munich, *In Honor of Öyvind Fahlström— An Exposition of His Friends*

· Fitzwilliam Museum, Cambridge, England, *Jubilation: American Art During the Reign of Elizabeth II*

· Kassel, documenta 6

· The Aldrich Museum of Contemporary Art, Ridgefield, Connecticut, *Fall 1977: Contemporary Collectors*

· Sable-Castelli Gallery, Toronto, *Drawings*

· The New York State Museum, Albany, *New York: The State of Art*

· The University of Michigan Museum of Art, Ann Arbor, *Works from the Collection of Dorothy and Herbert Vogel*

1978

· Flint Institute of Arts, Flint, Michigan, *Art and the Automobile*

· Margo Leavin Gallery, Los Angeles, *Three Generations: Studies in Collage*

· Neue Galerie am Landesmuseum Joanneum, Graz, *Von Arakawa bis Warhol Grafik aus den USA*

· Staatliche Museen, Preussischer Kulturbesitz, Berlin, *Aspekte der 60er Jahre aus der Sammlung Reinhard Onnasch*

· Mead Art Museum, Amherst College, Amherst, Massachusetts, *New York Now*

· Stamford Museum, Stamford, Connecticut, *The Eye of the Collector*

· The Brooklyn Museum, New York, *Graphicstudio U.S.F.: An Experiment in Art and Education*

· Leo Castelli Gallery at Northpark National Bank, Dallas

· Central Pavilion, Venice, *Sei stazione per artenatura: La natura dell'arte* (XXXVIII Biennale di Venezia)

· Leo Castelli Gallery, New York, *Chamberlain, Johns, Kelly, Lichtenstein, Oldenburg, Rauschenberg, Rosenquist, Warhol*

· Albright-Knox Art Gallery, Buffalo, *American Painting of the 1970s*, traveled to Newport Harbor Art Museum, Newport Beach, California; The Oakland Museum; Cincinnati Art Museum; Art Museum of South Texas, Corpus Christi; and Krannert Art Museum, University of Illinois, Champaign

1979

· Galerie Ricke, Cologne, *Drawings*

· Art Gallery of Ontario, Toronto, *Contemporary American Prints from Universal Limited Art Editions/The Rapp Collection*

- Montgomery Art Gallery, Pomona College, and Lang Art Gallery, Scripps College, Claremont, California, *Black and White Are Colors: Paintings of the 1950s–1970s*
- Whitney Museum of American Art, Downtown at Federal Reserve Plaza, New York, *Auto Icons*
- Galerie Daniel Templon, Paris, *Une Peinture Américaine*
- The Metropolitan Museum of Art, New York, *Summer Loans*
- Squibb Gallery, Princeton, *Selections from the Collection of Richard Brown Baker*
- Galerie d'Art Contemporain des Musées de Nice, *American Pop Art*
- Soft-Art Kunsthaus, Zürich, *Weich und Plastisch*

1980

- University Gallery, University of South Florida, Tampa, *Five in Florida: Recent Work by Anuszkiewicz, Chamberlain, Olitski, Rauschenberg, Rosenquist*
- Joe and Emily Lowe Art Gallery, Syracuse University, *Recent Acquisitions*
- The School of Visual Arts, New York, *The Object Transformed: Contemporary American Drawing*
- The Museum of Modern Art, New York, *Printed Art: A View of Two Decades*
- Allen Memorial Art Museum, Oberlin College, *From Reinhardt to Christo*
- Instituto di Cultura di Palazzo Grassi, Venice, *Pop Art: evoluzione di una generazione*
- Neuberger Museum, State University of New York, *Purchase, Hidden Desires*
- Pace Gallery, New York, *Major Paintings and Reliefs of the '60's from a New York Private Collection*
- La Jolla Museum of Contemporary Art, La Jolla, California, *Seven Decades of Twentieth-Century Art from the Sidney and Harriet Janis Collection of the Museum of Modern Art and the Sidney Janis Gallery Collection*, traveled to Santa Barbara Museum of Art
- Castelli Graphics, New York, *Master Prints by Castelli Artists*
- The Chrysler Museum, Norfolk, Virginia, *American Figure Painting 1950–1980*
- Castelli Graphics, New York, *Amalgam*
- The Brooklyn Museum, New York, *American Drawings in Black and White 1970–1980*
- Leo Castelli Gallery, New York, *Drawings to Benefit the Foundation for Contemporary Performance Art, Inc.*
- Walker Art Center, Minneapolis, *Artist and Printer: Six American Print Studios*, traveled to Sarah Campbell Blaffer Gallery, University of Houston

1981

- Richard Hines Gallery, Seattle, *Group Exhibition: Major Works*
- Neil G. Ovsey Gallery, Los Angeles, *Selections from Castelli: Drawings and Works on Paper*
- Whitney Museum of American Art, New York, *1981 Biennial Exhibition*
- Boehm Gallery, San Marcos, California, *Prints by American Artists: A History of American Art Through Printmaking*
- Gloria Luria Gallery, Bay Harbor Islands, Florida, *Leo Castelli Selects Johns, Judd, Lichtenstein, Rauschenberg, Rosenquist, Stella*
- Cologne, *Internationale Ausstellung Köln 1981*
- Akron Art Museum, *The Image in American Painting and Sculpture 1950–1980*
- New England Foundation for the Arts, Harold Reed Gallery, New York, *Works by the Yale Faculty 1930–1978*
- Landfall Gallery, Chicago, *Possibly Overlooked Publications: A Re-Examination of Contemporary Prints and Multiples*
- Whitney Museum of American Art, New York, *American Prints: Process and Proofs*

1982

- Milwaukee Art Museum, *American Prints 1960–1980*
- Rosa Esman Gallery, New York, *A Curator's Choice 1942–1963*
- Arras Gallery, New York, *Cast Paper and Intaglio Multiples*
- Glenbow Museum, Calgary (organized by the Art Gallery of Ontario, Toronto), *Pop Art Prints and Multiples*, traveled to Kitchener/Waterloo Art Gallery, Kitchener; London Regional Art Gallery, London, Ontario; Laurentian University Museum and Arts Centre, Sudbury; Rodman Hall Arts Centre, St. Catharines; The Art Gallery of Peterborough; Art Gallery of Ontario, Toronto; and Art Gallery of Nova Scotia, Halifax
- La Jolla Museum of Contemporary Art, La Jolla, California (organized by Aspen Center for the Visual Arts), *Castelli and His Artists: Twenty-five Years*, traveled to Aspen Center for the Visual Arts; Leo Castelli Gallery, New York; Portland Center for the Visual Arts; Portland, Oregon; and Laguna Gloria Art Museum, Austin
- Leo Castelli Gallery, New York, *New Works by Gallery Artists*
- Galerie Bischofmerger, Zürich, *Homage to Leo Castelli*
- Contemporary Arts Museum, Houston, *The Americans: The Collage*
- Edith C. Blum Institute, Avery Center for the Arts, Bard College, Annandale-on-Hudson, New York, *The Rebounding Surface: A Study of Reflections in the Work of Nineteen Contemporary Artists*
- The Museum of Fine Arts, Houston, *Post-1945 Prints from the Permanent Collection*
- Whitney Museum of American Art, *Downtown at Federal Reserve Plaza, New York, Universal Limited Editions: A Tribute to Tatyana Grossman*
- Contemporary Arts Museum, Houston, *In Our Time*
- The Fine Arts Museum of Long Island, Hempstead, New York, *The New Explosion: Paper Art*

1983

- Multiples Inc., New York, *An Exhibition of Small Paintings, Drawings, Sculpture and Photographs*
- La Jolla Museum of Contemporary Art, La Jolla, California, *A Contemporary Collection on Loan from the Rothschild Bank AG, Zürich*
- Wilhelm-Hack-Museum, Ludwigshafen, *Horrors of War: Prints of the War from Five Centuries*
- Castelli Graphics, New York, *Black and White: A Print Survey*
- The Aldrich Museum of Contemporary Art, Ridgefield, Connecticut, *Changes*
- Museum Haus Lange, Krefeld, *Sweet Dreams Baby!: American Pop Graphics*
- Godwin-Ternbach Museum, Queens College, City University of New York, *Twentieth Century Prints from the Godwin-Ternbach Museum*
- Spectrum Fine Art Gallery, New York, *Art and Sport*
- Nippon Club Gallery, New York, *Portfolios*
- National Museum of Contemporary Art, Tokyo, *Photography in Contemporary Art*, traveled to National Museum of Contemporary Art, Kyoto
- Margo Leavin Gallery, Los Angeles, *Art for a Nuclear Weapons Freeze*, traveled to Fuller Goldeen Gallery, San Francisco; Munson Gallery, Santa Fe; Delahunty Gallery, Dallas; Greenberg Gallery, St. Louis; John C. Stoller & Co., Minneapolis; Richard Gray Gallery, Chicago; Barbara Krakow Gallery, Boston; and Brooke Alexander, New York
- Associated American Artists, New York, *The Master Print: America since 1960*
- Grey Art Gallery, New York University, New York, *The Permanent Collection: Highlights and Recent Acquisitions*
- Hewlett Gallery, College of Fine Arts, Carnegie-Mellon University, Pittsburgh, *Harry Stein: Portraits of Artists*

1984

- The Minneapolis Institute of Arts, *The Vermillion Touch: Master Prints from the Minneapolis Studio's Archives*
- Alex Rosenberg Gallery, New York, *Techniques in Printmaking*
- Portland Center for the Visual Arts, Portland, Oregon, *Lewis and Clark Collection*
- Pratt Graphics Center, New York, *From the Beginning*
- Whitney Museum of American Art, Fairfield County, Stamford, Connecticut, *Autoscape: The Automobile in the American Landscape*
- Modern Art Museum of Fort Worth, *Pop! The Pop Art Print*
- Santa Barbara Museum of Art, *Art of the States: Works from a Santa Barbara Collection*
- Fuller Goldseen Gallery, San Francisco, *Fifty Artists/Fifty States*
- The Museum of Contemporary Art, Los Angeles, *Automobile and Culture*, traveled to Detroit Institute of Arts, as *Automobile and Culture: Detroit Style*
- Museum of Fine Arts, Boston, *Ten Painters and Sculptors Draw*
- Monique Knowlton Gallery, New York, *Ecstasy*
- Whitney Museum of American Art, New York, *BLAM! The Explosion of Pop, Minimalism, and Performance 1958–1964*
- Castelli Graphics, New York, *New Drawings by Castelli Artists*
- Museo Rufino Tamayo, Mexico City, *El Arte Narrativo*
- Marisa del Rey Gallery, New York, *The Masters of the Sixties: From New Realism to Pop Art*
- National Gallery of Art, Washington, D.C., *Gemini G.E.L.: Art and Collaboration*
- Marilyn Pearly Gallery, New York, *Plastics?!*
- Barbara Toll Fine Arts, New York, *Drawings*
- Getler/Pall/Saper, New York, *Major Prints*

1985

- Princeton University Art Museum, *Selections from the Ileana and Michael Sonnabend Collection: Works from the 1950s and 1960s*, traveled to Archer M. Huntington Art Gallery, University of Texas at Austin, and Walker Art Center, Minneapolis
- The Museum of Contemporary Art, Los Angeles, *The Museum of Contemporary Art: The Panza Collection*
- Art Gallery of New South Wales, Sydney (organized by The International Council of The Museum of Modern Art, New York), *Pop Art 1955–70*, traveled to Queensland Art Gallery, Brisbane, and National Gallery of Victoria, Melbourne
- Lorence-Monk, New York, *Drawings*
- The Mayor Gallery, London, *A Tribute to Leo Castelli*
- Smith College Museum of Art, Northampton, Massachusetts, *Dorothy C. Miller: With an Eye to American Art*
- Museum of Contemporary Art, Chicago, *Selections from the William J. Hokin Collection*
- École Nationale Supérieure des Beaux-Arts, Paris, *Cinquante ans de dessins américains*
- Castelli Graphics, New York, *Recent Editions by Castelli Artists*
- Janie C. Lee Gallery, Houston, *Charcoal Drawings 1880–1985*
- The Museum of Modern Art, New York, *Dedication of Tatyana Grosman Gallery*
- The Museum of Modern Art, New York, *New Work on Paper 3*
- ARCA Centre d'Art Contemporain, Marseille, *New York 85*
- Barbara Krakow Gallery, Boston, *Universal Limited Art Editions Recent Publications*
- Tatyana Grosman Gallery, *Tatyana Grosman Gallery: Inaugural Installation*
- Larry Gagosian Gallery, Los Angeles, *Actual Size: Small Paintings and Sculpture*
- National Museum of American Art, Washington, D.C., *Art, Design, and the Modern Corporation*

· Daniel Weinberg Gallery, Los Angeles, *AIDS Benefit Exhibition: Works on Paper*

· The Museum of Modern Art, New York, *Contemporary Works from the Collection*

· Solomon R. Guggenheim Museum, New York, *Transformations in Sculpture: Four Decades of American and European Art*

· Städtische Galerie, Frankfurt am Main, *Amerikanische Zeichnungen 1930–1980*

· Holly Solomon, New York, *Paintings, Sculpture and Furnishings*

1986

· The Brooklyn Museum, New York, *Public and Private: American Prints Today*

· The Museum of Contemporary Art, Los Angeles, *Individuals: A Selected History of Contemporary Art 1945–1986*

· Bell Gallery, Brown University, Providence, *Definitive Statements: American Art, 1964–66,* traveled to Parrish Art Museum, Southampton, New York

· Lorence-Monk Gallery, New York, *Real Surreal*

· Barbara Brathen Gallery, New York, *Surrealismo!*

· Butler Institute of American Art, Youngstown, Ohio, *Fiftieth Annual National Midyear Show*

· Museum Ludwig Cologne, *America/Europa*

· Museum of Fine Arts, Boston, *70s into 80s: Printmaking Now*

· The Clocktower, New York, *Neil Williams, James Rosenquist, Robert Creeley*

· Thomas Segal Gallery, Boston, *Salute to Leo Castelli*

· Gabrielle Breyers Gallery, New York, *Leo Castelli and Castelli Graphics at Gabrielle Breyers*

1987

· Helander Gallery, Palm Beach, Florida, *Five Floridians*

· Florida International University Art Museum, Miami (organized by the Art Museum Association of America, American Federation of Arts), *Postwar Paintings from Brandeis University,* traveled to University Gallery, University of Florida, Gainesville; Tucson Museum of Art; Palm Springs Desert Museum; and Scottsdale Center for the Arts

· University Art Museum, University of California, Berkeley, *Made in U.S.A.: An Americanization in Modern Art, the 50's and 60's,* traveled to The Nelson-Atkins Museum of Art, Kansas City, and Virginia Museum of Fine Arts, Richmond

· American Academy and Institute of Arts and Letters, New York, *Exhibition of Work by Newly Elected Members and Recipients of Awards*

· National Gallery of Art, Washington, D.C., *Twentieth Century Drawings: From the Whitney Museum of American Art,* traveled to Cleveland Museum of Art; California Palace of the Legion of Honor, San Francisco; Arkansas Arts Center, Little Rock; and Whitney Museum of American Art, Fairfield County, Stamford, Connecticut

· Centro Cultural de Arte Contemporáneo, Mexico City, *Leo Castelli and His Artists: Thirty Years of Promoting Contemporary Art*

· The Butler Institute of American Art, Youngstown, Ohio, *Leo Castelli: A Tribute Exhibition*

· Acme Art, San Francisco, *Small Paintings and Sculptures: 1960's*

· Padiglione d'Arte Contemporanea, Milan, *Dalla Pop Art Americana alla Nuova Figurazione: Opere del Museo d'Arte Moderna di Francoforte*

· Stanford University Museum of Art, Palo Alto, California, *The Anderson Collection: Two Decades of American Graphics 1967–1987*

· International Monetary Visitors' Center, Washington, D.C., *International Show for the End of World Hunger,* traveled to Minnesota Museum of Art, St. Paul; Henie Onstad Art Center, Oslo; Kölnischer Kunstverein, Cologne; and La Grande Halle de la Villette, Paris

· The Nelson-Atkins Museum of Art, Kansas City, *A Bountiful Decade: Selected Acquisitions*

· St. Louis Gallery of Contemporary Art, *Contemporary Masters: Selections from the Collection of Southwestern Bell Corporation*

· Clocktower Gallery, Institute for Contemporary Art, New York, *Modern Dreams: The Rise and Fall of Pop*

· Galerie Daniel Templon, Paris, *Hommage to Leo Castelli: Dedicated to the Memory of Toiny Castelli*

· Moderna Museet, Stockholm, *Implosion: A Postmodern Perspective*

· Sarah Campbell Blaffer Gallery, University of Houston, *Images on Stone: Two Centuries of Artists' Lithographs,* traveled to San Angelo Museum of Fine Arts, San Angelo, Texas; Tyler Museum of Art, Tyler, Texas; and Aspen Art Museum, Aspen, Colorado

· The Helander Gallery, Palm Beach, Florida, *New Space–New Work–New York*

1988

· The Museum of Modern Art, New York, *Committed to Print: Social and Political Themes in Recent American Printed Art*

· La Galerie de Poche, Paris, *Pop Art Americain: Les Cinq de New York*

· Galerie Kajforsblom, Helsinki, *Celebrating Leo Castelli and Pop Art*

· The Museum of Modern Art, New York, *In Honor of Toiny Castelli: Drawings from the Toiny, Leo, and Jean-Christophe Castelli Collection*

· Whitney Museum of American Art, Downtown at Federal Reserve Plaza, New York, *Made in the Sixties: Paintings and Sculpture from the Permanent Collection of the Whitney Museum of American Art*

· Castelli Graphics, New York, *Castelli Graphics 1969–1988: An Exhibition of Selected Works in Honor of Toiny Castelli*

· Museum of Fine Arts, Houston, *Twentieth Century Art in the Museum: Direction and Diversity*

· The Butler Institute of American Art, Youngstown, Ohio, *Leo Castelli: A Tribute Exhibition*

· Fundación Juan March, Madrid, *Colección Leo Castelli*

· Galerie des Ponchettes, Nice, *Hommage à Toiny Castelli: Prints*

· Parrish Art Museum, Southampton, New York, *Drawings on the East End, 1940–1988*

· Birmingham Museum of Art, Birmingham, Alabama, *Looking South: A Different Dixie,* traveled to Brooks Museum of Art, Memphis; Sheldon Swope Museum of Art, Terre Haute, Indiana; St. Petersburg Museum of Fine Arts, St. Petersburg, Florida; and The Columbus Museum, Columbus, Georgia

· Lawrence Oliver Gallery, Philadelphia, *That Was Then: This Is Now*

· Leo Castelli Gallery, New York, and Brooke Alexander Gallery, New York, *The Twenty-fifth Anniversary Exhibition to Benefit the Foundation for Contemporary Performance Arts, Incorporated*

1989

· Wight Art Gallery, University of California, Los Angeles, *Selected Works from the Frederick R. Weisman Art Foundation*

· Jacksonville Art Museum, Jacksonville, Florida, *Art in Bloom: The Flower as Subject*

· Leo Castelli Gallery, New York, *James Rosenquist, Joseph Kosuth, Meyer Vaisman*

· The Bass Museum of Art, Miami, *The Future Now: An Exhibition Commemorating the Twenty-fifth Anniversary of the Bass Museum of Art*

· University of South Florida Art Museum and Barnett Bank, Tampa, *Made in Florida*

· Galleria Nazionale d'Arte Moderna, Rome, *La Collezione Sonnabend: Dalla Pop Art in poi*

· Newport Harbor Art Museum, Newport Beach, California, *LA Pop in the Sixties*

· Helsinki Art Hall, *Modern Masters '89*

· Walker Art Center, Minneapolis, *First Impressions: Early Prints by Forty-six Contemporary Artists,* traveled to Laguna Gloria Art Museum, Austin; Baltimore Museum of Art, and Neuberger Museum, State University of New York, Purchase

· Duson Gallery, Seoul, *Five Great American Artists: Andy Warhol, Roy Lichtenstein, Robert Rauschenberg, James Rosenquist, Frank Stella*

· The Bemis Foundation, Omaha, *Sheldon at Bemis: American Contemporary Graphics*

· Whitney Museum of American Art, New York, *Art in Place: Fifteen Years of Acquisitions*

· Daniel Weinberg Gallery, Los Angeles, *A Decade of American Painting, 1980–89*

· Whatcom Museum of History and Art, Seattle, *A Different War*

· The Brunnier Gallery and Museum, Iowa State University, Ames, *American Contemporary Graphics*

· Susan Sheehan Gallery, New York, *American Prints from the Sixties*

· Whitney Museum of American Art, New York, *Image World: Art and Media Culture*

· Galerie Busche, Cologne, *John Baldessari, Robert Rauschenberg, James Rosenquist, Tishan Hsu, Holt Quentel*

· Tavelli Gallery, Aspen, *Medium Cool*

1990

· Washington County Museum of Fine Arts, Hagerstown, Md., *Art of the 60's and 70's*

· James Goodman Gallery, New York, *Pop on Paper*

· Tony Shafrazi Gallery, New York, *American Masters of the 60's: Early and Late Works*

· Pensacola Museum of Art, Pensacola, Florida, *Cars in Art: The Automobile Icon*

· Nassau County Museum of Art, Roslyn Harbor, New York, *Two Decades of American Art: The 60's and 70's*

· The Albuquerque Museum, *Printers' Impressions*

· Milwaukee Art Museum, *Words as Image: American Art 1960–1990,* traveled to Oklahoma City Art Museum and Contemporary Arts Museum, Houston

· Guild Hall, East Hampton, New York, *Prints of the Eighties*

· Nippon Convention Center, Makuhari Messe International Exhibition Hall, Tokyo, Pharmakon '90: Makuhari Messe Contemporary Art Exhibition

· Edith C. Blum Art Institute, Bard College, Annandale-on-Hudson, New York, *Art What Thou Eat,* traveled to New York Historical Society, New York

· Hofstra Museum, Hofstra University, Hempstead, New York, *The Transparent Thread: Asian Philosophy in Recent American Art,* traveled to Edith C. Blum Art Institute, Bard College, Annandale-on-Hudson, New York; The Salina Art Center, Salina, Kansas; Sarah Campbell Blaffer Gallery, University of Houston; Crocker Art Museum, Sacramento, California; and Laguna Art Museum, Laguna Beach, California

· The Museum of Modern Art, New York, *High and Low: Modern Art and Popular Culture,* traveled to The Art Institute of Chicago and The Museum of Contemporary Art, Los Angeles

· Galerie Montaigne, Paris, Virginia Dwan et les Nouveaux Réalistes, Los Angeles, *les Années 60*

· Whitney Museum of American Art, New York, *Image World: Art and Media Culture*

· Katonah Museum of Art, Katonah, New York, *The Technological Muse*

1991

· Margo Leavin Gallery, Los Angeles, *Twentieth Century Collage*

· Henie Onstad Art Center, Oslo, *Pop Art from the Lilja Collection*

· Galerie Nichido, Tokyo, *Lichtenstein, Rauschenberg, Rosenquist,* traveled to Galerie Nichido, Nagoya

- Tate Gallery, London, *Aspects of Printmaking in Britain and the USA, 1959–1982*
- National Gallery of Art, Washington, D.C., *Art for the Nation: Gifts in Honor of the Fiftieth Anniversary of the National Gallery of Art*
- Harumi New Hall, Tokyo International Trade Center, *Tokyo Art Expo*
- Virginia Beach Center for the Arts, *Motion as a Metaphor*
- Guild Hall, East Hampton, New York, *Aspects of Collage*
- Dorsky Galery, New York, *Prints*
- The Museum of Modern Art, New York, *Seven Master Printmakers: Innovations in the Eighties*
- Leo Castelli Gallery, New York, *Summer Group Exhibition*
- Tony Shafrazi Gallery, New York, *Summertime*
- Whitney Museum of American Art, New York, *Constructing American Identity*
- Setagaya Art Museum, Tokyo, *Beyond the Frame: American Art 1960–1990*, traveled to The National Museum of Art, Osaka, and Fukuoka Art Museum, Fukuoka
- Newport Harbor Art Museum, Newport Beach, California, *Committed to Print*
- Meredith Long & Company, Houston, *Important Works on Paper*
- Guild Hall, East Hampton, New York, *A View from the Sixties: Selections from the Leo Castelli Collection and the Michael and Ileana Sonnabend Collection*
- Holm Gallery, London, *Pop Art 1960–1969*
- The Mayor Gallery, London, *Summer Selection from the Sixties*
- Waddington Graphics, London, *Pop Art Prints in England*
- Royal Academy of Arts, London, *Pop Art*, traveled to Museum Ludwig, Cologne, as *Die Pop Art Show*, Centro de Arte Reina Sofía, Madrid, as *Arte Pop* and Musée des Beaux-Arts de Montréal
- Modern Art Museum of Fort Worth, *American Pop Art: A Survey of the Permanent Collection*
- National Gallery of Art, Washington, D.C., *Graphicstudio: Contemporary Art from the Collaborative Workshop at the University of South Florida*
- Richard Green Gallery, Santa Monica, *Five Artists from Coenties Slip: 1956–1965*
- Musée d'Art Moderne et d'Art Contemporain, Nizza, *Collage of the Twentieth Century*
- Paris, *Foire Internationale d'Art Contemporain*
- Vermillion Gallery, Minneapolis, *Group Show: Works on Paper*
- Leo Castelli Gallery, New York, *Large Scale Drawings and Prints*

1992
- Galerie Renate Kammer, Hamburg, *Pop Art*
- Museum of Art, Fort Lauderdale, *Stars in Florida*
- Richard L. Feigen & Company, Chicago, *Contemporary Masterworks*
- Yokohama Museum of Art, *Innovation in Collaborative Printmaking: Kenneth Tyler 1963–1992*
- Musée d'Art Moderne et d'Art Contemporain, Nice, *Le Portrait dans l'Art Contemporain*
- Telfair Museum of Art, Savannah, *Master Prints from Gemini G.E.L.*
- Brooks Museum of Art, Memphis, *Pop on Paper*
- Richard Green Gallery, Santa Monica, *The Pop Show*
- The Museum of Contemporary Art, Los Angeles, *Hand-Painted Pop: American Art in Transition 1955–62*, traveled to Museum of Contemporary Art, Chicago, and Whitney Museum of American Art, New York

1993
- Pace Gallery, New York, *Indiana, Kelly, Martin, Rosenquist, Youngerman at Coenties Slip*
- Musée d'Art Moderne et d'Art Contemporain, Nice, *7 Maîtres de l'Estampe: Innovations des Années 80's aux Etats-Unis*
- San Francisco Museum of Modern Art, *The Anderson Collection Gift of American Pop Art*
- Leo Castelli Gallery, New York, *Prints*
- Rose Art Museum, Brandeis University, Waltham, Massachusetts, *Prefab: Reconsidering the Legacy of the Sixties*
- Martin-Gropius-Bau, Berlin, *Amerikanische Kunst im 20. Jahrhundert, Malerei und Plastik 1913–1993*, traveled to Royal Academy of Arts and The Saatchi Gallery, London, as *American Art in the Twentieth Century–Painting and Sculpture 1913–1993*
- United States Pavilion, Expo '93, Taejon World's Fair, Taejon, South Korea, *Renewing Our Earth: The Artistic Vision; Art and the Environment, An Exhibition by American Artists*
- The Murray and Isabella Rayburn Foundation, New York, *Roma–New York, 1948–1964: An Art Exploration*
- Des Moines Art Center, *F-111 and American Pop Images*
- Contemporary Arts Center, Cincinnati, *The Figure as Fiction: The Figure in Visual Art and Literature*

1994
- Brenau University, Gainesville, Georgia, *Pop! A Print Survey of the Pop Art Style, from the Collection of Leo Castelli*
- Florida International University Art Museum, Miami, *American Art Today: Heads Only*
- Museum of Fine Arts, Santa Fe, Museum of Romantic Modernism, *One Hundred Years*
- Graphicstudio, University of South Florida, Tampa, *Portraits: Selections from Twenty-five Years of Graphicstudio Works*
- Marlborough Graphics, New York, *The Pop Image: Prints and Multiples*

1995
- Kunstal, Rotterdam, *Pop Art*
- Yale University Art Gallery, New Haven, *Collecting with Richard Brown Baker: From Pollock to Lichtenstein*
- Marisa del Re Gallery and O'Hara Gallery, New York, *The Popular Image: Pop Art in America*

1996
- Gagosian Gallery, Los Angeles, *Leo Castelli: An Exhibition in Honor of His Gallery and Artists*
- Leo Castelli Gallery, New York, *New Works*
- The Museum of Modern Art, New York, *Thinking Print: Books to Billboards, 1980–95*
- Musée d'Art Moderne et d'Art Contemporain, Nizza, *Chimériques Polymères, le plastique dans l'art du XXème siècle*
- Cincinnati Art Museum, *Pop Prints*
- The Art Museum, Florida International University, Miami, *Miami Pops! Pop Art from Miami Collections*
- Los Angeles County Museum of Art, *Hidden in Plain Sight: Illusion in Art from Jasper Johns to Virtual Reality*
- Centre Georges Pompidou, Paris, *Face à l'Histoire, 1933–1996: L'artiste moderne devant l'événement historique*

1997
- Leo Castelli Gallery, New York, *Exploration and Innovation: The Artists of the Castelli Gallery, Part One, 1957–1997*
- The Pacific Design Center, Los Angeles, *Gemini G.E.L.: Celebrating Thirty Years*

- Corcoran Gallery of Art, Washington, D.C., *Proof Positive: Forty Years of Contemporary American Printmaking at ULAE, 1957–1997*, traveled to Gallery of Contemporary Art, University of Colorado Springs, UCLA at the Armand Hammer Museum of Art and Cultural Center, Los Angeles, and Sezon Museum of Art, Tokyo
- Salvador Dalí Museum, St. Petersburg, Florida, *Prints and Processes*
- Contemporary Arts Museum, Houston, *Finders/Keepers*
- University Art Museum, California State University, Long Beach, *The Great American Pop Art Store: Multiples of the Sixties*, traveled to The Jane Voorhees Zimmerli Art Museum, Rutgers University, New Brunswick, New Jersey; The Baltimore Museum of Art; Montgomery Museum of Fine Arts; Frederick R. Weisman Art Museum, University of Minnesota, Minneapolis; Marion Koogler McNay Art Museum, San Antonio; Wichita Art Museum; Muskegon Museum of Art, Muskegon, Michigan; Joslyn Art Museum, Omaha; Lowe Art Museum, University of Miami, Coral Gables; and The Toledo Museum of Art
- Musée d'Art Moderne et d'Art Contemporain, Nice, *De Klein à Warhol: Face-à-Face, France/États-Unis*
- Contemporary Arts Center, New Orleans, *The Prophecy of Pop*

1998
- Galeria de Arte IBEU Copacabana, Rio de Janeiro, *Artistas Norte-Americanos*
- Seattle Art Museum, *Paintings from the Jon and Mary Shirley Collection*
- Hara Museum of Contemporary Art, Tokyo, *The Painted Vision: Selections from the Hara Museum's Permanent Collection*
- Kalamazoo Institute of Arts, *Art and the American Experience*
- Solomon R. Guggenheim Museum, New York, *Rendezvous: Masterpieces from the Centre Georges Pompidou and the Guggenheim Museums*

1999
- Colorado University Art Galleries, Boulder, *Pop! Selections From the Colorado Collection*
- Spencer Museum of Art, University of Kansas, Lawrence, *Decade of Transformation: American Art of the 1960s*
- Centre Cultural de la Fundació "la Caixa," Barcelona (organized with the Schirn Kunsthalle, Frankfurt am Main), *Made in USA 1940–1970: De l'Expressionisme Abstracte al Pop*, traveled to Schirn Kunsthalle, as *Between Art and Life: Vom Abstrakten Expressionismus zur Pop Art*
- The Museum of Modern Art, New York, *Pop Impressions Europe/U.S.A.: Prints and Multiples from the Museum of Modern Art*
- Seattle Art Museum, *The Virginia and Bagley Wright Collection of Modern Art*
- Massachusetts Museum of Contemporary Art, North Adams, *Test Site*
- Museu de Arte Contemporânea de Serralves, Porto, *Circa 1968*
- Whitney Museum of American Art, New York, *The American Century: Art and Culture 1900–2000/Part II, 1950–2000*
- National Building Museum, Washington, D.C., *Tools as Art V: Fantasy at Work*
- Michael Carr Art Dealer, Sydney, *Old and New: The Millennium Summer Exhibition 1999–2000*
- The Museum of Contemporary Art, Los Angeles, *Panza: The Legacy of a Collector*

2000
- Detroit Institute of Arts, Pop Art: *Prints and Multiples from the DIA Collection*
- The Museum of Modern Art, New York, *Open Ends*
- Fine Arts Museum of San Francisco, California Palace of the Legion of Honor, *An American Focus: The Anderson Graphic Arts Collection*
- San Francisco Museum of Modern Art, *Celebrating Modern Art: The Anderson Collection*

2001

· The Menil Collection, Houston, *Pop Art: U.S./U.K. Connections 1956–1966*

· Pasadena Armory Center for the Arts, *Contemporary Art and the Cosmos*

· Centre Georges Pompidou, Paris, *Les Années Pop: 1956–1968*

· Gagosian Gallery, New York, *Pop Art: The John and Kimiko Powers Collection, An Exhibition in Memory of John Powers*

· Wetterling Teo Gallery, Singapore, *Made in America*

· Matthew Marks Gallery, New York, *We Set Off in High Spirits*

· Rose Art Museum, Brandeis University, Waltham, Massachusetts, *A Defining Generation: Then and Now—1961 and 2001*

· Museum of Art, Fort Lauderdale (organized by Davis Museum and Cultural Center, Wellesley College, Massachusetts), *Surrounding Interiors: Views inside the Car*, traveled to Davis Museum and Cultural Center, Wellesley College, and Frederick R. Weisman Art Museum, University of Minnesota, Minneapolis

· Elliot Smith Contemporary Art, St. Louis, *Contemporary Print Expo*

2002

· Acquavella Galleries, New York, *XIX and XX Century Master Paintings and Sculpture*

· Tate Liverpool, *Pin-Up: Glamour and Celebrity Since the Sixties*

· The Art Students League of New York, *A Century on Paper: Prints by Arts Students League Artists 1901–2001*

· The Frances Young Tang Teaching Museum and Art Gallery at Skidmore College, Saratoga Springs, New York, *From Pop to Now: Selections from the Sonnabend Collection*, traveled to Wexner Center for the Arts at Ohio State University, Columbus, and Milwaukee Art Museum

· J. Johnson Gallery, Jacksonville Beach, Florida, *Contemporary Printmakers*

· Barbara Mathes Gallery, New York, *Collage: Abstract Expressionist and Pop*

· Miami Art Museum, *Miami Currents: Linking Collection and Community*

2003

· Lukman Gallery, California State University, Los Angeles, *Pop and More from the Frederick R. Weisman Art Foundation Collection*

· Institute of Contemporary Art, University of Pennsylvania, Philadelphia, *Intricacy*

· The Galleries at the Gershman Y, Philadelphia, *A Happening Place*

· Nassau County Museum of Art, Roslyn Harbor, New York, *A Century of Prints: 1900–2000*

· Tampa Museum of Art, *Modern Art in Florida 1948–1970: A Climate for Contemporary—Tampa Bay*

· Guggenheim Hermitage Museum, Las Vegas, *American Pop Icons*

· Stiftung Museum Kunst Palast, Düsseldorf, *The Pow!er of Pop*

· Arizona State University Art Museum, Tempe, *Andy Warhol and the Pop Aesthetic*

· Polk Museum of Art, Lakeland, Fla., *Print It! Printmaking Techniques and Artistic Solutions*

· Milwaukee Art Museum, *Think Big: Print Workshop Collaborations from the Tatalovich Collection*

· Contemporary Art Center of Virginia, Virginia Beach, *Contemporary Works from the Frederick R. Weisman Art Foundation*

· Polk Museum of Art, Lakeland, Forida, *Some Assembly Required: Collage Culture in Post-War America*

· Galerie Burkhard Eikelmann, Düsseldorf, *The Pop Art Show*

· Walker Art Center, Minneapolis, *Pop³: Oldenburg, Rosenquist, Warhol*

· Neuberger Museum of Art, Purchase College, State University of New York, *Purchase, Facing Reality: The Seavest Collection of Contemporary Realism*

· Allen Memorial Art Museum, Oberlin College, Ohio, *Going Modern at the Allen: American Painting and Sculpture 1950–1980*

· Bruce Museum of Arts and Science, Greenwich, Connecticut, *JFK and Art*, traveled to Norton Museum of Art, West Palm Beach, Florida

· North Carolina Museum of Art, Raleigh, *Defying Gravity: Contemporary Art and Flight*

· Miami Art Museum, *Between Art and Life: From Joseph Cornell to Gabriel Orozco*

· Galerie Wolfgang Exner, Vienna, *Pop Art—Druckgraphiken*

2004

· Brooke Alexander Editions, New York, *Under $2000: Albers < Zaugg*

· Kunsthalle Bielefeld, *Das Große Fressen: Von Pop bis Heute*

· Mori Art Museum, Tokyo, *Modern Means: Continuity and Change in Art, 1880 to the Present—Highlights from the Collection of the Museum of Modern Art, New York*

· ARoS Aarhus Kunstmuseum, Denmark, *Pop Classics*

· Katonah Museum of Art, New York, *Behind Closed Doors: Collectors Celebrate the Museum's Golden Anniversary*

· Addison Gallery of American Art, Phillips Academy, Andover, Massachusetts, *4 × 4: Selections from the Tyler Graphics Collection*

· Louisiana Museum of Modern Art, Humlebæk, Denmark, *The Flower as Image*

· Northern Illinois University Art Museum, Dekalb, *Highlights from the Permanent Collection*

· Essl Museum Contemporary Art, Klosterneuburg bei Wien, Österreich, *Visions of America: Contemporary Art from the Essl Collection and the Sonnabend Collection, New York*

2005

· Katherine E. Nash Gallery, Regis Center for Art, University of Minnesota, Minneapolis, *Looking Back and Moving Forward: Success in the Making*

· Lentos Kunstmuseum Linz, *The Spirit of Pop*

· Fondation Beyeler, Basel, Switzerland, *Flower Myth: Van Gogh to Jeff Koons*

· Contessa Gallery, Cleveland, Ohio, *Picasso to Pop*

· Museo Civico, Cremona, *Art and the Printing Press—Cremona 2005: Graphicstudio/Institute for Research in Art*

· Museum of Art, University of Michigan, Ann Arbor, *Pop!*

· Royal Academy of Arts, London, *Summer Exhibition 2005*

· Villa Manin, Centro d'Arte Contemporanea, Passariano, Italy, *Il Teatro dell'Arte: Capolavori dalla Collezione del Museo Ludwig di Colonia*

· Frederick R. Weisman Museum of Art, Center for the Arts, Pepperdine University, Malibu, *Eclectic Eye: Selections from the Frederick R. Weisman Art Foundation*

· Tufts University Art Gallery, Medford, Massachusetts, *Pattern Language: Clothing as Communicator*, traveled to Krannert Art Museum, University of Illinois, Urbana–Champaign; University Art Museum, University of California, Santa Barbara; Frederick R. Weisman Art Museum; University of Minnesota, Minneapolis; and Paul and Lulu Hilliard University Art Museum, University of Louisiana at Lafayette

· Printemps de septembre à Toulouse, Toulouse, *Vertiges*

· Museo de Arte de Puerto Rico, Santurce, *El Impulso Figurativo: Obras de la Colección de Arte UBS*

· Museo di Arte Moderna e Contemporanea di Trento e Rovereto, Italy, *Dalla Pop art alla Minimal*

· Bernard Jacobson Gallery, London, *Rauschenberg, Rosenquist, Lichtenstein*

· Museo de Arte Contemporáneo Esteban Vicente, Segovia, Spain, *Obras Maestras del Siglo XX en las Colecciones del IVAM*

· Andrea Rosen Gallery, New York, *Looking at Words: The Formal Use of Text in Modern and Contemporary Works on Paper*

· Museum of Contemporary Art, Los Angeles, *After Cézanne*

· Salvador Dalí Museum, St. Petersburg, Florida, *Pollock to Pop: America's Brush with Dalí*

2006

· Jacobson Howard Gallery, New York, *Group Show*

· Larissa Goldston Gallery, New York, *Red, Yellow, Blue*

· Polk Museum of Art, Lakeland, Florida, *Pop Art 1956–2006: The First 50 Years*

· Ullens Center for Contemporary Art, Beijing, *Inside a Book a House of Gold—Artists' Editions for Parkett*

· Whitney Museum of American Art, New York, *Whitney Biennial 2006: Day for Night—The Peace Tower*

· Woodward Gallery, New York, *Spring Paper 8*

· Miami Art Museum, *Big Juicy Paintings (and More): Selections from the Permanent Collection*

· Museo de Bellas Artes de Bilbao, Spain, *Mirada multiple*

· Thomas McCormick Gallery, Chicago, *Works on Paper from the Collection of Art Enterprises, Ltd.*

· Grimaldi Forum, Monaco, New York, *New York: Fifty Years of Art, Architecture, Cinema, Performance, Photography and Video*

· Kunst- und Ausstellungshalle der Bundesrepublik Deutschland and Kunstmuseum Bonn, *The Guggenheim Collection*

· Time Warner Center, New York, *Beauty Has a Taste*

· Minneapolis Institute of Arts, Minn., *Vermillion Editions Limited: Prints, Multiples, Artist's Books, 1977–1992*

· Max Lang, New York, *Gallery Selections*

· Los Angeles County Museum of Art, *Magritte and Contemporary Art: The Treachery of Images*

· Max Lang, New York, *Living with Pop*

2007

· Montana Museum of Art and Culture, The University of Montana, Missoula, *The Collectors' Art*

· James Goodman Gallery, New York, *Modern and Contemporary Masters*

· Contessa Gallery, Cleveland, *Whole Lotta Pop!*

· Gulf Coast Museum of Art, Largo, *Guild Hall: An Adventure in the Arts—The Permanent Collection of the Guild Hall Museum, East Hampton, New York*, traveled to LSU Art Museum, Baton Rouge, Louisiana; Visual Arts Center, Panama City, Florida; South Bend Regional Museum of Art, Indiana; Turtle Bay Exploration Center, Redding, California; Sangre de Cristo Art Center, Pueblo, Colorado; Southeast Missouri Regional Museum, Southeast Missouri State University, Cape Girardeau, Missouri; Lakeview Museum of Arts and Sciences, Peoria, Illinois; Mobile Museum of Art, Alabama; Museum of the Rockies, MSU, Bozeman, Montana; Norton Museum, Shreveport, Louisiana; Alexandria Museum of Art, Alexandria, Louisiana; Farmington Museum, Farmington, New Mexico; and Pensacola Museum of Art, Florida

· National Art Museum, Beijing, *Art in America: Three Hundred Years of Innovation*, traveled to Shanghai Museum and Shanghai Museum of Contemporary Art, Shanghai; Pushkin Museum of Fine Arts, Moscow; and Guggenheim Museum Bilbao

· Nassau County Museum of Art, Roslyn Harbor, New York, *Rembrandt to Rosenquist: Masters of Printmaking*

· Ekaterina Cultural Foundation, Moscow, *Movement. Evolution. Art.*

· Insitut Valencià d'Art Modern, Spain, *Speed 1: Natura Naurata*

· Insitut Valencià d'Art Modern, Spain, *El Pop Art en la colección del IVAM*

- Princeton University Art Museum, *Pop Art at Princeton: Permanent and Promised*
- Leo Castelli Gallery, New York, *The Wandering Eye: Works on Paper from the 60s and 70s*
- Deutsche Guggenheim, Berlin, *Affinities: Deutsche Guggenheim 1997–2007, New Acquisitions, Deutsche Bank Collection*
- Whatcom Museum of History and Art, Bellingham, Washington, *American Abstraction: Works from the Washington Art Consortium Collection*
- Centro Arte Moderna e Contemporanea della Spezia, Italy, *Il segno, il colore, la forma*
- Woodward Gallery, New York, *When Art Worlds Collide: The 60s*
- Tacoma Art Museum, Washington, *Sparkle Then Fade*
- Flint Institute of Arts, Michigan, *Recent Acquisitions of Works on Paper to the Flint Institute of Arts*
- Jacobson Howard Gallery, New York, *Group Show*
- Vonderbank Artgalleries, Berlin, *Prime Time—Icons and Idols*
- The Museum of Modern Art, New York, *What is Painting? Contemporary Art from the Collection*
- Colorado Springs Fine Arts Center, *The Eclectic Eye: Pop and Illusion—Selections from the Frederick R. Weisman Art Foundation*
- Des Moines Art Center, Iowa, *Sign Language*
- Bruce Museum, Greenwich, Connecticut, *Contemporary and Cutting Edge: Pleasures of Collecting, Part III*
- National Portrait Gallery, London, *Pop Art Portraits*, traveled to Staatsgalerie Stuttgart
- Museo Nacional de Bellas Artes, Santiago, Chile, *Homenaje a Picasso*
- Scuderie del Quirinale, Rome, *Pop Art! 1956–1968*

2008

- MODEM Centre for Modern and Contemporary Arts, Debrecen, Hungary, *The Story Goes On: Contemporary Artists in the Wake of Van Gogh*
- Galerie Burkhard Eikelmann, Düsseldorf, *Tom Wesselmann and the 11 POP Artists*
- Galerie Proarta, Zurich, *Modern Prints*
- Nassau County Museum of Art, Roslyn Harbor, New York, *Pop and Op*
- Fondation Beyeler, Riehen/Basel, Switzerland, *Fernand Léger: Paris–New York*
- Jane Voorhees Zimmerli Art Museum, Rutgers University, *Pop Art and After: Prints and Popular Culture*
- Rosenbaum Contemporary, Boca Raton, Florida, *All Colors in Mind*
- Galerie Wild, Zurich, *Amerikanische Kunst & Pop Art*
- Wetterling Gallery, Stockholm, *The 30th Anniversary: Part I*
- DePaul University Museum, Chicago, *1968: Art and Politics in Chicago*
- Ackland Art Museum, The University of North Carolina at Chapel Hill, *Circa 1958: Breaking Ground in American Art*
- Jablonka Galerie, Zurich, *Reverb*
- J. Johnson Gallery, Jacksonville Beach, Florida, *Contemporary Prints*
- Gemini G.E.L., Los Angeles, *Black and White Show*

2009

- Jacobson Howard Gallery, New York, *Gallery Artists*
- Fisher Landau Center for Art, Long Island City, New York, *Five Decades of Passion—Part One: The Eye of the Collector, 1968–1988*
- Leslie Sacks Contemporary, Santa Monica, California, *Universal Limited Art Editions Then and Now*
- Museum Tinguely, Basel, Switzerland, *Scapa Memories: Eine Sammlung*

- McNay Art Museum, San Antonio, Texas, *American Concepts and Global Visions/Selections from the AT&T Collection: Contemporary Paintings and Sculpture*
- Berkeley Art Museum and Pacific Film Archive, University of California, *Galaxy: A Hundred or So Stars Visible to the Naked Eye*
- The Museum of Contemporary Art, Los Angeles, *A Changing Ratio: Painting and Sculpture from the Collection*
- Leo Castelli Gallery, New York, *Electricity: Jim Dine, Dan Flavin, Joseph Kosuth, Roy Lichtenstein, Robert Rauschenberg, James Rosenquist, Keith Sonnier, Robert Watts*
- CAS Gallery, Kean University, Union City, New Jersey, *Past Pop: Robert Rauschenberg and James Rosenquist Graphics*
- White Columns, New York, *40th Anniversary Benefit Auction*
- Armand Bartos Fine Art, New York, *Collect with Us*
- Singapore Tyler Print Institute, Singapur, *Pulp Stories II*
- Gagosian Gallery, New York, *Go Figure*
- Galerie Wild, Zurich, *Summertime*
- Haunch of Venison, New York, *The Figure and Dr. Freud*
- Michael Rosenthal Gallery, Los Gatos, California, *Annual Biennial*
- The Menil Collection, Houston, *Body in Fragments*
- Allen Memorial Art Museum, Oberlin College, Ohio, *Out of Line: Drawings from the Allen from the Twentieth Century and Beyond*
- Palm Springs Art Museum, California, *The Passionate Pursuit: Gifts and Promised Gifts of Donna and Cargill Macmillan, Jr.*
- The Arnold and Marie Schwartz Gallery Met, The Metropolitan Opera, New York, *Something About Mary*
- Moderna Museet, Malmö, Sweden, *The 60s—The Moderna Museet Collection*

2010

- Woodward Gallery, New York, *Big Paper Winter*
- Pace Gallery, New York, *Pastiche*
- Acquavella Galleries, Inc., New York, *Robert and Ethel Scull: Portrait of a Collection*
- Galleria 1000 Eventi, *Milan, XXL*
- Benrimon Contemporary, New York, *Fleurs: 1880–2010*
- Loretta Howard Gallery, New York, *Artists at Max's Kansas City, 1965–1974: Hetero-Holics and Some Women Too*
- The Museum of Modern Art, New York, *Counter Space: Design and the Modern Kitchen*
- The Museum of Modern Art, New York, *On to Pop*
- Phyllis Harriman Mason Gallery, The Art Students League of New York, *Will Barnet and The Art Students League*
- Galerie Thomas Modern, Munich, *Popular: Brands, Symbols, Icons 1960–2010*
- Whitney Museum of American Art, New York, *Singular Visions*

2011

- Whitney Museum of American Art, New York, *Legacy: The Emily Fisher Landau Collection*, traveled to Norton Museum of Art, West Palm Beach, Florida; Grand Rapids Art Museum, Michigan; and San Jose Museum of Art, California
- Meadows Museum of Art, Shreveport Centenary College, Lousiana, *Copley to Warhol: American Art Celebrating the New Orleans Museum of Art*, traveled to Alexandria Museum of Art, Louisiana; Paul and Lulu Hilliard University Art Museum, University of Louisiana at Lafayette; and Louisiana State University Museum of Art, Baton Rouge
- Peggy Guggenheim Collection, Venice, Italy, *Ileana Sonnabend: An Italian Portrait*
- Museum of Contemporary Art, Los Angeles, *Common Objects: Pop Art from the Collection*
- Hickory Museum of Art, North Carolina, *NY 10 and International 10 Portfolios*

- Fundación Juan March, Madrid, Spain, *Homage to Leo Castelli—9 Works by 9 Artists*, traveled to Museu Fundación Juan March de Palma, Palma de Mallorca, Spain
- David Zwirner, New York, *Artists for Haiti*, traveled to Christie's, New York
- Ludwig Museum—Museum of Contemporary Art Palace of Arts, Budapest, *East of Eden—Photorealism: Versions of Reality*
- Solomon R. Guggenheim Museum, New York, *Pop Objects and Icons from the Guggenheim Collection*
- The Pace Gallery, New York, *Burning, Bright: A Short History of the Light Bulb*
- Gagosian Gallery, New York, *The Private Collection of Robert Rauschenberg*
- New Orleans Museum of Art, Lousiana, *NOMA 100: Gifts for the Second Century*

2012

- Daum Museum of Contemporary Art, Sedalia, Missouri, *10! The First Decade*
- Acquavella Galleries, Inc., New York, *Masterworks from Degas to Rosenquist*
- Islip Art Museum, East Islip, New York, *Prints Please: Selections from Universal Limited Art Editions*
- Salone Degli Incanti, Triest, Italy, *The Flash of Nature*
- Larissa Goldston Gallery, New York, *In the Garden: Editions*
- Ulmer Museum, Ulm, Germany, *At Eye Level: Masterpieces of Medieval and Modern Art*
- Large Glass, London, *A Drawing While Waiting for an Idea—Prototypes, Artists' Proofs and First Constructions*
- Art Affairs Gallery, Amsterdam, *Works on Paper—Summer Sale*
- Georgia Museum of Art, University of Georgia, Athens, *The New York Collection for Stockholm*
- Vitra Design Museum, Weil am Rhein, *Pop Art Design*, traveled to Louisiana Museum of Modern Art, Humlebæk, Denmark; Moderna Museet, Stockholm, Sweden; Barbican Art Gallery, London; Philbrook Museum of Art, Tulsa, Oklahoma; Emma Espoo Museum of Modern Art, Espoo, Finland; and Henie-Onstad Kunstsenter, Hovikodden, Norway
- Baltimore Museum of Art, Maryland, *On Paper: Drawings from the Benesch Collection*
- Guggenheim Bibao, Spain, *Selections from the Guggenheim Museum Bilbao Collection III*
- Minneapolis Institute of Art, Minnesota, *The World at Work: Images of Labor and Industry, 1850 to Now*

2013

- Mahady Gallery, Marywood University, Scranton, Pennsylvania, *Prints in a Series*
- Martin-Gropius-Bau, Berlin, *From Beckmann to Warhol: Art of the 20th and 21st Centuries—The Bayer Collection,*
- John Berggruen Gallery, New York, *The Time is Now*
- Acquavella Galleries, New York, *The Pop Object: The Still Life Tradition in Pop Art*
- McClain Gallery, Houston, *Celestial*
- Ca'Pesaro, Galleria Internazionale d'Arte Moderna, Venice, Italy, *The Sonnabend Collection*
- Gemini G.EL. at Joni Moisant Weyl, New York, *Summer Sailing*
- Minneapolis Institute of Arts, Minnesota, *It's New/It's Now: Recent Gifts of Contemporary Prints and Drawings*
- Krannert Art Museum, University of Illinois at Urbana-Champaign, *Correspondents of Ray Johnson*
- McClain Gallery, Houston, *More Than a Likeness*
- Sean Kelly Gallery, New York, *From Memory: Draw a Map of the United States*
- Museum of Art, Washington State University, Pullman, *Made in U.S.A.: Rosenquist/Ruscha*

- Daum Museum of Contemporary Art, Sedalia, Missouri, *Fit to Print*

- MANA Contemporary, Jersey City, New Jersey, *Pop Culture: Selections from the Frederick R. Weisman Art Foundation*, traveled to Boca Raton Museum of Art, Florida

- Palm Springs Art Museum in Palm Desert, California, *Galen at the Galen*

- Kemper Museum of Contemporary Art, Kansas City, Missouri, *Area Code*

- The Museum of Modern Art, New York, *Ileana Sonnabend: Ambassador for the New*

2014

- Woodward Gallery, New York, *Sur-Real*

- Brooklyn Museum, New York, *Witness: Art and Civil Rights in the Sixties*

- Nassau County Museum of Art, Roslyn Harbor, New York, *Garden Party*

- Smithsonian American Art Museum, Washington, D.C., *Pop Art Prints*, traveled to Robert Hull Fleming Museum, University of Vermont, Burlington, Vermont; Mennello Museum of American Art, Orlando, Florida

- Luxembourg & Dayan, New York, *The Shaped Canvas, Revisited*

- Serlachius Museum Gösta, Mänttä, Finland, *Superpop!*

- Rachel Uffner Gallery, New York, *The Crystal Palace*

- Whitney Museum of American Art, New York, *Shaping a Collection: Five Decades of Gifts*

- Cantor Arts Center at Stanford University, California, *Pop Art from the Anderson Collection at SFMOMA*

- Ikon Ltd. Contemporary Art, Santa Monica, California, *Ikon 15 Year Anniversary (2014)*

- Addison Gallery of American Art, Phillips Academy, Andover, Massachusetts, *POP!: Selections from the Collection*

- Museum Ludwig, Cologne, *Ludwig Goes Pop*

- Richard L. Feigen & Co., Inc., New York, *Ray Johnson's Art World*

- Museum of Fine Arts, St. Petersburg, Florida, *Robert Rauschenberg and James Rosenquist: Images from Everywhere, Prints and Photographs*

2015

- Paul Kasmin Gallery, New York, *The New York School, 1969: Henry Geldzahler at the Metropolitan Museum of Art*

- Walker Art Center, Minneapolis, *International Pop*, traveled to Dallas Museum of Art, Texas; and Philadelphia Museum of Art

- Acquavella Galleries, New York, *Off Canvas: Drawing*

- Museum der Moderne Salzburg, Österreich, *E.A.T.— Experiments in Art and Technology*

- Harvard Art Museums, Cambridge, Massachusetts, *Corita Kent and the Language of Pop*, traveled to San Antonio Museum of Art, Texas

- National Gallery of Art, Washington, D.C., *The Serial Impulse at Gemini G.E.L.*, traveled to Los Angeles County Museum of Art, California

2016

- Gemini G.E.L., Los Angeles, *Selected Works: Made in L.A.*

- Art Gallery of Ontario, Toronto, Kanada, *SuperReal: Pop Art from the AGO Collection*

- Galerie Fluegel-Roncak, Nuremberg, Germany, *Winter Accrochage*

- Hofstra University Museum, Hofstra University, Hempstead, New York, *In Print*

- The Museum of Modern Art, New York, *From the Collection: 1960–1969*

- Farnsworth Art Museum, Rockland, Maine, *Pushing Boundaries. Dine, Graves, Lichtenstein, Rauschenberg and Rosenquist: Collaborations with Donald Saff*

- Acquavella Galleries, New York, *Postwar New York: Capital of the Avant-Garde*

- The Baker Museum, Artis—Naples, Florida, *New Acquisitions: In Context—From the Collection of Paul and Charlotte Corddry*

- Neuberger Museum of Art, Purchase, New York, *POP! Prints from the Permanent Collection*

- Galerie Fluegel-Roncak, Nuremberg, *Winter Accrochage*

2017

- Hillstrom Museum of Art, Gustavus Adolphus College, Saint Peter, Minneapolis, *Rosenquist/Ruscha, and Recent Acquisitions*

Artist's Books, Writings, and Statements by the Artist

1962

· Statement. In *Art 1963—A New Vocabulary*, 5. Exh. cat. Philadelphia: Art Council of the YM/YWHA, 1962.

1963

· "James Rosenquist's 'New Realism.'" In "Young Talent USA," special issue of *Art in America* (New York) 51, no. 3 (June 1963): 48.

· Statement. In Dorothy C. Miller, ed., *Americans 1963*, 87. Exh. cat. New York: Museum of Modern Art, 1963.

1968

· "Experiences." In *James Rosenquist*, 88. Exh. cat. Ottawa: National Gallery of Canada.

1969

· "James Rosenquist: Horse Blinders." *Art Now: New York* 1, no. 2 (February 1969), unpaginated. Excerpt from a previously unpublished statement dated December 12, 1968; the statement appears in its entirety in *James Rosenquist*, translated by Javier García Raffi and Harry Smith, 27–29 (Spanish), 196 (English). Exh. cat., Valencia: IVAM Centre Julio González, 1991.

· Statements. In *New York 13*, unpaginated. Exh. cat. Vancouver: Vancouver Art Gallery, 1969.

1971

· Statement. In "Gene Swenson: A Composite Portrait." *The Register of the Museum of Art* (Lawrence, Kansas) 4, nos. 6–7 (October–December 1971): 24–27.

1972

· "Art Mailbag: James Rosenquist Replies." *The New York Times*, May 14, 1972, 23–24.

1977

· Statement. In Grace Glueck, "The Twentieth-Century Artists Most Admired by Other Artists." *Artnews* (New York) 76, no. 9 (November 1977): 98–99.

1978

· Statement. In Judith Goldman, "Touching Moonlight." *Artnews* (New York) 77, no. 9 (November 1978), 62.

1979

· Rosenquist, James. *Drawings While Waiting for an Idea*. New York: Lapp Princess Press, 1979.

· Statement. In *James Rosenquist: Seven Paintings*, unpaginated. Exh. cat. Moorhead, Minn.: Plains Art Museum, 1979.

1987

· Statement. In *James Rosenquist: Paintings 1987*, unpaginated. Exh. cat. Stockholm: Heland Thordén Wetterling Galleries, 1987.

1988

· Statement. In Catherine Barnett, "Wise Men Fish Here." *Art and Antiques* (New York), February 1988, 91.

1990

· Statement. In *James Rosenquist's Commissioned Works*, 6. Stockholm: Painters Posters in association with Wetterling Gallery, 1990.

1992

· Statement. In Paul Gardner, "Do Titles Really Matter?" *Artnews* (New York) 91, no. 2 (February 1992): 95.

· Statement. In *James Rosenquist: Paintings 1990–1992*, 1 (Spanish), 31 (English). Exh. cat. Madrid: Galería Weber, Alexander y Cobo, 1992.

· Statements. In *James Rosenquist: The Serenade for the Doll after Claude Debussy or Gift Wrapped Dolls and Masquerade of the Military Industrial Complex Looking Down on the Insect World*, translated by Nathalie Brunet, Neal Cooper, and Hélène Gille, 15, 39 (English and French). Exh. cat. Paris: Galerie Thaddaeus Ropac. Reprinted in *James Rosenquist: The Serenade for the Doll after Claude Debussy or Gift Wrapped Dolls and Masquerade of the Military Industrial Complex Looking Down on the Insect World*, 5, 15. Exh. cat. New York: Leo Castelli Gallery, 1993.

1993

· Statement. In Milton Esterow, "The Second Time Around." *Artnews* (New York) 92, no. 6 (Summer 1993): 152.

· Statement. In Margot Mifflin, "What Do Artists Dream?" *Artnews* (New York) 92, no. 8 (October 1993): 149.

1994

· Statement. In Eugenia Bone, "Welcome to Sponge City." *The New York Observer*, May 9, 1994, 15.

1995

· Statement. In "Returned to Sender: Remembering Ray Johnson: R.S.V.P." *Artforum* (New York) 33, no. 8 (April 1995): 75, 113.

1996

· Statement. In *James Rosenquist, 4 E 77 St 1970 Revisited and New Paper Constructions from Gemini G.E.L.*, 1. Exh. cat. New York: Leo Castelli Gallery, 1996.

· Statement, in *Target Practice: Recent Paintings by James Rosenquist*, exh. cat. Chicago: Feigen, 1996, p. 1. Reprinted in *James Rosenquist: New Works 1996*, 2. Exh. cat. Singapore: Wetterling Teo Gallery, 1996.

2000

· Statement. In *James Rosenquist Paintings/James Rosenquist Selects Dalí*, 47. Exh. cat. St. Petersburg, Florida: Salvador Dalí Museum, 2000.

2001

· Statement. In "James Rosenquist: 'What You See Is What You Don't Get.'" In *James Rosenquist: The Stowaway Peers Out at the Speed of Light*, 9. Exh. cat. New York: Gagosian Gallery, 2001.

2002

· Letter to the Editor. *The New York Times Magazine*, August 11, 2002, sec. 6, 12.

2009

· Rosenquist, James, with David Dalton. *Painting Below Zero: Notes on a Life in Art*. New York: Alfred A. Knopf, 2009.

Interviews

1964

· Swenson, G[ene] R. "What Is Pop Art? Part II: Stephen Durkee, Jasper Johns, James Rosenquist, Tom Wesselmann." *Artnews* (New York) 62, no. 10 (February 1964): 41, 62–64.

1965

· Swenson, G[ene] R. "*The F-111*: An Interview with James Rosenquist by G. R. Swenson." *Partisan Review* (New York) 32, no. 4 (Fall 1965): 589–601.

1968

· Swenson, Gene. "Social Realism in Blue: An Interview with James Rosenquist." *Studio International* (London) 175, no. 897 (February 1968): 76–83.

1971

· Schjeldahl, Peter. "Entretien avec James Rosenquist/ An Interview with James Rosenquist." Translated by Nicola Raw. *Opus International* (Paris), nos. 29–30 (December 1971): 46–49 (French), 114–15 (English).

1972

· Siegel, Jeanne. "An Interview with James Rosenquist." *Artforum* (New York) 10, no. 10 (June 1972): 30–34.

1974

· Tuchman, Phyllis. "Pop! Interviews with George Segal, Andy Warhol, Roy Lichtenstein, James Rosenquist, and Robert Indiana." *Artnews* (New York) 73, no. 5 (May 1974): 28–29.

1980

· Amaya, Mario. "Artist's Dialogue: A Conversation with James Rosenquist." *Architectural Digest* (Los Angeles) 37, no. 2 (March 1980): 46, 50, 52.

1982

· Snodgrass, Susan de Alba. "An Interview with the Man Who Painted Flying Bacon." *The Miami News*, June 14, 1982, B1–2.

1983

· Cummings, Paul. "Interview: James Rosenquist Talks with Paul Cummings." *Drawing* (New York) 5, no. 2 (July–August 1983): 30–34.

1986

· Allen, Jane Addams. "'Pop' Prince Rosenquist Looks Ahead." *The Washington Times*, October 24, 1986, B1, B9.

1987

· Staniszewski, Mary Anne. "James Rosenquist." *Bomb* (New York), no. 21 (Fall 1987): 24–29.

1990

· Adcock, Craig. "James Rosenquist Interviewed by Craig Adcock, March 25, 1989." In *James Rosenquist's Commissioned Works*, 8–58. Stockholm: Painters Posters in association with Wetterling Gallery, 1990.

1991

· Durand, Régis. "James Rosenquist: La réincarnation des images." *Art Press* (Paris), no. 158 (May 1991): 14–21.

· Shapiro, David. "Celebrating Everything." Translated by Javier García Raffi and Harry Smith. In *James Rosenquist*, 76–84 (Spanish), 209–12 (English). Exh. cat., Valencia: IVAM Centre Julio González, 1991.

· Taylor, Paul. "Interview with James Rosenquist." Translated by Brigit Wettstein. *Parkett* (Zurich), no. 28 (1991): 116–21 (English), 122–25 (German).

1992

· Bonami, Francesco. "James Rosenquist: Militant Pop." *Flash Art* (Milan) 25, no. 165 (Summer 1992): 102–04.

· Glenn, Constance. "James Rosenquist Interviewed by Constance Glenn." In *Pop Art*, edited by Andreas C. Papadakis, 8–13, 47. London: Academy Editions; New York: St. Martin's Press, 1992.

· Goldman, Judith. "An Interview with James Rosenquist." In Goldman, *James Rosenquist: The Early Pictures 1961–1964*, 85–104. Exh. cat. New York: Gagosian Gallery and Rizzoli, 1992.

1993

· Whitney, David. "James Rosenquist: Interview of February 25, 1993." In *James Rosenquist: The Serenade for the Doll after Claude Debussy or Gift Wrapped Dolls and Masquerade of the Military Industrial Complex Looking Down on the Insect World*, 2–3. Exh. cat. New York: Leo Castelli Gallery, 1993.

1994

· Adcock, Craig. "An Interview with James Rosenquist." In Susan Brundage, ed., *James Rosenquist, The Big Paintings: Thirty Years*, unpaginated. Leo Castelli. New York: Leo Castelli Gallery in association with Rizzoli, 1994.

1997

· Yanase, Kaoru, and Shunichi Kamiyama. "Interview with James Rosenquist." In *The Graphics of James Rosenquist*, 16–20 (Japanese), 44–49 (English). Exh. cat. Fukushima: Center for Contemporary Graphic Art and Tyler Graphics Archive Collection, 1997.

1998

· Rosenblum, Robert. "Interview with James Rosenquist by Robert Rosenblum." In *James Rosenquist: The Swimmer in the Econo-mist*, 7–11. Exh. cat. New York: Guggenheim Museum, 1998.

2000

· Rattermeyer, Christian. "Jeff Koons and James Rosenquist: If You Get a Little Red on You, It Don't Wipe Off/Rote Kleckser bringt man nie mehr weg." Translated by Goridis/Parker. *Parkett* (Zurich), no. 58 (2000): 36–43 (English), 44–50 (German).

· Jeffet, William. "William Jeffet in Conversation with James Rosenquist." In *James Rosenquist: Paintings/James Rosenquist: Selects Dalí*, 55–58, 61–69. Exh. cat. St. Petersburg, Florida: Salvador Dalí Museum, 2000.

2003

· Bancroft, Sarah. "An Interview with James Rosenquist." *Guggenheim Magazine* (Fall 2003): 16, 23.

2004

· Amy, Michaël. "Painting, Working, Talking." *Art in America* 92, no. 2 (February 2004): 104–09, 143.

· Andersen, Kurt. "Rosenquist, Still Life, Jingles." Studio 360, WNYC, January 17, 2004 (show no. 503). Radio broadcast.

2005

· "Magical Illusion by James Rosenquist." Interview with James Rosenquist. *Illywords* 14 (2005): 20–23.

· "James Rosenquist: An Interview." Interview by Ira Goldberg. *LINEA, Journal of the Art Students League of New York* 9, no. 2 (Fall/Winter 2005): 4–8.

2006

· Couto, Rodrigo Carrizo. "James Rosenquist: Artista." *El País*, June 18, 2006, 50.

· Van der Marck, Jan. "Reminiscing on the Gulf of Mexio: A Conversation with James Rosenquist." *American Art* 20, no. 3 (Fall 2006): 84–107.

2009

· Brown, Jeffrey. "Conversation: Painter James Rosenquist." PBS Newshour, December 23, 2009. Television broadcast.

· "Icon: James Rosenquist." Interview of James Rosenquist by Art Levy. *Florida Trend* 52, no. 5 (August 2009): 16–17.

· Murphy, Tim. "Intelligencer: 110 Minutes with James Rosenquist." *New York*, December 7, 2009, 22.

· Rosenquist, James. "Speed of Light." Interview by Alberto Dambruoso. *Terzo Occhio* 35, no. 9 (January–March 2009): 88–89.

2010

· Kipling, Kay. "In Town: Talking with Artist James Rosenquist." *Sarasota Magazine* 32, no. 7 (April 2010): 24.

2014

· Daniel Kunitz, "In the Studio: Master of Space and Time," *Art+Auction*, February 2014.

Articles and Essays

This section includes texts appearing in periodicals, collections of essays, and group-exhibition catalogues.

· Abdo, Geneive. "Iran Goes Pop: Works by Warhol and Lichtenstein On Show in Iran After Twenty Years of Repression." *The Guardian* (Manchester), September 21, 1999, 16.

· "The Agony and the Ecstasy." *Artnews* (New York) 98, no. 4 (April 1999), 30.

· Alexander, Darsie, and Bartholomew Ryan. *International Pop*. Minneapolis: Walker Art Center, [2015].

· Allen, Jane Adams. "'Pop' Prince Rosenquist Looks Ahead." *The Washington Times*, October 24, 1986, B1, B9.

· Alloway, Lawrence. "The Past Ten Decades." *Art in America* (New York) 52, no. 4 (August 1964): 20–21.

· "Derealized Epic." *Artforum* (New York) 10, no. 10 (June 1972): 35–41.

· [Althen, Michael, Thomas Kellein, and Angela Lampe.] *Das Große Fressen: Von Pop bis Heute*. Exh. cat. Bielefeld, Germany: Kunsthalle Bielefeld, 2004.

· Amy, Michaël. *Fleurs: 1880–2010*, 31–32. New York: Benrimon Contemporary, 2010.

· Anderson, Joel. "After Fire, Pop Art Icon Faces Bleak Landscape." *St. Petersburg Times*, April 27, 2009, 1A, 5A.

· Apple, R. W. "Discovering La Dolce Vita in a Cup." *The New York Times*, October 24, 2001, F1.

· Arbus, Doon. "The Man in the Paper Suit." *New York/The World Journal Tribune Magazine*, November 6, 1966, 7–9.

· "Aripeka Artist Honored with Hall of Fame Award." *St. Petersburg Times*, December 5, 2000, B2.

· "Artists Talkin' About Their Generation." *Boston Globe*, October 7, 2001, 6.

· "Artists vs. Mayor Daley." *Newsweek* (New York), November 4, 1968, 117.

· "Art: New Rosenquist Lithograph Commissioned by Troup." *Dallas Times Herald*, January 1, 1967, A29.

· "Art: Pop: Bing-Bang Landscapes." *Time* (New York), May 28, 1965, 80.

· "Art: Rosenquist and Lichtenstein Are Alive." *Time* (New York), January 26, 1968, 56.

· Arundel, Anne. "Best Bets: Contemporary Masters." *The Washington Post*, February 21, 2002, T20.

· Ayers, Robert. "Reviews: James Rosenquist." *Artnews* 109, no. 6 (June 2010): 100.

· Baker, Kenneth. "Double Bonanza for Modern Art Fans: Legions of Work from the Elite Anderson Collection On View at the Palace, SFMoMA." *San Francisco Chronicle*, August 27, 2000, 58.

· Baker, R. C. "The Information: James Rosenquist's *F-111* and Terry Winters' *Notebook* Series." *The Village Voice*, February 22, 2012.

· Barry, Rick. "Pop Art Bandage Helps 'Heal' Patients." *The Tampa Tribune*, January 31, 2002, 2.

· B[attcock], G[regory]. "In the Museums: James Rosenquist." *Arts Magazine* (New York) 42, no. 6 (April 1968): 54.

· Bean, Shawn. "Premium Blend." *Florida International Magazine* 7, no. 4 (April 2004), 90–91.

· Benbow, Charles. "Rosenquist Portrait of the Artist at Home a One-Man Show of Exuberence." *St. Petersburg Times*, September 23, 1984, E1, E7.

· Berg, Paul. "About-Face from the Abstract." *Pictures* (*St. Louis Post-Dispatch* magazine), December 31, 1961, 10–11.

· "Far Out, but No Laughing Matter." *Pictures* (*St. Louis Post-Dispatch* magazine), February 9, 1964, 2–5.

· Bennett, Lennie. "Gripping Reality: Artist James Rosenquist's Universe Expands in Color and Thought." *St. Petersburg Times*, June 15, 2008, 1L, 6L–7L.

· Bernstein, Roberta. "Rosenquist Reflected: The Tampa Prints." *The Print Collector's Newsletter* (New York) 4, no. 1 (March–April 1973), 6–8.

· Boorsch, Suzanne. "New Editions: James Rosenquist." *Artnews* (New York) 74, no. 7 (September 1975), 52.

· "New Editions: James Rosenquist." *Artnews* (New York) 77, no. 1 (January 1978), 136.

· Bourdon, David. "Art: Park Place: New Ideas." *The Village Voice* (New York), November 25, 1965, 11.

· Braddock, Alan C. "Shooting the Beholder: Charles Schreyvogel and the Spectacle of Gun Vision." *American Art* 20, no. 1 (Spring 2006): 36–59.

· Bradley, Jeff. "Large-scale Art, Huge Images Fill Rosenquist Works." *Denver Post*, March 26, 1999, E22.

· Braff, Phyllis. "Prints with All the Sweep of Their Century." *The New York Times*, March 7, 1999, 24.

· Braun, Emily. "Sex, Lies, and History." *Modernism/modernity* 10, no. 4 (November 2003): 729, 756.

· Brewster, Todd. "Evolution of a Painting." *Life* (Chicago) 4, no. 2 (February 1981), 84–94. Photographs by Robert Adelman.

· Brooks, Valerie F. "The Art Market: Rosenquist's Market: Pop Art Performs." *Artnews* (New York) 83, no. 3 (March 1984), 27.

· Calas, Nicolas, and Elena Calas. "James Rosenquist: Vision in the Vernacular." *Arts Magazine* (New York) 44, no. 2 (November 1969), 38–39. Reprinted as "James Rosenquist's Angular Vista," in Calas and Calas, *Icons and Images of the Sixties*, 117–22. New York: E. P. Dutton, 1971.

· Canaday, John. "Pop Art Sells On and On—Why?" *The New York Times Magazine*, May 31, 1964, 7, 48, 52–53.

· "It Would Be Awfully Nice If We Were All Wrong about the Whole Thing." *The New York Times*, February 25, 1968, sec. 2, 23.

· "Art: Well, the House Caught Fire, and—." *The New York Times*, March 17, 1968, D33.

· Catala, Paul. "Pop Artist James Rosenquist Joins Florida Hall of Fame." *The Tampa Tribune*, December 5, 2000, 7.

· Celant, Germano, and Lisa Dennison, eds. *New York New York: Fifty Years of Art, Architecture, Cinema, Performance, Photography and Video*. Monaco: Grimaldi Forum, 2006.

· Chandler, Mary Voelz. "213 Works Given to Denver Art Museum." *Rocky Mountain News* (Denver), February 8, 2002, A5.

· Charbonneaux, Catherine. "Marché: Le Pop Paie: James Rosenquist." *Connaissance des arts* (Paris), no. 420 (February 1987), 27.

· Charney, Melvin. "Le Monde du Pop." *Vie des Arts* (Paris), Fall 1964, 31–37.

· Codik, Emily. "Things to Do: 'The Serial Impulse at Gemini G.E.L.' Opens at the National Gallery of Art." *Washingtonian*, September 30, 2015.

· "Commissioned Works by the Deutsche Guggenheim." *Deutsche Guggenheim Magazine*, issue 4 (Summer 2008): 2.

· Conroy, Sarah Booth. "Embassies Display America's Artistic Gifts." *The Washington Post*, June 5, 2000, C2.

· Cosford, Bill. "Is It Art? Asking Is Unnecessary." *The Miami Herald*, May 15, 1983, L1, L5.

· Cotter, Holland. "Advertisements for a Mean Utopia." *Art in America* (New York) 75, no. 1 (January 1987): 82–89.

· "A Postwar Survey, Semi-Wild at Heart." *The New York Times*, September 29, 2000, E27.

· "We Set Off in High Spirits." *The New York Times*, August 3, 2001, E32.

· Coupland, Douglas. "James Rosenquist: F-111." *Artforum* (New York) 32, no. 8 (April 1994): 84–85.

· C[owart], J[ack]. "Three Contemporary American Paintings." *The St. Louis Art Museum Bulletin* 11, no. 5 (September–October 1975): 88–95.

· Crow, Kelly. "Scarred, Inspired by Fire." *The Wall Street Journal*, September 7, 2012: C14.

· "Guggenheim Abu Dhabi Acquires Postwar Artworks." *The Wall Street Journal*, March 22, 2013.

· Davis-Platt, Joy. "Artists Mix Art and Politics in Fundraiser." *St. Petersburg Times*, December 10, 2001, 1.

· Dalmas, John. "A Party for the Artsy." *The Journal News* (Rockland County, N.Y.), June 7, 1977, A7.

· Dalton, David. "James Rosenquist: Swimmer in the Cosmic Mist." *Art* 9 (Summer 2012): 3, 20–23.

· Danto, Arthur C. "The Rebirth of the Modern." *The Nation* 280, no. 4 (January 31, 2005): 32–35.

· [Davidson, Susan, ed.] *American Pop Icons*. New York: Guggenheim Museum Publications, 2003.

· Diblasi, Debra. "Seeing/Not Seeing." *SoMA* (San Francisco), no. 11 (1990), 30–33.

· "A Display of Romantic Works." *USA Today* (Arlington, Va.), February 11, 2000, D10.

· Dunlop, Beth. "Mural Drives Borman Up the Wall." *The Miami Herald*, December 8, 1981, A1, A14.

· Durand, Jean-Marie. "L'extase James Rosenquist, figure du Pop Art, exposé à Pantin." *Les Inrocks*, September 17, 2016.

· Ebony, David. "James Rosenquist at Acquavella." *Art in America* 96, no. 5 (May 2008): 189.

· *El Pop Art en la colección del IVAM*. With foreword by Francisco Camps Ortiz and essays by Consuelo Císcar Casabán, William Jeffet, Santiago Olmo, Lluís Fernández, and Clare Carolin. Exh. cat. Valencia: Insitut Valencià d'Art Modern, 2007.

· Esterow, Milton. "22 Stories Above Times Square." *Artnews* 108, no. 10 (November 2009): 106–9.

· Farrell, Jennifer. "Painter Rosenquist Lends Name to Gallery." *St. Petersburg Times*, February 26, 2000, 1.

· "Aripeka Jim." *St. Petersburg Times*, June, 4, 2000, F1.

· Feinstein, Roni. *Circa 1958: Breaking Ground in American Art*. With a foreword by Emily Kass. Chapel Hill, North Carolina: Ackland Art Museum, The University of North Carolina at Chapel Hill, 2008.

· Felix, Zdenek. "Horizon Home Sweet Home." Translated by Catherine Schelbert. *Parkett* (Zurich), no. 58 (2000), 52–55 (German), 56–57 (English).

· "Fifteen Artists' Protest Posted at Museum." *Richmond Times-Dispatch* (Richmond, Va.), May 30, 1970, B1.

· "Fine Art." *St. Louis Post-Dispatch*, January 3, 2002, G23.

· Formaggio, Dino, Vladimiro Elvieri, Margaret A. Miller, Deli Sacilotto, Laura Gensini, and Mauro Mainardi. *Art and the Printing Press—Cremona 2005*. Cremona, Italy: A.D.A.F.A. (Amici dell'arte—Famiglia Artistica), 2005.

· Foster, Hal. "At the Guggenheim." *London Review of Books* 25, no. 24 (December 18, 2003).

· Frank, Priscilla. "James Rosenquist, Pop Art Legend, On Romney, Multiple Universes, and Young'uns Who 'Don't Know How to Paint.'" *Huffington Post*, October 22, 2012.

· Fredricksen, Barbara. "Aripeka's Artists Pop Up, Even on U.S. 19." *St. Petersburg Times*, February 24, 2001, 1.

· Frisch, Marianne Brunson. "Letters to the Editor: At Reader's Digest, Good Art, Good Vibes." *The Wall Street Journal* (New York), May 1, 2000, A3.

· Gabriel, Trip. "Rosenquist Up Close." *United* (Greensboro) 30, no. 2 (February 1985), 46–51, 60–61.

· Galison, Peter L., Gerald Holton, and Silvan S. Schweber, eds. *Einstein for the 21st Century: His Legacy in Science, Art, and Modern Culture*. Princeton, New Jersey: Princeton University Press, 2008.

· Gassiot-Talabot, Gérald. "Les ambiguïtés de James Rosenquist." *XXe Siècle* (Paris), no. 41 (December 1973), 106–11.

· Geldzahler, Henry. "James Rosenquist's F-111." *The Metropolitan Museum of Art Bulletin* (New York) 26, no. 7 (March 1968), 276–81.

· Gladstone, Valerie. "James Rosenquist: Vikings and Vodka." *Artnews* (New York) 90, no. 8 (October 1991), 73–74.

· Glueck, Grace. "Art People." *The New York Times*, April 16, 1982, C25.

· "A Collector's Collector Whose Works Went Pop." *The New York Times*, May 4, 2001, E35.

· Goldman, Judith. "James Rosenquist." In *Contemporary Masters: The World Print Awards*, 49–52. Exh. cat. San Francisco: World Print Council, in cooperation with San Francisco Museum of Modern Art; California College of Arts and Crafts, Oakland; and Osaka University of Arts, 1983.

· "Time on His Mind." *Vogue* 197, no. 10 (October 2007): 404–9.

· Goukassian, Elena. "Express: 'Pop Art Prints,' at the Smithsonian American Art Museum, Proves that Pop Artists Weren't Shallow." *The Washington Post*, April 3, 2014.

· Gratz, Roberta Brandes. "Daily Closeup." *New York Post*, April 25, 1972, 41.

· Green, Alison. "James Rosenquist." *Art Monthly*, no. 301 (November 2006): 16–17.

· Greenfeld, Josh. "Sort of the Svengali of Pop." *The New York Times Magazine*, May 8, 1966, 34–35, 38.

· Glenn, Constance W. "Stories in T-Shirt Yellow/Geschichten in T-Shirt-Gelb." Translated by Susanne Schmidt. *Parkett* (Zurich), no. 58 (2000), 66–67 (English), 68–71 (German).

· Goldman, Judith. "James Rosenquist: Menil Collection and Museum of Fine Arts, Houston." *Artnews* 102, no. 9 (October 2003): 132–33.

· Grossman, Cathy Lynn. "Deserving Equal Space." *The Miami Herald*, December 10, 1981, B1.

· Guiducci, Mark. "James Rosenquist on the Re-staging of his F-111 at MoMA, the Zen of Duchamp, and Teaching Dalí to Drink a Screwdriver." *Vanity Fair*, January 20, 2012.

· Hale, Barrie. "Pop! You're (Still) Surrounded." *The Telegram* (Toronto), September 25, 1965, 73.

· Hamilton, Susan. "Big Is Beautiful." *The Peak* (Singapore) 11, no. 7 (1995), 48–53.

· Hanson, Sarah P. "Value Judgments." *Art + Auction* 35, no. 2 (October 2011): 102–107, 122.

· Harper, Cheryl. *A Happening Place*. With essays by Constance W. Glenn and Sid Sachs. Exh. cat. Philadelphia: The Galleries at the Gershman Y, 2003.

· Heartney, Eleanor. "Rosenquist Revisted." *Artnews* (New York) 85, no. 6 (Summer 1986), 98–103.

· "James Rosenquist at Gagosian." *Art in America* (New York) 89, no. 11 (November 2001): 145.

· Hermsen, Karen, et al. "Across the Region." *The Tampa Tribune*, December 10, 2001, 2.

· Herriman, Kat. "Strange Bedfellows? James Rosenquist Shows at Donald Judd's House in SoHo." *Blouin Art Info International*, May 13, 2016.

· Hertenstein, Barbara. "'Art in Bloom 2001' Blossoms with Flower Power This Weekend." *St. Louis Post-Dispatch*, March 15, 2001, 3.

· H[ess], T[homas] B. "Editorial: It Shouldn't Happen to a Hoving Happening." *Artnews* (New York) 67, no. 2 (April 1968), 29.

· Horn, Laurie. "Playing Critic at the Art Center." *The Miami Herald*, April 26, 1983, C6.

· Hultén, Pontus. "For Jim/Für Jim." Translated by Wilma Parker. *Parkett* (Zurich), no. 58 (2000), 51 (English and German).

· "It's Jimmy Rosenquist—An Artist in the Age of Pop." *The Tower* (New York), April 10, 1967, 4–5. Photographs by Bob Adelman.

· Itzkoff, Dave. "Arts, Briefly: Pop Artist's Works Lost in Fire." *The New York Times*, April 28, 2009, C2.

· Jacobson, Aileen. "At Hofstra, Printmaking from Dürer to Warhol and Beyond." *The New York Times*, March 17, 2016, L18.

· "Jarring Blend of Billboard Pieces." *Life* (Chicago) 52, no. 24 (June 15, 1962), 116.

· Jeffet, William. "James Rosenquist, entre el Pop y el Surrealismo." *Lapiz* (Madrid), no. 167 (2000), 16–19.

· Jensen, Knud W. "Pop-kunst pa Louisiana." *Louisiana Revy* (Humlebæk, Denmark), no. 4 (April 1964), 3–7.

· Johnson, Patricia. "Channeling Icons: Menil Showcases Pop Art Works." *Houston Chronicle*, January 27, 2001, D5.

· Johnson, Philip. "Young Artists at the Fair and at Lincoln Center." *Art in America* (New York) 52, no. 4 (August 1964): 112–21.

· Johnson, Ray. "Abandoned Chickens." *Art in America* (New York) 62, no. 6 (November–December 1974), 107–12.

· Kalina, Richard. "James Rosenquist at Full Scale." *Art in America* 92, no. 2 (February 2004): 96–103, 135.

· Karcher, Eva. "Blumengrüsse aus Flo." *Ambiente* (Munich), no. 10 (October 1990), 68–72.

· Kastner, Jeffrey. "In the Studio: James Rosenquist." *Art + Auction* 31, no. 3 (November 2007): 86–92.

· Kelly, Edward. "A Review of Neo-Dada." *Art Voices Magazine* (New York) 3, no. 4 (April–May 1964), 11–14.

· Kennedy, Randy. "James Rosenquist and Erró Discuss a Long Friendship Forged in Pop Art." *The New York Times*, March 17, 2016, C23.

· Keys, Elizabeth. "Pop Art Debuts with James Rosenquist Exhibit in Oklahoma State University Postal Plaza Gallery's 'New York Project.'" *Stillwater News Press,* November 19, 2014.

· Kifner, John. "Artist's Journey from Billboards to Supersize Art." *The New York Times*, October 29, 2003, B1, B2.

· Kimmelman, Michael. "Mixing Catchy Pop Images to Make Haiku Writ Large." *The New York Times*, October 17, 2003, E33, E42.

· Knight, Christopher. "Art Review; Panza's Two Divergent Worlds: While Part 1 of the MoCA Exhibition Features Critically Important Works, More Recent Post-Mainstream Selections in Part 2 Are Less Consistent." *Los Angeles Times*, February 5, 2000, F1.

· "Art Review; 2001: A Space Oddity; 'Contemporary Art and the Cosmos' Is Another Victim of Theme-Show Fever, in Which Works with a Common Element or Two Are Packaged in a Shorthand Stab at Significance." *Los Angeles Times*, February 10, 2001, F1.

· Kohen, Helen L. "'Star Thief' Deserves Better Reputation." *The Miami Herald*, May 13, 1983, C12.

· Kozloff, Max. "Art." *The Nation* (New York), April 29, 1968, 578–80.

· Killeen, Michael. "Rosenquist." *Soloarte*, no. 2 (November–December 2003): 110–15.

· Kinsman, Jane. "Rosenquist: Welcome to the Water Planet." *artonview*, no. 46 (Winter 2006): 24–31.

· "Rosenquist: Welcome to the Water World." *Imprint (The Journal of the Print Council of Australia Inc.)* 41, no. 2 (Winter 2006): 36–37.

· Kramer, Hilton. "Art: A New Hangar for Rosenquist's Jet-Pop 'F-111.'" *The New York Times*, February 17, 1968, 25.

· Kunitz, Daniel. "In the Studio: James Rosenquist, Master of Space and Time." *Art + Auction* 37, no. 6 (February 2014): 66–70.

· Kuspit, Donald. "James Rosenquist—The Fragments of a Romance: The Romance of the Fragment." *C Magazine* (Toronto), no. 11 (June 1986), 70–73.

· "James Rosenquist, Surrealist Esthete." *Artnet Magazine*, November 17, 2003.

· Lamb, John. "Plains Art Museum Gets $1.2 Million Mural." *The Forum* (Fargo-Moorhead), February 3, 2010, B2.

· Lane, Mary M. "Swedish Scientists Get Ready to Sell a Trove of Art." *The Wall Street Journal*, February 5, 2015.

· [Lavin, Sylvia.] *Modern Views*. With a foreword by Paul Goldberger. New York: Assouline Publishing, 2010.

· Lavrador, Judicaël. "Rosenquist, le papy pop art." *Libération*, October 16, 2016.

· Leiser, Erwin. "James Rosenquist." *Frankfurter Allgemeine Magazin*, August 22, 1986, 13–18.

· Letofsky, Irv. "Will Jones After Last Night." *Minneapolis Tribune*, November 18, 1968, 30.

· Lewis, Jo Ann. "Around the World, Diplomatic Displays; US Embassies, Benefiting from Artists' Touch—and Largess." *The Washington Post* (Final Edition), February 25, 2001, G4.

· Lindemann, Adam. "Schooled by the Sculls." *The New York Observer*, April 21, 2010.

· Lingemann, Susanne. "Mystiker mit Hang zur Grösse." *Art: Das Kunstmagazin* (Hamburg), no. 3 (March 1993), 78–91.

· Lippard, Lucy R. "James Rosenquist: Aspects of a Multiple Art." *Artforum* (Los Angeles) 4, no. 4 (December 1965), 41–45.

· Litt, Steven. "Icon of the Sixties." *The Plain Dealer* (Cleveland), October 26, 1991, F1–2.

· Littlejohn, David. "The Gallery: One Collection, Many Suitors—Two Shows in California Display a Wealth of Postwar Art; The Tastes of Hunk and Moo." *The Wall Street Journal* (New York), November 7, 2000, A24.

· Lobel, Michael. "Rosenquist's Craft—Painting and the Limits of the Machine/Rosenquists Handwerk—Die Malerei und die Grenzen des maschinell Machbaren." Translated by Wilma Parker. *Parkett* (Zurich), no. 58 (2000), 60–61 (English), 62–65 (German).

· Lobel, Michael, et al. "Sign Language." *Artforum* 42, no. 2 (October 2003): 126–33.

· Loft, Kurt. "James Rosenquist." *The Tampa Tribune*, May 20, 1984, G1–2.

· "Film on James Rosenquist Paints Artist into a Corner." *The Tampa Tribune*, May 22, 1987, F3.

· Loring, John. "James Rosenquist's Horse Blinders." *Arts Magazine* (New York) 47, no. 4 (February 1973), 64–65.

· Lucoff, Morton, and Donald P. Myers. "Flying Bacon." *The Miami News*, December 8, 1981, A5–6.

· Maki, Jasmine. "N.D. Native James Rosenquist's 17-by-46 foot, One-piece Painting on Display at North Dakota Museum of Art." *Grand Forks Herald*, August 21, 2013.

· Marger, Mary Ann. "Inside the World of a Pop Artist." *St. Petersburg Times*, May 22, 1987, D1, 4.

· "Rosenquist to Be Inducted in Florida Hall of Fame." *St. Petersburg Times*, June 10, 2001, F8.

· Margold, Jane. "Old Trends Will Shape New Works." *Newsday* (New York), January 4, 1968, A3, A5.

· Martin, Judy Wells. "'Days of Miracles' Haven't Ended for Murals Wizard." *The Florida Times-Union* (Jacksonville), June 14, 1978, A10.

· Mason, Brook. "Home from Home: James Rosenquist at the Judd Foundation." *Wallpaper**, May 24, 2016.

· McGill, Douglas C. "One of Pop Art's Pioneers Is Making Waves Again." *The New York Times*, June 22, 1986, sec. 2, 1, 29.

· "Pop Artist Rearranges Modern Life." *Sarasota Herald-Tribune*, June 29, 1986, G1, G4.

· "Pop Goes the Brush." *St. Petersburg Times*, July 6, 1986, E1, E4.

· McGuigan, Cathleen. "Newsmakers." *Newsweek* (Los Angeles), January 25, 1982, 61.

· Mednicov, Melissa L. "Pink, White, and Black: The Strange Case of James Rosenquist's Big Bo." *Art Journal* 73, no. 1 (Spring 2014): 60–75.

· M[essinger], L[isa] M. "Twentieth Century: James Rosenquist." In "Recent Acquisitions: A Selection 1993–1994," special issue of *The Metropolitan Museum of Art Bulletin* (New York) 52, no. 2 (Fall 1994): 73.

· "Twentieth Century: James Rosenquist." In "Recent Acquisitions: A Selection 1995–1996," special issue of *The Metropolitan Museum of Art Bulletin* (New York) 54, no. 2 (Fall 1996): 64.

· Milani, Joanne. "Adventures in Art." *The Tampa Tribune*, June 10, 2001, 10.

· Miller, Dana, Ed. *Legacy: The Emily Fisher Landau Collection*. With essays by Donna De Salvo and Joseph Giovannini. Exh. cat. New York: Whitney Museum of American Art, 2011.

· Mills, Nicolaus. "F-111: Death-Dealing, Pop-Art Masterpiece." *The Daily Beast*, October 15, 2014.

· Miro, Marsha. "Star Thief Invades DIA." *Detroit Free Press*, February 10, 1987, D8. Photographs by Manny Crisostomo.

· Moss, Hilary. "Installing Pop Art in Donald Judd's Former Home." *The New York Times Style Magazine*, April 19, 2016.

· Nadelman, Cynthia. "Reviews: New York." *Artnews* 111, no. 10 (November 2012): 144.

· Nakamura, Marie-Pierre. "James Rosenquist." *Art Actuel*, no. 29 (November–December 2003): 76–79.

· Neil, Jonathan T.D. "Robert and Ethel Scull: Portrait of a Collection." *Art Review* 42 (Summer 2010): 142.

· Nelson, Garet. "Artist Honored for Pop Prowess." *St. Petersburg Times* (Hernando Times Edition), May 7, 1987, 1, 7.

· Norland, Gerald. "Pop Goes the West." *Arts Magazine* (New York) 37, no. 5 (February 1963): 60–61.

· "One Man's Healing Vision." *St. Petersburg Times*, February 10, 2002, F8, F10.

· Osborne, Catherine. "A Brush with Greatness." *Profiles, Inc.* (New York) 1, no. 1 (March 1988): 34–35, 72.

· O'Sullivan, Michael. "Building Castles in the Air." *The Washington Post*, November 19, 1999, 68.

· Panza, Giuseppe. *Giuseppe Panza: Memories of a Collector*. Milan: Editoriale Jaca Book S.p.A., 2006.

· Parsons, Sarah Fatima. "Das nächste wird grauenhaft!" *Artinvestor* 5, no. 1 (2005): 46–52.

· Paschal, Huston, and Linda Johnson Dougherty. *Defying Gravity: Contemporary Art and Flight*. With contributions by Robert Wohl, Anne Collins Goodyear, and Laura M. Andre. Raleigh, North Carolina: North Carolina Museum of Art, 2003.

· Peers, Alexandra. "Art and Money." *The Wall Street Journal* (New York), June 9, 2000, W10.

· Perreault, John. "Art: Too Much of the Same." *The Village Voice* (New York), February 22, 1968, 18. Philadelphia: The Jewish Community Centers of Greater Philadelphia, [2003].

· Pincus-Witten, Robert. "Rosenquist and Samaras: The Obsessive Image and Post-Minimalism." *Artforum* (New York) 11, no. 1 (September 1972): 63–69.

· Pitman, Joanna. "Putting the Fizz into Pop." *The Times* (London), October 24, 2006.

· Porter, Bob. "Rosenquist Has Local Tie." *Dallas Times Herald*, January 6, 1966, A14.

· Powers, Austin M. *James Rosenquist: Speed of Light Lithograph Series*. New York: Universal Limited Art Editions; Beijing: DaFeng Gallery, 2009.

· "Prints and Portfolios Published: James Rosenquist, Night Transitions." *The Print Collector's Newsletter* (New York) 16, no. 5 (November–December 1985): 179.

· "Prints and Portfolios Published: James Rosenquist, Off the Continental Divide." *The Print Collector's Newsletter* (New York) 5, no. 3 (July–August 1974): 66.

· "Prints and Portfolios Published: James Rosenquist, Time Door Time D'Or." *The Print Collector's Newsletter* (New York) 21, no. 1 (March–April 1990): 26.

· Ragon, Michel. "Les Etats Unis sont à la recherche d'un art national." *La galerie des arts* (Paris), no. 17 (June 1964): 13–14.

· Rainbird, Sean, ed. *Print Matters: The Kenneth E. Tyler Gift*. With an essay by Pat Gilmour. Exh. cat. London: Tate Publishing, 2004.

· Reif, Rita. "James Rosenquist Painting Auctioned for Record Price." *The New York Times*, November 13, 1986, 21.

· "Revealed: Rosenquist's Monumental Tribute to Human Rights." *The Art Newspaper* (Art Basel Daily Edition), June 13, 2006: 1.

Rose, Matthew. "Signs of His Times: Pop Master James Rosenquist Scales New Heights." *Art and Antiques* 31, no. 5 (May 2008): 52–56.

Rosenberg, Karen. "Art in Review: James Rosenquist, Time Blades." *The New York Times*, November 16, 2007.

Rosenquist, James. "Eulogy [for Leo Castelli]." *Time* (New York), September 6, 1999, 25.

Rukeyser, William S. "The Editor's Desk." *Fortune* (Los Angeles), June 27, 1983, 4.

Russell, John. "Some Special Printmakers." *The New York Times*, January 21, 1979, 25–26.

"Time after Time/Am Puls der Zeit." Translated by Wilma Parker. *Parkett* (Zurich), no. 58 (2000), 29–31 (English), 33–35 (German).

Saarinen, Aline B. "Explosion of Pop Art: A New Kind of Fine Art Imposing Poetic Order on the Mass-produced World." *Vogue* (New York), April 1963, 78–89.

Sandberg, Betsy. "Life: James Rosenquist." *The Daily Freeman* (Kingston, N.Y.), December 8, 1986, 7.

Saltz, Jerry. "First-Round Knockout." *The Village Voice*, November 18, 2003.

Schmitter, Elke. "Kunst: Ekel statt schöner Schau; Eine abgründige Ausstellung zeigt Nahrungskunst aus Europa und den USA." *Der Spiegel*, January 19, 2014, 150.

Schwabsky, Barry. "James Rosenquist." *Artforum* (New York) 40, no. 1 (September 2001): 193.

Schjeldahl, Peter. "The Art World: Time Pieces, James Rosenquist at the Guggenheim." *The New Yorker*, October 27, 2003, 106–07.

"The Art World: Boola Boola, The Yale University Art Gallery Reopens." *The New Yorker*, December 17, 2012, 84–85.

Schudel, Matt. "Arts Briefs: Rosenquist Exhibit." *Sun-Sentinal* (Broward County, Florida), November 22, 2003.

Scull, Robert C. "Re the F-111: A Collector's Notes." *The Metropolitan Museum of Art Bulletin* (New York) 26, no. 7 (March 1968): 282–83.

Selz, Peter H. "American Painting 1970." *Arts in Virginia* (Richmond) 10, no. 3 (spring 1970): 10–23.

Shepard, Richard F. "To What Lengths Can Art Go?" *The New York Times*, May 13, 1965, 39.

Sheppard, Eugenia. "Guests Party Minus Painting." *The Dallas Morning News*, February 25, 1968, C5.

Sherrill, Steven. "Misremembering Jim: James Rosenquist is Back." *Art Review*, no. 4 (October 2006): 89–95.

Sischy, Ingrid. "Rosenquist's Big Picture." *Vanity Fair*, no. 513 (May 2003): 186–193, 228–230.

Slesin, Suzanne. "New York Artists in Residence: James Rosenquist." *Artnews* (New York) 77, no. 9 (November 1978): 70.

Smith, Roberta. "Art Center Has Room for the Big and the New." *The New York Times*, June 2, 1999, E1, E5.

"As Chelsea Expands, a Host of Visions Rush In." *The New York Times*, June 1, 2001, E29.

"Art: MoMA Revisits the 1960s." *The New York Times*, March 27, 2016, AR6.

Solomon, Alan R. "Den Nye Amerikanske Kunst." *Louisiana Revy* (Humlebæk, Denmark), no. 4 (April 1964): 2–3.

Solomon, Deborah. "The Pop Art Era." *The New York Times*, December 13, 2009, BR12.

Sparks, Esther. "James Rosenquist." In Sparks, *Universal Limited Art Editions: A History and Catalogue, The First Twenty-five Years*, 256–69. Exh. cat. Chicago: Art Institute of Chicago; New York: Harry N. Abrams, 1989.

Stallings, Dianne. "The Good News: Aripeka Artist's Mural Lures $2.09 Million." *St. Petersburg Times* (Hernando Times Edition), November 14, 1986, 1, 10.

Sterckx, Pierre. "La peau du collage selon Tom Wesselman [sic] et James Rosenquist." *Artstudio* (Paris), no. 23 (Winter 1991): 84–95.

Stevens, Mark. "King of Pop." *New York* 36, no. 37 (October 27, 2003), 86.

Stevenson, Wade. "Rosenquist, le peintre de l'imaginaire-réel." Translated by Georgette Minazzoli. *XXe Siècle* (Paris), no. 44 (June 1975), 155–61.

Storr, Robert and Mimi Thompson. *Selections from the Private Collection of Robert Rauschenberg*. New York: Gagosian Gallery, 2012.

Story, Richard David. "James Rosenquist." *USA Today* (Arlington, Va.), November 13, 1986, D5.

"A Suit So Crisp It Crackles." *The Straits Times* (Singapore), April 29, 1999, 10.

Swenson, Gene. "Peinture Américaine: 1946–1966." *Aujourd'hui*, no. 55–56 (January 1967): 156–57.

"The Figure a Man Makes." *Art and Artists* (New York) 3, no. 1 (April 1968), 26–29 (part 1), and *Art and Artists* 3, no. 2 (May 1968), 42–45 (part 2). Reprinted as "James Rosenquist: The Figure a Man Makes," in "Gene Swenson: Retrospective for a Critic," October 24–December 5, 1971, special issue of *The Register of the Museum of Art* (Lawrence, Kans.) 4, nos. 6–7 (1971), 53–81.

"Reviews and Previews: New Names This Month—James Rosenquist." *Artnews* (New York) 60, no. 10 (February 1962): 20.

"The New American 'Sign Painters.'" *Artnews* (New York) 61, no. 5 (September 1962): 44–47, 60–62.

"Reviews and Previews: James Rosenquist." *Artnews* (New York) 62, no. 10 (February 1964): 8.

Tallman, Susan. "Big." *Arts Magazine* (New York) 65, no. 7 (March 1991): 17–18.

Talmey, Allene. "Art Is the Core: The Scull Collection." *Vogue* (New York), July 1963, 116–23, 125.

Tannenbaum, Toby. "James Rosenquist: Master Pieces." *School Arts* (Needham, Mass.) 99, no. 3 (November 1999): 31–34.

Teodorczuk, Tom. "The 40-Year Overnight Success." *Evening Standard* (London), October 9, 2006.

Thon, Ute. "Eiscreme, Sex und Revolver—Willkommen in Amerika." *Art—Das Kunstmagazin*, no. 5 (May 2003): 10–28.

Tillim, Sidney. "Further Observations on the Pop Phenomenon." *Artforum* (Los Angeles) 4, no. 3 (November 1965): 17–19.

"Rosenquist at the Met: Avant-Garde or Red Guard?" *Artforum* (New York) 6, no. 8 (April 1968): 46–49.

Trini, Tommaso. "È la via Rosenquist." *Domus* (Milan), no. 455 (October 1967): 46–49 (Italian and English).

Tully, Judd. "Rosenquist Work Brings $2.1 Million." *The Washington Post*, November 13, 1986, B13.

Tschida, Anne. "Pop-art Icon Has Shaped American Art Scene for Decades." *The Miami Herald*, December 2, 2012, 1M, 12M.

Tully, Judd. "Seconds Coming." *Art and Auction* 25, no. 6 (June 2003): 92–102.

Turner, Elisa. "The Right Stuff." *Artnews* 102, no. 9 (October 2003): 96–99.

"James' Juxtaposition." *The Miami Herald*, April 9, 2006, 3M, 11M.

Twardy, Chuck. "Optic Nerve: Archeology at the Speed of Light." *Las Vegas Weekly*, February 12–18, 2004.

Tyler, Ken. "The Paper Dance." In *Master Prints by Hockney, Johns, Rosenquist, and Stella from the Lilja Collection*, 114–47. Exh. cat. Vaduz, Liechtenstein: The Lilja Art Fund Foundation in association with the Henie-Onstad Art Center, Høvikodden, Norway, and Azimuth Editions, London, 1995.

Ulferts, Alisa. "Some Walls Just Cry for a Big Band-Aid." *St. Petersburg Times*, February 1, 2001.

Updike, Robin. "SAM [Seattle Art Museum] Brings Power-Packed Display to Fourth Floor." *The Seattle Times*, July 9, 1998, G24.

van der Marck, Jan. "Of Course It's Art, and the Bacon Really Flies." *The Miami News*, February 15, 1982, A9.

Vander Weg, Kara. "What Is Pop Art?" *GQ* (New York) 71, no. 9 (September 2001), 360–65.

van Gelder, Lawrence. "Footlights." *The New York Times*, May 31, 2000, E1.

"The 'Vasari' Diary: 'Like Sending a Rocket into Space.'" *Artnews* (New York) 78, no. 5 (May 1979): 12–13.

Vigeant, André. "James Rosenquist: Temps-espace-mouvement." *Vie des Arts* (Montreal), no. 51 (summer 1968): 58–61, 80.

Vogel, Carol. "Inside Art: Rosenquist at Acquavella." *The New York Times*, October 7, 2005, B36.

"At Basel Fair, High Rollers and Blue-Chip Artists." *The New York Times*, June 15, 2006, B1, B7.

Wallach, Amei. "Making a Mural Emerge from a Printing Press." *Newsday* (New York), May 19, 1974, part 2, 19–20.

"New Flights of Fancy." *Newsday* (New York), June 29, 1986, 4–5, 13.

Watson, Bruce. "Big!" *Smithsonian* 34, no. 10 (January 2004): 70–75.

Wilmerding, John. *The Pop Object: The Still Life Tradition in Pop Art*. New York: Acquavella Galleries, 2013.

Wolf, Erica. "James Rosenquist." In Sam Hunter, *Selections from the Ileana and Michael Sonnabend Collection: Works from the 1950s and 1960s*, 85–87. Exh. cat. Princeton: Art Museum, Princeton University, 1985.

Woodward, Richard B. "Destruction All Around." *The Wall Street Journal*, March 10, 2012, C13.

Worrell, Kris. "MASS MoCA Milestone: The Large Arts Center in North Adams Is Thriving as Its First Birthday Approaches." *Times Union* (Albany, N.Y.), May 21, 2000, I1.

Worth, Alexi. "James Rosenquist." *Artforum* (New York) 40, no. 7 (March 2002): 27.

Ynclan, Nery. "'Star Thief' Takes Off to Final-Day Acclaim." *The Miami Herald*, June 6, 1983, B3.

Yoshiaki, Tono. "Two Decades of American Paintings." *Mizue* (Tokyo), no. 741 (October 1966): 10–40.

Zeitz, Lisa. "Keine Angst vorm Neuen." *Frankfurter Allgemeine Sonntagzeitung*, no. 19 (May 16, 2010).

Books

This section includes books, chapters of books, sections of dissertations, and brochures unrelated to exhibitions, as well as select book reviews.

· *Acquavella: The First Ninety Years.* With a foreword by William R. Acquavella and an essay by Eugene V. Thaw. New York: Acquavella Galleries, 2012.

· Adler, Edward Jerome. "James Rosenquist." In "American Painting and the Vietnam War," 273–92. Ph.D. diss., New York University, 1985.

· Alloway, Lawrence. *American Pop Art.* London: Collier Books, 1974.

· Amaya, Mario. "James Rosenquist." In Amaya, *Pop Art ... and After: A Survey of the New Super-Realism*, 94–96. New York: Viking Press, 1966.

· Battcock, Gregory. "James Rosenquist." In Battcock, *Why Art: Casual Notes on the Aesthetics of the Immediate Past*, 57–65. New York: E. P. Dutton, 1977.

· Bee, Harriet S., and Michelle Elligott, eds. *Art in Our Time: A Chronicle of The Museum of Modern Art.* New York: The Museum of Modern Art, [2004].

· Bennett, Lennie. "New Perspective." *St. Petersburg Times*, November 15, 2009, 4L–5L.

· Brundage, Susan, ed. *James Rosenquist, The Big Paintings: Thirty Years, Leo Castelli.* Exh. cat. New York: Leo Castelli Gallery in association with Rizzoli, 1994.

· Canaday, John. "F-111 and the Day the House Caught Fire." In Canaday, *Culture Gulch: Notes on Art and Its Public in the 1960's*, 63–73. New York, Farrar, Straus and Giroux, 1969.

· Cerri, Maria Grazia, Marcella Beccaria, Laura Cherubini, Carolyn Christov-Bakargiev, and Giorgio Verzotti. *Castello di Rivoli Museum of Contemporary Art: The Castle of the Savoy Dynasty—The Collection.* Turin, Italy: Umberto Allemandi & C., 2003.

· Chaffee, Cathleen. *Eye on a Century: Modern and Contemporary Art from the Charles B. Benenson Collection at the Yale University Art Gallery.* With a foreword by Jock Reynolds; a preface by Lawrence B. Benenson; and contributions by Katherine D. Alcauskas, Amy Canonico, Robin Jaffee Frank, Jennifer R. Gross, Jennifer Josten, Megan R. Luke, Keely Orgeman, Emily M. Orr, Sarah K. Rich, Maria Taroutina, Elisabeth Thomas, and Diane C. Wright. New Haven: Yale University Art Gallery, 2012.

· Ferguson, Russell, ed. *Hand-Painted Pop: American Art in Transition, 1955–62.* Exh. cat. Los Angeles: Museum of Contemporary Art in association with Rizzoli, 1992.

· Findlay, Michael. *The Value of Art: Money, Power, Beauty.* Munich, London, New York: Prestel Verlag, 2012.

· Garner, Dwight. "Rosenquist Writ Large, by Himself." *The New York Times*, October 28, 2009, C1, C6.

· Glenn, Constance W. *Time Dust, James Rosenquist: Complete Graphics, 1962–1992.* Exh. cat. and catalogue raisonné. New York: Rizzoli in association with the University Art Museum, California State University, Long Beach, 1993.

· Goldman, Judith. *James Rosenquist.* Exh. cat. New York: Viking Penguin, 1985.

· Grigoteit, Ariane. *Affinities: Deutsche Guggenheim 1997–2007; New Acquisitions; Deutsche Bank Collection.* Berlin: Deutsche Guggenheim in association with Deutsche Bank, Frankfurt am Main, 2007.

· *The Guggenheim Collection.* With essays by Anthony Calnek, Matthew Drutt, Lisa Dennison, Michael Govan, Jennifer Blessing, Diane Waldman, Kay Heymer, Susan Davidson, Julia Brown, and Ted Mann. New York: The Solomon R. Guggenheim Foundation, 2006.

· Haskell, David, and Adam Moss, eds. *My First New York: Early Adventures in the Big City.* New York: Harper Collins Publishers, 2010.

· Heartney, Eleanor. "Books: Mixing Cars, Girls and Ripe Tomatoes." Review of *James Rosenquist* by Judith Goldman. *Artnews* (New York) 85, no. 3 (March 1986), 44–45.

· Herkza, D[orothy]. *Pop Art One.* New York: Publishing Institute of America, 1965.

· Honnef, Klaus. *Pop Art.* Edited by Uta Grosenick. Cologne: Taschen, 2004.

· Israel, Matthew. *Kill for Peace: American Artists Against the Vietnam War.* Austin: University of Texas Press, 2013.

· *James Rosenquist.* Exh. cat. New York: Gagosian Gallery, 2001. Essay by William Jeffett.

· *James Rosenquist: Welcome to the Water Planet and House of Fire, 1988–1989.* Exh. cat. Mount Kisco, N.Y.: Tyler Graphics, 1989. Essay by Judith Goldman.

· *James Rosenquist's Commissioned Works.* Stockholm: Painters Posters in association with Wetterling Gallery, 1990.

· Kushner, Marilyn Satin. *Donald Saff: Art in Collaboration.* With an introduction by Avis Berman and a chronology compiled by Susie Hennessy. Munich: Prestel Verlag in association with Delmonico Books, 2010.

· Larson, Philip. *James Rosenquist: Time Dust.* Mount Kisco, N.Y.: Tyler Graphics, 1992.

· Lobel, Michael. *James Rosenquist: Pop Art, Politics, and History in the 1960s.* Berkeley and Los Angeles, California: University of California Press, 2009.

· Madoff, Steven Henry, ed. "James Rosenquist." In *Pop Art: A Critical History*, 241–63. Berkeley: University of California Press, 1997.

· *The Margulies Collection.* With an interview of Martin Margulies by Peter Plagens; essays by Peter Plagens and Klaus Kertess; and commentaries by Martin Z. Margulies and Katherine Hinds. Miami: The Martin Z. Margulies Foundation Inc., 2008.

· McCarthy, David. *American Artists Against War, 1935–2010.* Oakland: University of California Press, 2015.

· Meyers, Herb, and Richard Gerstman, eds. *Creativity: Unconventional Wisdom from 20 Accomplished Minds.* Houndmills, Basingstoke, Hampshire, United Kingdom and New York, New York: Palgrave Macmillan, 2007.

· Miller, Dana, ed. *Whitney Museum of American Art: Handbook of the Collection.* With an introduction by Adam D. Weinberg. New York: Whitney Museum of American Art, 2015.

· Mulas, Ugo, and Alan Solomon. "Rosenquist." In Mulas and Solomon, *New York: The New York Art Scene*, 256–69. New York: Holt, Rinehart and Winston, 1967.

· Pisano, Dominick A., ed. *The Airplane in American Culture.* With essays by Dominick A. Pisano, Roger Bilstein, Charles L. Ponce de Leon, Jill D. Snider, Suzanne L. Kolm, Katherine Sharp Landdeck, Tom D. Crouch, Laurence Goldstein, Gerald Silk, Timothy Moy, H. Bruce Franklin, and John Darrell Sherwood. [Ann Arbor]: The University of Michigan Press, 2003.

· Rainey, Tiffany. "A Work in Progress." *Florida International Magazine* 12, no. 12 (December 2009), 58–60.

· Robbins, Kadee, ed. *The Kirk Varnedoe Collection.* Savannah, Georgia: Telfair Museum of Art, 2006.

· Rublowsky, John, and Ken Heyman. "James Rosenquist." In Rublowsky, *Pop Art*, 87–107. New York: Basic Books, 1965.

· "Rosenquist, James." In Evelyn Weiss, Barbara Hermann, and Christine Schillig, eds., *L'Art du 20e siècle Museum Ludwig Cologne*, 635–39. Cologne: Taschen, 1996.

· Sandback, Amy Baker. "Books: James Rosenquist." Review of *James Rosenquist* by Judith Goldman. *Artforum* (New York) 24, no. 4 (December 1985): 15–16.

· [Taguchi, Hiroshi, Masashi Shiobara, Tomio Koyama, and Nobuyuki Hiromoto.] *Global New Art: Taguchi Art Collection.* Tokyo: Bijutsu Shuppan-Sha Co., Ltd., 2010.

· Tucker, Spencer C., ed. *The Encyclopedia of the Vietnam War, Second Edition.* Santa Barbara, California: ABC-CLIO, LLC, 2011.

· *VI5IONS 15 Years Deutsche + Guggenheim.* Frankfurt am Main: Deutsche Bank AG and New York: Solomon R. Guggenheim Museum and Foundation, 2012.

· [Weisman, Billie Milam, Richard Koshalek, Rosalind Bickel, David S. Rubin, Kimberly M. Stämmer]. *The Eclectic Eye: Selections from the Frederick R. Weisman Art Foundation.* Los Angeles: Frederick R. Weisman Philanthropic Foundation, 2004.

· "What It Is." Review of *James Rosenquist, The Big Paintings: Thirty Years, Leo Castelli*, edited by Susan Brundage. *Artnews* (New York) 94, no. 2 (February 1995): 27.

Museum Ludwig would like to thank

Peter und Irene
Ludwig Stiftung

ARoS Aarhus Kunstmuseum
would like to thank

Both museums would like to thank

TERRA
FOUNDATION FOR AMERICAN ART

This catalogue is published in
conjunction with the exhibition

**James Rosenquist
Painting as Immersion**

Curated by Stephan Diederich
and Yilmaz Dziewior

Museum Ludwig, Cologne
November 18, 2017 — March 3, 2018

ARoS Aarhus Kunstmuseum
April 14 — August 19, 2018

MUSEUM LUDWIG

Heinrich-Böll-Platz
D-50667 Cologne/Germany
Tel. +49 (0)221 221 26165
Fax +49 (0)221 221 24114
www.museum-ludwig.de

Museum Ludwig

Director
Yilmaz Dziewior

Secretary
Ursula Hübner

Curator
Stephan Diederich

Curatorial Assistants
Simone Schmahl, Talia Walther

Registrar and Tour Management
Christin Wähner
Assisted by Isabel Neuendorf, Gitta Hamm

Exhibition Coordination
Iris Maczollek with Helen Spätgens

Conservation
Kathrin Kessler with Yvonne Garborini,
Isabel Gebhardt, Sophia Elze, Petra Mandt,
Astrid Schubert

Carpentry
Leif Lenzner with Michael Bangert, Milan Scharf,
Rodrigo Ferreira Melo, Marie-Charlott Stenzel,
Max Rommeswinkel and Sven Bormes,
Hanjo Nonnast, Olaf Czosnowski

Building Management
Lukas Hofmann, Dirk Otter

Technical Management
Guido Fassbender with Thomas Loerzer, Mario
Morawitz, Peter Pier, Thomas Sydlik, Isa Uzun,
Ingo Weber, Andreas Wischum, Michael Zorn

Press and Public Relations
Sonja Hempel, Anne Niermann, Kirsten te Brake,
Donata aus der Wieschen

Archivists
Anina Baum, Beate Bischoff, Meike Deilmann

Fundraising
Lisa Schade

Education
Angelika von Tomaszewski

Administration
Angela Coenen, Marion Funken, Susanne
Brentano, Ursula Meyer-Krömer, Monique Rose,
Nadin Schön

ARoS Aarhus Kunstmuseum

Director
Erlend G. Høyersten

Chief Curator and curator
of the exhibition at ARoS
Lise Pennington

Senior Exhibition Coordinator
Anne Mette Thomsen

Head of Technical Department
Jakob Hvam

Art Handlers
Jørn H. Andersen
Thomas Rasmussen

Head of Education and Interpretation
Marianne Grymer Bargeman

Commercial Manager
Bettina Bach Nielsen

Communications Officer
Anne Riis

Catalogue

Editor
Stephan Diederich and Yilmaz Dziewior

Design
Tino Grass
Assisted by Elina Haridy and Barney Fagan

Publication Management
Iris Maczollek with Helen Spätgens

Text and Photo Editor
Leonie Pfennig
Assisted by Corinna Wolfien

Image and Text Research
Leonie Pfennig, Simone Schmahl, and Talia Walther

Translations
Ingrid Hacker-Klier (English-German), Stefan Ripplinger
(Chronology, English-German) / Lance Anderson, Sylee Gore,
Bronwen Saunders, Allison Moseley (German-English) /
SprogBiz (German / English-Danish)

Lektorat / Copyediting
Tas Skorupa (English)
Joachim Geil (German)
Lise Pennington and Anne Mette Thomsen (Danish)

Reprography
Heinrich Miess

Reproductions
Helio Repro GmbH

Editorial Direction
Constanze Holler

Production Management
Cilly Klotz

Printing and Binding
Printer Trento S.r.l.

Typeface
Trade Gothic Next

Paper
phoenixmotion xenon, 135 g/m^2

Verlagsgruppe Random House FSC® N001967

Printed in Italy

ISBN 978-3-7913-5724-9 (English edition)
ISBN 978-3-7913-5723-2 (German edition)
ISBN 978-3-7913-6818-4 (Danish edition)

www.prestel.com

© 2017 Museum Ludwig, Cologne, ARoS Aarhus Kunstmuseum,
the authors and artists and Prestel Verlag, Munich · London · New York
A member of Verlagsgruppe Random House GmbH
Neumarkter Strasse 28, 81673 Munich

Prestel Publishing Ltd.
14-17 Wells Street
London W1T 3PD

Prestel Publishing
900 Broadway, Suite 603
New York, NY 10003
A CIP catalogue record for this book is available from the British Library.

Photo credits

The numbers refer to the figure numbers in the catalogue

All reproductions of artworks by James Rosenquist unless otherwise noted:
Courtesy the Estate of James Rosenquist

Courtesy of the Estate of James Rosenquist: 15, 18–20, 49, 50, 53, 68,
 78, 115, 117, 118, 128, 131, 134, 145, 147, 148, 152, 167–69, 183,
 187, 197–99, 201, 203, 281, 286, 294–98, 303–10, 312, 313, 316, 317,
 322–24, 326–33, 335–40, 343, 344, 347, 350, 362, 366, 367, 374–77,
 379–82, 387, 388, 390, 393, 395, 398, 399, 401–02, 404, 405, 419,
 430, 432, 433, 436–38, 440, 442, 443, 446–52, 458, 462–63, 465, 471
Oliver Abraham: 453
Courtesy Acquavella Galleries: 456, 457, 460, 461
Bob Adelman Estate: 60, 64, 193, 226, 227, 229–35, 239–42, 299, 385,
 421, 424, 426, 427
Alexander Agor/courtesy the Estate of James Rosenquist: 427, 429
Alamy Stock Foto: 116
Marianne Barcellona: 431
Manfredi Bellati: 153
Paul Berg/courtesy the Estate of James Rosenquist: 71, 369–72
Russ Blaise: 248, 434
Charles Brittin: 293
Charles Brittin Archive, Getty Research Institute, Los Angeles (2005.M.11),
 © J. Paul Getty Trust: 292
Rudolph Burckhardt/courtesy the Estate of James Rosenquist: 51
Courtesy Center for Creative Photography, University of Arizona © 1991
Hans Namuth Estate: 48, 102, 138, 146, 236–38, 425, 428
Marabeth Cohen-Tyler: 249, 251–61, 439
John Corbett: 470
The Estate of David Gahr/Getty Images: 149
Sidney Felsen: 417
Hollis Frampton: 95, 349
Georg Goebel/picture-alliance/dpa: 66
Gianfranco Gorgoni: 55, 189, 190, 213, 297, 413–15, 420, 472
Michael Harrigan: 462, 463
Sol Hashemi © Judd Foundation: 474
David Heald © SRGF, NY: 454
Ken Heyman: 87, 195, 363
George Holzer/courtesy of U.S.F. Graphicstudio: 244
Courtesy of Gordon Hyatt: 401, 402
The Jewish Museum, New York: 150
© Permission Renate, Hans and Maria Hofmann Trust: 120
Peter A. Juley & Son Collection, Photograph Archives: 45
Annie Leibovitz: 475
Wilhlem Leuschner/dpa/picture alliance: 287
Carey Maxon: 469
Minneapolis Institute of Art: 52, 119
Alexander Mirzaoff/courtesy the Estate of James Rosenquist: 56, 225, 416,
 418
Jack Mitchell: 186
Jack Mitchell/Getty Images: 397
Peter Moore/courtesy the Estate of James Rosenquist: 386
Ugo Mulas © Ugo Mulas Heirs. All rights reserved. Courtesy Archivio
 Ugo Mulas, Milano – Galleria Lia Rumma, Milano/Napoli: 94
Jean-Erick Pasquier/Gamma-Rapho/Getty Images: 266
Claude Picasso: 184 a–l
Eric Pollitzer/courtesy the Estate of James Rosenquist: 194, 348
Wolf P. Prange/courtesy the Estate of James Rosenquist: 170

Wolf P. Prange/Zentralarchiv für deutsche und internationale Kunstmarkt-
 forschung (ZADIK), Cologne, Bestand H006_X_0001_0036:185
Rheinisches Bildarchiv Köln, Cologne: 17 (Michael Albers/rba_d024407_01,
 Michael Albers/rba_d024407_03), 18 (Britta Schlier, Sabrina Walz/
 rba_d050761_01–04), 19 (Britta Schlier, Sabrina Walz/
 rba_d050761_05), 202 (rba_130817), 288 (rba_d000087),
 408 (rba_L002364_12A), 409 (rba_L002364_8A), 410 (rba_138016),
 detail p. 137 (rba_d046973_02).
Roger-Viollet/Albert Harlingue: 47, Henri Manuel: 46
Louis Rosenquist/courtesy the Estate of James Rosenquist: 285, 311, 314,
 315, 318–21, 325, 391
Mathias Schormann © SRGF, NY: 40, 67
Steve Schapiro/Corbis/Getty Images: 388
Shunk-Kender: 389
Spencer Museum of Art, University of Kansas, Gift from the Gene Swenson
 Collection, 1970.0164: 368
Courtesy of Through the Flower Archive: 191, 192
Ricardo Torres: 440
Walker Arts Center, Minneapolis: 179
Ursula Wevers: 200

Every effort has been made to trace and contact copyright holders prior to
going to press but this has not been possible in every case. If notified, the
publisher will undertake to rectify any errors or omissions at the earliest
opportunity.